SHINTŌ

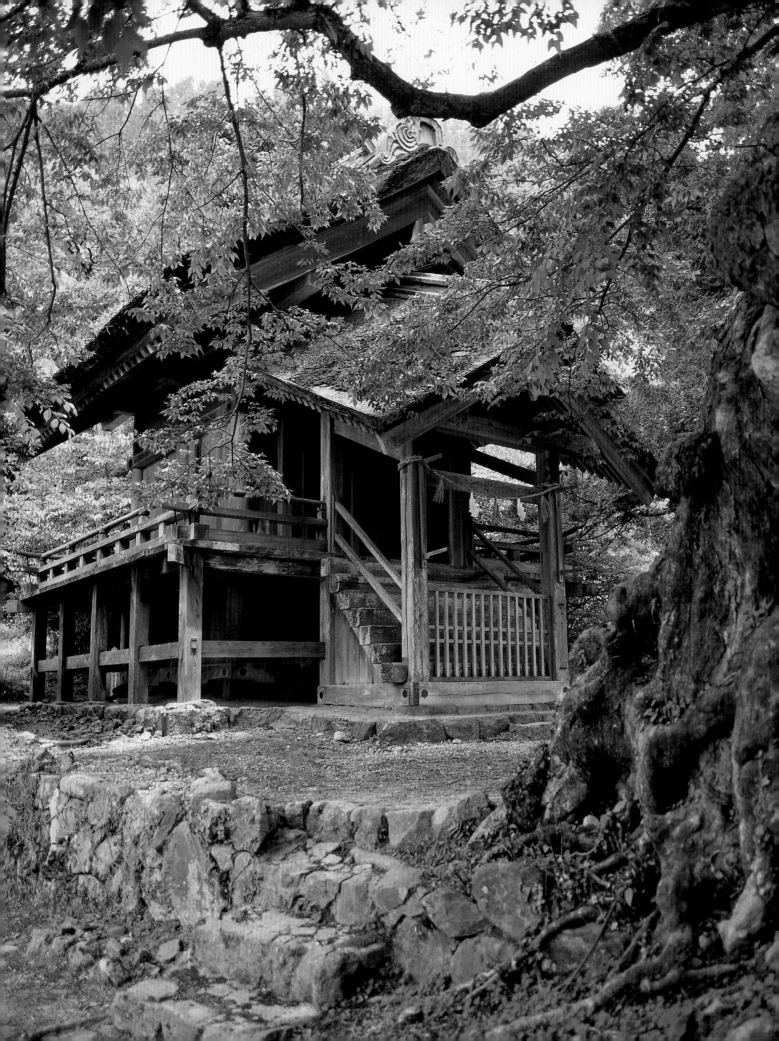

SHINTŌ

THE SACRED ART OF ANCIENT JAPAN

Edited by Victor Harris

THE BRITISH MUSEUM PRESS

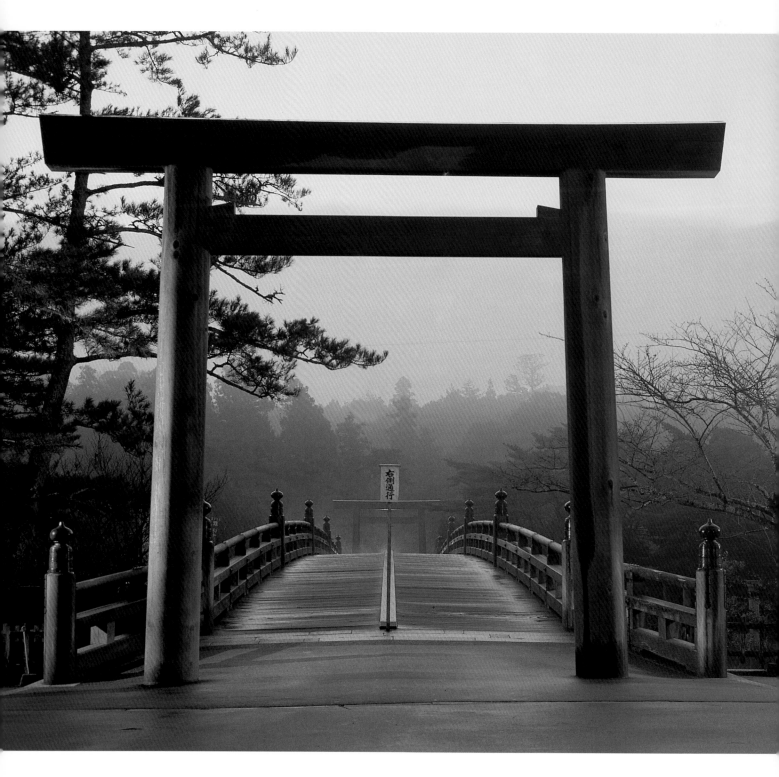

ABOVE The *torii* (gate) and Uji Bridge over the River Isuzu at the approach to Ise Shrine. (Photo: Jingū Office)

PREVIOUS PAGES Kamosu Inochinushi Jinja, subsidiary shrine of Izumo Ōyashiro, Shimane Prefecture, excavation site of the bronze halberd and *magatama* jewel (cat. no. 32) of the Yayoi period (300 BC–AD 300). (Photo: Izumo Ōyashiro)

FRONT COVER Mask of an aged woman (cat. no. 72), Kamakura period (1185–1333), wood with pigment and hemp. L. 17.6 cm. (Chūson-ji Temple, Iwate Prefecture)

BACK COVER Kasuga deer mandala (cat. no. 78), Kamakura period (1185–1333), colour on silk. H. 76.5 cm, W. 40.5 cm. (Nara National Museum)

© 2001 The Trustees of The British Museum
First published in 2001 by The British Museum Press
A division of The British Museum Company Ltd
46 Bloomsbury Street, London WC1B 3QQ

A catalogue record for this book is available from the British Library
ISBN 0 7141 1498 7
Designed and set in Palatino by Harry Green
Printed in England by Balding + Mansell

Contents

Message from The Japan Foundation

I should like to express my immense pleasure upon the opening of this exhibition, 'Shintō: The Sacred Art of Ancient Japan', which represents the Japanese tradition of sacred art. As the main event of 'Japan 2001' in the UK, we hope that many will visit The British Museum to view and enjoy this exhibition.

There are many aspects of the life of the ancient Japanese that we are not able to know or understand. From their beautiful artworks, however, we can guess their feelings towards sacred or holy things such as the weather (a heavy rain or drought), nature (mountains, ocean, rivers, forests) and animals. They might have some aspects in common with the British culture, which has been handed down from the ancient people who lived in the British Isles and from fairy tales of the spirits in forests which have been passed down through the generations.

In the Jōmon period (12,500–300 BC), people created powerful works, using delicate techniques as well as bold and dynamic ones, and these ancient works still have a strong influence on various fields of artistic activity today. We hope that visitors will be able to feel the Japanese spiritual world from the works that artists from each age created from their souls, using refined techniques and skills.

Since its establishment in 1972, The Japan Foundation has engaged in cultural exchange programs with more than 130 countries – in scholarship and research, the arts and other fields – aimed at the promotion of mutual understanding and friendship between Japan and other countries. The Japan Foundation organizes and sponsors many exhibitions each year with the co-operation of its counterparts both overseas and in Japan.

Outstanding works of art possess the power to appeal directly to those who gaze upon them. I am confident that the masterpieces on display in this exhibition will transcend all differences of time, culture and language and will appeal directly to the sensibilities of the viewers. We hope that all will be able to savour fully the rich world of Japanese art and that this exhibition will contribute to greater familiarity with Japanese culture as well as to deepened friendship and continuing cultural exchange between Japan and the UK.

This exhibition would not have been possible without the co-operation and goodwill of many people. We are profoundly grateful to those who have loaned many valuable works from their collections, as well as to the many individuals and organizations whose support made it possible.

FUJII Hiroaki
President
The Japan Foundation

Message from Agency for Cultural Affairs

Friendship between Japan and the United Kingdom has a long history. William Adams (Miura Anjin), an Englishman who landed in Japan after being shipwrecked while on the Dutch ship *De Liefde* in 1600, was one of the first links with Britain, but it was not until the signing in 1894 of a Treaty of Friendship, Commerce and Navigation that formal relations between the two countries were established. Exchanges over the past century have expanded to include dimensions such as culture, politics and economics.

The Japanese have always been very interested in the UK, one of the world's most developed countries to introduce the parliamentary system of government under a constitutional monarchy. Towards the end of the Edo period and into the beginning of the Meiji era (mid nineteenth century), a number of Japanese studied at its fine institutions. Among them were Mori Arinori, Fukuzawa Yukichi and Natsume Sōseki, who later played important roles in the modernization of Japan.

Located at opposite ends of the vast Eurasian continent, Japan and the UK are both civilizations that have evolved from ancient times to become unique in their context. Inspired by a coincidentally common environment and uniquely positioned, the people of our countries have also developed friendly sentiments towards each other, which has further accelerated recent exchanges in both human and material assets.

British exhibitions continually attract the attention of the Japanese public, and its artwork and cultural property have stimulated intellectual interest, resulting in a deeper understanding of your country.

Likewise, the Agency for Cultural Affairs of Japan organizes, on a yearly basis, many Japanese historical art exhibitions around the world. One exhibition often remembered is the one held at the British Museum during the Japan Festival 1991, entitled 'Kamakura: The Renaissance of Japanese Sculpture'. It drew much attention from the British people and contributed greatly to a deeper understanding of Japanese history and culture.

'Shintō: The Sacred Art of Ancient Japan' aims at introducing the Japanese sense of beauty and religion as developed over many centuries. It is hoped that this important exhibition in 'Japan 2001' will provide an opportunity for visitors to learn more about Japan, leading to mutual understanding and a strengthened friendship.

Finally, I would like to express my great appreciation to the Director of The British Museum, the people who offered kind assistance and the lenders of the items exhibited.

SASAKI Masamine
Commissioner
Agency for Cultural Affairs

Lenders and Contributors

The Trustees of The British Museum warmly acknowledge the generosity of the co-organizers, sponsors and lenders for this exhibition.

Co-organizers
AGENCY FOR CULTURAL AFFAIRS
SUZUKI Norio and YUYAMA Ken-ichi, Planning
OKUBO Masahiro and NODA Kiyoshi, Co-ordination
ITŌ Shirō, Organization

THE JAPAN FOUNDATION
MATSUNAGA Fumio and FURUYA Masato, Co-ordination

Lenders
Agency for Cultural Affairs
Akana Hachiman-gū, Shimane Prefecture
Aomori Prefectural Archaeological Research Centre
Atsuta Shrine, Aichi Prefecture
Chūson-ji Temple, Iwate Prefecture
Dai Shōgun Hachi Jinja, Kyoto
Dannō Hōrin-ji, Kyoto
Fujioka Shinzō
Fuji-san Hongū Sengen Shrine, Shizuoka Prefecture
Fujita Art Museum, Ōsaka
Fuki-ji Temple, Ōita Prefecture
Fukuiken Tōgeikan (Fukui Prefectural Ceramic Museum)
Fukuoka City Museum
Gumma Archaeological Research Centre
Gumma Prefectural Museum of Art History
Hachinoe City Museum, Aomori Prefecture
Hase-dera, Nara
Hosomi Art Institute, Kyoto
Hyakusai-ji, Shiga Prefecture
Ibaraki Prefectural History Museum
Ichinoe-machi, Iwate Prefectural Museum
Idemitsu Museum of Arts, Tokyo
Idojiri Archaeological Museum, Nagano Prefecture

Imperial Household Agency
Inō-jinja, Mie Prefecture
Isonokami-jingū, Nara Prefecture
Iwate Prefectural Museum
Izumo Ōyashiro
Jingū Chōkokan-Nōgyōkan Museum, Mie Prefecture
Kagawa History Museum, Kagawa Prefecture
Kannon-ji, Kagawa Prefecture
Kasuga Taisha, Nara
Kibitsu Jinja, Hiroshima Prefecture
Kitakami Municipal Museum, Iwate Prefecture
Kōbe City Museum, Hyōgo Prefecture
Kokugakuin University Archaeological Museum, Tokyo
Kongōbu-ji, Wakayama Prefecture
Kōzan-ji, Kyoto
Kuraishi-mura, Aomori Prefecture
Kurayoshi City Museum, Tottori Prefecture
Kushigata-chō Educational Commission, Yamanashi Prefecture
Kyoto National Museum
Kyūshū Historical Museum, Fukuoka Prefecture
Machida City Museum, Tokyo
Masuda Tetsuya
Matsuo Taisha, Kyoto
Meiji University Archaeological Museum, Tokyo
Mikami Shrine, Shiga Prefecture
Minamiichi-machi, Nara
Minami-Kayabe-chō, Hokkaidō
Mitsumachi Kiyoko
Miyako City Educational Commission, Iwate Prefecture
Munakata Taisha, Fukuoka Prefecture
Nara National Museum
National Historical Folk Museum, Chiba
Ninna-ji, Kyoto
Nōman-in, Nara
Okaya Art and Archaeology Museum, Nagano Prefecture
Ōminesan-ji, Nara Prefecture
Ōsaka Furitsu Museum for Yayoi Culture

Ōyamazumi Jinja, Ehime Prefecture
Saidai-ji, Nara
Saitama Prefectural Museum
Sata-jinja, Shimane Prefecture
Seikadō bunko, Tokyo
Sen-oku Hakukokan, Kyoto
Seto Jinja, Yokohama
Shiga-Kenritsu Biwako-Bunkakan, Shiga Prefecture
Shimane Prefectural Centre for Studies of the Ancient Culture
Shimane Prefectural Museum
Shintō Village Museum for Earrings, Gumma Prefecture
Shirayama Hime Jinja, Ishikawa Prefecture
Sōji-ji Temple, Tokyo
Suntory Art Museum, Tokyo
Tamadare Shrine, Fukuoka Prefecture
Tōkamachi City Museum, Niigata Prefecture
Tokyo National Museum
Tokyo University Museum
Tottori Prefectural Museum
Yamanashi Prefectural Archaeological Museum
Yanagi Takashi

Contributors
TD DOI Takashi
SG GYŌTOKU Shin-ichirō
MH HARADA Masayuki
VH HARRIS Victor
OH HAYASHI On
SI ITŌ Shinji (cat. nos. 98–101, 107–110)
SI ITŌ Shirō
YK KAWASE Yoshiteru
TK KIHARA Toshie
MM MORITA Minoru
TO OKU Takeo
TS SAITŌ Takamasa
TY YAMAZAKI Tsuyoshi

Preface

On behalf of The Trustees of The British Museum I should like to express profound pleasure that this exhibition of the sacred art of ancient Japan is being held in our Japanese Galleries. It hardly seems that ten years have passed since the first of the great loan exhibitions organized together with the Agency for Cultural Affairs and the Japan Foundation was held here on the occasion of the Japan Festival in 1991, the centenary of the founding of the Japan Society. During those ten years the British Museum's Japanese Department's activities have gone from strength to strength, with more than thirty special exhibitions in the Japanese Galleries as well as many loan exhibitions within the United Kingdom and to museums in Japan. I am especially pleased that we have been able to participate fully in JAPAN 2001 and proud that we have been able to produce three exhibitions in the Japanese Department, with three further exhibitions being arranged by the Departments of Ethnography and Education for this very important year.

The 1991 exhibition was of the flowering of Japanese Buddhist sculpture during the Kamakura period, and it drew the eyes and the interest of the world. At the time it was remarked that while the British Museum was rich in sculpture of the classical world, the exhibition was effective in drawing attention to equally impressive sculpture, poorly represented outside Japan. On this occasion in 2001 the content of the exhibition is even less available outside Japan, and we are indeed privileged to be the venue for this most quintessentially Japanese subject, 'Shintō: The Sacred Art of Ancient Japan'. Shintō, the distillation of the ancient religious sensibility of Japan, is something at once inherently Japanese, yet with universal resonances. The precepts of Shintō include a special reverence for nature, which is something central to the cultures of many long-established societies but in Japan has proved to be the very nurse of the arts and crafts. I believe it is most apposite that the world is able to come here to the British Museum in this first year of the twenty-first century to celebrate a subject so meaningful in terms of Japanese culture, and with so much promise for the future of mankind and our natural environment. I welcome this exhibition in the sure knowledge that it will be a lasting mark of the deep friendship between the United Kingdom and Japan, and another great stepping-stone in the international understanding of world cultures. It is an exhibition of which every Japanese citizen must surely be proud.

I am deeply grateful to the Japan Foundation and the Agency for Cultural Affairs, Tokyo, for organizing the exhibition with us, and to the Asahi Shimbun, with whom we have such a deep and long relationship, together with Panasonic, NEC, NTT and Japan Airlines for their most generous support, and to the many shrines, temples, museums and other owners of the exhibits which they have so generously made available for the exhibition.

Dr R G W Anderson
Director
The British Museum

Acknowledgements

Victor Harris

So many people have been helpful and encouraging over the past five years or so since this exhibition was first planned that it is not possible to name them all. But I am particularly grateful to the many friends and colleagues in Japan who have given advice and, in many cases, practical help. These include many curators in museums, especially Kyoto National Museum, Nara National Museum, Tokyo National Museum, Shimane Prefectural Museum, the Kashihara Archaeological Institute and its Museum in Nara Prefecture and Shimane Kodai Bunka Centre. I also owe much to the Agency for Cultural Affairs, not only for their planning of the exhibition and scholastic input into both the exhibition and this catalogue, but for their personal kindness on the several occasions I have been in Japan in connection with the project, in particular Suzuki Norio and Yuyama Ken-ichi, who undertook the planning of the exhibition, the co-ordinators Okubo Masahiro and Noda Kiyoshi, and Itō Shirō, who was responsible for the organization. Colleagues in The Japan Foundation in Japan and the UK have been no less supportive, especially Matsunaga Fumio and Furuya Masato, who co-ordinated the operation in Japan, and Waketa Munehiro and Takekawa Junko, of the London office. Several colleagues in the Agency for Cultural Affairs contributed essays and entries to this catalogue, and they are listed on page 8. The Japan 2001 Committee and the Japanese Embassy in London have been encouraging throughout. The Asahi Shimbun, with whom this Museum has had such a close relationship over the years, has always given me the confidence that, despite the poor economic climate in Japan, the exhibition costs in the UK would be funded through their endeavours. I am grateful to the number of Asahi personnel who have handed down their enthusiasm for the project through staff changes over the past seven years or so, and particularly to President Hakoshima Shin-ichi, the current Director of the Cultural Projects Division Takagi Toshiyuki, and Okura Mieko, also of the Cultural Projects Division.

While in Japan earlier this year at the invitation of the Nara National Museum, I was privileged to visit a number of Shintō shrines and see some of their ancient treasures, including a number of pieces included in this exhibition. Washizuka Yasumitsu, Director of the museum, and his staff, particularly the Chief Curator Sakata Munehiko, his recent successor Kajitani Ryōji, and Inokuchi Yoshiharu, gave me every support. The priests and officials of Ise-jingū, Izumo Ōyashiro, Mankusen Jinja, Isonokami-jingū, Yaegaki Jinja, Sata-jinja and Mikumori Jinja were equally generous with their time and knowledge.

Colleagues in The British Museum have as usual been most tolerant of my shortcomings, particularly the staff of British Museum Press, who were provided with manuscripts at an unreasonably late time. I owe it largely to Emma Way that the catalogue has been produced in such a lavish style, and to Nina Shandloff that it was published in time for the exhibition. Both Nina and Mitzi Bales, the copy editor, spent many late nights working on the book. Jill Towner also performed magnificently, turning out processed copy at short notice. Sarah Levesley managed somehow to keep the production under control, and Harry Green has, as always, put his whole heart into the book design.

The design of the exhibition itself has been most competently devised by Paul Tansey, and the two-dimensional element by Paul Goodhead and Richard Dunn. The staff of the Department

of Japanese Antiquities have all helped throughout, but I would particularly like to thank Mavis Pilbeam for her sterling help and advice on the text, and for applying her linguistic, literary and organizational skills over many weeks to complex and exacting aspects of the project. The administrative work was competently undertaken by the exhibitions officer, Sally Morton, and Catherine Edwards, who has seen the exhibition through from its inception. Timothy Clark helped in translating a number of the catalogue entries and advising on many details of the manuscript. Meri Arichi also translated many entries, helped with proof-reading, and gave me advice on that content of the catalogue which falls within her specialist area.

The inspiration has come directly from the art and antiquities of Japan.

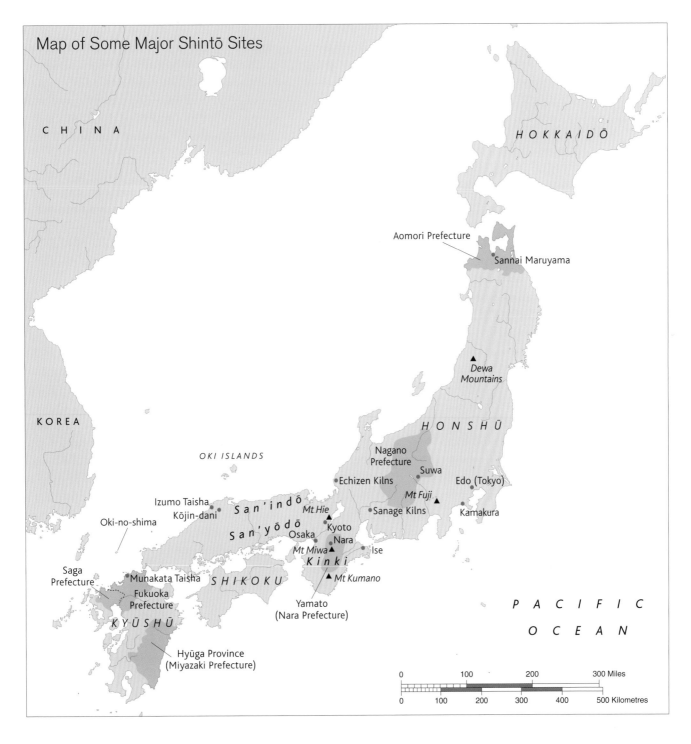

Map of Some Major Shintō Sites

Introduction

Victor Harris

This exhibition explores the arts and crafts of Japan associated with medieval religious practice centred on sacred places, Shintō shrines and Buddhist temples. The *kami* of Shintō at the time of the first Japanese written records in the early eighth century AD were nature deities of the land, skies and waters. They existed in countless forms, many personified as ancestral deities and many presiding over various human activities. Religious beliefs in Japan had developed from many sources. Prehistoric shamanistic practices are believed to be the origin of much Shintō belief and ritual. Immigration from China and Korea via both northern and southern routes brought numerous customs which helped shape regional cultures inside Japan. From about two thousand years ago, various Chinese systems including divination, astrology, and cosmology, added to the mix of magic and nature worship. Chinese social philosophies such as Confucianism, Daoism and concepts of the afterlife influenced the formation of Japan into a unified nation and theocracy, and helped crystallize the obscure and varied scattering of local beliefs into Shintō.

The exhibition sets out to trace the origin and development of Shintō by examining artefacts of the past preserved in shrines and temples, or excavated from ritual and tomb sites over the past century or so. These artefacts enable the subject to be examined back through time to the first written legends of the creation mythology in the eighth century, and beyond that into Japanese prehistory.

Following the adoption of Buddhism as the national religion in the early seventh century, the indigenous Shintō faith took on aspects of the new religion. By the ninth century, the nature deities of Shintō, the *kami*, were depicted in human form like the Buddhas and Bodhisattvas brought from China and Korea. Shintō rites and festivals were added to and enriched by Buddhist and other Chinese and Korean practices. Buddhism itself developed along particularly Japanese lines, which has ensured its continuation as a flourishing faith until the present. This is so, long after its decline in India, where Buddhism originated, and in the nations through which it travelled to reach Japan.

One of the most remarkable aspects of Japanese culture is the careful preservation of artefacts, ensuring that objects from the distant past have been kept in near-pristine condition. This suggests a particular awareness of, and respect for, the spiritual in material things which is at the heart of Shintō. It is exemplified in the 'Three Sacred Treasures' (*sanshu no jingi*) of Shintō: the sword, the mirror and the jewel. These are kept as sacred objects in shrines. Spirituality in material things is also exemplified in the wide range of everyday equipment still deposited as votive offerings at shrines. Although the origins of the nature rites which developed into Shintō lie in the distant past, the Three Sacred Treasures as they are currently recognized owe much to Chinese and Korean cultural and material imports, which were greeted in Japan with awe and reverence.

Around the third century BC waves of immigrants arrived in Japan from China and Korea, bringing agricultural and metallurgical technology. The first bronze bells, mirrors, spears and swords they brought were regarded as holy. These objects have been found buried either singly or in clusters in the early centres of power. By the third century AD a small

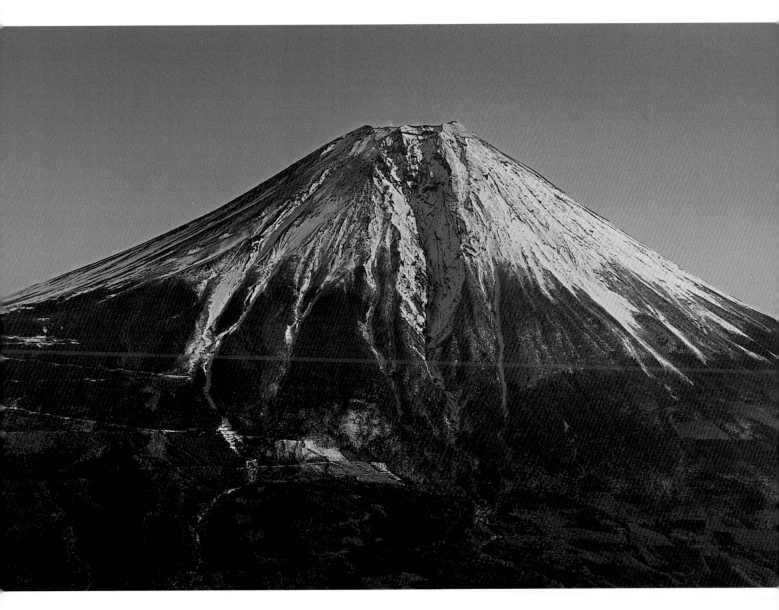

Fig. 1 Mt Fuji.
(Photo: Asahi Shimbun)

number of powerful clans ruled different areas of Japan. The *Wei shi*, Chinese chronicles of the third century, tell of thirty such power bases. The major ones were in Kyūshū, Yamato (now the Nara basin), Izumo (now Shimane Prefecture) and Kantō (eastern Japan). Their rulers were buried in stone chamber tombs set into large earth mounds (*kofun*), giving a name to the Kofun period of around the third–sixth century AD. During this period the nation became unified, and the larger mounds are recognized as the tombs of the first of an unbroken succession of emperors.

Material excavated from *kofun* includes examples of the Three Sacred Treasures and other ritual objects. The first creation myths are contained in the *Kojiki* (AD 712), translated into English by R. Chamberlain, and the *Nihongi* or *Nihon shoki* (AD 720), translated by W. Aston.[1] They describe the long process of unification during this period in terms first of the activities of *kami* sent down from heaven, and later of the emperors and their relationship with China and Korea.

The origins of Shintō are further manifested in the artefacts of the Jōmon period (12,500 to 300 BC), during which Japan seems to have enjoyed a relatively stable and untroubled history compared with the rest of Asia and Europe. The period is marked by the oldest ceramics known, including mysteriously decorated flame pots, vessels decorated with human and animal

forms, and complete figurines. Jōmon peoples seem to have been favoured with peaceful and secure lives and an abundance of natural resources. It is suggested that closeness to, and gratitude towards, nature were engendered during this long period, and that these characteristics have persisted as the essential components of Shintō, in spite of population and cultural changes over the ages.

An appreciation of the part played by natural phenomena during the manufacturing process, resulting in effects beyond the maker's control, has given rise to a quintessentially Japanese aesthetic, which at the same time is of universal significance. It is only in the past hundred years that the world has become aware of the beauty that metallurgical phenomena give to the heat-treated steel blades of highly polished Japanese swords, the accidental beauty of natural ash glaze on ceramics, and the concepts of *wabi* (the quality of frugality) and *sabi* (patina of age) bestowing merit on the humblest creations. The exhibition attempts to show something of the philosophy and art of Shintō, its continuity since prehistoric times and the origins of the Japanese aesthetic sense. It also questions the meaning of art and artefacts from the distant past whose significance can perhaps never be fully explained. At the same time, the objects in the exhibition represent some of the very finest Japanese art.

The Essence of Shintō

The essence of Shintō lies in nature worship, or rather the expression of gratitude towards nature, and in an ecologically balanced coexistence with nature. The *kami*, the gods of Shintō, are associated with strong feelings for nature. Nature's power may be felt in beautiful scenery, a sense of awe, recognition of nature's beneficence in providing for human wants, or fear of the dangers it can unleash in storm, flood, earthquake, and volcanic eruption. The *kami* can inspire or terrify. To feel the deep rumble of an earthquake or to witness the approach of a typhoon in Japan is to sense the immediate presence of a power very much to be respected and placated.

The *kami* themselves defy exact description

and exist in an altogether different world while making their presence felt in the works of nature and of humans. Shintō is essentially the relationship of people to nature, and its rites express requests, gratitude and propitiation. Gratitude for life and for the satisfaction of needs is common to all religions, and it is likely that in prehistoric cultures elsewhere in the world, something like Shintō existed. But Japanese culture seems to have a quality that transcends change and revolution, so that the primeval sits easily with modern science and society.

Shintō is composed of two ideograms, one for *kami* and one for 'the way'. It has been translated as The Way of the Gods, although opinions are divided over whether Shintō is a religion at all, whether it is unique to Japan, and whether the *kami* can be defined as gods. Shintō developed closely together with Buddhism over a long period up to the Meiji Restoration of imperial government in 1868, when it was made the official state religion. In accordance with the *Shimbutsu hanzen rei* (Law of Separation) of Buddhism from Shintō of that year, many Buddhist temples were demolished and removed from shrine precincts. But some temples practised such a deeply interwoven complexity of ritual that the *kami* could not be separated from their Buddhist equivalents.

In the most general sense, the word *kami* refers to all divine beings of heaven and earth that appear in the classics. More particularly, the *kami* are the spirits that abide in and are worshipped at the shrines. In principle, human beings, birds, animals, trees, plants, mountains, oceans, all may be *kami* (fig. 1). According to ancient usage, whatever seemed strikingly impressive, possessed the quality of excellence, or inspired a feeling of awe was called *kami*.[2]

A modern survey of Japanese religion defines Shintō as follows: 'Shintō as a religious system can be regarded as having four main forms: the Shintō of the imperial house (*kōshitsu Shintō*), shrine Shintō (*jinja Shintō*), sect Shintō (*kyōha Shintō*), and folk Shintō (*minkan Shintō*)'.[3]

The Shintō of the present-day imperial house is of a formal and reserved nature and, apart from certain public agricultural rites which the emperor carries out, is private. Shrine Shintō art

is the main subject of this exhibition. The emperor's representative is present at certain annual rites at the shrines of Ise, Izumo and other major shrines. Sect Shintō comprises religious organizations recognized by the Japanese government. It is relatively recent, all thirteen listed sects having been established at the end of the nineteenth century. Folk Shintō is a broad and varied mixture of agricultural rites and festivals, superstitions, divination, faith healing, astrology and popular magic. It is at the heart of Japanese rural life and overlaps with shrine activities.

The Unnamed *Kami*

Although there are many different kinds of *kami*, those embodying aspects of nature are among the most ancient and widespread. There are gods of the wind, sea, rivers and mountains, rice fields, trees and plants, and fertility. The alternately benign and malignant aspects of nature are the subjects of gratitude, awe and terror, and the gods have to be appeased with festivals and offerings. Everywhere in Japan – in the busy streets of the great cities, in the humblest hamlet, in the lonely and desolate places – are found markers to signify the abode of a *kami*: straw ropes around rocks or trees (fig. 2), paper talismans on the branches of trees, small piles of stones. These places are called *yorishiro*, *iwakura*, or *himorogi* (each meaning something like 'temporary abode').

Before the large-scale building of networks of shrines during the Nara and Heian periods (710–1185), nature *kami* were believed to come from their places in heaven, the mountains, or the sea to take up residence in the *yorishiro* when seasonal festivals were enacted. Agricultural communities still invite their particular *kami* to annually prepared sacred places in the fields to reside there until the autumn harvest, afterwards to be escorted back to their normal abode. *Kami* with no formal name are known just by their attribute, such as *Fūjin* (wind) and *Raijin* (thunder). The *kami* of a mountain, waterfall, river, stretch of sea or island may be known by the place name. Thus Miwa-san (Mt Miwa) in Nara Prefecture implies the *kami* as well as the mountain.

There are countless *yorishiro* throughout Japan, many unlisted and known only through folk memory. But the most unmistakable indication of the presence of a *kami* is the shrine building (*yashiro*). There are around 100,000 listed Shintō shrines. Some are vast and tended by a permanent staff, in turn supported by the local parishioners (*ujiko*). Some are almost insignificant, looked after by a single hereditary shrine attendant (*shinkan*). In most cases there will be no image of a deity, whose presence will be only hinted at by the existence of the shrine building and its formal gateway (*torii*). The *torii* is usually a simple wood structure in the rough shape of the Greek letter pi, although there are some of stone. It may be many metres high or so small that a person cannot enter.

The great number of shrines and deities, both known and unknown, is indicated in an expression from the *Nihongi*: *yaoyorozu no kami* ('eight million gods'). The diversity of the nature of the *kami* is indicated in the homily 'even a sardine's head is a god'. Although used flippantly and self-mockingly, this saying is known universally in Japan. There are many minor and familiar *kami*, like the fire gods of folk Shintō which, although cautiously respected, are not usually accorded much ritual in the home. In rural areas, a grotesque mask hung from a pillar in the kitchen is the 'hearth *kami*' (*kamado-gami*), who will protect the dwelling against fire. In artisans' places of work, especially potters' kilns and smiths' forges, the fire *kami* would be given more attention, even if lacking a formal name. Some workshops are devoted to a specialist trade or professional *kami*. There are also stone roadside figures, frequently of male and female couples called *dōsojin*, who are placed at crossroads to inhibit the passage of evils spirits. (A similar function is fulfilled by the Buddhist deity Jizō Bosatsu.)

The Named *Kami*

Of the named *kami*, many are worshipped at networks of shrines in the different regions of Japan. The most ubiquitous of the well-established named *kami* is probably Inari-sama, the deity of rice production, to whom around a third of the 100,000 listed shrines are dedicated. They range

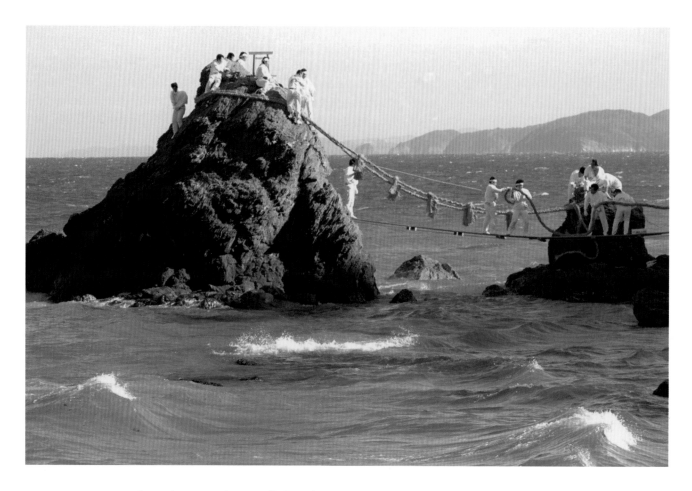

Fig. 2 The *meoto-iwa* (husband and wife rocks) at Futamigaura Bay, Mie Prefecture. Their sacred nature is signified by the straw *shime-nawa* rope joining them.
(Photo: Asahi Shimbun)

from the main shrine called Fushimi Taisha in Kyoto to small structures in the corners of fields. Many have an image of a white fox, the messenger of Inari-sama, holding a key to the rice house. But even though rice is central to Shintō, Inari-sama is outside the mainstream families of *kami* defined in the earliest Japanese histories.

The most important class of named *kami* are those which figure in the creation mythologies, recorded in the *Kojiki* and the *Nihongi* or *Nihon shoki*. These *kami* form a hierarchy with Amaterasu-ōmikami, the Sun Goddess, in the prime position as the ancestor of the early emperors of Japan, and related deities associated with the formation of the unified nation of Japan during the Yayoi period (300 BC–AD 300) and Kofun period (third–sixth century AD).

Ancestral *Kami*

The emperors in Yamato (present-day Nara Prefecture) ruled from around the third century AD through a system of subservient clans, or *uji*. These governed their inherited lands through

Shintō observances called *matsurigoto*, the origin of present-day festivals. The *matsurigoto* were means of religious, social and economic control, whereby the relations between the harvest, the people, the *kami* and the government were continually reconfirmed. Each clan had its own *uji-gami* (clan deity). Although originally the *uji* comprised family or military alliances, they came to be indistinguishable from the residents in the locality of shrines, the parishioners (*ujiko*).

Aspects of ancestral worship in Shintō probably borrowed heavily from Confucianism and Daoism early in Japanese history. Thus a family's ancestors, even recent ones, came to be regarded as *kami*.

Historical Persons

Historical persons were sometimes appointed as official *kami*, with shrines of their own. They were deified in respect of their having an extraordinary talent or having done great deeds for the nation. Prominent among such *kami* is Sugawara no Michizane (AD 845–903). He was a

brilliant scholar and politician of the Soga clan who rose to prominence at the Kyoto court, so inspiring envy among his peers. Through intrigues by the Fujiwara clan, he was falsely accused of wrongdoing and was exiled to Kyūshū in AD 901, where he died in despair after two years. Thereafter the capital, Kyoto, was wracked with storms and other calamities, and

his lifetime. Several centuries later, Tokugawa Ieyasu (1542–1616), the first of the line of shōguns to rule from Edo (present-day Tokyo), was posthumously deified in the Nikkō Tōshō-gū Shrine as Tōshō Daigongen (Great Illuminating Avatar of the East).

At the time of the Meiji Restoration in 1868 there were a number of offices called *shōkon-jo* in

Fig. 3 Origins of Kitano Tenjin Shrine. Six-fold screen, ink, colours and gold on paper, mid to late seventeenth century. The angry unappeased spirit of Sugawara no Michizane (845–903) is depicted in the form of the thunder deity visiting his anger on the courtiers of Kyoto who caused his downfall. (BM JP 1256)

it was decided that the *onryō*, the restless and avenging spirit of Michizane, was the cause. His spirit was appeased by sanctifying a shrine to him, and the storms stopped. By imperial decree he was nominated Temman Kitano (Tenjin), worshipped as the deity of learning. Shrines to Tenjin are found all over Japan and visits to the shrine are virtually mandatory for any parents with academic aspirations for their children. During the Heian period, Tenjin came to be identified with the Buddhist saviour Kannon. Tenjin's *ara-mitama* (wild spirit, as opposed to *nigi-mitama*, the appeased gentle spirit of the deity), is frequently depicted as one of the gods of wind and thunder visiting his wrath on the people of Kyoto (fig. 3).

There are many other examples, among them two important military figures. The first shōgun who ruled Japan, Minamoto no Yoritomo (d. 1199), is deified at the Tsurugaoka Hachiman-gū Shrine in Kamakura, the seat of his government. The shrine was established in 1063, and Yoritomo was a firm patron of the *kami* Hachiman during

which were enshrined those who had died for the country. These had a Buddhist aspect. In 1868 they were converted to Shintō shrines called *shōkon-sha*, and in 1939 the name was changed to *gokoku jinja* (shrines for protection of the nation). The nearly 2,500,000 war dead since the Meiji Restoration are enshrined in the Yasukuni Jinja, Tokyo.

Syncretic *Kami*

There were also Buddhist deity equivalents of *kami* and hybrids of pre-Buddhist Indian origin. One popular example is a group called *shichi-fukujin*, or Seven Lucky Gods, an ensemble of seven *kami* of mixed origin. The range of different attributes, which they bring together as the passengers on a treasure ship (*takara-bune*), indicates the readiness with which Japan has always absorbed foreign gods. Among them Benten (or Benzai-ten), is a female deity deriving from the Hindu river god, Sarasvati. She is depicted with a *biwa* (a kind of lute) and often with a snake. Bishamon-ten is one of the Four Heavenly

Guardians of ancient Buddhism. The cheerful Daikoku-ten is a form of the Shintō deity *Ōkuni-nushi-no-mikoto* of Izumo, and is also associated with the Hindu god Mahakala. His attributes of a sack of plenty, a magic mallet and rats represent the riches of the rice harvest. Daikoku-ten is often paired with Ebisu, the god of prosperity and merchants, who is frequently depicted with a fishing rod and sea bream and who figures in the festivals of fishing villages. Jurōjin and Fukurokuju were originally Daoist hermits particularly associated with longevity. Hotei (Chinese: Pu Tai) was a historical character, portrayed as a jolly rotund Chinese priest. The deity Kisshōten (Kichijō-ten) is associated with fertility and fortune. She is a female deity derived from Lakshmi, the wife of the Hindu deity Vishnu. Kisshō-ten is sometimes depicted as the consort of Bishamon-ten.

The Creation Myths and the Named *Kami*

The Records

The earliest surviving books written in Japan, the *Kojiki* and *Nihongi* or *Nihon Shoki*, were commissioned originally by the Emperor Temmu (r. AD 673–86). His purpose was to present what was known of Japanese history in a form that would consolidate the ancestry and authority of the Yamato clan, with the imperial family at its head. Buddhism had already been adopted, together with aspects of Chinese culture, as mechanisms for the development of stable government. There are also records of contemporary local geographies, customs and legends of the provinces commissioned in AD 713 by Empress Gemmei (r. AD 707–15) called *fudoki*. Only the *fudoki* of the provinces of Izumo, Harima, Hizen, Hitachi and Bungo survive, and only that of Izumo in its entirety.

The *Nihongi* tells first of the creation of the islands of Japan, then of the descent from heaven of Susano-o-no-mikoto, the brother of the Sun Goddess Amaterasu, and the arrival on earth of her grandson Ninigi-no-mikoto. The great-grandson of Ninigi-no-mikoto is eventually named as the Emperor Jimmu, the progenitor of the imperial line.

The writings contain semi-legendary, semi-historical records of warfare between the clans which made up Japan during the early centuries AD, of intercourse with China and, particularly, of links with the three nations then occupying the Korean peninsula, Kokuri (Koguryō), Shira (Silla) and Kudara (Paekche). The heroes of the conflict are at first the *kami* themselves. Following the ascendancy of the Yamato clan as the supreme power over all Japan, the later emperors and aristocracy are said to descend from the *kami*.

The established rules of shrine Shintō, the genealogies of the *kami* and the relationship of Shintō with political activity during the formative centuries up to AD 697 are recorded with varying degrees of accuracy in the *Nihongi*. Of particular significance is the origin of the 'Three Sacred Treasures' of Shintō, as these were also symbols of imperial authority.

The writer(s) of the *Nihongi* apparently gathered material from many sources, and frequently referred to alternative versions of events. Traditions were perpetuated by the specialist guild of reciters called *katari-be*, keepers of oral traditions and histories. The *katari-be* survived long after the introduction of writing into Japan from China might have been expected to make them obsolete, and some believe that their hereditary traditions survive to this day.[4] W. G. Aston's English translation of the *Nihongi* consists of more than 300,000 words and describes the activities of both the *kami* and historical persons. Sections relating to government, relations with Korea, and Shintō symbolism are of historical relevance, although open to differing interpretation. Much of the activity of the *kami*, on the other hand, is confusing. Nevertheless, the basis of shrine Shintō can be seen in the early part of the record, which deals with the creation of Japan itself. The main events of the creation take place both in heaven and in identifiable locations in Japan. Elements of the creation myths have been popularly reenacted in shrine drama since the Nara period and form an integral part of Shintō ritual. Parts of the quasi-historical early material can be shown to be based on fact, and the later part of the work contains histories that are substantially accurate.

The Creation of Japan

The creation myth starts in a distant age when the *kami* lived in heaven, among them two *kami* of the seventh generation, the male Izanagi-no-mikoto and the female Izanami-no-mikoto. Izanagi, standing on the Floating Bridge of Heaven, plunged the Jewel Spear of Heaven through the clouds and into the waters below. When he withdrew it, the droplets that fell formed the island of Onokoro-jima (a part of Japan). The pair conjoined to make Oyashima-guni (the country of eight islands) which was the rest of Japan. Their act of procreation is described in several versions, involving both deities going round a sacred pillar erected on Onokoro-jima. The divine couple bore children, but the birth of the last, the fire *kami*, killed Izanami who went to Yomi-no-kuni (World of Darkness). Izanagi followed and, seeing her in a state of loathsome decomposition, fled in horror back to Onokoro-jima. The proximity of death had induced a state of *kegare* (sin or impurity) basic to Shintō belief. It was necessary to regain a state of purity by ablution.

As Izanagi washed to purify himself, Amaterasu-ōmikami, the Sun Goddess, was born from his left eye and Tsukiyomi-no-mikoto, the moon deity, from his right eye. From his nose was born the Sun Goddess' younger brother, Susano-o-no-mikoto. Amaterasu was to rule the day, Tsukiyomi the night, and Susano-o the land and sea. These three deities are enshrined in Shirayama-hime Jinja Shrine in Ishikawa Prefecture and its many sub-shrines throughout Japan. This event has been cited as the origin of Shintō purification rituals.

Susano-o-no-mikoto was a boisterous *kami* who tormented his sister Amaterasu by obliterating the divisions of her rice fields, flaying her piebald colt and defecating beneath her seat in the palace. Distressed by this behaviour, Amaterasu hid in a cave and closed it with a great stone door. The light of the world thus being extinguished, all eight million *kami* set about to bring her forth again by arranging an entertainment outside the cave, having consulted the divine deities. They bedecked the sacred tree called *sakagi* with a string of five hundred *magatama* (comma-shaped jewels) and blue and white *gohei* (paper streamers), hung the 'eight-hands' mirror from its branches and recited prayers in her praise.

The *Kojiki* says that a number of cockerels were brought together and made to crow. The *Kojiki* version also speaks of the manufacture of a halberd made of iron taken from the rocks of a river. One version of the event describes Ama-no-uzume-no-mikoto performing a comic dance with a spear wreathed in eulalia grass. When Amaterasu opened the mouth of the cave and looked into the mirror, she was led to think that her reflection was a superior deity (fig. 4). At this moment of uncertainty, she was pulled out by a strong *kami* and the entrance of the cave was sealed with a *shirikume-nawa*, a rope made of rice straw.

Susano-o-no-mikoto was forced to do penance and was ejected from heaven. On earth, he went to Izumo Province where he obtained a wife, Kushinada-hime, by saving her from the Yamata-no-orochi, an eight-headed dragon. He made Yamata-no-orochi drunk by giving it eight tubs of saké then cutting off all its eight heads with his sword. In the tail of the creature Susano-o discovered the sacred sword known as Kusanagi-no-tsurugi (Grass Cutter), otherwise called Ama-no-mura-kumo-no-tsurugi (Sword of the Layered Clouds of Heaven), which he gave into the possession of Amaterasu in heaven. His wife was the daughter of Yamatsumi-no-kami. Their son was Fuha-no-moji-kunusunu-no-kami, and his grandson – or in another version, his sixth or seventh descendant – was Ōkuninushi-no-mikoto, otherwise called Ōnamuchi-no-kami or Kuni-tsukuri (Country-maker).

This grandson and his brothers went to Inaba to sue for the hand of a beauty named Yagami-hime-no-mikoto. On the way they encountered a rabbit who had been stripped of his fur by sea creatures, the *wani*, because the rabbit had attempted to use them as stepping stones across the sea. The brothers persuaded the rabbit to bath in salt water, which hurt him further, but Ōnamuchi healed him so that his white fur grew back again. This extraordinary story, which is an essential part of folklore in Izumo, has been interpreted as a military encounter with Korea.

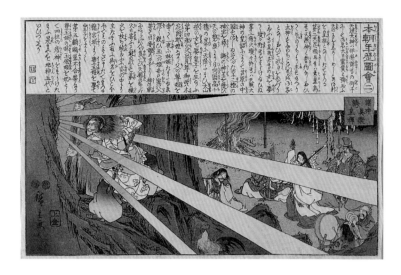

Fig. 4 *The Assembled Gods Perform Music to Entice the Sun Goddess (Shoshin gakusō kōki o sasou).* Colour woodblock print published by Jōshūya Kinzō about 1847–52, from the series *Illustrations of Japanese History (Honcho nenreki zue)* by Utagawa Hiroshige (1797–1858). (BM 1921.11.15.3)

A scholar has pointed out the similarity between the word *wani* and the contemporary word *wang-i* which meant 'king' in Chinese. Ōnamuchi proceeded to take control of the land after his brothers were twice revived from death. He married Yagami-hime (another version tells of his marriage to Suseribimeno-mikoto, the daughter of Susano-o) and ruled over Izumo, together with the *kami* Sukunabikona-no-kami who had come from overseas.

The Sun Goddess Amaterasu planned to send her child Masakatsu-akatsu-katsu-hayabiame-o-oshi-no-mimi-no-mikoto to a warring Izumo, but he, standing on the Floating Bridge of Heaven and seeing how restless the world was below, decided against going. A conference of the *kami* was called, and another son Takemikazuchi-no-mikoto (otherwise Takefutsu-no-kami or Toyofutsu-no-kami) was despatched together with an attendant called Amatori Fune-no-kami (Futsunushi-no-kami). The two gods went to Izumo and demanded control of the land. One son of Ōkuninushi was quickly subdued. The other son fought against Takemikazuchi, but lost. This fight is sometimes cited as the origin of *sumō* (fig. 41).

The vanquished deity fled to Nagano in central Japan, where he is fêted at Suwa Jinja Shrine. As a compromise, Ōkuninushi agreed to give up control of Izumo, but on the condition that he could build a large palace and keep control of 'invisible things', to which Amaterasu agreed. This episode is usually interpreted as the making of a truce between the powerful

Izumo and Yamato clans, with the agreement that Izumo should retain autonomy of religious practices within the province centred on Izumo Ōyashiro, the Grand Shrine of Izumo (fig. 5). The subordinate relationship of Izumo Ōyashiro to Ise Jingū was thus that of the wayward younger brother Susano-o to the elder sister Amaterasu. Amaterasu-ōmikami sent her grandson Amatsu-hiko-hikoho-ninigi-no-mikoto (Ninigi-no-mikoto) to earth, specifically to Toyo-ashihara-no-naka-tsu-kuni (Place where Reeds Grow in Abundance, or Japan) to rule over the inhabitants and civilize them. His descent was opposed by another *kami*, Sarutahiko-no-mikoto, who, being distracted by the voluptuous female *kami* Amano-uzume-no-mikoto, eventually allowed him passage.

This event is celebrated in popular *kagura* drama, usually with comic undertones, with the bearded, round-eyed, long-nosed Sarutahiko being distracted by the charms of Uzume. The place of his arrival was in Hyūga, traditionally Takachiho-no-mine (Mt Kirishima in the volcanic range of Hyūga Province straddling modern Kagoshima and Miyazaki Prefectures in Kyūshū). Amaterasu gave her grandson the 'Three Sacred Treasures': the Yasaka jewel, the Yata-no-kagami (eight-hands mirror) and the sword named Kusanagi (Grass Cutter). Five deities accompanied him, including the ancestors of the mirror makers and jewellers, and the Imbe and Nakatomi clans. This episode has been interpreted as the arrival of agricultural people from continental Asia during the Yayoi period.

The next phase of the mythology treats the events leading to the settlement of the Amaterasu clan in Yamato. It tells the adventures of the grandson of Ninigi-no-mikoto, called Kamu-yamato-iware-biko, who was to become the first emperor, Jimmu, and of his journey of subjugation from Kyūshū via the inland sea to Yamato, where he established his palace at Kashihara and later died. 'The Emperor died in the palace of Kashiba. His age was then 127. The following year, Autumn, the twelfth day of the ninth month, he was buried in the *misasagi* (*kofun* tomb) northeast of Mt Unebi' (*Nihongi*, p. 135). This marked the establishment

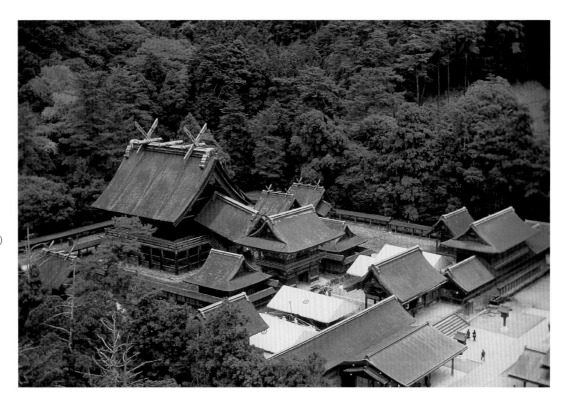

of the imperial lineage invested in the Yamato clan. The *Nihongi* gives a genealogy of the imperial family starting from this time, which when extrapolated back from the known dates of the non-mythical emperors, gives a date of 660 BC. An early Kofun period tomb in the location described in the *Nihongi* is recognized as that of Jimmu. Professor William Gowland (1842–1927) reported the visit of an imperial envoy bringing traditional offerings of the mountain, river and sea to the tomb.

Campaigns moved to eastern Japan. The indigenous Ainu people were driven further and further north to settle finally in Hokkaidō, where the Jōmon pottery style persisted for a time after the *Nihongi* was written. The wars leading to the unification of Korea are recorded, with much detail of immigration and intermarriage. The details of the events leading up to Yamato supremacy are confusing and provide endless opportunity for historical argument, but the end result is clear. From around the fourth century, the emperors of Japan ruled from Yamato after a number of major military campaigns of subjugation involving Korea, Kyūshū, Izumo and eastern Japan, and talented immigrant Koreans were

welcomed and formed an essential component of the Yamato aristocracy.

The creation myths are fundamental to an understanding of Shintō since they contain the origins of much of Shintō ritual and give an account of the prehistoric unification of Japan. Although the histories are couched in terms of the mythical activities of the ancestral *kami*, they are becoming increasingly respected in the light of recent archaeological discoveries and anthropological studies.

The Practice of Shintō

As explained above, Shintō was separated from Buddhism and made the national religion during the Meiji Restoration. It remained so until after the Second World War when new laws allowed virtually complete religious freedom. In some cases, clear-cut Shintō practices were distinct from Buddhism in well-established ritual. In other cases, where Buddhism and Shintō were inextricably combined, the Buddhist element often prevailed, though deeply imbued with Shintō concepts. In minor shrines, it is often unclear whether the deity is

primarily Buddhist or Shintō. It is not uncommon for Buddhist sutras to be chanted at Shintō festivals.

The clearest example of the grey area surrounding Shintō practice is in everyday life and in the seasonal festival customs both out of doors and at home. Shintō is regarded as the religion of life and regeneration, and consecrates such personal occasions as weddings, births and various coming of age ceremonies. It also is invoked for the blessing of motor cars, the opening of shops, academic success and the building of houses. For public buildings in particular there is a Ground Pacification Ceremony (*jichinsai*) in which the building site is made into a *yorishiro*, with the laying out of *sakaki* tree branches and various offerings. A Topping Out (*mune-age*) ceremony is conducted on the completion of a building.

The *kami* of the household shrine is provided daily with sustenance and with special treats on festival days. Until recently Shintō shrines were found in most homes and are still found in the dwellings of artisans. Most households still bring out a formal set of aristocratic dolls signifying the ancestral *kami* or *o-hina-sama* for the *hina-matsuri,* the annual girls' festival on 3 March. They will also fly carp-shaped streamers and display dolls of boys wearing armour for the boys' festival on 5 May.

Although such festivals are today lighthearted, some have origins in magical rites. An original form of the girls' festival is still practised at the Awaji Jinja Shrine in Wakayama Prefecture, when dolls are floated down river in model boats to carry away misfortune. Children will be taken to the local shrine to be shown off to the *kami* and to invoke the *kami*'s goodwill on the third and fifth birthdays of boys and the third and seventh birthdays of girls. Girls are dressed in kimono to visit their special shrine on New Year's Day, and visits to shrines on festival days are treated much like fairs once were in Britain.

Buddhism, on the other hand, provides for spiritual salvation, which for the most part implies enlightenment at or after death. Buddhist temples provide comfort for the distressed soul in the form of services, spiritual teaching through sutras, and a funeral by cremation, after which the departed becomes a Buddha. Apart from devout Buddhists or sightseers, most people rarely visit a temple except for funerals.

Now few houses have their own small Shintō shrine upon which daily offerings are made to the ancestral deity. Conversely, a Buddhist altar is invariably installed whenever there is a death in the household, so there is one in most homes. For forty-nine days after death, the ashes of the deceased are kept on the altar and given daily provision of food, drink and fresh flowers accompanied by the burning of incense and intimate family prayers. Thereafter the ashes are interred, and although customs vary, the altar remains tended daily, with extra care on Buddhist festivals, until the family eventually becomes dispersed or dies out. The altar may contain a photograph of the ancestor or ancestors and their posthumous Buddhist names (*kaimyō*) on tablets, as well as the image of a Buddha or Bodhisattva. The family dead have become ancestral *kami*, their existence not clearly defined either in heaven or on earth. Their spirit is to be summoned with the ringing of a bell and the clapping of hands, just as the *kami* are summoned to a Shintō shrine.

Formal Shrine Shintō

Although there are paintings and sculptures of the *kami* in human form, the *kami* are usually represented by an object in which the spirit of the *kami* resides, called the *go-shintai* (body of the *kami*). This object is placed in the *honden* (main building) of the shrine. Typically it will be one of the 'Three Sacred Treasures': a sword, mirror or jewel. The *kami* are continually served with sustenance and entertainment on a daily basis and with large-scale festivals on a seasonal basis. During the festivals the *go-shintai* may be taken out of the shrine and carried in a palanquin with great ceremony on an appointed route ending back at the shrine (fig. 6). This resembles the folk Shintō practice of seasonally welcoming mountain deities to the rice fields. There is often a procession of parishioners, some wearing traditional clothing. A priest, or a parishioner's

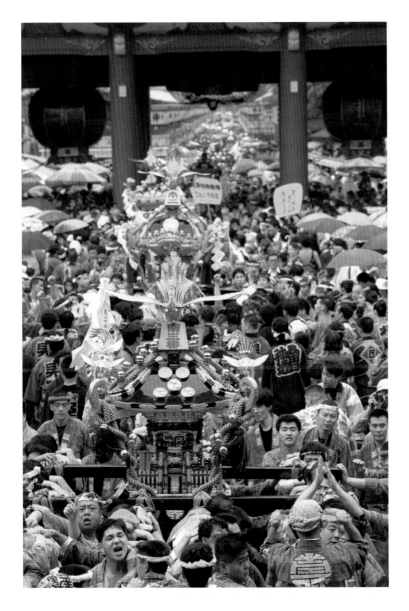

Fig. 6 Asakusa Sanja Matsuri (Festival of the Three Shrines), showing the annual procession carrying three *mikoshi* (palanquins) containing the *kami* from Asakusa Shrine on the third weekend in May, with a joyous throng of parishioners and general public. (Photo: Asahi Shimbun)

Izanagi-no-mikoto when he washed away the defilement of the Land of Darkness, thereby giving birth to his three great children. Worshippers may visit a shrine at any time, and having been purified, throw a few coins into a collection box. They next announce themselves, usually by ringing a hanging bell, bowing deeply twice, clapping hands twice, and then bowing once more. They do this in front of the *honden,* although they may be prevented from approaching too close to it by a number of gates and enclosures. They may then silently make their greeting or request, and withdraw. A special prayer can be arranged with the shrine priests, when they will be further purified by reciting the special prayer and waving a paper wand before withdrawing.

The Shrine Complex

The *honden* in which the *go-shintai* is deposited is a wooden structure supported above the ground on columns, typically but not always nine in number, forming a regular rectangular framework which carries the floor, walls, and internal partitions. Some, like Ise Jingū, may have a much larger number of supports. There are no windows, and the door is kept locked. The roof is heavily thatched with either grass or tree bark, which can be as much as a metre thick. A veranda surrounding all four sides at the raised floor level is accessed by ladder-like stairs. The door to the room is set to the side or in the middle of the front wall. Inside there will usually be a partition between the columns. Beyond this partition is the holiest place where the *go-shintai* is deposited and concealed from everyone's view except that of the chief priest when conducting his ritual duties.

The pitched roof has a succession of cylindrical timbers (*katsuogi*) arranged perpendicularly across the ridge all along its length. At each end the slope of the roof continues up into two projecting pieces called *chigi* which form an X-shape. This type of architecture has remained unchanged since at least as long ago as the Nara period, and it derives from grain storehouses of the Yayoi period, or even earlier. It is graphically

child, might be appointed to represent a deity and ride on a horse. At the appointed destination and upon return to the shrine, there will be some sort of entertainment for the deity. This can vary from the solemn and sophisticated to the uncontrolled and ribald.

Everyday Worship

Despite the absence of clearly defined moral precepts in Shintō, the essential components of all Shintō practice are cleanliness, purification, gratitude and regeneration. Before worshipping at a shrine, worshippers will wash to purge themselves of impurities. This is frequently related to the self-purification of

described in the *Nihongi*, in the passage in which the arrival and settlement of the first emperor, Jimmu is recorded: 'In Kashiha-bara in Unebi, he mightily established his palace pillars in the foundation of the bottom rock, and reared aloft the cross roof timbers to the plain of High Heaven' (*Nihongi*, p. 132).

The *honden* will usually be surrounded by an enclosure within which there may be roofed platforms for offerings, and a roofed gate. There may be a number of such enclosures, each with a gate symbolizing an increasing level of sanctity as the priests approach nearer to the *honden*. The enclosures may also contain subsidiary shrines devoted to related *kami*, and various auxiliary buildings. The Grand Shrine at Ise has four such enclosures, which is the greatest number. The approach to a shrine is through a *torii* (gate) at the outer enclosure. This may be set a long distance away from the centre of the shrine, since some shrine precincts contain large areas of sacred ground which might include whole mountains (fig. 7). Within the boundary defined by the *torii*, there is always a source of running water and a stone basin with wooden ladles provided for the purifying of hands and mouth before proceeding to worship. In larger shrines, there will be buildings with stages for sacred drama (*kagura*), a supply of amulets for visitors giving protection against calamity, and administrative buildings associated with the upkeep of the shrine and preparations for rituals.

Until the Asuka period (late sixth century– AD 710) it was customary for a new emperor to move the palace to his own new site. This practice seems to have been related to the custom of rebuilding shrines at twenty-year intervals, which is still observed assiduously by Ise Shrine. Twenty years is said to be the optimum time that undressed timber looks clean. It has also been said that a twenty-year interval allows sufficient time for an apprentice carpenter to mature and oversee the rebuilding as a skilled artisan during his lifetime, thus perpetuating traditional building skills. Shrines would thus regularly be moved from one site to another, sometimes a long distance from the original building. The profession of *miya daiku*, carpen-ters traditionally specializing in the building of shrines and palaces, still uses the tools and the wood-felling and seasoning methods of centuries ago. The process fulfils one of the precepts of Shintō, that of reproduction and regeneration, and thereby the propagation of ancient traditions. The *go-shimpō*, votive offerings to the *kami* of weapons, clothes and utensils for everyday use, are also traditionally made anew every twenty years, assuring the continuation of craft skills.

The Grand Shrine at Ise

The shrine at Ise is the national centre of Shintō, being the main shrine of Amaterasu-ōmikami, embodied in the sacred mirror which, according to the *Nihongi*, was given by the Sun Goddess to her grandson Ninigi-no-mikoto on his descent to earth from heaven (fig. 8).

The *Nihongi* tells how the mirror was kept in the palace of successive emperors until the reign of Sūjin, the tenth emperor according to the mythological genealogy. Sūjin decided that the mirror was too holy to be moved from place to place with each imperial succession, and had a shrine made to contain it at Kasanui-no-mura in present-day Nara Prefecture. The place was selected by a princess, Toyosukiirihime-no-mikoto. Her name implies a *kami*, suggesting that she was a shaman with religious responsibility for the *go-shintai*. In the twenty-sixth year of the reign of the next emperor, Suinin, another princess, Yamatohime-no-mikoto, chose the present location. The site is among the densely forested foothills of Mt Kamiji by the River Isuzu, whose waters are still used by pilgrims and priests for purification. Although the date of the move to Ise is uncertain, a further shrine was built at a later time, according to Ise Shrine records in AD 477. The *gekū* (outer shrine), as opposed to the original *naikū* (inner shrine), was made for the *kami* Toyouke-no-ōkami, the deity of rice provision. This deity provides offerings of food twice a day for Amaterasu-ōmikami enshrined in the *naikū* (fig. 9). There are now 127 shrines and related buildings at Ise.

Sites adjacent to both the *gekū*, the *naikū* and the fourteen subsidiary shrines lie in prepara-

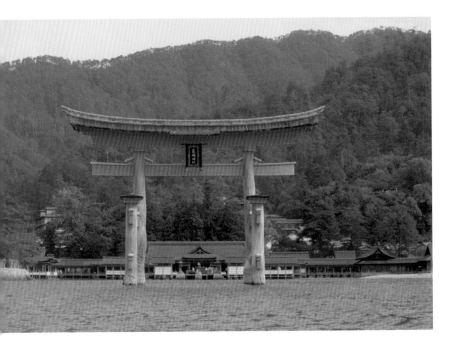

Fig. 7 The *torii* (gate) to Itsukushima Shrine on the sacred Miyajima Island, Mie Prefecture. (Photo: Asahi Shimbun)

white-clad priests in procession on foot. Special ceremonies held on particular days include *kagura* unique to Ise Shrine and *bugaku* drama. The most significant ceremonies are the *kinen-sai* (17 February), the *kanname-sai* (15 October) and the *niiname–sai* (23 November), in which an envoy from the emperor brings special offerings of silk, reflecting the ancient tradition related in the *Nihongi*.

Izumo Shrine

The shrine of Izumo Ōyashiro is a most impressive wooden building, yet records indicate that it was once much larger. The *Kuchizusami* document, written in AD 970 by Minamoto no Tamenori, speaks of Izumo as equivalent to 48 metres high, taller than the *honden* of Tōdai-ji Temple. This is the hall which houses the great Nara period bronze figure of Roshana Buddha, which is 45 metres tall. The height of Izumo shrine was reduced to the present size in 1774. A painting in the possession of the Senge family, who are hereditary priests of the shrine, is said to date from the Heian period and depicts the *shinden* of the shrine on tall columns with a stairway over 100 metres long leading to it.

The present building (fig. 10) is some distance away from the site of the Heian period building, where recent excavations have unearthed the post holes of three of the nine columns which supported the earlier structure. Each column was formed of three immense logs, each over a metre in diameter, bound together with iron bands. The scale is consistent with the Heian period record, and adds weight to the *Nihongi* record.

The *Nihongi* recounts how Amaterasu-ōmikami promised aid to Ōkuninushi-no-mikoto in building his residence 'with colossal columns and broad planks in the same architectural style as mine, and name it Amenohisu-no-miya'. The government of Izumo when the *Nihongi* was written was in the hands of Izumo Ōyashiro, and the incumbent high priest is recorded as being the eighty-third generation of his family to hold the office. The shrine, like Ise, celebrates many festivals during the course of the year and is visited annually by an envoy of

tion for the next twenty-year rebuilding, when the *go-shimpō* and the *go-shintai* are moved at night to the new home. The treasures and the shrine priests will be purified at the riverside in preparation for this event. Rice for offerings is grown in a special field irrigated by the waters flowing from the nearby mountains, and vegetables are cultivated at a separate site. The rice field is the scene of a planting ceremony, still performed today by rows of girls in colourful traditional dress working in unison across the field to the accompaniment of an ancient song. A festival on 24 June of the rebuilding year prepares the ground for this. A tall bamboo pole decorated with an oval *uchiwa* (fan) is ritually pulled to the ground by a muddy throng of fishermen clad in loincloths. The spectacle is cause for celebration and revelry.

Like water, salt has an important purification function and the *kami* must be provided with it according to time-honoured ritual. Salt for the *kami* is prepared at two other sites, both marked as sacred by a *torii* at the entrance. The first is a field onto which seawater is panned to evaporate and leave a salty residue. This is gathered and carried to the second site, where once a year it is baked in a great cauldron inside a ground-level thatched building, the *mi-shioden* (salt field) shrine. It is then formed into pyramids of solid salt and carried several kilometres to Ise by

Fig. 8 Ise Shrine.
Hanging scroll, ink
and colours on silk,
by Kawabata Gyokushō
(1842–1913).
(BM JP 2664)

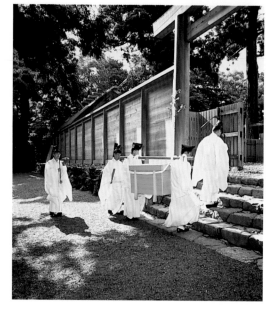

Fig. 9 The Higoto
Asayu Omikesai
ceremony at Ise Shrine.
Twice daily offerings
of sacred food are
taken before the *kami*.
(Photo: Jingū Office)

the emperor for a special festival. This begins on 14 May and heralds a further two days of grand celebration.

The shrine is unique in having two auxiliary *shinden* of great length built to house all 8,000,000 *kami* (excepting Ebisu) who gather at Izumo each year in October. A delegation from the shrine goes to meet the *kami* at the shore to escort them to Izumo Ōyashiro (fig. 11). They will stay there before going on for two further periods of rest at Sada Shrine and Mankusen Shrine, then return to their homes. On the morning of the *kami's* departure, the priest at Mankusen Shrine knocks on the door of the sacred quarters with a plum branch to initiate the final part of the festival by awakening the *kami* (fig. 12).

Go-Shimpō – Shrine Treasures

The 'Three Sacred Treasures' – jewel, mirror and sword – were the essential properties of the ancestral *kami* and part of the imperial regalia. As such they are found both in the tombs of the early rulers and emperors of Japan, and buried separately in remote and sacred places. The *Nihongi* tells how they figure among the possessions of the gods. In addition, the properties of the *kami* include objects made for ritual and everyday use. These vary from shrine to shrine and according to the nature or sex of the resident *kami*. Clothing, musical instruments, military equipment, weaving looms, riding gear and more personal cosmetic paraphernalia are found, together with various tokens and banners used in ancient ritual. The *Sendai kuji honki* (or *Kujiki*, early Heian period) tells how the deity Nigihayahi-no-mikoto came down from Takama-ga-hara (heaven) bringing ten kinds of *kandakara* (*shimpō*, treasures of the *kami*). They included two kinds of mirrors; a *yatsuka-no-tsu-rugi* type sword; four jewels including a 'life' jewel and a 'rebirth' jewel; and three kinds of *hire* (a kind of banner – possibly the origin of the ceremony involving waving aloft the *kandakara* while reciting the deity's names). This is clearly related to the kind of ritual practised during the Kofun period as shown in clay images (*haniwa*) of female shamans, who carry mirrors, wear swords (cat. no. 42) and are adorned with necklaces of *magatama* (comma-shaped jewels). These and other objects were exchanged as gifts and tribute between Japan and China and the old nations of Korea during the Yayoi and Kofun periods, according to the *Nihongi* and *Wei shi*:

Suinin Tennō: third year, Spring, third Month:
The Silla prince, Ama-no-hiko [Spear of Heaven] arrived. The objects which he brought were: one *ha-boso* (leaf-slender) gem, one *ashi-daka* (high leg) gem, one red-stone, *ukaka* gem, one Idzushi (place name) short sword, one Idzushi spear, one sun-mirror, one *kuma-himorogi* (possibly 'bear paws' according to Aston), seven things in all.
These were stored in the land of Tajima [north of present-day Hyōgo Prefecture], and made divine things for ever. (*Nihongi,* vol. II, p. 168)

Traditionally at the time of the twenty-year reconstruction of shrines and replacement of their treasures, the new *go-shimpō* are made as exact replicas of the old, although economy and practicality has frequently necessitated departure from that rule. When the new *go-shimpō* are deposited in the shrine, the old are either buried in the ground or preserved safely in the shrine. A ritual link with the burial of swords, mirrors, and jewels during the Yayoi and Kofun periods may be inferred. *Go-shimpō* of the Kamakura period (1185–1333) buried at Ise have been excavated during the work on the foundations for a new fence, and are now preserved as Important Cultural Properties.

In addition to the complete replacement of the *go-shimpō* every twenty years, other treasures are offered at certain times. The most important event is still the accession of a new emperor, when *dai-shimpō* (Great Sacred Treasures) are offered. There are also ceremonies when the emperor's envoy presents an offering of silk at the seasonal festivals. Special offerings may also be made in time of emergency.

It is not known exactly how old the custom is, but *Shoku Nihongi* (AD 797) tells of such treasures

Fig. 10 The *honden* (main building) of Izumo Shrine, in which the *kami* is enshrined. National Treasure. (Photo: Izumo Ōyashiro)

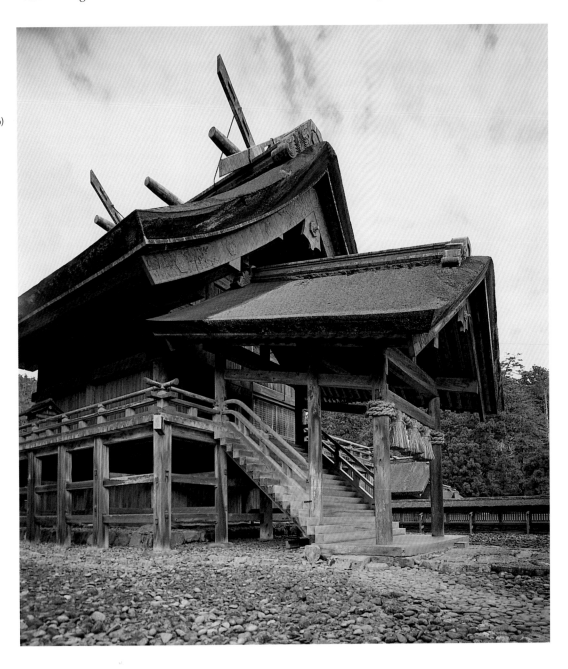

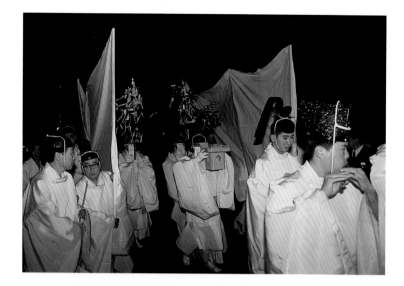

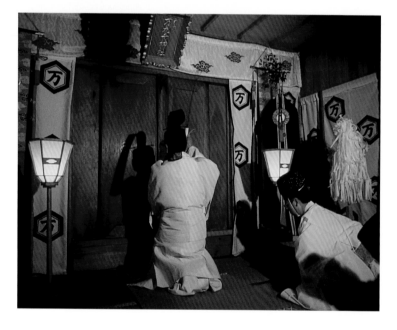

Fig. 12 *Karasade-sai* festival at Mankusen Jinja. At night, the priest knocks at the door of the shrine with a plum branch to awaken the *kami* for their return to their respective residences after their annual stay. (Photo: Shimane Prefectural Museum)

LEFT Fig. 11 The *kamiari-sai* festival. Priests from Izumo Shrine go to welcome the arrival of all the *kami* of Japan, excepting Ebisu, for their annual repose at Izumo during the month of October after the harvest. (Photo: Shimane Prefectural Museum)

tatari, one *tsuma* (a spool for taking up the thread), twenty-four bows, 2200 arrows, one *tamamaki-no-tachi*-type sword (cat. no. 53) and twenty *sukari-no-tachi*- type swords (cat. no. 54).

The other accessories cover a wide range of garments and objects for everyday use: *hime-yugi* (women's quivers of arrows), twenty *gama-yugi* (quivers covered with a weave of cattail), twenty-four leather quivers of arrows, twenty-four archers' wrist guards, twenty-four shields and twenty-four halberds. This list includes the various treasures which are still being made today. The spinning equipment reflects the female sex of Amaterasu-ōmikami. Earlier origins of the treasures, including objects (either real or models) found buried in the *kofun* and those carried by *haniwa* figures, are discussed in the section on archaeology.

Buddhist Influence on Shintō

Buddhism is the religion founded by the Indian prince Siddartha Gautama around the sixth or fifth century BC. (He is believed to have lived either 566–486 BC or 463–383 BC.) It teaches the illusory nature of existence and that suffering arises from human desires. The enlightenment of the Buddha is beyond the illusion of life and death, and supreme knowledge is to be found through the annihilation of self-awareness. Gautama became enlightened, and upon his physical death became the Buddha Sakyamuni. Buddhism, like Shintō, originally had no religious images. Sakyamuni was represented by an empty throne, the Wheel of the Law or the *bodhi* tree beneath which he became enlightened.

The religion spread from India, its scriptures translated from Sanskrit into Chinese and then Korean, and those texts were brought to Japan via Korea during the sixth century AD. The first teachings are known as Hinayana (Minor Wheel), and propose a path to enlightenment

being donated to the Ise Shrine by Tachibana no Sukune, Nakatomi Ason Umi, and the Onmyō Kashira (Yin–Yang overseer) called Shirataka Mukita. Early Heian period documents about the Ise Shrine, *Kōtai jingū gishiki-chō* and *Toyouke-gū gishiki-chō* (AD 804), also describe the donation of *go-shimpō* in detail. *Engi-shiki* (50 scrolls, completed in AD 927) delineates twenty-one different objects under the classification *go-shimpō*. *Kōtai jingū gishiki-chō* lists nineteen objects as treasures for the *naikū*, and a greater number of various accessories. The treasures are two gilt copper *tatari* (a device for winding spun textile), two mirrors, two rolls of hemp cloth, two *kasehi* (a further type of spinning tool), a silvered copper

through individual application to the scriptures and the accumulation of merit. The religion developed into Mahayana (Major Wheel) which propounded a vast number of Buddhas past, present and future, and a pantheon of Bodhisattvas – those who are enlightened but remain in an earthly phase of existence prior to Buddhahood, and help others along the path. This was the form of Buddhism brought to Japan. It was to find compatibility with the Shintō concept of countless deities, among whom were some who, although residing in their own distant abodes, could mingle with humans in a beneficent way.

The Buddhas, or Nyorai, were depicted in

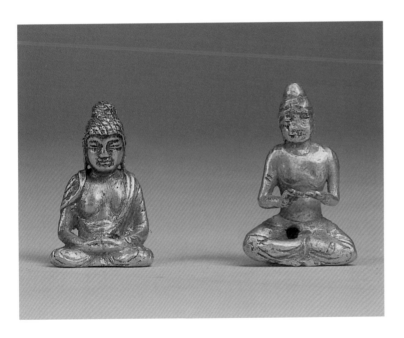

Fig. 13 Gold Amida Buddha and a Bodhisattva, excavated during repairs to the *honden* shrine building on the 1720-metre-high summit of Mt Ōmine, centre of the *Shugendō* sect. H. 3.2 cm (Amida) and 2.8 cm (Bodhisattva). (Photo: Ōmine Sanji Tobanji Chikurinin)

idealized human form with additional superhuman attributes – golden skin, webbed fingers, elongated ears, a protuberance on top of the head and a round mark (*urna*) in the forehead. Bodhisattvas were of human aspect with Chinese-style robes and crowns (fig. 13).

The *Nihongi* records that in AD 552 an envoy arrived from the king of Kudara (Paekche on the Korean peninsula) with Buddhist paraphernalia including sutras and a shining gold figure, probably gilt-bronze. Emperor Kimmei had never seen such a thing and found the face of the Buddhist image startling, and the account tells that he was uncertain as to whether he should worship it. This in itself indicates that the wor-

ship of an image was not normal practice in Japan at the time.

The introduction of Buddhism in this form was followed by internal strife between powerful clans, of which the Soga were in favour of Buddhism and the Mononobe and Nakatomi opposed it, lest the *kami* should be offended. For some decades the future of Buddhism in Japan stood in the balance, with the two sides blaming each other for the occurrence of natural calamities. Similar reactions against Buddhism were to occur later in Japanese history, especially during the fourteenth, seventeenth and nineteenth centuries. One cause of the opposition to Buddhism must have been the alien aspect of the worship of images. Notwithstanding the initial strife between the two factions, Japan had generally been receptive to foreign wisdom, and had always readily welcomed foreign visitors and foreign innovations.

Further Buddhist envoys came from Paekche in AD 577, and by the end of the sixth century Buddhism had become established at court, although the emperors still also paid service to the Shintō deities. Shōtoku Taishi, prince regent for Empress Suiko from AD 594 until his death in 622, was a firm champion of Buddhism. He supported the Soga clan in their violent struggles against the anti-Buddhist Mononobe, and commemorated their victory by building Shitennō-ji Temple devoted to the Four Guardian Kings of Buddhism in Naniwa (present-day Osaka). Shitennō-ji Temple still stands, and has among its treasures two swords which belonged to the prince. Following their victory, Soga no Umako caused Asuka-dera Temple to be built to house a bronze figure of Buddha, made in AD 606 by the Korean Kuratsukuri no Tori (according to the *Nihongi*). The figure, over two metres high, is still kept in a surviving building of the temple, Ango-in. Hōryū-ji Temple was built at the site of Shōtoku's palace, at Ikaruga.

Buddhism gradually strengthened and a series of edicts passed in AD 646, collectively known as the Taika Reform, brought all estates of land under imperial control and made Buddhism an integral part of the governmental system. Early Buddhism in Japan was very much seen as a means of obtaining favour and

aid from the deities at a national level. Buddhas and Bodhisattvas were supplicated in much the same way as were the *kami*, and the friction between the two religions was more a contest of prestige than of spirituality. The adoption of Buddhist funerary practices signalled the end of the Kofun period. Under the rule of Empress Gemmei, the capital was moved from Asuka to Nara in AD 710, where Buddhism thrived with the establishment of six major sects. Emperor Shōmu made Buddhism the state religion. He ruled from AD 724 and abdicated in 749 to devote his time to Buddhist studies.

Tōdai-ji Temple was built in Nara to house the great bronze figure of Dainichi Nyorai (Vairocana). Monk Gyōgi (668–749) of the Hossō sect of Buddhism, was an active fund-raiser for the Tōdai-ji project, and preached the concept of mutual equivalence. According to this, the Shintō *kami* were equivalents of Buddhist deities. A proclamation by Ise Jingū confirmed that Dainichi Nyorai, whose name signified the sun, was in fact the sun itself, thus cementing the equivalence of Amaterasu to Buddha.

In this context of religious and political union, a powerful provincial group from Usa in Kyūshū supported the Tōdai-ji venture. They were a people probably originating from Korea who possessed advanced mining, medicine and other technologies. Their *kami*, Hachiman-shin, was escorted to Nara by the priestess Ama-no-ōmiwa-ason-morime. She rode in a palanquin of imperial purple, and government officials cleared the road before her. Usa Shrine became influential in the capital and Hachiman was enshrined in the precincts of Tōdai-ji in AD 749. The deity later appears in the guise of a Buddhist priest with shaven head (cat. no. 85), sometimes accompanied by two female *kami* as Japanese aristocrats, and is entitled Hachiman Daibosatsu (as a Bodhisattva). Hachiman later became identified with Emperor Ōjin, and was regarded as a god of war and archery although he is not named in the hierarchy of *kami* contained in the *Nihongi*. In AD 752 the retired emperor Shōmu, his empress Kōmyō and Empress Kōken (749–58?) had the Great Buddha dedicated with both Shintō and Buddhist officials taking part in the ceremony, further enhancing the close relationship between the two religions.

After Emperor Shōmu's death in AD 756, the empress had his effects, together with objects that had been presented at his inauguration, enshrined in the Shōsō-in (storehouse) of Tōdai-ji where in all around 100,000 objects are still preserved. The Shōsō-in is a wooden structure raised on columns in the manner of shrine architecture. The contents include Korean, Chinese, Japanese and even Persian objects, many preserved in perfect condition. (Sometimes their like does not survive in their lands of origin.) The status of the collection could be equated with the *go-shimpō* of a Shintō shrine, and it belongs to the present emperor under the delegated custodianship of the Imperial Household Agency. The Shōsō-in itself is a monument to the Japanese genius for conservation and preservation in the traditional architecture of the prehistoric storehouse. The timbers swell and contract seasonally to provide alternate ventilation and insulation. The woods used for the building and the storage boxes are chosen for their inertness, durability and resistance to insects.

The seventh and eighth centuries witnessed the extensive building of Buddhist temples to contain images, either sculpted in wood or cast in bronze and then gilded. The early images were made by immigrants from Korea in the style of images that had been worshipped in Paekche. In the Nara and early Heian periods, Chinese styles and technologies came to be favoured, and it was at this time that the first sculptures of *kami* were made to be housed in permanent shrine buildings.

The Mutual Equivalence of Shintō and Buddhist Deities

Gyōgi's concept of mutual equivalence and other ideas to promote the amalgamation of Buddhism and Shintō (*shimbutsu shūgō*) resulted in the adoption of the *honji suijaku* concept, whereby the Buddhas were considered to be the original forms (*honji*) of their manifestations (*suijaku*), the Shintō *kami* in Japan.

Painted mandalas (Japanese, *mandara*) of the hybrid Shintō-Buddhist type might depict just

Fig. 14 The shrine buildings of Kasuga Taisha, Nara, from above, showing the sacred forests on the lower slopes of Mt Kasuga. (Photo: Kasuga Taisha)

the *kami* (*suijaku*), just the Buddhist equivalents (*honji*), or both together (*honjaku*). Buddhas and Buddha realms might be represented together with aspects of the real world such as depictions of shrines and their precincts, temples, background scenery and the sky. The sky, by extension, could contain the Buddhist cosmos at the same time. The mandalas are a clear statement of the closeness of the *kami* to human beings and to human activity. Even mandalas that show Buddhas in an idealized heavenly setting might include recognizable landscapes. Pure Land Buddhist mandalas, which put the Buddha Amida enthroned in a heavenly mansion accompanied by Bodhisattvas and other beings, can also include a real landscape. An example of this is the painting showing Amida above Mt Kumano (cat. no. 82), in which Amida

is the equivalent of the *kami* of the mountain, Ketsu-no-miko-no-ōkami.

Kasuga Shrine in Nara represents an important example of the adoption of the *honji suijaku* concept. Amanokoyane-no-mikoto and his wife Hime-gami are the joint *uji-gami* (ancestral patron *kami*) of the Fujiwara clan, and they are usually enshrined together with local deities in areas where the Fujiwara gained prominence. Their main shrine is at Kasuga (fig. 14). The Fujiwara were descended from the Nakatomi clan, whose power and prominence at court is attested by many references in the *Nihongi*. Nakatomi no Kamako (AD 614–69) was given the name Fujiwara (wisteria plain) Kamatari in 669 through imperial favour.

When the capital moved to Nara in AD 709 the Fujiwara elected to enshrine their *uji-gami* together with the two local deities at the foot of Mt Mikasa. Of the two local tutelary deities, one is enshrined separately at the Wakamiya (Young Shrine), the other being Mt Mikasa itself. They were joined by two *kami* from Kantō (eastern Japan), Futsunushi-no-kami from Katori Jingū Shrine in Shimosa Province (present-day Chiba Prefecture) and Takemikazuchi-no-kami from Kashima Jingū Shrine in Hitachi province (present-day Ibaraki Prefecture). Both these *kami* were of a martial nature, which reflected the military power of the clans of the Kantō region from the Kofun period through to the medieval age, culminating in the establishment of the first military government at Kamakura in 1185 under Minamoto no Yoritomo. He himself was deified after death, as previously mentioned.

The five *kami* are enshrined in separate *yashiro* in the Kasuga Shrine complex (fig. 15). The son of Kamatari, Fujiwara Fuhito (AD 659–720), ensured his family's continuing prosperity by marrying off two daughters successively to Emperors Mommu and Shōmu. The clan founded Kōfuku-ji as their family temple, thereby affiliating the temple to Kasuga Shrine. The pagoda of the temple is one of two buildings surviving from the Nara period, and is depicted on some Kasuga mandala paintings. From the beginning, Kōfuku-ji was built as a shrine temple (*jingūji*), and the *kami* were accorded Buddhist deity equivalents (*honji*):

The deer, which still roam freely in Nara, are depicted in Kasuga mandalas as divine envoys (fig. 16). Eventually, the whole complex of mountain, *kami* and Buddhas was contained in one deity, Kasuga Daimyōjin (cat. no. 74).

The Appearance of the *Kami*

Initially, the *kami* were depicted in painting and sculpture as their Buddhist equivalents, generally following the dictates of Chinese or Korean tradition. Later the *kami* came to be depicted in a variety of native guises: as stern noble figures with ancestral dignity; youths; armoured warriors; beautiful aristocratic women (see Yoshino Mikomori Shinzō, cat. no. 75); or as apparently ordinary people going about their everyday occupation (see Kariba Myōjin, cat. no. 80). Female *kami* might also wear Chinese Tang

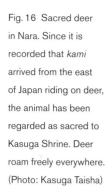

Fig. 15 Kasuga Taisha, Nara. Four of the *kami* reside in the *honden*, the main shrine building. The fifth, Wakamiya, is close by. (Photo: Kasuga Taisha)

Fig. 16 Sacred deer in Nara. Since it is recorded that *kami* arrived from the east of Japan riding on deer, the animal has been regarded as sacred to Kasuga Shrine. Deer roam freely everywhere. (Photo: Kasuga Taisha)

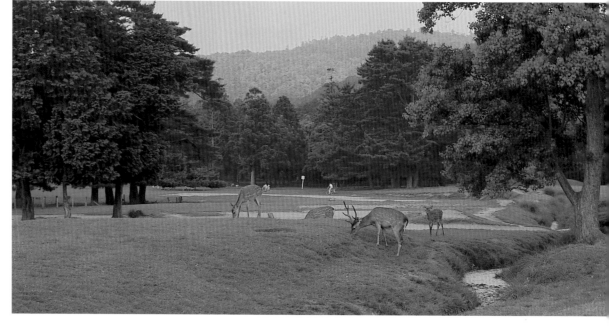

Shaka Nyorai for Takemikazuchi-no-mikoto; Yakushi Nyorai for Futsunushi-no-kami; Jizō Bosatsu for Ame-no-koyane-no-mikoto; Jūichimen Kannon for Hime-gami; and Monju Bosatsu for the Wakamiya *kami*. These equivalents varied from time to time; for example, Takemikazuchi-no-mikoto might be represented either as Shaka Nyorai or as Kannon Bosatsu. The deities from Kashima and Katori are said to have arrived at Kasuga Shrine mounted on deer.

period costume. Aristocratic male *kami* are often attired in court dress and carry *shaku* (wooden sceptres of authority). An exception is Hachiman in his guise as a Buddhist priest. But even though clothed in Buddhist robes and with a shaven head, Hachiman is always depicted with a solidity that proclaims his essential Japanese nature in his *suijaku* role.

As the *kami* had so many varied forms, even their assumed form (*go-shintai*) might not be

depicted on a painting. One alternative was to represent them by their dedicated shrine. Another was to hint at their presence, for example, by the carriage in which an emperor or divinity might travel, or the screen behind which he or she might sit when at audience. In yet other cases the *kami* might be represented by a natural *go-shintai*, like the sacred mountain of the Kasuga mandala, the deer envoy of the Kasuga *kami*, the Nachi waterfall, or the sun and moon. Painted mandalas sometimes include straightforward representations of *kami* with their Buddhist counterparts, or sometimes Sanskrit characters instead of images. The shrine itself might be set in a stylized landscape with a pilgrimage path through it. Such mandalas in the form of hanging scrolls were displayed in shrines. They were also used as lecture aids by various sects, carried about by travelling monks and nuns to attract pilgrims to their sects, temples and shrines.

There are few references to the manufacture of *kami* images before the Heian period. *Tado Jingū-ji garan engi shizai chō* (Historical Record of Tado Shrine-Temple, compiled AD 801) describes how the priest Mangan Zenshi had a six-foot (*shaku roku*) figure of Amida Nyorai made for Tado Jinja Shrine, and how he lived for some time in the East Hall (*higashi dōjō*) of the shrine. In response to various local misfortunes said to result from the reduced standing of the *kami*, Mangan was inspired to erect a separate shrine. This was at the behest of the *kami*, who had decided to evolve into a Buddhist form for the sake of salvation. He had a figure made and established it as Tado Daibosatsu in a separate sacred place to the south of Goshinzan.

In Kongōshō-ji Temple in Mie Prefecture there is a wooden figure of Uhō Dōji, a manifestation of Amaterasu-ōmikami as she appeared in Hyūga. It is said to have been made in AD 825 at the direction of the Sun Goddess herself. The figure holds the Buddhist jewel of enlightenment in her left hand and a wand in the right. Her head is surmounted by a four-tier stupa.

In general, wooden Shintō sculpture is made with the same technology as Buddhist wood sculpture up to the late Heian period. This method is known as *ichiboku-zukuri*, by which the whole figure is carved from a single block of wood. This restricted both the size and range of shapes possible, and could lead to eventual splitting of the wood when it dried out over time. Not unnaturally, since the *kami* can be interpreted as aspects of nature, wood sculptures were made from trees which had in themselves the *kami* nature. Particularly haunting are sculptures that are left in a half-finished state with part of the rough-hewn block remaining, as if to show the deity in the process of emerging almost cautiously into human form. This kind of respect for the original material is remarkable in the works of the Edo period sculptor Enkū (1632–95), whose figures of deities bear the crude marks of the chisel. Enkū was an itinerant follower of *Shugendō* who became ordained into the Tendai sect of Buddhism in later life.

The *yamabushi* (mountain ascetics), priests of *Shugendō*, were foresters, whose attribute is an axe in addition to the priest's staff. They are believed to have been the carvers of images onto living trees in the Heian period, although the only known examples of this form of sculpture have been felled and installed in temples. Some of these retain the shape of the root formation at their base. An example is the Tachigi Kannon (Standing-Tree Kannon) in Chūzen-ji Temple affiliated to Tōshō-gū Shrine in Nikkō. The figure is said to have been sculpted by the monk Shōdō, who is believed to have founded the temple in AD 784. A late Heian period sculpture of the Jūichimen Kannon (Eleven-Headed Kannon) in Seiko-in Temple, Ibaraki Prefecture, was carved from an enormous tree, and is 5.15 metres tall. It retains much of the cylindrical form of a tree, and the base broadens, following the profile of the trunk.

Esoteric Buddhism and Mountain Asceticism

The Buddhism of the six sects established at Nara allowed for merit to be gained by good acts, and for a steady accumulation of virtue through study and repetition, leading to eventual enlightenment. But this enlightenment required such devotion that it was not necessarily expected to happen during one's lifetime,

and would only be available to ordained priests and those who had the resources to have sutras copied, temples built, and to carry out other virtuous acts.

A more pragmatic approach was required by many Buddhists, and particularly quasi-Buddhist and Shintō visionaries who had inherited traditions of close contact with the supernatural through nature. There were unofficially ordained monks and practitioners of magical arts living among hermits in the mountains away from the cities, whose practices were linked with prehistoric sacred sites and with mountain and forest religions. Indigenous beliefs included a wide-ranging number of religious and magical practices which had been adopted from China and Korea during the Yayoi and Kofun periods, as well as those inherited from their distant Jōmon ancestors. Methods of divination using tortoise shell and burned deer bones still survive in ritual form in the Nukisaki-jinja Shrine of Gumma Prefecture and other shrines. Methods of divination brought from China and Korea enriched the existing shamanistic systems. This is described in the *Nihongi*: 'In the tenth year of the reign of Empress Suiko a monk from Paekche named Kwal-Leuk brought to Japan books on subjects including the manufacture of calendars, the art of invisibility and magic' (*Nihongi*, p. 126).

The imperial court established an Office of Yin and Yang as part of the *ritsuryō* (administrative system) for the purposes of divination and geomancy, and for the setting of calendars for religious rites. Such practices had been a vital tool of government since the first quasi-states were established around the beginning of the Yayoi period. From the *Nihongi*: 'On the day on which first began the Heavenly Institution, Michinoomi-no-mikoto, the ancestor of the Ōhotomo House, accompanied by the Oho-Kume Be, was enabled, by means of a secret device received from the Emperor [Jimmu, the first emperor], to use incantations and magic formulae, so as to dispel evil influences. The use of magic formulae had its origin from there' (*Nihongi*, Reign of Emperor Jimmu, p. 133).

Wei shi, the Chinese chronicle of the Wei Dynasty (AD 220–65), tells of the *wajin*, or Japanese people, and of Himiko (or Pimiko), the queen of the 'country' called Yamatai, who ruled over thirty of the more than one hundred provinces comprising Japan at the time: '… she occupied herself with magic and sorcery, bewitching the people. After she became ruler there were few who saw her. She had one thousand attendants, but only one man. He served her food and drink and acted as a medium of communication. She resided in a palace surrounded by towers and stockades with armed guards in a constant state of vigilance.'[5]

The queen exchanged envoys with China on several occasions, and was given a rich gift in AD 240 which included one hundred bronze mirrors, two swords, silks and a gold seal. The account is particularly important in as much as mirrors excavated from *kofun* have been linked with this gift. The description of Himiko's palace is in accordance with Yayoi-period archaeological sites such as Yoshinogari and Toro.

Himiko seems to have been a female shaman ruler in the tradition of the matriarchally inclined Jōmon society. After her death, a succession of male rulers proved unable to control the land, and a young female relative of Himiko was elected as queen. There were many female rulers of Japan during the early history of the nation. Some like Empress Jingū inherited the magical powers of female shamans. Other later empresses embraced Buddhism as well as the native Shintō rites, just as Emperor Shōmu had done. According to the *Nihongi*, Empress Jingū ruled Japan following the death of Emperor Chūai, the son of Yamatotakeru-no-mikoto. She is said to have ruled with great competence and instigated and led an invasion of the Korean state of Silla (cat. no. 91). The *Nihongi* records two occasions when she communicated with the *kami* by means of playing the *koto*, once for seven days non-stop and with 'a thousand pieces of cloth' (*Nihongi*, p. 225) used in the ritual: 'And the Empress played upon the lute (*koto*), in accordance with the words of the Gods. Hereupon the Gods spake by the mouth of the Empress' (*Nihongi*, p. 233). Despite wholehearted support for Buddhism by the then government, forms of the old magical rites and

nature worship were strongly entrenched in the mountains of Yamato. Vestiges of such oracles are still to be found in folk Shintō today.

The status of mountains as *kami* in their own right, or at least as sacred places, is emphasized by the archaeological evidence of ritual activity on their summits, slopes and foothills in the period before the arrival of Buddhism. Similar excavated material shows that Shintō shrines were built on the sites of prehistoric sacred places. A clear reference in the *Nihongi* tells of the marriage of Ninigi-no-mikoto to the daughter of a mountain *kami*. At the time of the *Nihongi,* there were *hijiri* (holy men) and *yamabushi* who practised forms of non-affiliated Buddhism, Shintō, Daoism, geomancy, soothsaying and derivations of Chinese yin-yang studies. All were independent of the early formal Buddhism of the Six Sects of Nara.

The austere form of mountain religion known as *Shugendō* is said to have been established on Mt Kimpusen and Mt Katsuragi, both in Nara Prefecture, by the hermit En no Gyōja (En no Ozuno), who was exiled in AD 699. His magical prowess is recorded in the *Shoku Nihongi*. Through extreme asceticism he is said to have been able to converse with wild creatures and to levitate. He is usually depicted with two demonic attendants, one of whom carries an axe, attribute of *yamabushi*.

The principal deity of *Shugendō* is Zaō Gongen (cat. nos. 98–99), an angry figure brandishing a *vajra*, and with one foot raised in an aggressive martial posture. The figure is reminiscent of Fudō Myō-Ō (Acala, The Unmoving), one of the Kings of Light of Shingon Buddhism (fig. 18). He derived from a form of the Hindu deity Shiva but became distinctively Japanese, like Zaō Gongen. An early representation of a wild-looking man with unkempt hair who holds the two-edged sword of Fudō Myō-Ō appears on the stone wall of a Kofun chambered tomb.[6] This may be an early representation of a mountain hermit or an original form of the deity Zaō Gongen. It is said that Sakyamuni appeared to En no Ozuno first in his form as the historic Buddha, then as the Bodhisattva Miroku, the future Nyorai, but was urged by the hermit to take on an appearance more in keeping with the mountains, hence Zaō Gongen.

In *Shugendō* various extreme practices were devised to bring about enlightenment or co-substantiation with the Buddha-mountain deity during one's lifetime (fig. 17). By the Heian period there were centres of the religion on over a hundred mountains throughout Japan. The activities of *yamabushi* include arduous mountain-climbing rituals: the mountains themselves form the mandala in which *yamabushi* find spiritual progress. During certain extreme forms of training, they subsist only on nuts and other wild foods gathered in the mountain forests. Their training requires trials of extreme hardship through which the candidate is brought almost to the point of death, and finally to death, without which ultimate enlightenment is not possible.

Dewa Sanzan (Three Mountains of Dewa province, present-day Yamagata Prefecture) are steeped in the practices of *Shugendō*. They are Mt Gassan, Mt Haguro and Mt Yudono, each with its own isolated shrine (fig. 19). Adherents who have passed stages of self-denial at Gassan and Haguro would proceed to Yudono for the final awsome stage. The route was taken barefoot through the snow on the mountain peaks to Yudono Shrine which originated in a huge rock by an effluent hot spring, the ancient *yorishiro* of the *kami* of the mountain. One thousand days were spent subsisting only on nuts and other wild foods. Finally, the adherent, when fully prepared, was sealed in an underground stone chamber with just a supply of running water and a bell to signal that he was still living. Here he would become a 'living Buddha' (*sokushin*) and expire alone.

Many examples of this rite are known, among them the monk Tetsumonkai. Having prayed to the Dragon God of the River Sumida in Edo (present-day Tokyo) for the cessation of a prevalent eye disease in 1821, he plucked out his own left eye and threw it into the river to seal his request. He died in the stone chamber on Mt Yudono. Today his one-eyed body, clad in the priest's robes of his last hours, sits in a mummified state with other living Buddhas in Chūzen-ji Temple, proclaiming his living Buddhahood.

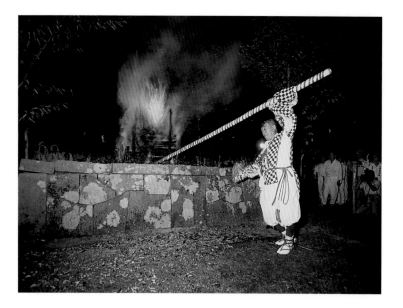

OPPOSITE Fig. 19 Mt Gassan and the great *torii* in spring. Dewa Sanzan, the three mountains of Dewa Province (Yamagata Prefecture), rank with Mt Ōmine in the Kinki region as centres for the practice of the ascetic *Shugendō*, a fusion of Buddhism and indigenous Japanese beliefs. Arduous practices are enacted at the summits of the mountains. (Photo: Dewa Sanzan Jinja)

BELOW Fig. 18 Fudō Myō-Ō (The Immovable King of Light), one of the Five Great Kings of Light of Esoteric Buddhism and the mountain sects. He stands among flames, unmoving, with a rope to ensnare and a sword to cut through the illusory aspects of existence. Bronze, fourteenth century. (Collection Yamagase-gumi/Photo: Nara National Museum)

Fig. 17 Saitō Goma ritual. The *yamabushi* (mountain ascetics) undergo gruelling practices in the mountains in order to absorb the mysterious power of the mountain *kami*. This fire ceremony is the most important ritual. It was adopted into Buddhism from Zoroastrianism. (Photo: Dewa Sanzan Jinja)

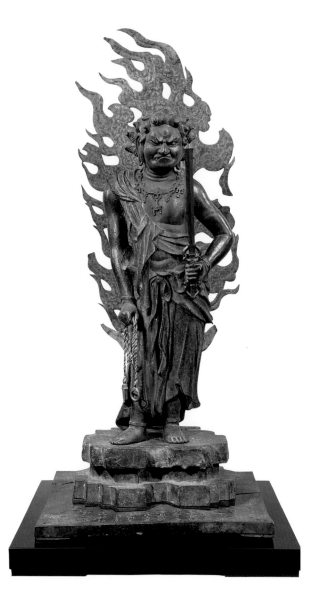

Shugendō provided an ideal ground for growth of the Chinese sects of Esoteric Buddhism. Two priests, Saichō (or Dengyō Daishi, AD 767–822), and Kūkai (or Kōbō Daishi, AD 774–835), were both influenced by the mountain ascetics in their youth. They were prominent in setting up centres of Esoteric Buddhist studies on sacred mountains. Saichō, at the age of only 19, had been ordained in Tōdai-ji Temple, Nara, but left to study among the mountain people of Mt Hiei. He embraced the form of Buddhism known as Tendai, according to which the Lotus Sutra, recording the words of Sakyamuni, enabled enlightenment to be attained during one's lifetime. In AD 788 he built a temple on Mt Hiei, north of Kyoto, and installed an image of Yakushi Nyorai, the 'healing Buddha'. In AD 804 he joined a mission of *kentōshi* (ambassadors) on four ships bound for China, where he stayed at Tien-tai (Tendai) to continue his work. He gained insight into both Zen and Tantric practices (*mikkyō*).

Returning to Japan, Saichō founded Enryaku-ji Temple on Mt Hiei in AD 805. After his death, the Tendai sect obtained imperial permission to ordain priests in AD 822. Tendai activities were both spiritually and physically demanding with long periods of meditation, chanting while both sitting and walking, and arduous mountain climbing. Through such practices, Tendai held that the Buddha-nature inherent in everyone could be realized. Saichō's aesceticism spread,

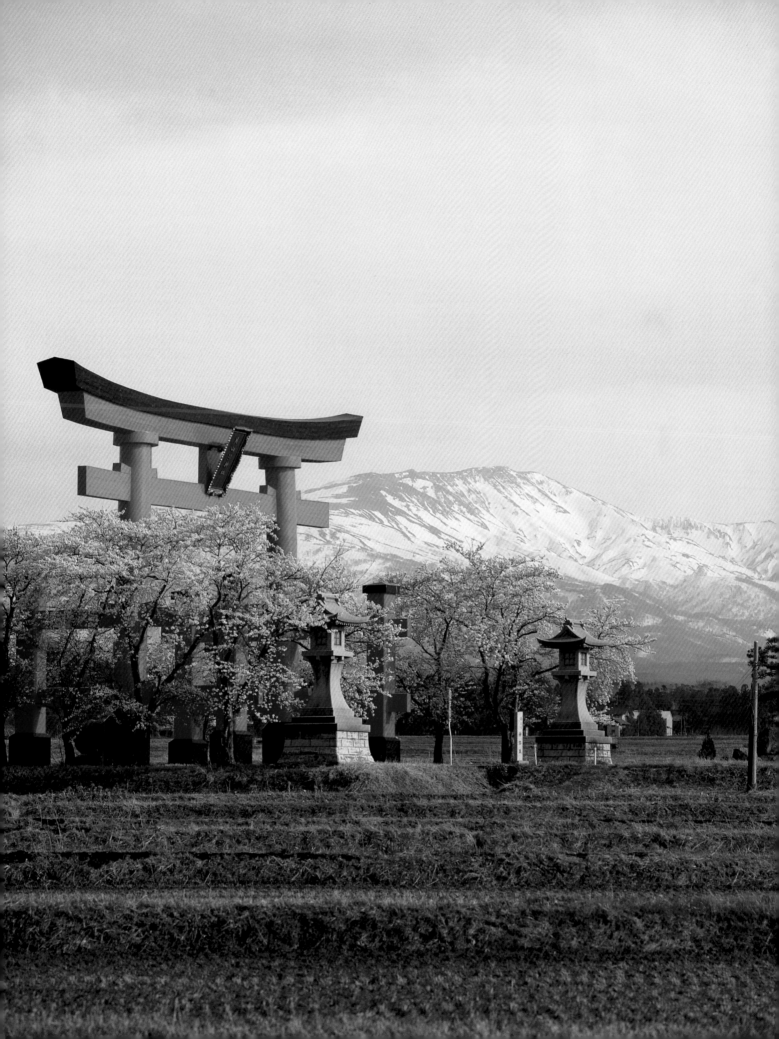

and during the Heian period the Buddhism of Mt Hiei became prominent, establishing many temples. The search for enlightenment through gruelling trials still continues today among the monks of Mt Hiei.

Kūkai had been to China on the same voyage as Saichō. He brought back a knowledge of Tantric which was called Shingon (True Word) and established it on Mt Kōya at a temple which came to be called the Kongōbu-ji. During the period when Saichō and Kūkai were active, the magical elements of Shingon and the austere practices of Tendai must have been closer to the beliefs of the *yamabushi* than to conventional Nara Buddhism. Kūkai is said to have encountered the *kami* Niu Myōjin face to face on Mt Kōya after a protracted period practising austerities alone on the mountain (cat. no. 80).

The supreme Buddha of the Shingon sect is Dainichi Nyorai, the Buddha of Boundless Light, the ideograms of whose name imply the sun. Like Tendai, Shingon also provides for enlightenment in the here and now. The sect employs formulae of contemplation assisted by magical hand gestures and using a variety of *vajra* and bells, the fragrance of incense and the intonation of sutras. The Buddhist world is expressed in two diagrams, the *taizō-kai* and the *kongō-kai*, which have been expressed as The Womb World and The Diamond World. These are essentially numbers of Buddhas in geometric arrays, and could be represented either as three-dimensional models or, more commonly, in paintings. The *taizō-kai* was basically a concentric arrangement of eight Buddhas on the petals of a lotus, with a further rectangular matrix of many Buddhas in the background. The *kongō-kai* was based on a regular arrangement of nine squares, again with a larger background matrix.

A simplified explanation of the two worlds is that the *taizō-kai* represents intellectually comprehensible Buddhism, and the *kongō-kai* represents the unimaginable truth beyond this, expressed in the symbol *kū* (void). The *kongō-tai* expresses understanding beyond intellect and words, which the Nara- and Heian-period monks must have equated with the undefinable essence of the *kami*. Ultimately the two worlds are inseparable – in a sense, a unity of heaven and earth – which related readily to the way the *kami* make their presence felt in everyday life.

The mandala concept became central to the art of *shimbutsu shūgō*, the unification of *kami* with Buddhist deities which was endorsed by both Tendai and Shingon through their period of greatest growth. Tendai and Shingon spread over Mt Kimpusen and Mt Kumano. Kumano, where mountain religions had been practised before the arrival of Buddhism in Japan, was presented to pilgrims as the *taizō-kai*, and Kimpusen as the *kongō-kai*. *Shugendō* adherents provided spiritual guides for pilgrims over the whole mountain complex from Kimpu in Yoshino to Kumano. During the course of the Heian period, countless thousands made the pilgrimage to Kumano. This is a place of great natural beauty and includes the Nachi waterfall (fig. 20), which is over 100 metres high. Since Amida Buddha was held to be the Buddhist equivalent of the *kami* of the mountain, the mountain itself became synonymous with Amida's Pure Land paradise. Aristocrats from Kyoto followed a route marked by ninety-nine designated shrines of the *kami* of Kumano Sanzan which took several weeks, hoping to gain entrance into this paradise. Several emperors who were devout Buddhists made the pilgrimage, some many times over many years – Gotoba-In (r. 1183–98) went 28 times, and Go-Shirakawa (r. 1155–58) went 34 times.

Until the Meiji era (1868–1912) there were two shrine buildings, the Shin-gū at the foot of the mountain and the Hon-gū high on the River Kumano. The third deity originally had no shrine, for it is the Nachi waterfall itself. Now at Nachi there are thirteen *kami* enshrined under six roofs of a shrine complex. The deity enshrined at the Shin-gū is Hayatama-yahazu-no-kami. At the Hon-gū it is Ketsumiko-no-mikoto-no-kami, whose Buddhist equivalent is Amida. The Nachi waterfall is the female *kami* Fusumi-no-ōkami.

The pilgrim takes a strenuous route up the mountain, which should include a period of immersion under the waterfall. This is where the Heian-period monk Endō Morito (later to become monk Mongaku) spent a thousand days in contemplation beneath the fall in order to

atone for having mistakenly killed his wife. He was aided during moments of distraction by Kongara Dōji and Seitaka Dōji, the two acolytes of Fudō Myō-Ō, whom Endō was to see in his moment of enlightenment (fig. 21). Kumano was identified with Fudaraku-san (Mt Potalaka), the earthly paradise of Kannon, the prime Bodhisattva of Amidism, and so was a particularly important place on the pilgrims' way. Until the eighteenth century, the River Nachi was the scene of an extreme part of the pilgrimage. Candidates for a spiritual journey to Fudaraku-san were launched from the mouth of the river on to the sea sealed in a boat with neither sail, oars nor rudder – effectively a launch into death.

Archaeology and the Origins of Shintō

Some practices of Shintō derived from Chinese religious practices and were tempered by the relationship between Korea and Japan leading up to the introduction of Buddhism in the sixth century AD. There are also enduring aspects of the religion which seem inseparable from the land of Japan itself, and of which custom, folklore and archaeology can provide hints and glimpses from the distant past. A brief outline of Japanese prehistory will provide a background for the objects in this exhibition to tell the story. Prehistory can be ordered into three periods: the Jōmon, from around 12,500 BC until around 300 BC; the Yayoi, from then until around AD 300, and the Kofun period, from then until around AD 600.

The Jōmon Period

Recent advances in archaeology have shown that Japan may have enjoyed the longest-known stable civilization in the world since around the end of the last Ice Age.[7] Around that time, there were land bridges which linked Japan to the Asian mainland, at Hokkaidō in the north and Kyūshū in the south. Mongol peoples are believed to have come to Japan from north-east China via the northern land bridge to become a main component of the Jōmon population. From around the third or fourth century BC, increased

Fig. 21 *Mongaku beneath the Nachi Waterfall*, from *Wakan ehon sakigaki shōhen* (*Picture Book of Heroes of China and Japan*, Part 1), by Katsushika Hokusai (1760–1849). Woodblock illustrated book, published by Kawachi Mohei, Osaka, and others, 1836. (BM JIB 224)

contact with China and Korea over a period of several centuries revolutionized society, resulting in the unification of the nation as it is known today.

The Jōmon period is named after the cord patterns on the distinctive pottery of its advanced phases. The earliest pottery has been carbon dated to around 12,500 BC, which gives Japan the earliest substantial pottery culture so far known. The early pots were pointed at the base for insertion into a cooking fire and decorated with marks made with the fingernail or the crescent end of a reed or piece of bamboo. Later pieces were decorated with cord marks made by rolling a piece of cord, twisted in various ways, over the surface of the clay before baking it in an open fire. Some pottery of a similar age has been discovered in China,[8] but the quantity of excavated pieces in Japan indicates a comparatively rich and stable society throughout the period.

Climate and land changes did nevertheless cause the relocation of centres of occupation. Settlements first recognized by huge mounds formed of discarded seashells have been shown to have been continuously occupied for more than a thousand years.[9] Yet the Jōmon peoples

were hardly sedentary. Despite differences in living style between the west and east of Japan, there is ample evidence of trade and exchange throughout the Japanese archipelago. Examination of polished stone implements shows that Jōmon people traded by sea the length of Japan and beyond, from Hokkaidō and the northern islands to as far south as Polynesia. Their ships were made of hollowed-out trees, which could be in excess of 5 metres long. Refuse heaps contain a variety of fish bones in such quantity as to prove Jōmon peoples competent fishers in their small rowing ships, from which they caught deepwater fish and even whale and dolphin.

While Europe and mainland Asia were in the inclement latter stages of the last Ice Age, Japan enjoyed a relatively mild climate. Although there were climatic changes and areas of Japan suffered extreme cold,[10] in the main there was plentiful food from the sea and from the mountainous areas, which made up about ninety per cent of the land. Varieties of nuts, roots and fruits were gathered and animals such as boar and deer were hunted. The diet necessitated pickling, drying and detoxification processes. Excavations of villages of the Jōmon period have indicated a close-knit communal life with communal food stores. The Late Jōmon (*c.* 1500 BC) Ryūzu site, in Oita Prefecture, revealed sixty storage pits, one of which contained around 13,000 acorns. The need to detoxify wild nuts by long immersion in flowing water implies large-scale communal activity, as does their storage on communal village ground separate from the dwellings.

There is as yet no evidence of any form of defence associated with any settlement. Since there was minimal or no agriculture, it is probable that there was a communal lifestyle with no division of land or concept of individual ownership. The peoples of the middle Jōmon period typically lived in pit houses, which could be well in excess of 10 metres long. The roofs were probably thatched and supported by beams propped up from the ground. Long-established settlements were often rebuilt, so that the excavated remains of houses may overlap over and over again.

Sannai Maruyama (Aomori Prefecture) is a well-preserved site of a village occupied continuously from around 3500 to 2000 BC (fig. 23). The village had a dwelling area, communal food storage area, separate burial grounds and a well-constructed road which led to the sea. Typically for a Jōmon village, there was no stockade nor well-defined boundary, suggesting that, at least for the fifteen hundred years of its occupation, the villagers of Sannai Maruyama had no concept of war or territorial struggle. A set of six regularly spaced post holes of 2 metres in diameter, separated by intervals of 4.2 metres, suggests an imposing building. The remains of posts of more than a metre in diameter in the holes suggest a building of impressive height, perhaps 15 metres or so. It has been variously conjectured that this might have been a watchtower, raised storehouse, ritual edifice or even a lighthouse, since Sannai Maruyama was obviously an important coastal village. Whatever its primary function, the tower and other similar buildings must have been prominent and welcome landmarks indicating human habitation both to ships at sea and to travellers by land (fig. 22). Since food was plentiful, it is easy to imagine the hospitality extended to sailors trading obsidian, pitch, stones and perhaps textiles.

Sculpted stone and earthenware anthropomorphic Jōmon figurines are of a number of types. Many represent pregnant or amply endowed females, possibly for use in fertility or childbirth rituals; others are funerary. Many figurines are found deliberately broken, sometimes in many pieces scattered over large areas. Stones carved in phallic forms during the Middle and Late Jōmon periods (cat. no. 20) may be the ancestors of the stone and wood phalluses which represent the deities of some Shintō shrines today. Other ritual objects in the form of stone rods are found buried beneath the hearths of Jōmon houses, indicating an understandable regard for fire as sacred. But the ceramic vessels are the most striking aspect of Jōmon culture. The distinctive cord marks form complex patterns which can defy analysis. Curvilinear designs may be the precursors of the *chokko-mon* (cat. no. 34) pattern prevalent during the later Kofun period. The so-called *kaen doki* (flame pots) have rims with exaggerated sculpted protuberances that seem to resemble flames, but are not clearly definable.

A quality of these and other highly decorated pots is that the designs are often asymmetric. The decorative sense of Jōmon peoples is at first sight perhaps somewhat bizarre, and seems to belong to a different world. Compared with the inexplicable arrangements of the whorls and contortions of the rims of the flame pots, designs of other world cultures, however intricate, are based on relatively straightforward geometrical models. Whatever the flames on the *kaen doki* may have signified, it is completely beyond present understanding.

Certain pots have modelled animal or human shapes and faces on them. These sometimes face inwards and sometimes outwards. A recurring image is the snake, and a class of human faces with a snake-like appearance suggests a form of deification of the abundant forest snakes (cat. no. 4), which is evident in later Shintō shrines. Many of the faces are so stylized as to defy classification, however. Some of the humanoid faces on pots are similar to the faces on earthenware figurines, in all their variations. Some seem to be tattooed persons, perhaps forebears of later tattooing customs in Japan recorded in Chinese chronicles such as *Wei shi*, and still observed within living memory among the indigenous Ainu population of Hokkaidō. The tattoo patterns are close to some of the patterns on the pottery.

Some pottery figurines seem to be wearing masks, reminiscent of earthenware and seashell masks of the period, of which some are meant for wear and some for decoration or ritual. It has been suggested that late Jōmon figurines of northern Japan with bulbous eyes may be wearing a form of snow goggles similar to those used by the Alaskan Inuit people. Other theories include the suggestion that the bulging eyes may represent the eyes of the dead, and that the figurines are ancestor memorials (cat. no. 5). A striking feature of many figures is that the mouth is open in a round O, as if singing, like some later *haniwa* figures of the Kofun period.

Until the importation of Chinese ideographic script to Japan in the sixth century, and excepting inscriptions on some Chinese mirrors and

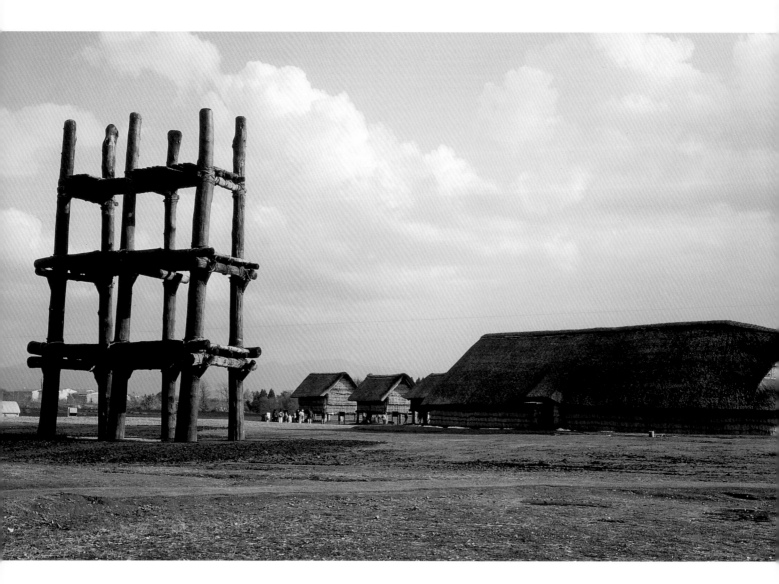

Fig. 22 Sannai Maruyama site, Aomori Prefecture. Reproductions of the great tower and other buildings of the Middle Jōmon period (3000–1000 BC). (Photo: Aomori-ken Kyōiku linkai)

swords, there was no writing in the Jōmon culture. But the complex geometry of the decoration on Jōmon pottery vessels from the Middle period onwards, the evident degree of organization of society, and the proven ability to travel long sea distances all presuppose widespread intellectual communication. Presumably, learning was by oral tradition and memory, like the aborigines of Australia, so the open mouths on the figurines can indicate song or intonation. One of the reputed writers of the *Kojiki*, Yasumaro, is said to have recorded it directly from the lips of one Hieda no Are who had recited the entire epic to him from memory. Hieda no Are was no doubt one of the hereditary *kataribe* (reciters) of Shintō history. They are mentioned in the *Nihongi* as passing on the secrets of ritual and the quasi-histories of the gods.

The continuity of the Jōmon culture, rare if not unique among world civilizations, must have shaped a particular national character, part of which was the ready acceptance of immigrants and their customs from mainland Asia in the Yayoi and Kofun periods. While it is not possible to define exactly what the religious beliefs of the Jōmon people were, their stable and relatively unchanging lifestyle may have provided the foundation for some aspects of Shintō that have persisted to the present day.

The Yayoi Period

The Yayoi period is named after the place in Tokyo where its distinctive pottery was first discovered, in a shell mound at Yayoi-chō, Hongō district. The pottery, although hand built from

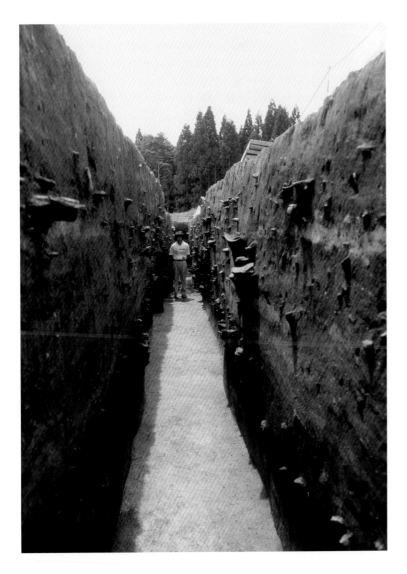

Fig. 23 Sannai Maruyama site, Aomori Prefecture. Excavated trench in a refuse mound beside the settlement, showing pottery sherds embedded through several metres' depth over the 1500 years of constant occupancy of the site between 3500 and 2000 BC. (Photo: Sannai Maruyama Kyōiku Iinkai)

coils of clay and baked in a surface fire like Jōmon pottery, is generally less decorative and has a greater variety of utilitarian shapes. This reflects the needs of an agricultural community. The period is defined broadly by the six or so centuries between the arrival of peoples from Korea and China bringing both wet-rice agriculture and bronze and iron technology, and the unification of Japan into a single nation under the Yamato clan around the end of the third century AD.

The rice and other cereal fields planted by the first agricultural communities in the early Yayoi period signalled the start of territorialism in Japan. The Jōmon peoples had mainly hunted, fished, and gathered their food although in the late Jōmon period there is evidence of a degree of control of natural forest resources, of cut-and-

burn agriculture, and of some rice and cereal cultivation without paddy fields. To demarcate their land, Yayoi peoples made field boundaries, which had to be protected against intrusion by people and beast. Communities gradually developed into land-owning quasi-states with stockaded villages to guard their valuable grain stores. An excavated village at Yoshinogari in Fukuoka Prefecture has been reconstructed with a ditch and ramparts, gate and watchtower. The houses follow the basic pattern of Jōmon period pit dwellings, and buildings thought to be grain stores are raised above the ground and supported on columns. Graves away from the stockade are situated on raised ground and contain ovoid-shaped pottery coffins.

A complete late Yayoi period agricultural village site was discovered in 1943 at Toro in Shizuoka city. The layout had been well preserved as a result of a flood after which the village was abandoned. The wet ground preserved much of the basic wood structure of the buildings. Pit dwellings built over oval-shaped sunken recesses were roofed directly into walls of earth around the edges of the pits. There were also more sophisticated storehouses raised on columns and having wooden-plank walls. Such storehouses were the forerunners of both early palaces and Shintō shrines. The elevated storeroom was reached by a stairway constructed from a single log with steps cut into it, a method still used for Ise Shrine today. Other excavations of Yayoi sites, such as Uriyodo (in Osaka) have more recently[11] provided further fuel for the ongoing debate about the true location of the ancient state of Yamatai recorded in Chinese documents.

The Kofun Period

From the middle Yayoi period onwards, important people began to be buried in small tumuli. During the first few centuries AD, major clans increased in size in Kyūshū, Shikoku, and the Kinki and Kantō regions. Tombs became larger towards the end of the period, when the military and social influence of the Yamato people of the Kinki region spread outwards to Kyūshū, Shikoku, and Kantō, until Japan was unified

under the Yamato clan around the end of the third century AD.

The Kofun period describes the time from around the third to the sixth century AD, during which the rulers and early emperors of Japan were interred in *kofun* (tombs). Japan was unified under the Yamato hegemony and there was a burst of international activity. Goods interred in the tombs with the dead owed much to Chinese and Korean precedents, and in certain cases were actually of Korean or Chinese manufacture. In fact, some occupants of the tombs were probably Korean immigrants. The tombs consisted of stone chambers covered with mounds of earth. Initially they were constructed by laying flat stones one above the other to form walls gradually converging towards the top of the chamber then covered with a roof of larger stone slabs and earthen mounds. These were the *tateana-shiki kofun* (vertical entry chamber tombs) into which the body of the deceased in a wooden coffin was lowered from above.

This type of tomb later developed into the *yoko-ana-shiki kofun* (horizontal entry chamber tombs) in which the burial chamber was made of larger standing stones covered with great stone slabs. This created a space large enough to take more than one stone coffin, and left sufficient room for the coffin bearers to move around. The rectangular burial chambers of the later type of tomb were approached by a narrow passage that sometimes opened into a primary chamber in which rituals could be conducted. Early examples of the horizontal entry tombs are remarkably similar to those of Neolithic Europe and elsewhere, but towards the end of the period, came to be constructed with more sophisticated squared masonry.

The mounds over the tombs of more important personages were huge. Typically they were of a keyhole shape with the chamber in the conical part, connected to a regular trapezoidal section on which it is believed memorial rites were conducted. Keyhole mounds could be hundreds of metres long – for instance, in the case of the tomb of the Emperor Nintoku in Osaka, the mound is some 486 metres in length. They were often surrounded with huge moats to prevent profane visitations (figs. 24–27).

Although some tombs have in the past been levelled to the ground, many survive. Tombs of emperors are particularly protected, and now cannot be entered except by members of the Imperial Household Agency. The single approach to a *kofun*, like a Shintō shrine, was defined by a *torii*, signifying the holy nature of the place and its status as a dwelling of an ancestral *kami*. Although many imperial tombs are now identified and protected against excavation, it remains possible that tombs unrecognized as imperial may be excavated in the future.

Izumo and Yamato

Both the *Nihongi* and the *Izumo fudoki* (AD 733) contain historically accurate explanations of the subordinate relationship of Izumo to Yamato at the time of writing. But the earlier parts of the *Nihongi*, containing the creation myths as they relate to the adventures of Susano-o-no-mikoto, can be interpreted as an allegorical history of the transition from Jōmon to Yayoi culture in Izumo in which the Koreans were involved and where the final struggle between the Izumo and Yamato clans resulted in national unification.

The beginning of wet rice cultivation during the Yayoi period necessitated cutting back the forests which the Jōmon people had relied upon for food in order to make rice fields. In contrast, the mountainous areas were left untouched in the main, although large deciduous trees were felled in the mountains. However, there seemed to be sufficient awareness of the need for conservation – probably by agreement between the indigenous population and the new arrivals – and the trees were coppiced to ensure future supplies of timber.[12] The denser forests survived and the substantial wild animal population gave rise to folk tales of feral visitations and changelings. Many of the protected mountain areas, still known as *satoyama* (village mountains), became the sacred places of later shrines which grew from the rice culture.

The process is parallelled in the *Nihongi*, with Susano-o-no-mikoto taking on the role of a warlike invader. When he went to Izumo (p. 20), 'Many people of the land died and the green Mountains withered'.

Fig. 24 Konabe *kofun*, Nara Prefecture, one of the great keyhole-shaped moated mounds which contain stone burial chambers of the early rulers and emperors of Japan (third–sixth century AD). (Photo: Professor William Gowland, 1880s/BM)

Fig. 25 Ōzuka *kofun*, Fukuoka Prefecture. Aerial view of the keyhole-shaped tomb of the Kofun period, sixth century AD. (Photo: Ōzuka Sōshoku Kofunkan)

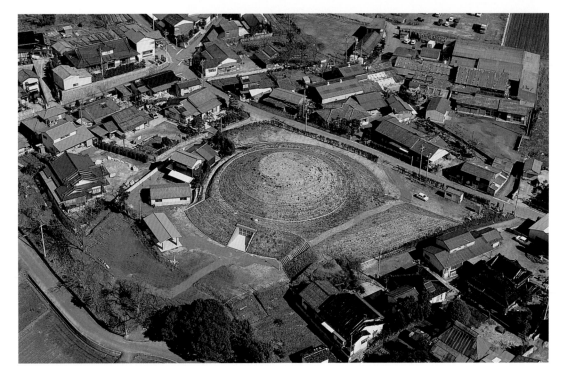

The *Nihongi* description of the Yamata-no-orochi (eight-headed serpent) is very much that of a landscape, making the killing of the serpent an allegory for the taking of the land and the introduction of rice paddies: 'It had an eight-forked head and an eight-forked tail; its eyes were red, like the winter-cherry; and on its back firs and cypresses were growing. As it crawled it extended over the space of eight hills and eight valleys' (p. 53). 'This serpent had rock firs growing out of each of its heads, and on each of its sides there is a mountain' (p. 56).

The *Nihongi* then continues with the allegory, showing how the Yayoi people (embodied as Susano-o) continued to practise forestry conservation:

Susano-o-no-mikoto said: 'In the region of the land of Han[13] there is gold and silver. It will not be well if the country ruled by my son should not possess floating riches.' So he plucked out his beard and scattered it. Thereupon cryptomerias [*sugi*] were produced. Moreover, he plucked out the hairs of his breast which became thuyas/white cypress [*hinoki*]. The hairs of his

TOP Fig. 26 Ōzuka *kofun*, Fukuoka Prefecture. The ruler or dignitary was buried in the inner of two chambers of the sixth-century tomb. This shows the outer chamber, where rituals were conducted, with wall paintings in red and black pigment of animal silhouettes and shapes resembling young ferns. (Photo: Ōzuka Sōshoku Kofunkan)

ABOVE Fig. 27 Tomb of Jimmu Tennō, the first emperor of Japan according to the quasi-historical *Nihongi* (AD 720), from *Views of 31 Imperial Tombs*, 1867, by Okamoto Tōri (active late nineteenth century). Hand scroll, ink and colours on paper. (BM JP 1148)

buttocks became podocarpi [*koyamaki*, an umbrella pine unique to Japan]. The hairs of his eyebrows became camphor trees [*kusunoki*]. Having done so, he determined their uses: viz the cryptomeria and the camphor tree were to be made into floating riches [ships]; the white cypresses were to be used as timber for building fair palaces; the podicarpus was to form receptacles in which the visible race of man was to be laid in secluded burial places. For their food he well sowed and made to grow all the eighty kinds of fruit' (vol. I, p. 58).

This passage highlights the practical aspect of Shintō as the nurse and preserver of forestry. It also emphasizes the sacred nature of trees, discussed elsewhere. Archaeology has shown that the uses of these woods from long before the time of the *Nihongi* was as described in its text, for the timber of the coffin of Munyeong (r. AD 501–23), king of Paekche, Korea, was of umbrella pine imported from Japan. The coffin had been made using a log 130 centimetres in diameter by 3 metres in length, from a three-hundred-year-old tree.[14] This example of the export of timber to Paekche for a coffin confirms the close relations between the two nations in spiritual matters shortly before the time the first Buddhist image was brought to Japan in the reign of the Korean King Syeong-Myeong in AD 545.

Yayoi period bronze objects which originated in Kyūshū are among those unearthed from ritual deposits in Izumo. A bronze halberd blade of Kyūshū type and a jade *magatama* (comma-shaped jewel) of the Yayoi period were discovered in the early seventeenth century at the site of Inochinushi Shrine at Manai (cat. no. 32). The shrine was a subsidiary of Izumo Ōyashiro, and the find indicates the sacred status of the site on which it was built. The spot where Manai Shrine is situated was once close to the water's edge of Lake Shinji (fig. 28), where ships had access from the Japan Sea before the River Hii-kawa silted up.

A Yayoi pot excavated at the Inayoshi Sumita site[15] is incised with a sketch of the shrine high on its supporting pillars and a long, steep ladder leading to its platform. The sketch includes the arrival of a ship nearby. It is highly probable that ships trading with Korea would have landed at

this place. The lowering of the level of the coast is told in a local legend recounted in the *Izumo fudoki* (c. AD 733), the only complete example of the five surviving local government records commissioned by the central government for all the provinces during the Nara period and kept in the Shōsō-in. Both this record and a document in Gakuen-ji Temple tell the same story: Susano-o-no-mikoto found a land floating in the sea and moored it, making it into a mountain. The temple also owns a painting depicting the deity Sannō Gongen pulling a mountain to shore using a rope, while Susano-o-no-mikoto pegs it to the mainland. This probably relates to the silting up of the River Hii-kawa and the forming of Lake Shinji, although other theories interpret it as a relationship between places in Korea and elsewhere in Japan.[16]

Significant finds at Kōjin-dani and Kamo Iwakura in Izumo in 1985 may prove to mark the close of the Yayoi period and the start of the Kofun period. The Kōjin-dani (Violent Kami Valley) find was of six *dōtaku* (ritual bronze bells) buried in two rows of three with the tops facing each other, and at right angles to them a row of sixteen bronze spears laid alternately base to point (fig. 29, cat. no. 28). Post holes suggest there was a roofed structure over the site at some time. The site is on the southern slope of a short, steep valley called Kōjin-dani leading into the main western valley at Kamba to the southwest of Lake Shinji. Not far away, a further excavation yielded 358 bronze swords laid in rows.

With the exception of one, the *dōtaku* are believed to have been made in the Kinki region where the Yamato clan later became the supreme power in Japan. Some of the spears are of a type found in northern Kyūshū. The swords are of a type which has been found in the Chūgoku and Shikoko regions around the Inland Sea. Such a large-scale ritual burial involving Izumo, Kyūshū and Yamato can be interpreted as representing a treaty between the three areas, and probably the recognition of the

Fig. 28 Sunset over Lake Shinji, Izumo
(The Layered Clouds of Heaven).
(Photo: Shimane Prefectural Museum)

Fig. 29 Kōjin-dani site, Shimane Prefecture, showing sixteen bronze spear blades and six *dōtaku* as they were when excavated from the second- to third-century ritual burial site on a remote mountainside overlooking the Kamba valley. (Photo: Shimane Prefectural Museum)

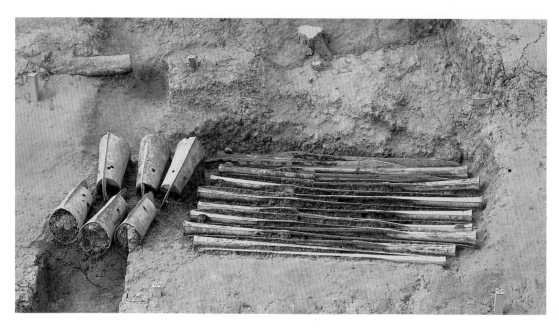

supremacy of Yamato. The transition to Yamato-style key-hole shaped *kofun* in Izumo also signifies the Yamato supremacy. At Kamo Iwakura, a group of thirty-nine *dōtaku* was found buried at a similar site on a steep hillside. X-shaped marks incised on some of the *dōtaku* correspond to marks on 344 of the Kōjin-dani swords, although the significance of this has not been determined.

The relationship between Izumo and Yamato according to the *Nihongi* prevails today. Although governed by Japan, Izumo Ōyashiro is a centre of palpable religious independence. The position of the *kuni-no-miyatsuko* (regional governor), which was vested in Ōkuninushi-no-mikoto, was subsequently inherited by the chief priests of Izumo Shrine whose direct descendants still serve the shrine today.

Hashira – Sacred Pillars

In the Japanese language, different classes of objects have different words used to count them. The counter for the *kami* is *hashira*, a word which also means 'pillar'. This underlines the significance of the sacred nature of wood and wooden pillars in ritual and in traditional architecture.

The sacred nature of trees is universal, according to Shintō belief, and extends also to felled timber. Trees can be venerated as *kami* in their own right, and particularly impressive old trees are often bedecked with a *shime-nawa* (sacred rope) signifying their holy status. Every effort is made to preserve trees, and even after being cut down, the nature of their timber is respected and aspects of its original form are often preserved. Thus a part of the outside of a trunk or branch used in a building might be left unfinished. Tables made of a cut section of an old tree retain their original circumference profile. Parts of a tree or its roots of unusual shape are valued as ornaments. In Kasuga Shrine, a pine tree several hundred years old is allowed to grow through the roof of one of the shrine buildings. Its branches are supported, its trunk is bound with straw, and every effort is made to allow it to continue to age further despite the apparent inconvenience.

The same applies to trees in the wild on a grander scale. Trees which live to a great age are particularly holy, and in historic times sacred forests have been preserved to ensure a supply of massive old trees for temple and shrine buildings. The *Nihongi* record of tree production by the *kami* Susano-o-no-mikoto tells of conscious, careful husbandry in prehistory. Jōmon period archaeology indicates that trees were allowed to grow to a great height, and were cut down to be venerated as totems. The practice continues today at Suwa Shrine in Nagano Prefecture.

Sacred trees were used for sculptures of images of Buddhist deities and, from the Nara period onwards, for Shintō images. The felling

of trees would be accompanied by a propitiation rite marking not the death of the tree, but its transformation into a new life. In the 1920s, the sculptor Niiro Shunosuke was permitted to use a sacred tree for the figure of the Kudara Kannon (in Hōryū-ji Temple), made for the British Museum (fig. 31). The sculptor was present at a ceremony for the felling of the tree, which was conducted by a Buddhist priest since it was to be a Buddhist image. This is just one example of the deep influence that Shintō has had on Japanese Buddhist practices (fig. 30).

There was a remarkable persistence of tall buildings elevated on columns from the Jōmon period onwards. The six-pillared structure at Sannai Maruyama is one of a number of recent discoveries of this kind of architecture. The layout of the post holes is similar to that of grain stores of the Yayoi period, excavated at sites like Toro, and is illustrated vividly on the Kofun period mirror from the Samida Takarazuka *kofun* (cat. no. 33). Although shrine architecture was also influenced by mainland Asian styles, the overall construction of the Sannai Maruyama is very close to that of prehistoric storehouses, which were built above ground to

prevent the ravages of animals. The basic structure is also similar to the palaces of the early emperors of Japan and to all Shintō shrines today. Shrines themselves are landmarks and centres of communities: many are situated conveniently in coastal locations or in the foothills of mountains.

The emphasis on the height of the pillars, and the archaeological evidence for tall buildings elevated on tall columns dating from the Jōmon period, is parallelled by an ancient custom of venerating single raised pillars. Some of the sacred Jōmon columns, like the European maypole, may have had an element of phallic significance. A 2-metre-high sculpted standing stone phallus of the late Jōmon period in Saku-Machi, Nagano Prefecture, is one of the larger and more realistic examples, although there are many smaller versions (fig. 32).

An early Jōmon site at Mawaki in Ishikawa Prefecture yielded a 5-metre-high wood pillar, sculpted on the upper part, set in a pit containing several hundred dolphin skulls. Although the purpose is not clear, it was probably a form of propitiation, and at the same time, a means of inviting further catches. Stone circles with tall

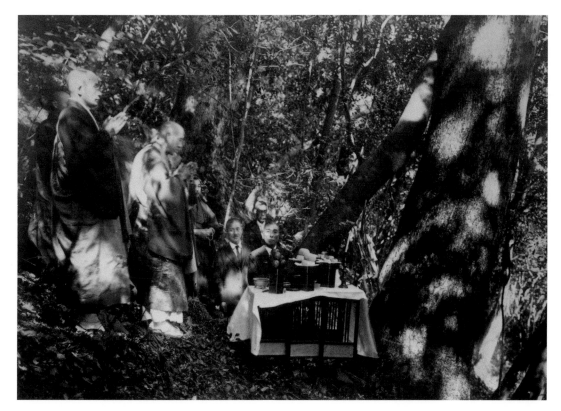

Fig. 30 *Mokurei kuyō*, service of appeasement and memorial for the spirit of the tree to be felled for the manufacture of the representation of the Buddhist figure of Kudara Kannon for the British Museum in the early 1920s. The sculptor, Niiro Shunosuke, is centre right. (Photo: BM)

stones arranged radially and with a central standing stone, at one time popularly believed to have been sundials, have been found in the north of Japan. As well as indicating a possible sun-related ritual, these have also been found in association with burials. A late Jōmon period wood circle at Chikamori in Ishikawa Prefecture is formed of segments of trees with the circumferential portions arranged inwards. The remnant of a post has two holes pierced through it near the edge with a groove running between them, suggesting that the whole circle might have been tied with a band of some material that has disintegrated.

It has been suggested that the method of strengthening high columns by binding the logs together in threes, like the supports of the Heian period Izumo Shrine, may be the origin of the shime-nawa which is used to encircle sacred trees and rocks, and which is placed over shrine entrances. The raised circumferential bands on cylindrical haniwa (fig. 33) and cylindrical ritual sueki vessel stands of the Kofun period can also be compared with shime-nawa, and some cylindrical sueki have inscribed bands of wavy lines reminiscent of woven straw, although no connection has been definitely proved.

Pillars are still regarded as sacred today, as exemplified by the heart pillars (shin-bashira), the central pillars of the naikū and gekū shrines at Ise and Izumo. When the Ise Shrine is moved to an adjacent site every twenty years, the heart pillar remains embedded in the ground in the centre of the site of

Fig. 31 Kudara Kannon, representation of the Bodhisattva Kudara Kannon, c. 1926. The seventh-century original is in Hōryū-ji temple. (BM OA+8, bought with contributions from Sir Percival David, Bt, the National Art Collections Fund and Mrs Alexander White)

the old shinden. The heart pillar of the naikū is buried deep underground, but a portion of that of the naikū stands. The pillars are surrounded by a wall built under the raised floors of the shrines to conceal them. The heart pillars are mentioned in the Kōtai jingū gishiki-chō (AD 804) so were already considered sacred by that date. By tradition, the heart pillar is dressed with branches of sacred sakaki tree and a small building erected over it to conceal and protect it. A ceramic vessel is placed beside the pillar, to lie dormant until, after twenty years, the site once again becomes the scene of daily offerings to Amaterasu-ōmikami. This apparent continuation of religious custom going back to the Jōmon period is confirmed by the existence of stone circles sacred to the kami also within the Ise Shrine grounds.

Single wood pillars are held as sacred in a number of shrines. For example, the Suwa Shrine in Nagano Prefecture is the setting for a periodic rite involving a pillar-deity. Every seven years, sacred trees (shimboku) are felled high on the mountain which towers over the shrine. They are used to erect sixteen pillars forming squares around the two buildings of the Upper Shrine and the two of the Lower Shrine. In the most colourful of the ceremonies, the tree is stripped of its branches, and at an appointed time, is sent careering down the mountainside. Young men of the locality attempt to jump on it as it goes past to ride it down to the Lower Shrine precincts, where it is to be raised. Their daring often results in injury and even death. But however dangerous, the tradition is so deeply ingrained in custom that the authorities are powerless to stop it.

The festival is typical of many local traditions in which the way is prepared for a mountain deity to come down to the rice fields for the period between spring and autumn to ensure a successful yield. When the trees are about to be launched on their passage down the mountainside, the people cry: 'The great tree from the deep mountains comes down to our village and becomes a god'. Another ditty suggests: 'If you want to see a man, it is once in seven years, felling the Suwa tree and sending it downhill'.

Although there is no honden on Mt Miwa, the

Fig. 32 Standing stones of the Late Jōmon period (c. 1000 BC), Nagano Prefecture. (Photo: Mrs Michiko Abe)

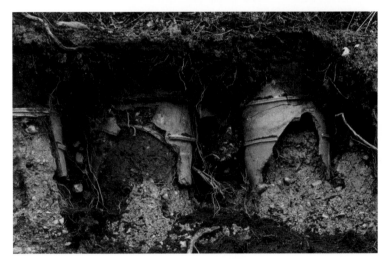

Fig. 33 Cylindrical *haniwa* on one of the terraces of a *kofun* said to be that of Emperor Chūai, photographed after their exposure following a storm. (Photo: Professor William Gowland, 1880s/BM)

stone buildings were the burial chambers inside *kofun* (tombs), a custom brought from outside Japan. Early forms of these *kofun* resemble European chamber tombs of two or three millennia before their appearance in Japan.

One possible interpretation of the 'Three Sacred Treasures' is to think of them as representing the progression of the Stone (*magatama* jewel), Bronze (mirror) and Iron (sword) Ages against the background of a deeply ingrained wood culture.

Ritual Burial in the Yayoi and Kofun Periods

Kofun-period tombs are rich in the Three Sacred Treasures: the jewel, the mirror and the sword. Examination of these, particularly of the mirrors and swords, together with a study of Japanese, Korean, and Chinese written records, is gradually permitting a more accurate dating of the *kofun* tombs themselves. Many objects are found ritually buried in other sites as well. An example of the latter is Mt Miwa. There is no structure to contain the deity of Mt Miwa since the whole mountain is regarded as the *kami*. The *torii* at the foot of the mountain announces the sanctity of the whole area, and there are a number of related shrine buildings. On the summit, a number of stones surround a large boulder which is considered to be the *yorishiro*. Relics deliberately buried there show that the mountain was sacred in prehistoric times. Among the material excavated from the site were Kofun period *sue* and *haji* ware ceramic vessels, models of implements including agricultural tools, stone jewels, and a set of *saké*-brewing equipment. The latter is particularly significant since the *kami* of the mountain is described in the *Man'yōshū* anthology of poetry (about AD 720) as Ōmononushi-no-kami, the god of brewing. Model figures and implements from the Tanibata site in Tottori Prefecture (cat. no. 49) of the same period are thought to have been ritually hung from a tree by a village as protective tokens. Rising steeply from the sea off northern Kyūshū, the densely forested island of Okinoshima (fig. 34) is also regarded as a *yorishiro* of the *kami*, identified with Munakata Jinja Shrine on the mainland. Although there

approach to the *haiden* (worship hall) has a tree dressed with a *shime-nawa* in which a white snake is said to have dwelled, making it the *yorishiro* of the snake *kami*. Forest creatures and trees are still revered in areas where rice agriculture made slow progress. Until medieval times, fortified buildings were rarely of stone. In fact, bronze and iron were introduced at around the same time as stone buildings, around two thousand years ago, and there were never clearly defined Bronze and Iron Ages in Japan. The first

were no *kofun* on the island, objects similar to those found in *kofun* including the 'Three Sacred Treasures' were deposited on the island during the Kofun period. These were in supplication to the *kami* for a safe sea passage to and from Korea and north China. The objects were placed in natural *yorishiro* formed in rocky places (figs. 36, 37). The practice continued from the fourth century through the Nara and early Heian periods until the cessation of regular contact with China in AD 894. The island is unoccupied except for a single priest of Munakata Shrine. Priests are sent one after another in fortnightly rotation to serve the *kami*. Continuing the long tradition, the priest has to be purified by immersion in the sea before landing on the holy place (fig. 35).

Among objects discovered in *kofun* are stone models of working implements, body adornments, rings, necklaces of beads, weapons including daggers (in the later tombs), pottery, spearheads, arrowheads and gilt-copper horse accoutrements. The ritual pottery found is either of a low-fired type called *haji* ware (made by the *hajibe* potters' guilds referred to in the *Nihongi*) or, more abundantly from around the fifth century, a high-fired stoneware called *sue* ware. Kofun period *sue* vessels are sometimes decorated with models of humans and animals from which a hint of the relationship between the ritual and the secular worlds can be gleaned. *Sue* ware is markedly similar and in some cases indistinguishable from Korean pottery of the same period. Such high-fired pottery would have needed the kiln technology brought to Japan by Korean immigrants, also referred to in the *Nihongi*.[17] Later *kofun* contain gilt-copper horse accoutrements and richly ornamented swords. Gilt shoes and crowns in the richer tombs are further indications of skilled Korean craftwork and suggest that the occupants of some of the *kofun* may even have been Koreans.

Some of the later tombs have wall paintings similar to those in Korean tombs and also show scenes reminiscent of present-day Shintō religious customs and paraphernalia. A wall painting in Takehara *kofun* in Fukuoka Prefecture shows nobles with long-handled ritual parasols identical to those still made today as part of the *go-shimpō* of Ise Shrine, and an attendant with

two horses. The north wall of the inner chamber of the Zhangzhou No.1 tomb in Jilain Province, Ji'an County, China, depicts a crowded scene which might illustrate knowledge of or indeed the origin of the Japanese creation myth.[18]

The wall painting shows the hunting of deer by mounted archers, a pair of wrestlers of the stature of *sumō* wrestlers each holding the other by the large belt, standard in *sumō*, and a crowd including dancers before a tree bedecked with various tokens. It has been suggested that the latter scene in particular links it with Japanese mythology, for it conforms to a passage in the *Nihongi*. The account there says that, when Amaterasu hid in the cave of heaven (*ama no iwayato*), she was enticed out in the following way: Ama-no-nukado-no-kami, the ancestor of the guild of mirror makers, made mirrors for her; Futotama-no-mikoto made offerings of cloth; Toyodama, the ancestor of the jewel-makers' guild, offered her jewels; Nu-zuchi, the moor deity, made her combs; and the mountain *kami* Yama-tsuki made a 'five hundred-branched *sakagi* tree', trimmed with the treasures.

The Jewels

The sacred stone jewels are of three kinds: spherical, tubular and comma-shaped. Tombs contain other jewellery, but it is not of a sacred nature. Decorative accessories include earrings, necklaces and bracelets. But it is the comma-shaped *magatama* that is the sacred treasure. *Magatama* have a hole pierced through the bulge of the comma so that they can be strung. *Haniwa* figures of female shamans – the precursors of present-day female shrine attendants (*miko*) – wear necklaces of one or more *magatama*, sometimes strung with tubular or spherical beads. The *haniwa* are sometimes also depicted holding a mirror and a sword, so in effect they are empowered with all of the 'Three Sacred Treasures' at once (cat. no. 42).

Some *magatama* have additional comma shapes applied over their surfaces, probably symbolizing regeneration and growth of the clan (cat. no. 48). Turning to written accounts, the procreative power of the jewel is described in the *Nihongi*: 'Amaterasu-ōmikami took the curved jewels of Yasaka, and having made them float on

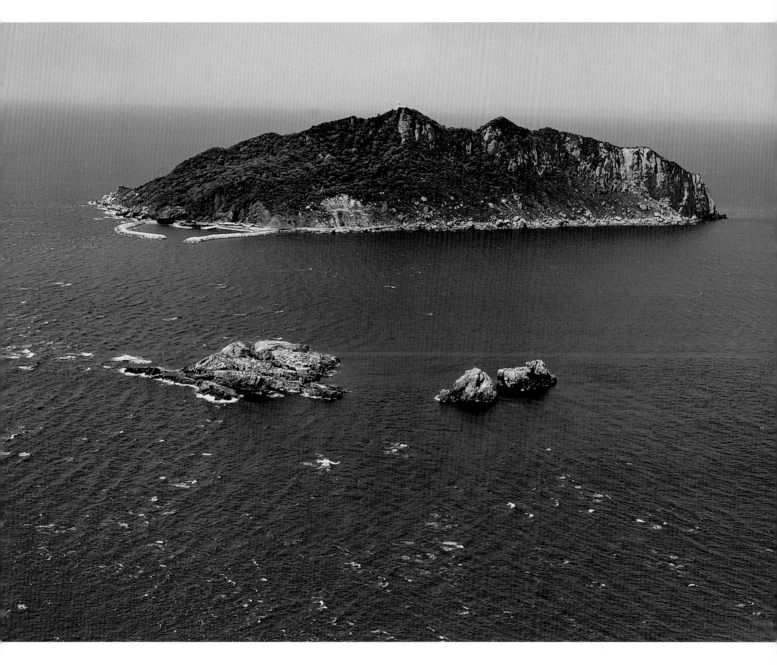

Fig. 34 The Holy Island Okinoshima. Here offerings of objects (cat. nos. 34, 45–47) were made to the *kami* to supplicate safe sea passage to and from the mainland between the fourth and ninth centuries AD. (Photo: Munakata Taisha)

the true well of heaven, bit off the heads of the jewels and blew them away. The deity which was produced from amidst her breath was called Ichiki-shima-hime-no-mikoto' (*Nihongi*, p. 38).

The account continues with a contest between Amaterasu and her brother Susano-o. Susano-o also produced deities, by biting off the end of his sword. Amaterasu followed this by eating three swords to produce children. Then, 'Susano-o took in his mouth the string of 500 jewels which was entwined in the left knot of his hair, and placed it on the palm of his left hand, where-upon it became converted into a male child'.

As mentioned above, not all jewels found in *kofun* were necessarily of ritual significance. The *kofun* excavated in the 1880s by William Gowland at Shiba in Kawachi Province (eastern part of present-day Osaka-fu) contained a body in a wooden coffin with ritual sword and jewels. Beside the coffin were the remains of a second body which Gowland deduced to be the wife. There were over a thousand coloured beads with this body. The Shiba tomb yielded three large *magatama* together with green stone tubular beads, and a number of smaller *magatama*, these associated with the main interment. No

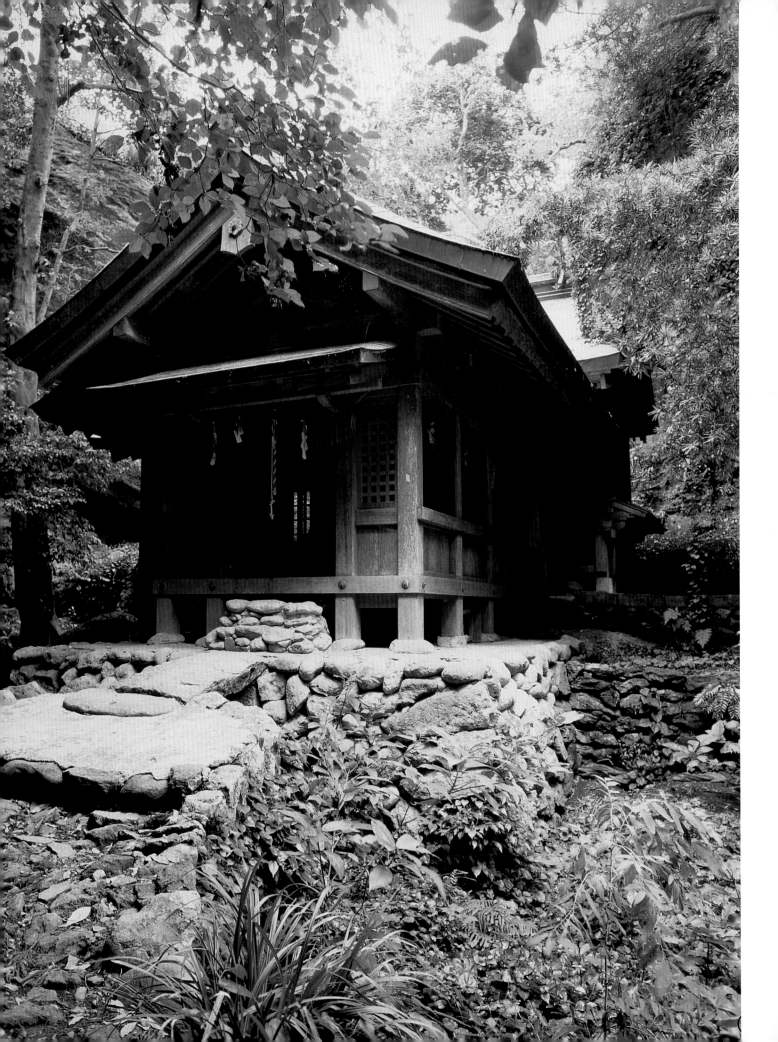

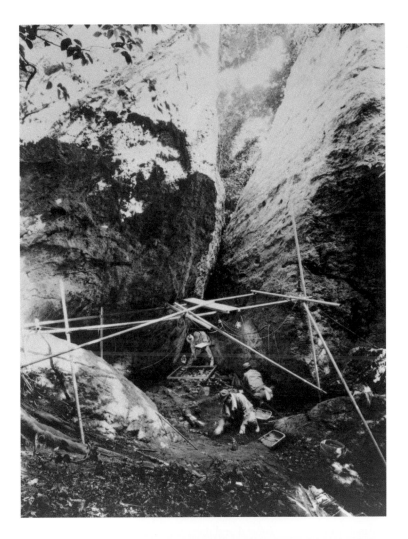

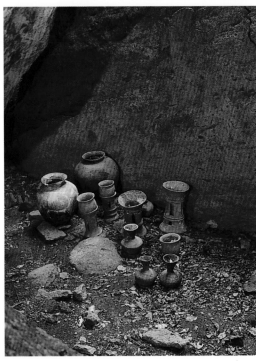

mirror was found but it could be assumed that it had probably been removed previously, since the tomb had been entered a number of times and much material taken away before Gowland's arrival. The Kofun period jewels were made of glass and a variety of gemstones including jade, jasper and nephrite. It is known that, in the Late Kofun period, softer talc was also used.

The Mirror

The mirror given by Amaterasu-ōmikami to her grandson Ninigi-no-mikoto was intended by the Sun Goddess to enable him to remember her divine form. This very mirror is said to be the one preserved in Ise Shrine as the *go-shintai* of Amaterasu.

Bronze mirrors first came to Japan from China during the Yayoi period together with bronze weapons and *dōtaku*, based on Korean ritual bells. These were the first bronze objects to be brought to Japan in any substantial number, although it is thought that a few may already have arrived in the late Jōmon period. These mirrors were in the form of a disc with one polished reflecting surface and decoration on the reverse of designs cast in relief. A central raised boss with a hole in it permitted the passage of a loop of cord with which the mirror could be held secure in the hand when used; some early Korean mirrors have two loops for this purpose.

Designs on Chinese Han Dynasty (206 BC– AD 220) mirrors which have been unearthed in Japan from Yayoi period sites, predominantly in Kyūshū but also in the Kinki region, include those with concentric regular designs of stylized petals and linked arcs (cat. no. 34), and the so-called TLV design with geometric forms resembling those letters. The TLV design has been interpreted as forms of the square and compasses, indicating a belief in an architectural

Fig. 37 The *okanagura*, where sacred offerings were deposited around the sixth century AD. Reproductions of ceramics are shown exactly as the originals were found. (Photo: Munakata Taisha)

order to the universe, and thereby associated with immortality.

Later Han Dynasty mirrors have depictions of deities. One type has the set of the four heavenly creatures – the blue dragon, white tiger, red bird, and black turtle – whose colours have been adopted in Japan for Shintō ritual, and these are also the colours of the sacred curtains in Kasuga Shrine. Others have Daoist deities and various other creatures, some of which are obviously maritime, and some are imaginary or unidentifiable today. Some have seated human figures that are believed to be Buddhas. The first written inscriptions known in Japan are on Han mirrors excavated from *kofun*.

Mirrors placed in Chinese Han Dynasty tombs were included among the goods to accompany the deceased. They are found together with other cosmetic equipment, but mirrors also had a further magical function.

In his 'Longevity like Metal and Stone: The Role of the Mirror in Han Burials' (T'oung Pao LXXXI), K. E. Brashier observes of Chinese Han Dynasty burial practices that interment was preceded by a lying in state of the body in its coffin, which would be placed into the final tomb for as long as weeks or months after death. The Eastern Han commentator Fu Quian tells of a special lacquered box made to house a mirror suspended inside the coffin during the time the body was being prepared for burial. The purpose of the mirror seems to have been to protect the body during the period of mourning, and perhaps to quieten the restless spirit of the departed. It also had a preservative function. Excavations have shown such single mirrors situated near the head, while more mirrors are found together with other goods further away from the coffin.[19]

Michael Lowe, in 'The Imperial Tombs of the Former Han Dynasty and their Shrines' (T'oung Pao LXXVII, 1992), points out that metal (bronze) and stone (jade) were valued in China because they do not deteriorate, and were thus believed to last for what the ancient Chinese thought was eternity. The use of a mirror in the coffin and jade ornaments to seal the orifices of the body were to ensure a form of eternal life. Exactly what eternal life meant at the time is

suggested in the *Chunqiu fanlu*, ascribed to Dong Zhongshi (179?–104? BC), who writes about a deceased ruler: ' … his reputation and soul extend to oblivion, and he enjoys extreme longevity without end'.[20]

Certain Chinese beliefs and burial customs were adopted in Japan. The *Nihongi* records that eighteen months elapsed between the death and burial of the first emperor Jimmu (*Nihongi*, p. 135).

Chinese mirrors in particular had a special place in the burials of the early Kofun period. A form of Chinese mirror found uniquely in Japan is the 'triangular-rim deities and creatures mirror' (*sangaku-fuchi shinjū-kyō*). This has a raised triangular-sectioned rim and roundels with figures of deities interspersed with figures of various creatures both real and mythical. Of the thirty-six mirrors of this type found in Japan in the 1953 excavation of the Tsubai Ōtsukayama *kofun* in Kyoto Prefecture, thirty-three were found propped up along the side walls of the tomb. The other three were placed separately: one close to the skull was a Chinese Han Dynasty piece, and the other two were Japanese copies, reflecting the adoption of the Chinese burial practice recorded by Fu Quian.

The Kogane-zuka *kofun* at Izumi, Osaka, had three separate burials within the mound. The central and most imposing of these is believed to be that of a woman because of the absence of swords and the preponderance of jewels. There were also three mirrors, with one resting against the skull. A number of mirrors remote from the actual burials had been discovered some years before the main excavation. Kobayashi Yukio (d. 1989) had proposed in the 1950s that the 'triangular-rim deities and creatures mirrors' were part of the gift of a hundred sent to Queen Himiko of Yamatai in AD 240 by the Chinese Wei emperor.[21] The date of manufacture in the inscription, AD 239, accords with this. Kobayashi's theory implies a high degree of unification under the Yamato clan at the time, the beginning of the Kofun period. Kobayashi further argued that the dispersal of the mirrors, and of the copies of them made from identical moulds in Japan found in various regional tombs, indicated a sovereign relationship in which mirrors were given to subordinates in

much the same way the Wei emperor had sent the gift of mirrors to Himiko.

Another mirror with a Chinese date in accordance with AD 239 was excavated in 1972 from the Kanbara Jinja *kofun* in Shimane Prefecture. The dates around AD 238–40 on this type of mirror suggest that Yamato supremacy and the start of the Kofun period proper might have coincided roughly with the time of the ritual bronze deposits (fig. 29) at Kōjin-dani and Kambara in Izumo. This is also indicated by a growing uniformity in the style of the keyhole-shaped tombs. A more recent excavation at Kurozuka *kofun* (1998) in Nara Prefecture produced over thirty such mirrors, again with one at the head and the others propped up along the sides of the chamber. This find was seen as strengthening Kobayashi's theory that the Yamatai referred to in the *Wei shi* was Yamato, since Kurozuka is one of the more imposing of the earliest Kofun period tombs there.

The designs of the Chinese mirrors were copied in Japan, sometimes made with greater precision and in a larger size than the Chinese originals. Some mirrors made in Japan in the Kofun period were already uniquely Japanese in design. One excavated from Samida Takarazuka *kofun* in 1881 (cat. no. 33) is a valuable source for the study of architecture at the time, and may illustrate early shrine buildings. It is decorated with four different kinds of buildings, two of which are raised on columns and might represent rice storehouses or shrine buildings. Outside one of these is a long-handled parasol, somehow supported and inclined at an angle. It is reminiscent of the Ise *go-shimpō* and the wall painting of the Takehara *kofun* previously described. Similar buildings appear in the decorations of bronze pommels of Kofun period swords. Mirrors with peripheral bells (cat. no. 36) were also peculiar to Japan. They are not found in tombs, but must have been part of ritual. They are depicted in *haniwa* as the possession of female shamans.

The Han Dynasty belief in mirrors as talismans and the source of longevity took deep root in Japanese popular belief, and by the Heian period the designs on mirrors incorporated many Japanized Chinese concepts. Common motifs included: *sennin* (mountain man, a hermit with superhuman powers) riding on a flying crane; Hōrai-zan, the Island of Longevity, with pine, turtle and crane; and various combinations with Japanese themes like cherry and plum blossoms and bamboo. The importance of the mirror makers, together with the swordsmiths, is emphasized during the Edo period when many members of both professions were given honorary titles under the imperial ranking system.

Mirrors were also of significance in Buddhism, particularly in the mountain religion during the Nara and Heian periods. During the Meiji period, an excavation of a sacred pond in front of the *honden* of Dewa Shrine on Mt Haguro (present-day Yamagata Prefecture) yielded over five hundred mirrors. The pond, known as *Haguro-ike* (Pond of Mt Haguro) or *Kagami no ike* (Pond of Mirrors), is the *mitama* (spirit entity) of the *kami* of the mountain. The mirrors were predominantly of a type made in Kyoto, and were probably offerings made by female aristocrats after their long pilgrimage from Kyoto to the mountain shrine.

Mirrors are identified with the halo of infinite light and clarity behind a Buddhist image. As such, they came to be used from the Heian period as supports for arrays of seated Buddhist figures called *kake-botoke* (hanging Buddhas). In later popular Buddhism of the Edo period (1615–1868), mirror makers made so-called 'magic mirrors'. These looked like ordinary mirrors, but had artifices on the surface imperceptible to the naked eye. In clear sunlight these reflected an image of Buddha on to a white wall or similar surface.

The mirror, directly revealing the nature of the object it reflects, became a symbol of Zen Buddhism. It exemplifies the phrase 'direct vision of one's true nature is the enlightenment of Buddha' (*jikishi ninshin kenshō jōbutsu*). The enlightened swordsman Miyamoto Musashi (1684–1745) wrote in his classic treatise on the Way of the Sword, *A Book of Five Rings*: 'Polish the twofold spirit, heart and mind, and sharpen the twofold gaze, perception and sight. When your spirit is not in the least clouded, when the clouds of bewilderment clear away, there is the true void'. The mirror has often been used as a

metaphor in this context. The essential reality underlying the image and the sensible perception of the image, whether the mirror is cloudy or not, parallels the Shingon concept of *kongotai* and *taizōkai*. Yamaoka Tesshū (1836–88), the enlightened Meiji period swordsman and calligrapher, wrote: 'On a clear day,/ Or on a cloudy day,/ The original form of Mt Fuji/ Is unchanging' (*Harete yoshi,/ kumoritemo yoshi,/ Fuji no yama, / moto no sugata wa,/ kawarizari keri*). This short poem expresses the nature of enlightenment in terms of a direct comparison with the Shintō deity of Mt Fuji, the clouds equivalent to clouds painted on a shrine mandala, or the curtains which partly obscure the presence of an emperor or other *kami* in a shrine.

The Sword

The Japanese steel sword is unique in the world in its terrible efficacy, the beauty of its form and textures, its exquisite surface hues – and because it can of itself be the manifestation of a *kami* according to Shintō, or an instrument of enlightenment in Buddhism.

The creation mythology of Japan tells of a number of miraculous swords, some of which are said to be in the possession of Shintō shrines today. Although part of the mythology overlaps with fact and reality, and the *go-shintai* kept in shrines cannot be viewed, some shrines possess swords and other treasures dating back to the Kofun period, well before the time when the *Nihongi* and the *Kojiki* were compiled. Such swords may provide an insight into the mythology.

The first of the swords mentioned in the *Kojiki* was named Tozuka (Ten Fists). A sword ten fists long would necessarily be made of iron, hence dating from the Kofun period (cat. nos. 51, 52), since bronze weapons of that length are impractical. It was used by the deity Susano-o-no-mikoto to kill the Yamata-no-orochi, the Eight-Headed Serpent. Susanao-o took from the serpent's tail the sword named Ama-no-mura-kumo (The Layered Clouds of Heaven). The legend of his subjugation of the Yamata-no-Orochi has been interpreted as his journey along the turbulent, winding River Hi-kawa, and the sword in the tail of the dragon as the plentiful iron ore found in the sands of the river bed. The Hi-kawa became a rich source of *satetsu* (sand iron) used in the feudal era for the manufacture of swords and agricultural implements. Even today its waters run red with iron oxide washed down from the mountains. According to the *Nihongi,* when Susano-o was banished from heaven he went to Silla (in Korea) to obtain gold and silver, and later made his home on Mt Kumano in Izumo.[22] The *Izumo fudoki* tells how the *kami* dwelled in present-day Suwo village.

The sword named Ama-no-mura-kumo was the one that, with the sacred mirror, the Sun Goddess had previously given into the care of her grandchild, Ninigi-no-mikoto, when he descended from heaven. Later entrusted by Yamato-hime-no-mikoto, the priestess of Ise Shrine, to Prince Yamato Takeru-no-mikoto, it became known as Kusanagi (Grass Cutter). This was so because the prince escaped from an ambush set by his enemies by firing and cutting the grass around him. The sword was later deposited at Atsuta Jingū Shrine by Takehiko-no-mikoto, the prince's son, where it became the *go-shintai.*

The *go-shintai* of the *kami* enshrined in Isonokami Jingū Shrine is the sword called Futsu-no-mitama-ōkami or Kunimuke-no-tsurugi, said to have been sent from heaven to aid Emperor Jimmu in the subjugation of his opponents in the Kumano area of Yamato. Of the other two *kami* enshrined at Isonokami, Furu-no-mitama-ōkami and Futsu-shi-mitama-ōkami (Tōtsuka-no-tsurugi), the latter is also embodied as a sword. According to the *Nihongi,* a man named Kumano no Takakuraji dreamed of Amaterasu speaking to Takemikazuchi-no-mikoto, who pledged to send his sword down to the man's storehouse to aid Jimmu. The sword was deposited in Isonokami Shrine during the reign of Emperor Suijin (*Nihongi,* p. 115). Isonokami Jinja, which contains the storehouse referred to in the account, was the armoury for the Yamato state, under the custodianship of the Mononobe clan. The *Nihongi* describes it so: 'Suinin Tennō: thirty-ninth year, Winter, tenth Month. Inishiki-no-mikoto, while dwelling in the palace of Udo in Chinu, made a thousand swords. They were deposited in the shrine of

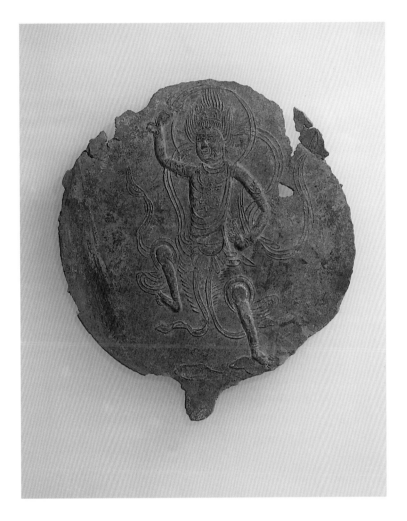

Fig. 38 Bronze relief casting of the Zaō Gongen, main deity of the *Shugendō* sect, found during repairs to the shrine building on the summit of Mt Ōmine. Heian period (794–1185). (Photo: Ōminezanji)

there is a river source which issues from Mt Cholsan [iron mountain] in Kong-na. It is seven days journey. It need not be approached, but one should drink of this water, and so having gotten the iron of this Mountain, wait upon the sage Court for all ages' (*Nihongi*, p. 251).

The historical record confirms the close relationship with Paekche at the time and hints of the barter of Korean iron. Another passage in the *Nihongi* speaks of a gift of silks, bows and arrows, and forty bars of iron.

An excavation in 1978 of the Sakitama-Inariyama *kofun* in Saitama Prefecture of an intact burial revealed a warrior with a *magatama* necklace, a mirror placed at his head, and four single- and two double-edged swords. One of the double-edged swords has a long inscription in gold which identified the owner and his title, Omi no Kabane, the name of the ruler at the time, Wakatakeru, and a date which has been interpreted as either AD 471 or 531. The sword was made from steel imported from China. The inscription verifies the existence in the fifth or early sixth century of the *kabane* system of titles of rank recorded in the *Nihongi*, which were in use until the Taika Reform of AD 684. A similar sword excavated in 1873 from the Etafuna-yama *kofun* in Kumamoto Prefecture, Kyūshū, also has a long silver-inlaid inscription with a name believed to be that of the same ruler, probably the Emperor Yūryaku.[23]

Thirty-five similar swords were excavated from troughs on either side of the burial chamber at the fourth-century Tōdaiji-yama *kofun* at Tenri, together with a number of small pedestalled cups made of talc. The cups are reminiscent of those held by *haniwa* figures of female shamans, and have a ritual significance beyond that of merely providing for the needs of the deceased. One of the swords has a gold-inlaid inscription dated in the Chinese Chuhei era equivalent to AD 184–189. It was evidently treasured for two centuries before it was mounted in gilt-bronze, perhaps specially for the interment. The sword has a decorated gilt-bronze pommel with floral motifs. The inscription also contains the four characters that can be interpreted as 'metal forged 100 times' (*hyaku ren sei ko*). Whatever the actual meaning of this

Isonokami. After this the Emperor gave orders to Inishiki-no-mikoto, and made him have charge of the divine treasures of the shrine of Isonokami' (*Nihongi*, p. 183).

Isonokami Shrine also possesses the sword known as Nanatsusaya-no-tachi (Sword with Seven Scabbards), or Shichishi-tō (Sword of Seven Branches) (fig. 39), which is a Japanese National Treasure. The blade has a long inscription inlaid in gold stating that it was presented by the prince of Paekche in the year AD 372 to the emperor of Japan, thus making it an unique historical record. According to the *Nihongi*, such a sword was brought from Paekche and presented to Empress Jingū. The account goes:

> Kutyo and the others came along with Chikuma Nagahiko and presented a seven-branched sword and a seven-little-one mirror [a mirror with peripheral bells, cat. no. 36], with various other objects of great value. They addressed the Empress, saying: 'West of thy servants' country

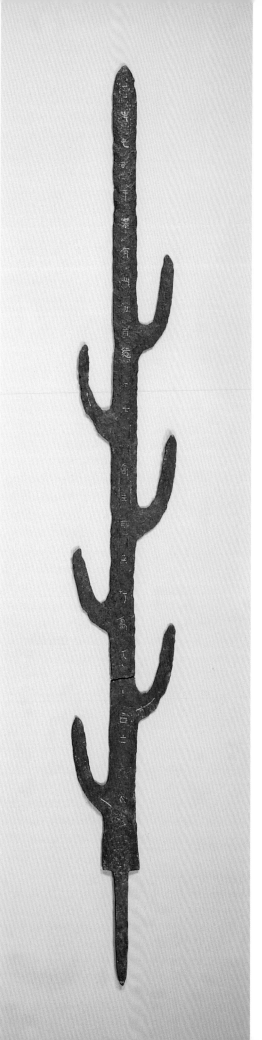

inscription, it at least implies a superior method of manufacture. It may refer to a form of pattern welding, since the basic technology of sword manufacture by the folding and welding of pieces of steel was first introduced into Japan from China sometime during the Kofun period.

Yayoi and early Kofun period iron swords were probably all imported from China. Later, swords were made in Japan at first using iron imported from Korea and China, and then with indigenous iron produced initially in Izumo and the San'indō and San'yōdō regions. The archeological context and inscriptions on such swords has strengthened the historical validity of the *Nihongi* in recent years, enabling a more confident approach to studies of the early development of the 'Three Sacred Treasures'.

Two Chinese straight single-edged swords in the collection of Shitennō-ji Temple in Osaka, which are reputed to have belonged to Shōtoku Taishi, survive in remarkably perfect condition. They are characteristic of later straight single-edged blades of the Nara and early Heian periods. They have a visible grain structure on the polished surface due to the repeated folding process, and a distinct whiter crystalline structure running along the edge showing where the blade has been preferentially hardened by heat treatment. This *hamon* (badge of the blade) is the main metallurgical characteristic of Japanese swords. It is produced after the forging and shaping process by partially covering the blade with a layer of clay to leave the cutting edge exposed. The edge is then hardened by heating it red-hot then quenching it in water.

A number of Kofun period swords that survive in sufficiently good condition have been polished since excavation to reveal this manufacturing process (cat. no. 51). One of the Shitennō-ji swords is known as Heishi Shōrin Ken, from a gold-inlaid inscription on the blade. (Heishi is a zodiacal date and Shōrin is probably a maker's name.) Another is the Shichi Sei Ken (Seven Stars Sword), known as this from the gold-inlaid depiction of a stellar constellation on one side of the blade. The other side has an engraving of a dragon's head and clouds. It is not difficult to imagine either that the sword named Ama-no-mura-kumo, which Susano-o-no-mikoto found

Fig. 40 *Inariyama no kokaji* (*The Swordsmith of Inari Mountain*) by Ogata Gekkō
(1859–1920), from the series *Miscellaneous Drawings from Gekkō, Gekkō Zuihitsu*.
Colour woodblock published by Takekawa Risaburo, Tokyo, 1893.
(BM JA 1982.5.27.01, given by Timothy Clark)

in the tail of the Yamata-no-orochi in Izumo, was the inspiration for the engraving, or that the design originated in China and was the origin of the Susano-o legend.

Shintō in the Arts

A number of major Japanese arts were born and nurtured within Shintō and developed into their present forms through the influence of Shintō traditions. They include *sumō* wrestling, *yabusame* (mounted archery), *kyūdō* (archery), *kendō* (swordplay) and masked drama including Noh.

Sumō

Sumō is believed to have originated as the celebration of a conflict between the two sons of Ōkuninushi-no-mikoto of Izumo and Taka-emikazuchi-no-mikoto, who had been dispatched from Kantō by Amaterasu-ōmikami. *Sumō* is known certainly to date from the Kofun period, from the modelled figures of wrestlers applied on to *sueki* ceramics. Bouts are conducted according to Shintō precepts. The ring itself is bordered by a straw rope, as if it were the *yashiro* of the *kami*. Both ring and wrestlers are ritually purified with salt before the contests. High-ranking *sumō* wrestlers wear a belt of woven straw equivalent to the *shime-nawa*, signifying the holiness of their status. This is removed before the bout. The referee wears Heian period court dress suitable for a Shintō priest (fig. 41).

Fourteenth-century wooden models of two wrestlers and a referee are part of the Shintō paraphernalia kept at Mikami Shrine (cat. no. 97). The winner's ritual involves a series of expansive movements including the double hand-clap used when worshipping the *kami*, accompanied by a kind of dance holding a bow, one of the traditional Shintō treasures.

Yabusame

Archery has no doubt existed from earliest times in Japan, and bows around 2 metres in length have been found in Jōmon excavations. The present form of the Japanese bow with the grip offset low was recorded in the *Wei shi*, the Chinese third-century chronicle. *Yabusame* is an important part of several shrine festivals. It may have originated in Chinese hunting customs (note the Zhangzou tomb fresco mentioned earlier). However, horses were apparently little used in Japan until the latter part of the Kofun period around the end of the fourth and beginning of the fifth century, when horse accoutrements are first found in tombs. These include

elaborate gilt-bronze bits, stirrups, saddle fit-tings, and harness ornaments and are similar to those found in Korean tombs of the same time. Objects and people moved freely between Korea and Japan, and it is known that Korean immi-grants brought much of their culture and tech-nology. The *Nihongi* tells in particular of the King of Paekche sending a present of a pair of horses to Emperor Ōjin with an attendant named Achiki. A stable was made for them at a place called Kuraakanoue in Kashihara, where Jimmu had built his original palace.

Late Kofun period tombs, like Fujinoki *kofun*, have yielded elegant horse trappings, including a remarkable gilt saddle bow sculpted with mainland Asian motifs. The *Nihongi* tells of the arrival of Korean saddle makers, the *kuratsukuri-be*, in Asuka. These were skilful metalworkers who had come to stay, and it was a certain Kuratsukuri no Tori (Tori, the saddlemaker), who made the bronze figure of Sakyamuni in Asuka-dera Temple in AD 605. It is not too diffi-cult to imagine horses being accorded a status in the Shintō hierarchy, having been brought from outside Japan by the same people who had brought bronze, iron and rice.

Whatever the early connection with Shintō, at least as early as the Heian period horses have fig-ured prominently in shrine activities. Ritual team races have been held annually at Kamo Jinja Shrine since their introduction by Emperor Horikawa (r. 1086–1107) in 1093. *Yabusame* is per-formed at a number of prominent shrines, includ-ing Kasuga Taisha, Tsurugaoka Hachimangū at Kamakura, where it was established by the first shōgun, Minamoto no Yoritomo, at the beginning of the thirteenth century, and Tōshōgū Shrine at Nikkō. In the past, horses were given as offerings to shrines, where they were used ritually to bring about weather changes: a black horse for rain and a white horse for fair weather. The custom of pre-senting horses to shrines is of great antiquity. This expensive method of asking the *kami* for benefits was replaced in later times by donations of paintings of horses. Grand examples are full-sized sliding doors or screens, but more common are small wood votive plaques with depictions of horses called *ema* (horse picture).

Live horses are still traditionally given as imperial gifts to Ise Shrine. They stand in turn in a ritual stable, to be paraded before the deity on the first, eleventh and twenty-first of each month. The preparation of the horses for both this event and for *yabusame* is highly ritualized, and emphasizes the sacred nature of the animal.

Masks and Drama

The various forms of drama practised at Shintō shrines include imports from mainland Asia from the seventh century, such as *bugaku* and *gigaku*, and a wealth of ritual dance dramas known as *kagura* (*kami*'s enjoyment). The dramas were per-formed initially for the entertainment of the *kami* and the aristocracy in shrines and temples.

Much of *kagura* derives from the creation myths, but its origins are probably much older. Ceramic and seashell masks dating back several thousand years suggest shamanistic drama. Two main forms of *kagura* are preserved today. *Mi-kagura* is a form of highly conventional dance of mainland Asian origin, confined to court festi-vals and ceremonies. This involves an elegant purification ritual. *Sato-kagura* (village or local *kagura*) is more shamanistic in nature. In *shishi* (lion) *kagura*, the performers wear or carry a lion mask with a body of textile and parade around a locality to bring luck to the inhabitants. The lion dance arrived in Japan around the seventh cen-tury AD. As lions were not indigenous to Japan, early depictions relied on Chinese Tang Dynasty versions, but soon developed a uniquely Japanese appearance. The mask with a textile body was also worn or carried by one or more performers in an exorcisim ritual at the head of Buddhist *gyōdō* processions. In this ritual, a Buddhist image is paraded along a given route and represents figuratively the descent of the Buddha accompanied by Bodhisattvas to bring salvation to human beings.

Various lion dances involving the mask have been used in all forms of drama including *bugaku*, *gigaku*, Noh, Kabuki and especially *kagura*. Traditional New Year celebrations in particular involve a lion dance in which the performers travel around a locality dispelling misfortune and sometimes enacting fire-prevention rituals.

Fig. 41 *Sumō Wrestlers*, colour woodblock print by Katsukawa Shunshō (1726–92). (BM 1943.10-09.9, donated by Mrs Eric Rose)

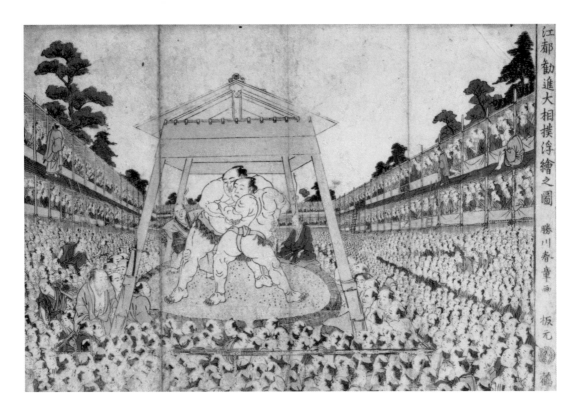

Gigaku is a raucous play by performers wearing masks with exaggerated non-Japanese features, some seemingly of Indian and Persian origin. Said to have been introduced into Japan by Mimashi, a Korean, in the seventh century, *gigaku* flourished during the Nara and Heian periods in connection with Buddhist ceremonies.

Bugaku is a drama with an orchestral accompaniment called *gagaku*, which derives from sources in China, India, Korea and elsewhere in Southeast Asia (fig. 42). It consists of alternate warlike and peaceful episodes, a number of dances involving women and children, and more exotic pieces using animal masks. Demon masks known as *tsuina* are used in a ceremony involving throwing beans away from a household to dispel misfortune.

Among the main forms of *kagura* based on the creation myths are three that feature the adventures of Susano-o-no-mikoto in Izumo, the episode of Amaterasu-ōmikami in the Cave of Heaven (Ama-no-iwayato), and the descent of Ninigi-no-mikoto in Kyūshū.

Izumo Shrine is the centre of the drama involving Susano-o-no-mikoto, in which he slays the eight-headed serpent. Ise Shrine dramatizes the tale of how the Sun Goddess Amaterasu-ōmikami was lured out of the cave in which she had hidden by an entertainment performed by the other *kami*. The entertainment inclues a dance by the female deity Ama-uzume. The myth is also reenacted in the dances of young female shrine attendants (*miko*) in which masks are not worn. The Ninigi-no-mikoto drama tells how the descent of the 'heavenly grandchild' from heaven was initially opposed by the terrifying Saruta-hiko-no-mikoto, a tall *kami* with round eyes and a long nose. The other gods persuaded Ama-uzume to distract Sarutahiko and Ninigi-no-mikoto arrived safely in Kyūshū. Ama-uzume is popularly depicted as a chubby, smiling beauty, and is frequently shown in comic or mildly erotic encounters with Sarutahiko-no-mikoto in his form as a *tengu* (a long-nosed, winged inhabitant of mountains). These three main dramas are performed with varying degrees of solemnity; in many smaller shrines, they are decidedly light-hearted.

The Sacred Nature of Masks

In *kagura* and Noh the masks themselves become occupied by *kami* and are in this respect a kind of equivalent to a *yorishiro*. In folk Shintō the masks may be worn, carried or placed in a

fixed position to become the equivalent of an image of the resident *kami*. There are many provincial variations of the fixed-position mask.

A form of mask found in Hyūga province (modern Miyazaki Prefecture), where Ninigi-no-mikoto is said to have descended from heaven, is of fearful appearance. It has no eyeholes and is too heavy to wear. A mask of this type is in the British Museum collection. On the inside, in the position corresponding to where the eyes would normally be cut through, are found exquisitely formed cusp-sectioned openings with inlaid circular plugs of a different wood, as if to provide the *kami* with a means of sight not available to people. The broad nostrils, on the other hand, are pierced through and spread into smoothly curved, widening openings as if to allow the passage of voluminous breath.

Jōmon period masks made of earthenware or shells have holes for strings, showing that they were made to be worn. It is probable that other materials were also used, but only earthenware and shells have survived. Some masks are remarkable in that the face is slightly twisted – with either the nose bent or the mouth offset to one side. In the case of certain masks made of shell, the natural whorl of the shell produces the effect of such distortion, and it is possible that this was the origin of the shape. However, it is also found in clay examples (cat. no. 14). This peculiarity is characteristic of a mask used in a popular, racy form of *kagura* involving the *kami* Uzume and a peasant called Hyottoko. His face is twisted into a grimace with one eye squinting, as if perpetually frozen in the act of blowing to kindle a fire. Although no direct connection bridging thousands of years can be demonstrated, the recurrence of such a strange facial expression is nevertheless remarkable.

Noh developed from Shintō agricultural forms of *kagura* called *dengaku* or *sarugaku*, and was perfected during the late fourteenth and early fifteenth century by the performer Zeami (1364–1443) under the sponsorship of the then military ruler of Japan, Ashikaga Yoshimitsu (1358–1408). Yoshimitsu encouraged the application of Zen Buddhism to arts like swordplay, the tea ceremony, calligraphy and drama. The Noh created by Zeami incorporates Buddhist concepts into refined forms of *kagura*. In certain *kagura* the *kami* are ritually invited to take possession of the priest. This is parallelled in Noh drama by the interaction between the main participants, the *shite* (leading actor) and the *waki* (supporting actor). In the performance, the *waki* summons a spirit or ghost into the masked *shite*, the high point of the drama expressing a kind of Buddhist enlightenment just as possession by the *kami* is the focus of *kagura*.

The leading actor prepares himself for the part by sitting before a special mirror in a sideroom and meditating to negate his own personality so that the mask may become the focus of the drama. The Noh mask itself is therefore treated with all the reverence accorded to *go-shintai*, and is subject to further respectful ritual by the actor before being worn and carried onstage. The play parallels shrine festivals in which the *go-shintai* is taken from the shrine to a spot where the presence of the *kami* is induced to enter it, later to be returned until the next festival.

The earliest clearly recorded and transmitted Noh drama is the *Okina*, which dates from the Heian period. The mask is that of an old man and is the only Noh mask to have an articulated chin attached separately. *Okina* is linked with an event that occurred beneath a pine tree on the path leading to Kasuga Shrine, when an elderly man seen dancing there was revealed to be a *kami*. The tree, known as the Yōrō Pine, still provides the setting for enactments of the drama at Kasuga. This play is regarded by all four of the present schools of Noh as the most important of the repertoire. The pine itself is identified with the *kami* and, for this reason, a painted pine tree forms the backdrop for every Noh stage. The plot and language are of such antiquity and sacredness that they are not intelligible today, the drama being accepted as beyond mere intellectual interpretation.

Shintō and Japanese Aesthetics

The beauty in the textures and hues of a finely polished sword blade result from the manufacturing process, which is uniquely Japanese. The amount of repeated folding and beating-out

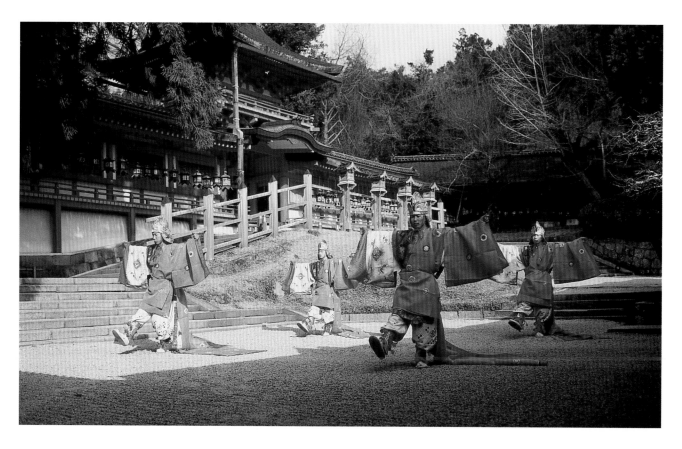

Fig. 42 *Manzairaku*, a classical *bugaku* drama, performed at Kasuga Shrine. (Photo: Kasuga Taisha)

reaches a limit beyond which the delicate sandwich of steel would break down and the mass become homogenous. Therefore the hammering must be exactly controlled to avoid this breakdown, and the last hammer stroke on the blade must be the optimum blow commensurate with the perfect whole. Less work would result in a blade of less strength. The same meticulous care and skill rules the heat-treating process, during which the blade must be brought 'to the colour of the moon in February or August'. It is immediately then quenched in cold water. If the heating temperature is too low, there will be insufficient growth of the highly tensed crystals of steel along the cutting edge for the required hardness to be obtained. If the temperature is too high, the crystals might break down altogether, or the stresses induced during the quenching might fracture the blade.

The sword-polishing process is also uniquely Japanese. The stones used for the final stages are relatively soft although of varying degrees of coarseness, and crumble away during use. This method of polishing allows for a differential treatment of the varying quality areas of the blade, so that the folding grain and the various metallurgical structures appear as lines, clusters of crystals, and shadows over the blade. Any attempt to polish or burnish the blade by another method will not reveal these structures.

The early tenth-century *Engi-shiki* tells of the many stages involved in sword polishing. This can involve around twenty different processes using stones of as many different grades. So it is certain that swords were regarded as objects of beauty at least as long ago as eleven hundred years.

By the Kamakura period, critical appraisal of swords had developed to a high level. Retired Emperor Gotoba-in spent much of his twenty years exile on Okinoshima personally making swords, with the best smiths throughout the provinces attending him by rota. Gotoba-in was praised as 'having an eye better than that of a man of the way', implying a spiritual aspect to his appreciation of the art of the sword.

The qualities in the textures of the steel surface of swords depend wholly on the laws of metallurgy. The metallurgical phenomena observable in carbon steel are known as face-

centre cubic; body-centre cubic; the molecular array of iron and carbon into cementite and pearlite, austenite, martensite and so on; and their crystal growth into matrixes or tree-like dendritic structures. Such phenomena were already observed and recorded a thousand years ago in Japan, though naturally the terms used were different.

Thus an area of crystals of steel in the *hamon* which is so fine as to be individually invisible to the naked eye was called *nioi* (fragrance) a term which in the poetry of the Heian period referred to a visual sense. Qualities of smoke, clouds or the Milky Way are invoked to describe this phenomenon. Larger crystals were *nie* (boiling), which have been likened to clusters of stars at night or the frost on morning grass. Wandering linear formations might be *inazuma* (lightning) or *sunagashi* (drifting sand). The overall form of the *hamon* might be straight, in parallel with the cutting edge, or of irregular form, or punctuated with patterns, depending on the structure of the steel and the method of heat-treating. From the late Heian period, decorative *hamon* reminiscent of rows of flower petals known as *chōji* (clove pattern) were developed. These patterns were deliberately induced by refinements in the forging process and by varying the thickness of the clay applied to the blade during hardening, and schools of swordmaking from the Kamakura period onwards can be identified by their characteristic *hamon* (fig. 43).

Before this refinement of technique, the *hamon* on the earliest curved swords were uncontrived, and since they were a natural phenomenon, they reflect other phenomena in nature: the formation of clouds and snowflakes, the configuration of the terrain, and the destructive power of earthquakes. Some *hamon* resemble cloud formations along the profile of mountain ranges, with the peaks and valleys formed by the undulations along the blade. This may also suggest the play of light and shadow among distant woods or on snowy ground. 'Lightning bursting through ragged clouds' accurately characterizes patches of the *hamon* of the great Heian period smiths, such as Yasutsuna of Hōki Province (cat. no. 106), Sanjō Munechika of Kyoto and Yukihira of Bungo Province.

The part played by nature in swordmaking is evidenced by the reliance that the swordsmiths then, and now, placed on Shintō. Every swordsmith's forge has a shrine to the *kami*, and swordmaking is conducted according to the ancient precepts of Shintō: cleanliness, respect for materials, adherence to tradition and a selfless attitude to work. Isonokami Shrine is the scene of the Noh drama *Kokaji* (Swordsmith), which tells of the manufacture of the sword (now lost) known as Ko-kitsune-maru (Little Fox) (fig. 40). The sword was commissioned by the emperor from the master swordsmith Munechika of Sanjō in Kyoto. The smith prayed for the aid of the rice deity, Inari-sama, who appeared first as a boy and then as a fox to assist him in forging the sword.

A similar appreciation for the work of nature is evident in the traditional connoisseurship of pottery. Ceramics of the Jōmon period were gradually built up with coils of clay, then shaped with bamboo or other wood spatulas, decorated with cord impressions, and burnished to give a smooth surface. For ten thousand years, pots were baked in fires on the ground. While surface fires were sufficiently hot to give a hard-fired body, such firing would not produce a watertight vessel. Non-porosity had to be achieved by lacquering or sealing with wood soot. The *anagama* or climbing kiln, introduced from Korea around the fifth century, enabled higher temperatures and better temperature control. The new-style kiln, built on sloping ground, had an enclosed chamber with a rising chimney. Its higher temperatures produced watertight stoneware. The resulting grey *sue* ware was hard and strong, used for ritual vessels for the tombs of the Kofun period between the fourth and sixth centuries.

The temperature in these kilns was so high that material from the walls vitrified and impinged on the pottery, forming patches of natural glaze. The imported potter's wheel, previously unknown in Japan, was used in the production of these wares (cat. no. 56), though the wheel was not universally adopted. Fine-quality white clay found in the Sanage region of present-day Aichi Prefecture was used to produce wares in Chinese style (cat. no. 57). These

Fig. 43 The point section of the sword (cat. no. 103) made by Miyamoto-Shikibu-no-Jo-Nobukuni in 1397 as a sacred offering to the *kami* of Mt Fuji. (Photo: Tokyo National Museum)

were wheel-turned and intended for both ritual and domestic use. They were the precursor of the tradition of ceramic production at Seto, to which the potters moved around the end of the Heian period.

Seto potters continued to use a wheel and developed applied glazes to produce Chinese-style wares of the kind required particularly for the tea ceremony. But virtually every other ceramic-producing area of Japan persisted with the old method of hand building pots, which had continued from the Jōmon period and still remains a dominant feature of Japanese pottery today. In contrast to the resistance to the wheel, the improved kiln technology was universally adopted. This may have been because fire was sacred in Japan, so perhaps the higher temperatures it afforded could be accepted as a gift of the *kami*. The natural glazes produced in those early kilns are still induced today and are highly regarded throughout Japan (cat. nos. 58, 59).

The tea ceremony was introduced from China during the Kamakura period and was eagerly adopted as an aid to meditation for priests. After around five centuries of following the more elaborate Chinese style, the tea master Murata Jukō (1422–1502) popularized a return to the use of hand-built everyday wares. Sen-no-Rikyū (1522–91) followed his example, advocating rustic simplicity and harmony in the tea cere-

mony. This reemergence of the indigenous Japanese style of pottery in a cultural activity which had come initially from China has an unmistakable parallel in the persistence of Shintō within Buddhism. The beauty of the early natural glazes was beyond the contrivance of the potter, just as the beauty of steel texture was beyond the contrivance of the early sword-smith. This vision of nature seems to be an inseparable aspect of Shintō, and the basis of the Japanese aesthetic sense. The accidental patterns produced by a natural ash glaze, which might have been thought unattractive when first introduced to the West, are now universally recognized as beautiful.

NOTES

1 Aston, W. G. (trans.), *Nihongi: Chronicles of Japan from the Earliest Times to AD 657*, Supplement to *Transactions of the Japan Society*, 1896. Quotations in the text are from the Charles E. Tuttle Co., Inc. edition, 1972.

2 *Japanese Religion*, survey by the Agency for Cultural Affairs, Kodansha International, 1972, pp. 37, 38. The words are those of Motoori Norinaga (1730–1801).

3 Ibid., p. 29.

4 Shiba Ryōtarō, *Rekishi no Naka no Nippon*, 1974.

5 Aikens, M. and Higuchi, T., *Prehistory of Japan*, Academic Press, 1982, p. 249.

6 Mito No. 9 Hitachi Ōmiya, excavation report.

7 Aikens, M. and Higuchi, T., op. cit., pp. 25–35.

8 Nanzhuangtou, Hebei Province (Boading PAPCP 1992); discussed in Imamura, K., *Prehistoric Japan*, UCL Press, 1996, p. 55.

9 Morse, Edward S. (1838–1925), American zoologist who excavated the Ōmori Shell Mound near Tokyo in 1877. He called Japan's earliest pottery 'Jōmon' (cord pattern) from its characteristic impressed decoration, which in turn gave the name to the Jōmon period (12,500–300 BC).

10 Sasaki, T., *Nihonshi Tanjo*, Shūeisha, 1991, pp. 114–16.

11 Uriyodo Chōsakai reports, 1971 and 1973.

12 Yasuda, Y., *Mori to Bunka*, NHK Ningen Daigaku, April–June 1994, p. 120.

13 Han is used in reference to both China and the three ancient nations of Korea (see also note 18).

14 Mori, K., *Tennōryō Kofun*, 1996, p. 226.

15 Owned by Yodoe Chō Kyōiku Iinkai.

16 Shingi, M., *Kunihiki Shinwa no Saikentō*, Kodai Bunka no Kenkyū No. 6, Shimane Prefecture Ancient Culture Centre, 1998.

17 Aston, W. G. (trans.), *Nihongi*, vol. I, pp. 169, 170, referring to the arrival of the Silla prince Ama-no-hi-hoko at Tajima, and to the potters of the Valley of Mirrors being his servants; p. 350 refers to the potters' guild moving to the Imaki (newcomers' place) Aya (also read 'Han'). Aston identifies the word Han with immigrants of Chinese descent from Paekche.

18 Inokuchi, Y., 'Komochi Daitsuke Tsubo Ni Miru Kodai No Shūryō', abstract from *Narazaki Shoichi Sensei Koki Kinen Ronbunsho*, 1998.

19 Henan Shan Xian Liujiaqu Han Mu', *Kaogu Xuebao* 1: 1965, p. 154. Cited in Brashier (see bibliography).

20 Su Yu, *Chunqiu fanlu yizheng*, Taibei, He Le Tsushu Chubanshe, 1974, pp. 142–3. Cited in Brashier, op. cit.

21 Kobayashi, K., 'Dōhankyōkō', *Kofun Jidai no Kenkyū*, Aoki Shoten, 1961, pp. 95–133, translated by Edwards, W., *Kobayashi Yukio's 'Treatise on Duplicate Mirrors': An Annotated Translation*, Tenri University Report No. 178, 1995.

22 Aston, W. G. (trans.), *Nihongi*, vol. I, p. 59. Aston equates Kuma-nari (bear river) with Kumano in Izumo deriving from Koma, meaning Paekche, and suggests that Kumamoto in Kyūshū similarly derives from a Korean connection.

23 The Etafuna-yama sword and the Sakitama-Inariyama swords and inscriptions are all fully illustrated in *Ancient Archaeological Treasures: Inscribed Works*, exhibition catalogue, Nara National Museum, 1996.

The Catalogue

1 Archaeological Insights into Primitive Belief

The Pre-Mythological religion of the Japanese peoples can be characterized by a belief in the Earth Mother (*Jiboshin*), and by ceremonial activities connected to rites of passage. The Earth Mother is symbolized by small clay figurines (*dogū*) in female form. Most of these *dogū* represent pregnant women but in a few cases the actual process of birth is depicted. Such clay figurines began to appear during the early stage of the Jōmon period (12,500–300 BC)when society was organized around hunting and gathering, and continued to be made thereafter as symbolic representations of birth and death. They disappeared when an agricultural society was established in the Yayoi period (300 BC–AD 300). *Dogū* are considered to be the embodiment of primitive belief in Japan.

The Initial Jōmon period (8000–5000 BC) was a time of transition from a roaming community to a more settled society, and apart from the clay figurines, the most distinctive artefacts found are funerary objects. These typically are ornamental headbands, chest ornaments and shell rings that decorated the dead for their journey to the other world. Therefore the chief characteristics of belief in the Initial Jōmon period lie in the concept and symbolic representation of birth and death. However, surviving individual examples do not necessarily represent the common current of belief, being essentially local, provincial forms of expression.

Around 6000 BC, permanent settlements began to appear in Japan. The term 'permanent settlements' indicates continuous habitation extending over generations: in other words, a village where the cycle of human life from birth to death can be sustained. The development of per-

manent settlements arose from changes in habitation from mobile tents to much stronger dwellings with roofs high enough to accommodate a hearth. The need for a hearth in turn came from the change in eating habits from outdoors to communal meals indoors.

Permanent settlements, made up of several families, naturally created a need for fundamental rules of behaviour to be observed by every member of the community. These rules encouraged the development of rituals focused on the individual life cycle. The rites accompanying death meant that the community had to establish a burial area for long-term use. Rituals marking various other stages of human life included events such as birth, marriage, the birth of a child, and even roles within the community. While the rites of passage were associated with individuals, there was also a wider belief focused on nature and the environment outside the community. In this case, the concept was not based on an individual's relationship to nature, but on the community's relationship to nature, and was recognized as a common belief. Archaeological remains suggest a belief in snakes or seashells in some communities. In other cases, the formation of dwellings suggests that they were arranged as if to worship a sacred mountain, often shaped like Mt Fuji. This is indicative of the origin of the worship of mountain gods in a later period.

Changes in the concept of death during the Pre-Mythological period can be tracked by examining the methods used for the disposal of corpses. Ornaments for the dead have already been mentioned, but the examination of human bones reveals that in some cases during the

Initial Jōmon period bodies were laid among shell mounds (*kaizuka*) along with other waste. In other words, there was no special burial place. In the Middle Jōmon period (2500–1500 BC) the practice of reburial (*senkotsu-sō*), was developed. This involved gathering deposited bones after a set interval for disposal in another way. One refinement of reburial was the placement of bones in clay containers. In another method, corpses were left in a sunken floor of a dwelling which, abandoned, became a tomb (*haiokubo*). At about the same time, cremation seems to have emerged in the Tokyo area, but without the religious significance that developed later. The discovery of a burial dwelling with a wooden tablet on which an earthenware mask of the deceased had been attached points to the development of personal tombs by the Final Jōmon period (1000–300 BC).

The changes in the burial of corpses indicate an increasing respect towards the dead. The strengthening of family ties within the community encouraged respect towards the senior members of the family and gave rise to the practice of ancestor worship which continued in the later agricultural society.

Following this shift towards an agricultural economy, some of the ruling class became increasingly wealthy through possession of land. Their desire for larger tombs containing luxurious funerary goods such as mirrors and swords encouraged the development of huge burial mounds (*kofun*).

Among the rites of passage practised by the earliest Japanese peoples, the most observed during the prehistorical period were the funerary rituals. These were similar in form to those practised in many other parts of the world as an expression of religious belief. Funerary ornaments were made from precious materials such as jade and rare shells from the Southern Seas, artistically decorated to show veneration for the dead. Such reverence for ancestral spirits inspired the concept of Shintō. TD

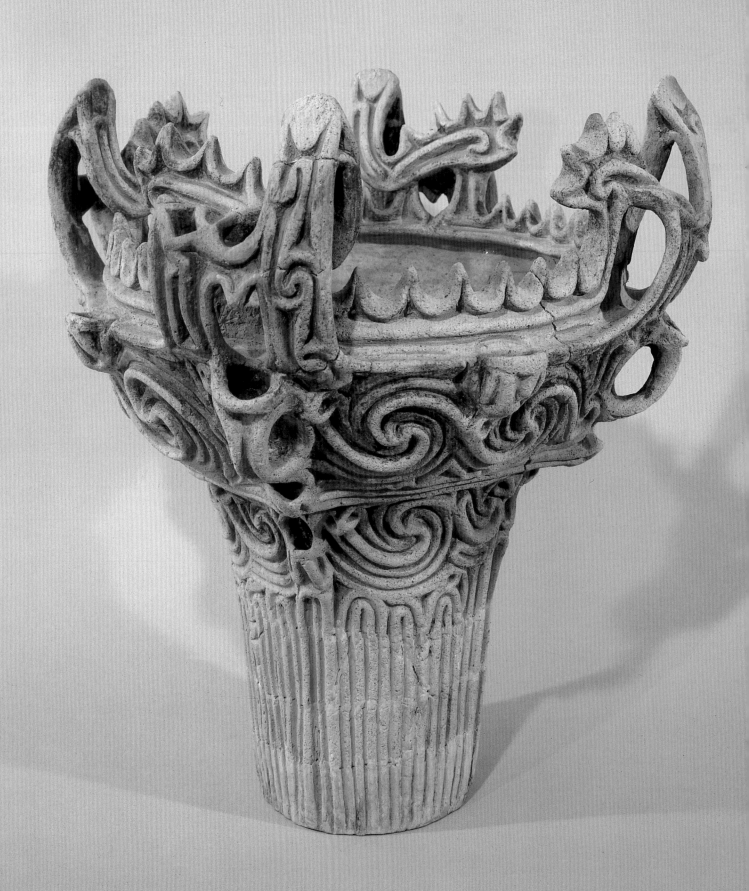

1 Two deep earthenware
vessels with flame decoration

Middle Jōmon period (2500–1500 BC)

Sasayama site, Niigata Prefecture

Tōkamachi City Museum

H. 46.5 cm (opposite); 34.5 cm (right)

National Treasures

During the Jōmon period, several distinct types of earthenware appeared in particular areas at certain times. This trend can be observed in central Japan in the Middle Jōmon period and in northeastern Japan in the Late (1500–1000 BC) and Final Jōmon periods (1000–300 BC). These earthenware vessels with flame decoration are typical of one type and are the most exuberant of all those made during the Jōmon period. The beauty of their dynamic design is exceptional among Jōmon artefacts; and they are often admired as the ultimate creative achievement of the Jōmon culture.

Umataka, the archaeological term for earthenware vessels with flame decoration, derives from the name of the site in Nagaoka City, Niigata Prefecture, where the first example of this type was discovered. Excavations carried out in the last half century reveal that *umataka* were produced mainly along the River Shinano which runs in a north-south direction through Niigata Prefecture. The earthenware culture seems to have flourished independently in this area.

Over a slim lower body, the vessels have a large flaring upper section with handles in almost excessively vigorous shapes around the rim. In contrast to the flowing vertical lines of the lower half, the upper half is covered with varying shapes of scrolls, circles and wavy patterns that create an impression of blazing flame, after which the vessels were named. The apparently free motifs actually follow a strict scheme, creating the scrolls and handles which are attached to face in the same direction. Traces of carbonized food are often found in these vessels, indicating that they were used for cooking.

However, the evidence suggests that

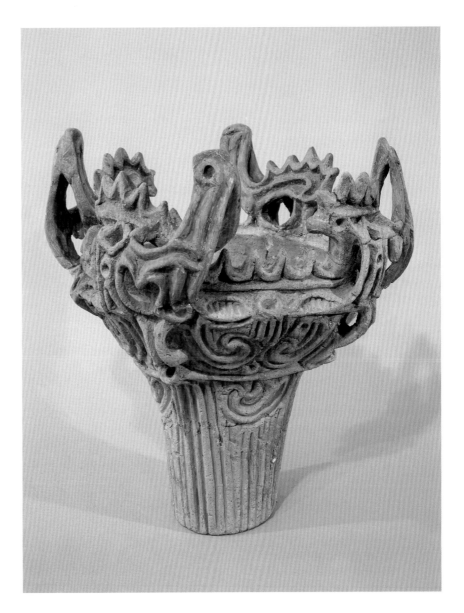

these particular vessels were not used as daily utensils. The excavation sites yielded a huge quantity of plainer earthenware vessels (*taigi*) along with the flame vessels. This indicates that *umataka* ware had a special significance and was used in religious rites to hold sacred food. The concept of *hare* and *ke*, making a distinction between *hare* (fine weather) days for rituals and *ke* (ordinary days), is an inherent characteristic of Japanese religiosity and seems to have already been established by the Middle Jōmon period. MH

2 Deep earthenware vessel with dancing figures

Middle Jōmon period (2500–1500 BC)

Imojiya site, Yamanashi Prefecture

Kushigata-chō Educational Commission

H. 54.0 cm

Important Cultural Property

In addition to ordinary utensils, such as earthenware pots and stone implements, objects such as clay figurines and stone clubs used for religious and ritual purposes dramatically increased during the Middle Jōmon period. This deep vessel with dancing figures exemplifies the great variety of funerary objects of the period.

The body of the vessel is broad, shaped like a wine barrel. Small pierced holes occur in intervals of every few centimetres immediately below the flat rim, and a clay strip is applied underneath the holes to strengthen the rim. The most prominent feature is the human figure in relief on the body. The figure, made from a thin clay slab, is attached to the surface, and the face is hollowed to emphasize its three-dimensionality. The posture, including the raised arm, can be interpreted as a figure in a ritual dance.

Dances are often incorporated into ritual activities in the religious world. Dances can sometimes express the spiritual unity of *kami* and human, or can be dedicated to *kami* in order to seek the granting of human wishes. Many aspects of Jōmon religious rituals have yet to be clarified, but it is apparent that the Jōmon people acknowledged a transcendental presence within nature and recognized the power of the *kami* to respond to their desires.

The connection with rituals can also be detected from the similarity to clay figurines in the facial expressions and body shapes. Clay figurines symbolized in Jōmon belief the abundance and prosperity which the Earth Mother had in her power to dispense, and the application of such figures to vessels transformed them into sacred objects.

There are three main opinions regarding the function of this type of vessel. One is that it was a container for brewing fruit wine, another claims it was a drum, and the third that it was a storage jar for seeds used in burnt-field agriculture. None has been confirmed, but it seems most likely to have been a drum. A large object of this shape could have been covered with animal skin over the flat rim, and drums are percussion instruments essential in religious rituals. MH

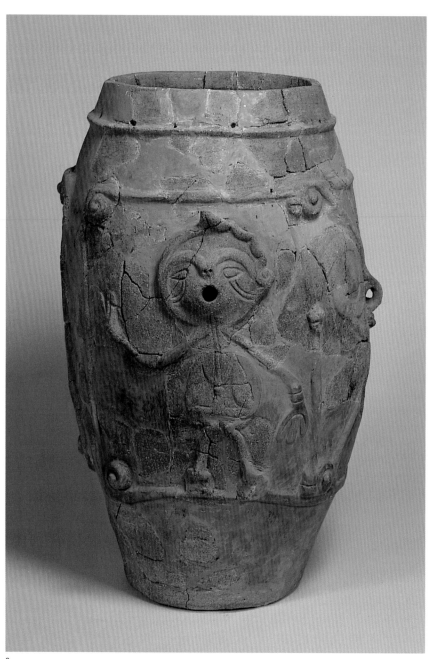

2

3 Deep earthenware vessel with a face handle

Middle Jōmon period (2500–1500 BC)

Kaido site, Nagano Prefecture

Okaya City Art and Archaeological Museum

H. 43.0 cm, W. 30.8 cm

Important Cultural Property

The lower body of this deep earthenware vessel is curved sharply to form a narrow waist, and then flares out in an acute angle to form the upper body. The surface is decorated with simple but clear cord markings, and a handle with the bold design of a face, almost too big for the vessel, is attached.

The Jōmon culture was full of creative energy for abstract and geometric patterns, but the Jōmon people rarely attempted realistic depiction. The only known example is a birth scene drawn with black pigment on the outside of an earthenware vessel excavated from the Tōtonomiya site, Nagano Prefecture. Even by expanding the criteria to include incised images on stone, there are only about twenty examples of figurative images among the thousands of vessels excavated from many sites. These images include salmon-like fish, humans and the sun.

A motif of a human face incorporated within scrolls began to appear in the Early Jōmon period (5000–2500 BC), and developed into large handles similar to this example of the Middle Jōmon period. They are occasionally found in the Katsusaka-style earthenware vessels discovered in central Japan and the western area of the Kantō region, of which the majority of face-shaped handles are made with the front facing inwards as if to look into the vessel. An example such as this vessel, with the front facing outwards, is rare. The face has eyes that slant upward, a mouth that is opened innocently, and a modest nose, all of which conform to the usual style of clay figurines.

Many earthenware vessels from the

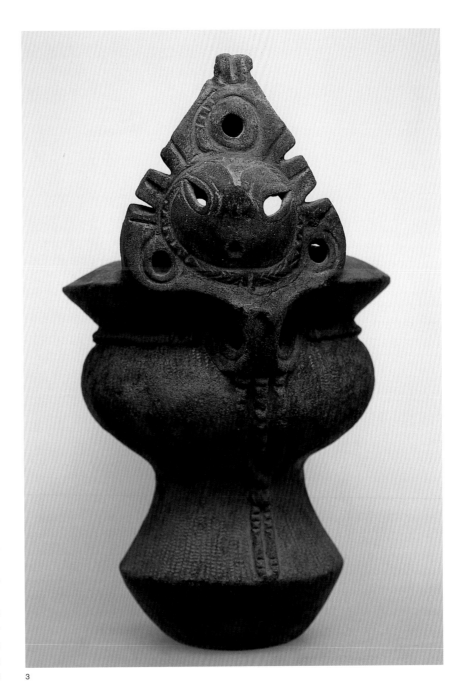

3

Middle Jōmon period are decorated with highly stylized motifs of creatures such as frogs, centipedes and flying fish. In an age when no writing system existed, these motifs could have functioned as a way to transmit mythology or legends to descendants. MH

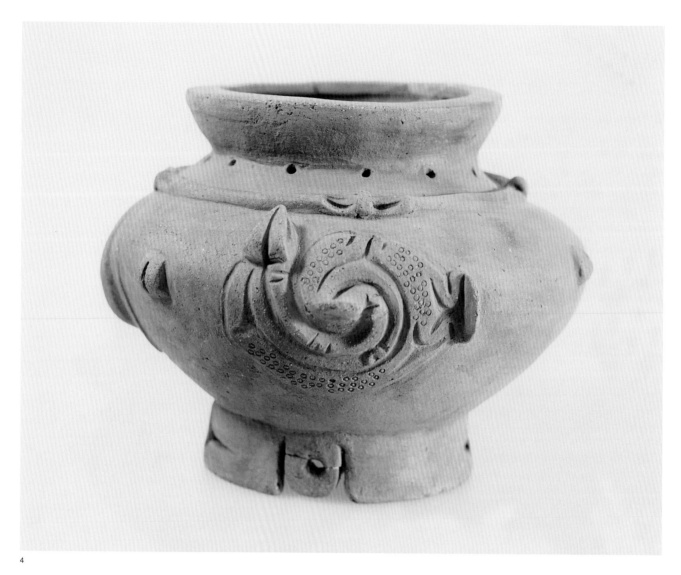

4

4 Earthenware vessel with serpent

Middle Jōmon period (2500–1500 BC)

Andōji site, Yamanashi Prefecture

Yamanashi Prefectural Archaeological Museum

H. 23.0 cm, W. 32.0 cm

Earthenware vessels with a flat rim and small holes pierced at regular intervals immediately below the rim began to appear in the Early Jōmon period (5000–2500 BC). The earliest examples were restricted to the shallow bowl shape, but gradually during the Middle Jōmon period the shape developed into larger deep vessels with a wide protective clay strip to strengthen the pierced section. Such vessels have been discovered in high central Japan in the area of present-day Nagano and Yamanashi Prefectures.

The shape of this vessel is nearer to a vase, whereas the majority of examples, such as cat. no. 2, are shaped like a barrel. The vessel has a foot with pierced motifs. The foot was added in order to make the vessel stable, but it also serves as a decorative feature with the pierced triangular and circular motifs and incisions. Above the circular motif of the foot, a coiled serpent in three dimensions is attached, surrounded by a band with pressed circular patterns. Jōmon earthenware vessels are usually decorated with repeated motifs, which make it difficult to identify the front. This vessel is a rare example in which there is a clear intention to create a complete form with an identifiable front.

The attached serpent has the distinctive head of a viper (*mamushi*). *Mamushi* (*Agkistrodon blomhoffi*) are the only poisonous snakes in Honshū. They measure 40–60 cm in length. Small but aggressive reptiles, their venom can be fatal. In the Jōmon period, particularly in the Middle period, many earthenware vessels and the heads of clay figurines were decorated with motifs inspired by *mamushi*. This can be interpreted as an expression of reverence by the Jōmon people to the vitality of vipers, emerging from the earth in spring as they do, and of their power to bring death with their venom. This awe-inspiring feeling overlapped with that for the Earth Mother and bestowed a sacred quality on vipers. MH

5 Deep earthenware pot

Late Jōmon period (1500–1000 BC)

Yakushi-mae site, Aomori Prefecture

Kuraishi-mura (on loan to Hachinoe City Museum

H. 43.5 cm

Important Cultural Property

This earthenware jar has been cut in two across the centre to be used as a two-part funerary jar (*awaseguchi kamekan*). In 1977 three large earthenware pots including this example were found by chance in a farmer's field. Each contained clean human bones (*senkotsu*) and a number of ornaments including shell rings and pendants. The discovery offered a remarkable example of the funerary practice of the time. The bones were placed with the skull at the bottom, surrounded by the bones from the arms and legs leaning against it. A shell ring was placed over these limbs, then small bones including the ribs were placed together on top of the pile. The ornaments were clearly intended for the ritual of reburial. This involved digging up a previously buried body after an interval and then washing the bones in the sea or a river.

There are four handles immediately below the rim. The exterior is decorated with a set of motifs around the rim and two other kinds of motifs in the lower section. Clay strips are applied to the middle to create the raised circular decoration. The decorative scheme is consistent with raised lines for straight marks and indentations for curves. The motifs on this pot are typical of this period in north-eastern Japan.

Such vessels could be the precursors of the two-part funerary jars used in western Japan in the following Yayoi period (300 BC–AD 300).

The objects from this site have shed light on the possible significance of funerary ornaments. Previously thought

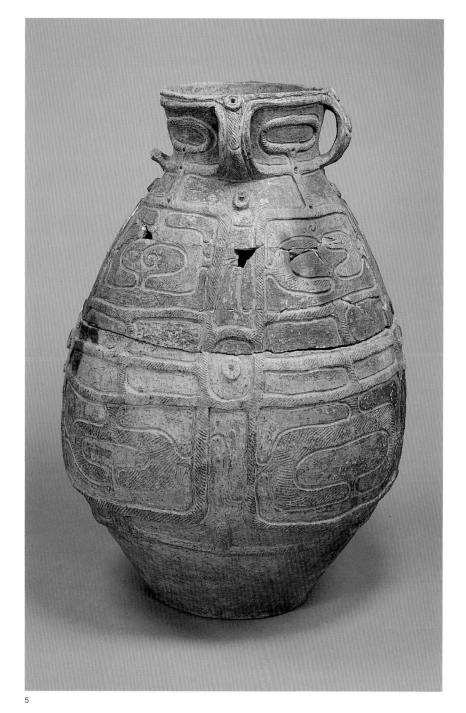

5

to reflect personal possessions of the deceased while living, the ornaments discovered here seem to be related to later textual references to the journey to the nether world. Their presence with the bones can be interpreted as an expression of deep grief for the loss of a respected or trusted person. TD

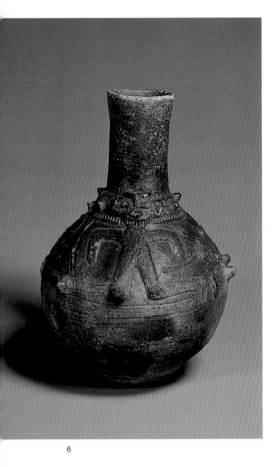

6

6 Earthenware jar
with human figures

Late Jōmon period (1500–1000 BC)

Tōkoshinai site, Aomori Prefecture

Tokyo National Museum

H. 22.4 cm

Important Cultural Property

This earthenware jar has a globular body
with a long neck. The main motifs, two
human figures, appear in the upper half
of the body. Two cords of clay with
notches are applied between the neck
and the body. The widest part of the
body is wrapped with two bands with
cord markings, and the two human fig-
ures appear in relief, above the bands.
They are applied in corresponding posi-
tions, front and back, and show a certain
similarity in posture. They stand with
legs apart and arms bent downwards.
Details in facial expressions and the
shape of the feet differ slightly. One face
has a Y-shaped line for the eyebrows and
nose; and the other a T-shaped line. The
ears of one have holes and those of the
other have none, and there are also dif-
ferences in the necklaces.

The earthenware vessels of this period
occasionally have corresponding figures
as in this example, and they all show
deliberate differences between the two.
The recently discovered earthenware
vessel from Takisawa village in Iwate
Prefecture clearly indicates the sexual dis-
tinction, and suggests that the religious
concept of yin and yang (negative and
positive, male and female) could possibly
have existed by the Late Jōmon period.

The exact circumstances surrounding
the excavation of this vessel are unclear,
but earthenware vessels with human
figures such as this example are often
discovered in relatively good condition.
This suggests that they were created and
treated with special care, unlike the
utensils for daily use. Although there is
no supporting evidence, this vessel was
most likely one of the funerary objects
made to accompany the burial of the
dead. MH

7 Red earthenware jar with lid

Late Jōmon period (1500–1000 BC)

Ōishitai site, Aomori Prefecture

Archaeology Research Centre, Aomori Prefecture

H. 32.0 cm, W. 24.8 cm

Important Cultural Property

This earthenware pot was sliced across
the upper section before drying and a
thick layer of red pigment was applied to
the exterior. The body of the jar is deco-
rated with a raised geometric pattern of
diamond and rectangular shapes run-
ning diagonally. Although this jar was
not found in a tomb, it is similar to those
so found with neck sections removed.
This suggests its function as a funerary
jar. The custom of depositing clean
human bones in earthenware pots began
to appear in north-eastern Japan from
the Middle Jōmon period (2500–1500 BC)
onwards. Most examples have a wide
opening to accommodate whole bones.

In contrast, this jar has a very small
opening, so the bones had to be broken
into fragments. This demonstrates the
custom of crushing cleaned bones into
small pieces. Cremation was another pos-
sible method for breaking down bones in
order to insert them through a small
opening. There is a trace of black resin
around the rim indicating that the jar was
sealed after placement of the bones.

Similar funerary jars with a sliced-off
neck section covered in red pigment can
be found in examples from the Yangshao
culture (c. 5000–1500 BC) in China. The
discovery of glass beads and tripod
earthenware dating from the Jōmon
period display a close similarity to main-
land Chinese objects. The relationship
with mainland China suggests the possi-
ble origin of the funerary customs for
which this jar was used. Funerary jars
such as this example point to reverence
towards death as an aspect of primitive
religious belief. TD

7

8

8 Pair of earthenware incense burners

Late Jōmon period (1500–1000 BC)

Hirobakama site, Machida City Museum, Tokyo

H. 21.1 cm; 20.2 cm

These earthenware incense burners stand on a slightly flaring foot, with a swelling body shaped like abacus beads topped with a flaring trumpet-shaped mouth. They belong to the style of earthenware vessels made during the second half of the Late Jōmon period. The pair were discovered in perfect condition lying approximately 5 metres apart on the floor of a pit dwelling.

Both objects have plain rim sections with a pair of circular windows on the body and are decorated with raised lines of applied clay cords that wrap around the body as if to tie it. There are a pair of circular windows in the foot sections as well, but these face a different direction from those on the body, and provide accents to the form. The patterns on the foot of one are created by thin diagonal lines, while the other has cord markings.

Earthenware vessels in specific shapes are believed to have been used for burning incense during religious rituals. Since no actual incense has been discovered, their use can only be guessed, but remains of herbs, animal fat and amber support the theory, especially as textual sources state that amber was used as incense (*kunriku*) for Buddhist rituals during the much later Nara period (AD 710–94).

The shape and size of these two objects indicate that they were made as a pair. About ten examples of earthenware vessels of this type have been found so far, mainly in the Kantō region of Honshū, and over half of them have been excavated in pairs. MH

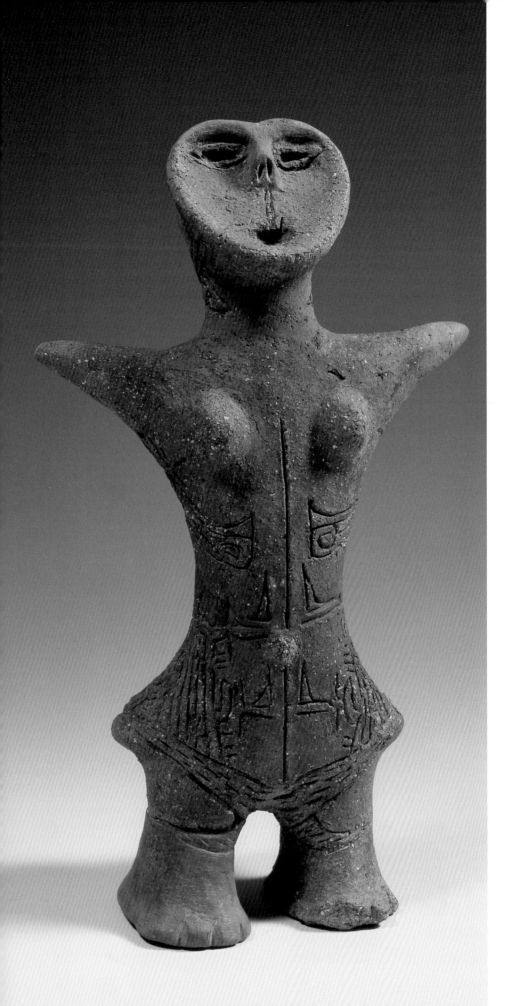

9 Clay figurine

Middle Jōmon period (2500 BC–1500 BC)

Sakaue site, Nagano Prefecture

Idojiri Archaeological Museum, Nagano

H. 22.0 cm

This clay figurine spreads both arms towards the sky as if to take a deep breath. The face is formed like a shallow dish in the shape of a heart and tilted slightly upwards. The upper outline forms the eyebrows which are connected to the nose. The eyes are long with double eyelids, and the small mouth is marked by a round hole. In contrast to the flat face, the back of the head is a three-dimensional sphere akin to a helmet. A hole, possibly for threading a cord, is pierced through the head. The spreading arms are pointed but have no elbows or fingers. The body is clearly that of a female with a slim waist and ample breasts. The hip section flares out over short legs. Complex patterns of thin lines cover the lower half of the body and legs. At first sight, these patterns seem to have been made at random, but they follow a strict decorative scheme that characterizes the figurines of this period. First, a vertical line is drawn from the navel, which is marked by a small protuberance, and curved spatula-shaped lines are made symmetrically under the breasts. The hip section is covered with a symmetrical geometric pattern consisting of triangular shapes. Such a decorative scheme began to appear at the beginning of the Middle Jōmon period (2500–1500 BC) and developed into the more complex pattern of this example by the second half of the Middle period.

In the Jōmon world, clay figurines were made for a long period of just under ten thousand years, from the time of the Jōmon genesis to the start of the Yayoi period (300 BC–AD 300). There are varying opinions concerning the production of figurines, but current consensus recognizes them as representative relics of Jōmon religious belief. The significance of figurines in the early period was related to personal or family worship to ensure prosperity and protection, but it is generally acknowledged that they

developed into an anthropomorphic image embodying the worship of much larger communities, sometimes many villages or the whole region, from the Middle Jōmon period onwards.

Approximately 15,000 figurines have been excavated from numerous sites all over Japan, but they were not produced nor used continuously in every region. While there were periods and locations of concentrated production, there were others when hardly any figurines existed. This example comes from the central region of Honshū, where the custom of using figurines became widespread. However, it was customary to break and discard figurines after use in rituals. Consequently, 99 per cent of clay figurines excavated are damaged. This figurine is an extremely rare example of one in perfect condition. It was probably regarded as a special symbol of a whole community and therefore kept safely by burial without damage. MH

10 Cone-shaped clay figurine

Middle Jōmon period (2500–1500 BC)

Imojiya site, Yamanashi Prefecture

Kushigata-chō Educational Commission

H. 25.5 cm

Important Cultural Property

This clay figurine has a semicircular head on top of a hollow conical body. It dates from the first half of the Middle Jōmon period. The fine, continuous motifs on the body, similar to nail-marks, and the triangular incised motifs on the sides are a common feature of the Aramichi style of earthenware which can provide a basis for dating the figurines.

A particular feature of this figurine is the swelling abdomen, and the incised lines seen from the front seem to indicate the stretch marks of a pregnant woman. Below the scrolling navel is a carved composition containing an inverted triangle. This is a common motif found only in figurines from this period, and serves to emphasize the pregnant state in particularly spellbinding fashion. The left hand is placed on the abdomen as if to protect the foetus, and the right arm is

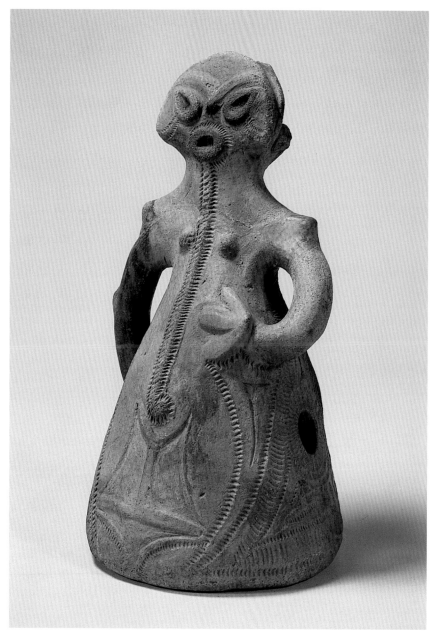

10

bent around to stroke the back. This posture seems to convey the hope for a prosperous family line and safe childbirth. The facial features are highly stylized, and a trace of red pigment is preserved inside the grooves of the eyes. Clay cords are combined in complex form and attached to the back of the head to depict tied hair. The hairstyle of some figurines of this period resembles coiled snakes, suggesting the existence of a snake cult for assisting childbirth.

Figurines such as this are named coni-

cal figurines (*ensui-kei dogū*), and about ten examples have been discovered from the central and Kantō regions of Honshū. Among these, an example from the Nakahara site in Tokyo contains small stones in the hollow body which produce fine sounds when shaken like a bell, and which represent the foetus. This figure contains no stones, but it could still have been made originally as an earthenware bell. Apart from the stones, it is a typical example of pregnant figurines. MH

11 Clay figurine
with palms pressed together

Late Jōmon period (1500–1000 BC)

Kazahari site, Aomori Prefecture

Hachinoe City Museum

H. 19.8 cm, W. 14.2 cm, D. 15.2 cm

Important Cultural Property

This clay figurine is called *gasshō dogū* after the position of the hands. The legs are slightly apart with the knees pulled up, and both arms are placed on top of the knees with palms pressed together as if to pray. *Gasshō* denotes the hand gesture of prayer, but the figurine's hands are actually clasped. The chin is jutting out slightly, and the head is tapering towards the top which is shaped like a chignon or hat. No ears are marked, but clay strips are applied for the eyebrows, eyes, nose and mouth. The broad nose aligns with the centre of the eyes, and the tiny holes around the mouth are of note. The mouth section shows similarity to the mouth-shaped earthenware pieces that were probably attached to leather or woven objects. The two lines in relief with incisions indicate a necklace, and suggest that necklaces of this period were of double strands. A single line of dots runs from between the smallish breasts all the way down to the female genitalia. The hands have six fingers, but abnormality in the number of fingers is not rare. There are figurines with three fingers dating from the Middle Jōmon period (2500–1500 BC), and other six-fingered hands occur. Both three-fingered and six-fingered figurines seem to have been made intentionally, and do not reflect a lack of awareness of numbers. There is some indication of a mask.

This figurine was discovered in five broken pieces on the floor of a pit dwelling. The reconstruction of the house established that the figurine was placed on the flat part of the wall, facing the entrance. A trace of natural asphalt fixed on the cracked left leg suggests that the figurine was repaired once by its Jōmon owner. The use of natural asphalt as an adhesive for mending bone and stone implements was widespread by this period.

In most cases, clay figurines were

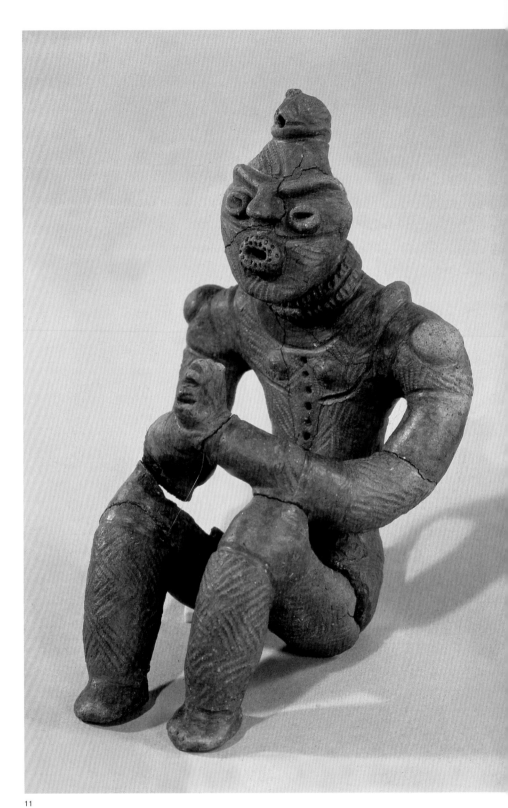

11

broken, buried or discarded after rituals, but in some rare cases they were repaired with care and displayed in dwellings. This figurine must have been an object of significance for the inhabitants of this dwelling. The realistic depiction of the female genitalia could be interpreted as the expression of supernatural force or birth, but the mask and ornaments suggest a special occasion. The traces of pigments indicate that the figurine was originally painted all over in red. TD

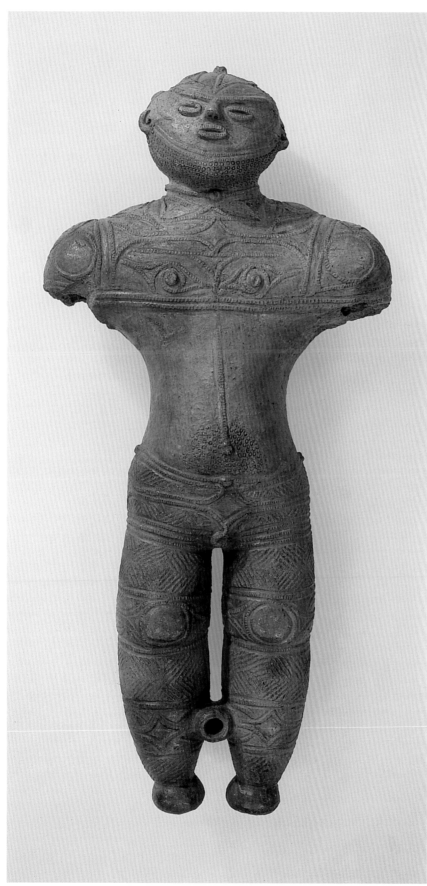

12

12 Hollow clay figure

Late Jōmon period (1500–1000 BC)

Chobonaino, Hokkaidō

Minami-Kayabe-chō

H. 43.0 cm

Important Cultural Property

This hollow clay figure is approximately a quarter of the height of a human, the largest example of its kind. It was discovered on its own by chance in what seems to be a tomb at a seaside site in southern Hokkaidō. Apart from the missing arms, it is in almost perfect condition. The beard is painted in black lacquer, but it is possible that the whole figure was originally covered in black lacquer. Some scholars identify this *dogū* as a male figure on the basis of the beard and the small breasts. Others contest this assumption, as the abdomen is covered with numerous dots around the navel which are considered to indicate pregnancy.

The face is tilted slightly upwards and leans towards the left. There is a small protuberance on top of the head which could be a chignon. The eyebrows and nose are marked by an applied strip of clay. (Depicting the eyebrows and the nose in one continuous line seems to be one of the characteristics of clay figures). Coils of clay with tiny notches are applied to the head, chest, back, hips and legs, creating the motifs of raised diamond, triangle and circles.

The lower half of the body is covered in a trouser-like garment, and the knees are slightly bent when seen from the side. The most noticeable feature is the shins, which are extended by clay tubes. The intersections are pierced and are connected to the hollow main body. The perforations would have helped ventilation and prevented the figure from cracking when fired at a high temperature. A similar technique was used for firing *haniwa* in a later period.

As it was discovered in a site which is thought to be a tomb, the figure was most likely a funerary object which was made to resemble the deceased.　TD

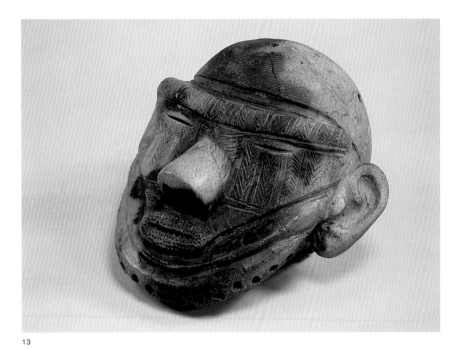

13

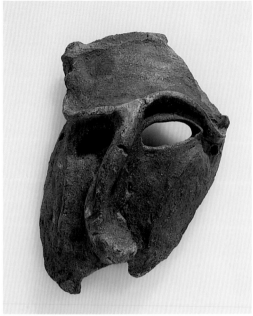

14

13 Head of a clay figure

Late Jōmon period (1500–1000 BC)

Shidanai site, Iwate Prefecture

Agency for Cultural Affairs

H. 25.0 cm, W. 22.3 cm

Important Cultural Property

If the entire figure were preserved, this would be the largest known clay figure from the Jōmon period. It was discovered in several pieces in the same hole. There are fragments from below the neck section as well, and its original height is estimated to be over 1 m. From the circumstance of its excavation, it was assumed to have been broken and buried after some kind of ritual. There is a raised line above the eyebrows, and the sections from the outer edge of the cheeks towards the upper jaw are also raised. A fairly large nose and a mouth surrounded by tiny pierced holes indicate that this Jōmon figure is wearing a mask. There are many, slightly larger deep holes under the chin, which probably held birds' feathers. Similar holes appear above the head and the sides, likewise probably decorated with feathers.

The head is covered in cord marks that suggest short hair. The surface of the mask from the raised line above the eyebrows towards the cheeks is divided into nine sections and marked with chevron patterns in incised lines. The closed eyes, suggested by the two thin incised lines, are marked on top of the pattern. The long eyes have a tranquil quality suggestive of a death mask.

It is hard to imagine a clay figure of such a size being used indoors. Judging from its death-like facial expression, it was most likely propped up or hung from a tree out of doors, and used as a symbolic representation in a funerary ritual attended by members of the community. This figure is not hollow, and the heat from the firing did not reach the clay in the centre. TD

14 Clay mask with bent nose

Late Jōmon period (1500–1000 BC)

Makumae site, Iwate Prefecture

Ichinoe-machi, Iwate Prefectural Museum

H. 18.0 cm, W. 11.3 cm

Important Cultural Property

The eyebrows, eyes and mouth of this mask slant up towards the left, and the nose is also bent towards the left. There are several other examples of clay masks that have a nose bent to the left. The study of bugaku (court dance) masks made during the Heian period (AD 794–1185), some 2500 years later, reveals the same bent nose and position, which then expressed a state of inebriation. These examples are not related to each other, but belong to the same category of universal expressions. In view of similar bugaku masks, this clay mask could also be interpreted as an expression of ecstasy, but it might also convey suffering. The ambiguity that characterizes this mask was an important quality in later Japanese philosophy and behaviour.

The function of masks has been studied by examining examples from various cultures. On this basis, it can be said that masks are generally used for festivals, exorcism, dance and drama, and as tools

of expression on special occasions. Their purpose can be either to hide facial expressions or to exaggerate them. The early masks in Japan were made from large seashells, pierced by three holes to resemble the eyes and mouth of a human face. These primitive masks dating from the Middle Jōmon period (2500–1500 BC) were found in Kyūshū. They display stylistic similarities to the excavated materials from mainland China and the Korean peninsula, but these seashell masks did not spread to the Honshū area.

Two types of clay masks, one with and one without holes for the eyes and the mouth and dating from the Late and Final Jōmon periods, are frequently found in northern Honshū. The type with holes have animated expressions. The second type tends to be too small to cover the entire face and was probably attached to the forehead. The masks with animated expression date from the earlier period and then developed into the more frozen expression of the second type. This change seems to suggest that the masks were originally worn by the participants in rituals, but later developed into funerary ritual ornaments. Such a change in function indicates that the clay masks, unlike the seashell masks, appeared during the Middle Jōmon period in the Honshū area as an entirely separate tradition from that in China. Originally worn over the face, they gradually diminished in size to be attached to the forehead or to tombstones. In the latter case they became a kind of amulet, with a face drawn on clay slabs. TD

15 Small clay mask

Final Jōmon period (1000–300 BC)

Asō site, Akita Prefecture

Tokyo University Museum

Diam. 14.7 cm

Important Cultural Property

This clay mask is too small to cover a human face, therefore belonging to the tradition of masks thought to be funerary ornaments. The eyebrows are not marked, and the outline of the eyes is connected to the nose. The oblong eyes of a single incised line are similar to the eyes of a *dogū* excavated from the Shidanai site, Iwate Prefecture. The head, both cheeks and the lower mouth are decorated in cloud-shaped patterns, a typical motif of this period, which are thought to have been painted in red. The single line within the eyes indicates they are closed, and expresses death. The left eye was deliberately gouged out, and this is thought to have occurred during a ritual.

The earlier examples of clay masks from the Jōmon period often had lively, exaggerated facial expressions and were large enough to cover the whole human face. Changes in their purposes and functions led them to diminish in size. In comparison to examples from the Late Jōmon period (1500–1000 BC), masks from the Final Jōmon period are smaller and expressionless. They were at first used for ritual dances but gradually were transformed into funerary ornaments or tomb signs. This mask is a typical example of one that was probably attached to the forehead of the deceased. If the mask was an image of the deceased person, the red pigment suggests that there was a custom of painting faces of the dead in red. Red pigments were often used to paint earthenware pots and clay objects in the Japanese archipelago from an early period, and there are instances of red pigments scattered over a dead body. This custom continued into the Yayoi (300 BC–AD 300) and Kofun (third–sixth century AD) periods, suggesting a strong association between death and the colour red in the prehistorical period. TD

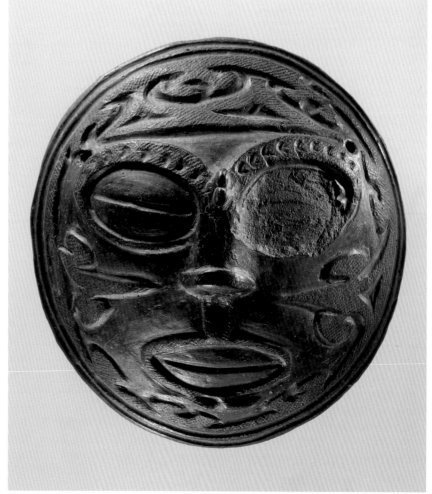

15

16

16 Clay ear, nose and mouth pieces

Late Jōmon period (1500–1000 BC)

Hatten site, Iwate Prefecture

Agency for Cultural Affairs

Ear: H. 8.4 cm, W. 4.4 cm

Important Cultural Properties

These clay pieces faithfully portray the human ear, nose and mouth. Such pieces are only found in north-eastern Japan. They are thought to have been attached to masks made of wood, textile or animal skin, but the actual masks are yet to be discovered. The study of clay figures suggests the function of these pieces lay in the worlds of the living and the dead. For the living, masks may have been used in ritual dances, but their scarcity suggests that they were not worn by all members of the community, but only by a chosen few, either skilled dancers or a specific professional group. Masked dancers were the leading participants in rituals, and their actions were far from routine. For the spectators, the dances were the concrete manifestation of spiritual and supernatural forces. It is not clear if the concept of *kami* existed at this time, but in a primitive society, where natural forces dictated people's lives absolutely, such a religious belief would be a logical outcome.

It is easy to imagine that these pieces of ear, nose and mouth covered the face of a dead person except for the eyes. The custom of covering the face of the dead with a cloth still survives in Japan, but early funerary rituals could have been more complex. The custom of covering the dead with gold or silver developed later in China, and it is useful to investigate and compare early Japanese funerary rituals with the transmission of customs from the mainland. TD

17 Clay shell-shaped vessel

Late Jōmon period (1500–1000 BC)

Chikanai-Nakamura site, Iwate Prefecture

Miyako City Educational Commission, Iwate Prefecture

L. 23.5 cm

This vessel, together with a clay figure of a wild boar and *dogū*, was discovered in a residential site in an estuary facing the Pacific Ocean. The clay is rendered realistically, shaped like a conch with small lumps attached to the body. A channel at one end indicates that the vessel was probably used for pouring wine or liquid medicine.

The raised lines created by coiled clay are in two widths, one thin and the other much thicker. The thicker raised lines are used for outlining and dividing patterns and are incised by chevron markings. The thin raised lines appear within the motifs, consisting of two parts in each unit, and form a mosaic-like pattern.

Three examples of clay shell-shaped vessels have been discovered in Japan, all in the north-eastern region. This one is not painted, but the other two are covered in red pigment. There is a pierced hole in this example, which may have been made deliberately. As it was found in a dwelling with a wild boar figure and *dogū*, these objects are all thought to have been ritual items denoting the wish for success in hunting and gathering. TD

17

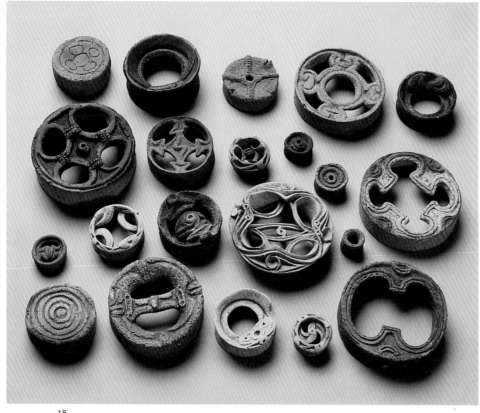

18

18 Clay ear ornaments

Final Jōmon period (1000–300 BC)

Kayano site, Gumma Prefecture

Shintō Village Museum for Earrings,
Gumma Prefecture

Diam. 3.0 cm (largest), 1.9 cm (upper left)

Important Cultural Properties

These ear ornaments were inserted into the pierced holes of earlobes. The ear ornaments of the Early Jōmon period (5000–2500 BC) were mainly of the type that pinched the earlobes, but this type became more common in later periods. These examples have decorative motifs on only one side. Such ear ornaments are often discovered in Final Jōmon period sites in the central and Kantō regions of Honshū, sometimes in their hundreds. By the Final Jōmon period, the economy had evolved from hunters and gatherers, and some communities may have had members who specialized in the production of ear ornaments.

The Kayano site, the source of these examples, demonstrates concentrated production with 577 earthenware ear ornaments having been found so far. They vary in size from 1 to 8 cm in diameter, suggesting that wearers adjusted their ear ornaments as they grew older. Many of the ornaments were painted red, and their decorative motifs suggest that they were not everyday objects, but rather special ornaments worn by a chosen few during rituals. Some of the sculptural forms are delicately executed and could be described as the masterpieces of Jōmon decorative art.

There were various developments in religious rituals during the Jōmon period, but the form and spirituality of these earthenware ornaments express the maturity of their culture in the Final period. The popularity of ear ornaments mysteriously declined sharply in the following Yayoi period (300 BC–AD 300) and, curiously, they were not revived until the middle of the Kofun period (third–sixth century AD), when Chinese culture was introduced. MH

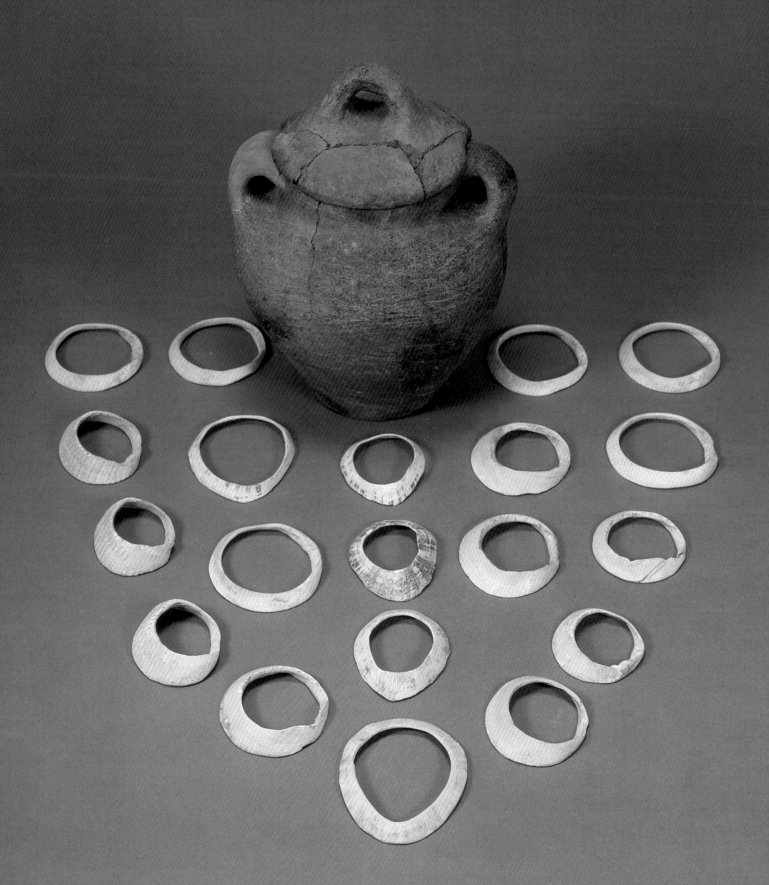

19 Shell rings and lidded container

Late Jōmon period (1500–1000 BC)

Kosaku shell mound, Chiba Prefecture

Tokyo University Museum

Container: H. 21.2 cm, W.16.0 cm

Shell rings: Diam. 5–10 cm

Twenty shell rings, fashioned by slicing *benkeigai* (bittersweet clam) and *ōtsutanoha* (star-shaped limpet) shells and then polishing the edges, were discovered in a plain clay pot with a lid. The shape of the clay pot is rare, with handles on the shoulders for threading a rope. The exterior of the pot is well polished. It is difficult to date pots without motifs, but the shape of the lid indicates that it dates from the Late Jōmon period.

Shell rings were typical ornaments made from the Early period (5000–2500 BC) and were worn widely from the Middle period (2500–1500 BC). Some seaside sites near Tokyo show evidence of concentrated production of such shell rings, suggesting popular demand for them.

The *ōtsutanoha* shells used for these shell rings, which are peculiar to an island approximately 100 km east of Tokyo Bay, are called 'shells from the Southern Sea'. These examples provide valuable evidence for the transportation of rare shells from distant locations despite the difficulties of travel, as they have also been discovered in north-eastern Japan. The beautiful colour of the shell made them in demand. *Takaragai* (cowrie) and *suijigai* (spider conch) shells from Okinawa were also taken to distant places. Similarly, rare stones were also in demand, and jade from central Japan was distributed from the northern end of Honshū to Kyūshū.

These examples indicate that there was a large network for the circulation of ornaments, and the most effective materials for decoration were eagerly acquired and manufactured. The function of ornaments of the Jōmon period changed from funerary use to symbolic objects worn by the select few, such as a leader of the community or a shaman, and eventually changed to ornaments worn by all the participants in rituals. Reconstruction of the position in which this pot was discovered indicates that the shell rings were deposited in the pot and buried as precious objects. This further suggests that they were not worn in everyday situations. Burial for safekeeping indicates that there was a distinction between ordinary and special days, or rituals, and these ornaments must have been kept for special occasions. TD

20 Stone club

Middle Jōmon period (2500–1500 BC)

Ōzakai cave, Toyama Prefecture

Tokyo University Museum

L. 95.0 cm

This stone club measures almost 1 m long, and is one of the larger stone objects from the Jōmon period. The largest examples of stone clubs are over 2 m. Remains of Early Jōmon period (5000–2500 BC) sites with erect stones, stone circles, or stones arranged in holes have been found in central Japan. The erect stones were probably a kind of sign for a ritual spot or a grave. Stone arrangements are thought to have been made as graves, and rituals performed at the spot must have involved the belief in ancestral spirits rather than being ceremonies to assure good hunting and fishing. The shape of erect stones developed into phallic stone clubs.

Stone clubs did not develop independently in the Japanese archipelago, as similar examples have been discovered in north-east Asia from Siberia to China. Elsewhere they were originally used in ceremonies related to agriculture, but agricultural society had not yet been established in Japan.

The early stone clubs are small. Early Jōmon examples have been found in the vicinity of Tokyo, often in residential sites, and point to the worship of ancestral spirits within a family unit.

The early stone clubs plainly depict the phallus, but the later ones are carved with motifs. This example has raised lines and a carving of circle and tripartite lines symbolizing female organs. Such motifs consisting of male and female symbols sometimes appear in the decoration of clay pots and figurines. The combination of male and female symbols may indicate a family or communal unity. At a later time, stone clubs were not only erected at ritual spots, but also at the entrances of dwellings. The size of stone clubs varied depending on whether they signified the worship of ancestral spirits by a family or by the community. TD

◀ 19

20

2 Archaeology and the World of Mythology

Archaeology attempts to reconstruct the history of human activity from relics left behind by past cultures. One aspect of this study in Japan is religious archaeology, which examines the spirit (*kokoro*) of the people of long ago. It is akin to Christian archaeology and other European scholarship. *Shintō* archaeology is likened to the study of ancient folk beliefs as revealed in ritual sites and relics from the early ages onwards. But the folk beliefs of Japan are shown by archaeology to have a many-faceted and complicated history. Because of this, recent scholarship has approached primitive beliefs as the archaeology of ritual.

An important aspect of the archaeology of ritual is research into mythology. Japanese mythology was officially documented in the Nara period (AD 710–794) with the publication of the *Kojiki* in three volumes (AD 712) and the *Nihon Shoki* in thirty volumes (AD 720). These established the mythology of the origin of Japan through the actions of the *kami*, and the unification of the nation under the Yamato court. It is thought that there were many different regional versions transmitted orally in places like Kyūshū and Izumo. Only fragments of such versions have survived. They are found in the *Kojiki* and the *Fudoki* (records gathered in AD 713 from each province), of which only those from five areas including Izumo (present-day Shimane Prefecture) and Hitachi (present-day Ibaraki Prefecture) survive; that of Izumo is the only one surviving in full. However, it is possible to gather much of the essence of the lost folk stories from archaeological investigation, particularly of ritual sites and *kofun* (tombs).

Ritual sites of the Jōmon period (12,500–300 BC) include stone altars and stone circles. Those of the Yayoi period (300 BC–AD 300) include special pottery for ritual use, like that from the Kurita site in Fukuoka Prefecture (cat. no. 21) and the group of bronzes in sites like Kōjin-dani in Shimane Prefecture. During the Kofun period (third–sixth century AD) such relics became more remarkable in nature. The largest site is the Munakata Taisha Okitsugū Shrine on the island of Okinoshima, Fukuoka Prefecture (cat. nos. 37, 45–7). The Kofun period was characterized by importation both of metal products from China and the technologies of manufacturing them. This became linked to the power of the great clans, by the bestowal of a sacred character upon the objects, without which the establishment of regal authority would not have been possible, and the development of complex rituals to support it. The mirrors, rings, jewels and other articles deposited on the island include both imported and domestic objects showing that, for the ancient clans of Japan, the island of Okinoshima was a place of prayer to the *kami* of the sea for a safe sea passage.

Apart from sites directly linked to regal authority, there are also places where folk beliefs come into play. Excavated material of the *harai* (purification) rite from the entrance to the village at the Tanihata site in Tottori Prefecture is an example (cat. no. 49). The remains include numbers of simple earthenware figurines and models of agricultural implements used in rituals for purification and in supplication for the safety and prosperity of the village and the villagers.

An ensemble of sword, mirror and jewel, the *sanshu no jingi* ('Three Sacred Treasures') were

buried as funerary goods in the tombs of the great clans from around the third century AD in an expression of the clans' authority and their religious beliefs. These reflect the deification of regal authority; they became paramount and were adopted by Shintō from among folk beliefs that are still central to Shintō today. The earliest complete example of this ensemble is from the earlier Yayoi period tomb site at Yoshitake in Fukuoka Prefecture (cat. no. 31). The three articles were frequently interred in tombs of the Kofun period. Looked at in detail, buried treasure in the first half of the Kofun period included mirrors and jewels among the sacred objects, whereas in the latter half of the period there was more military equipment, primarily swords and armour. This reflects the change in emphasis from religious to military authority and the struggle for ruling supremacy on the eve of the birth of the Japanese nation. Notable ritual objects from the Yayoi period include bronze *dōtaku* (bronze bells), and *dōhoko* (bronze spear blades); from the Kofun period the *komochi* (child-bearing) *magatama* (comma-shaped jewels), named from the smaller comma forms projecting in relief over their surface; and from the Nara period pieces like dragon-head finials and miniature weaving looms. The bronze *dōtaku* are believed to have been used in agricultural ritual. The *dōtaku* from the Sakuragaoka site (cat. no. 29) is decorated with creatures found around water, such as dragonflies and turtles, hinting at the existence of an agricultural mythology of the time. The *komochi magatama* (cat. no. 48) well reflect folk beliefs and the concept of the proliferation of descendants central to the later Shintō

faith. The dragon-head finial (cat. no. 46) and the model *koto* (Japanese harp, cat. no. 47) are examples of the arrival of ritual practices (music and ceremony) and paraphernalia from China during the Nara period. They show something of the process establishing regal authority and the development of Shintō ceremonies from earlier rituals.

Archaeological sites and relics are, therefore, invaluable in helping to reconstruct the history of the human spirit (*kokoro*) from ages when there were either no written records or whose written records have been lost.

At the time of writing there are around 110,000 Shintō shrines in Japan. They include large shrines such as Izumo Taisha and Ise Jingū with well-recorded histories and small shrines without a resident priest in towns and villages whose origin is unknown. In every shrine the faith and mythologies based on sacred concepts are kept alive, nurtured since ancient times. In many cases everyday customs, social observances and faith are inseparable. The Shintō religion is a folk belief emerging from natural spiritual behaviour, for which reason it has no creeds nor scriptures. However, there are common beliefs dating back to the ancient past, which formed both religion and society and which characterize Japanese history.

Mythology as such is not history, but in the Japanese context it gives a spiritual support to people. Religious archaeology is a worthwhile method of studying and recording the spiritual history of the Japanese people. Its application to mythology is on the way to giving this study its true place in the human sciences. MH

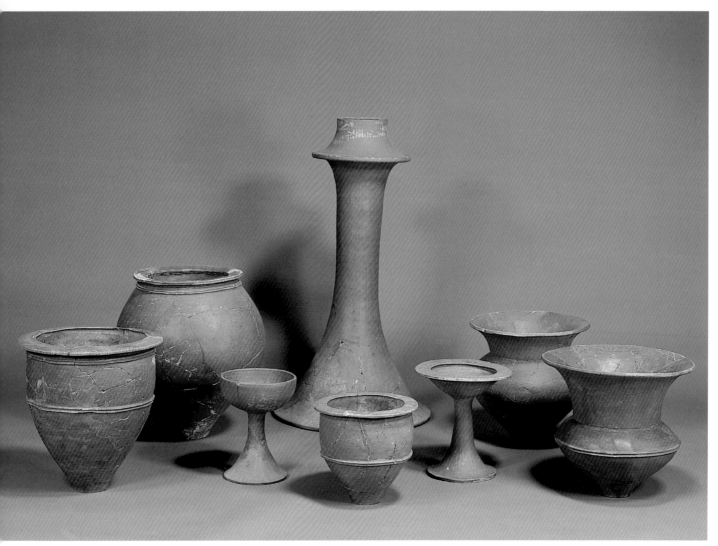

21

21 Group of red burnished pottery vessels

Yayoi period (300 BC–AD 300)

Kurita site, Fukuoka Prefecture

Agency for Cultural Affairs

Tallest: H. 82.8 cm

Important Cultural Properties

In contrast to the richly decorated pots of the Late Jōmon period (1500–1000 BC), found in eastern Japan the Yayoi pots of western Japan were undecorated and shaped for functional uses related to the introduction of wet rice agriculture from overseas. There were functional storage vessels, jars for boiling water, and containers for pouring liquids. Among the ritual vessels are those with pedestals, intended for ritual offerings. Such red burnished vessels are excavated mainly from sites in northern Kyūshū particularly in Saga Prefecture and the southern part of central Fukuoka Prefecture. They were used in rituals conducted beside pottery coffins. This group of ritual vessels includes wide-mouthed jars, narrow-mouthed jars, pedestalled vessels, bowls and large vessel stands, all highly burnished and with their red pigment giving a metallic appearance. Some have a design burnished on to the surface, giving them a mysterious appearance when reflected in the light. MM

22 Pottery jar

Yayoi period (300 BC–AD 300)

Funabashi site, Ōsaka-fu

Ōsaka Furitsu Museum for Yayoi Culture

H. 50.1 cm

By the Late Jōmon period (1500–1000 BC), wet rice agriculture had been introduced into the Kinki region from northern Kyūshū. This necessitated the production of pottery vessels for domestic use. Such vessels in northern Kyūshū, simply decorated with horizontal linear bands, give a strong impression of metallic beauty. Those east of Kinki developed into new shapes, though Jōmon designs were still in evidence as wet rice agricul-

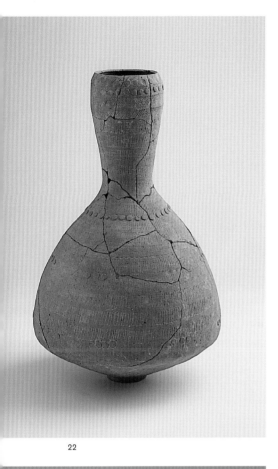

22

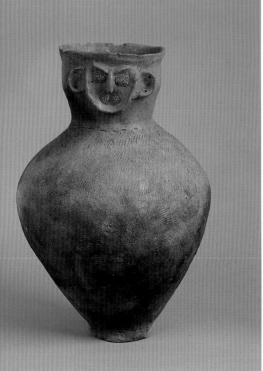

23

ture spread to the north-east during the early Yayoi period. In the Kinki region, however, unique decorations on pottery for everday use were devised.

The Ōsaka Funabashi site was a dwelling complex that existed from the Yayoi to the Kofun periods (third–sixth century AD). It extended from Kashihara City Furumachi, to Fujidera City Funabashi and was a major habitation by the Late Jōmon period.

This narrow-mouthed jar is representative of Kinki artisanry. It is decorated with the motif called *renjōmon*. This is created by applying a comb-shaped implement horizontally over the surface, stopping periodically to press it into the body, then repeating the process over and over again.

Another favoured design in the Kinki region during the Yayoi period was the *ryūsuimon* (flowing water) motif. It was formed by a number of wavy parallel lines repeated continuously. Many *dōtaku* (bells) from the Kinki region have this flowing water decoration, which has enabled their dating in the lack of other evidence.

Still other unique Kinki decorations on pottery included the *rettomon* (lines of repeated point impressions), applied clay and incised patterns. MM

23 Jar with human face

Middle Yayoi period (100 BC–AD 100)

Kaigo site, Ibaraki Prefecture

Ibaraki Prefectural History Museum

H. 42.8 cm

The mouth of this globular, thin-walled jar is in the form of a funnel on which a human face is modelled in relief. The body is covered with a slanting cord pattern of Jōmon origin and the narrow part of the neck is encircled with a row of point impressions. The human face is heart shaped and outlined with raised lines as are the ears. The face gazes straight ahead intensely. The eyes and mouth are formed with outlines and point impressions. Both ears are pierced with a small hole at the top and bottom, but it is not certain that these were for ear decorations. The row of point impressions around the neck of the vessel give the appearance of a necklace on a human form.

This kind of expression in pottery was sometimes to be found in the eastern part of Honshū. Such vessels were invariably made to contain the remains of the dead, thus becoming pot-coffins. The faces may have been meant as guardians for the dead or as an expression of hope for rebirth, but in either case, many of them are of great dignity.

The custom of depicting human faces on vessels is believed to date back to the figurines of the Jōmon period (12,500–300 BC). But Jōmon figurines were primarily for festival purposes, whereas the Yayoi vessels with human faces were primarily equipment for funerals. In the Late Jōmon (1500–1000 BC) period the clear religious definition between festival and funeral which had existed since the Middle Jōmon period (2500–1500 BC) became confused, and there are examples of figurines being used for funerary purposes in places from eastern Japan to Hokkaidō. It is possible to interpret the Yayoi practice as an extension of this funerary custom. The lack of differentiation between festival and funeral persisted through the Yayoi and into the mid Kofun period (third–sixth century AD), after which they once again became clearly separated upon the official formulation of the national folk beliefs of Japan. MH

24 Earthenware jar
with human face

Yayoi period (300 BC–AD 300)

Izuruhara site, Ibaraki Prefecture

Meiji University Archaeological Museum

H. 23.0 cm

Important Cultural Property

The mouth of this earthenware vessel turns through 90 degrees and represents the open mouth of a human being. To the left and right of the mouth are two pierced holes which represent the eyes. The vessel is covered overall with cord markings in the Jōmon style, over which are incised straight and curved lines. The face is rendered clearer by the application of raised clay modelling.

The form of this vessel can be seen to derive from the hollow figurines of the Jōmon period (12,500–300 BC) which held the bones of a dead person. It was not possible to put all bones from one body into such jars, so bones were reduced in size by pulverization or cremation. This is believed to have been the origin of the cinerary urn.

At around the same time, jar- and urn-shaped earthenware vessels were made in north-eastern Japan following the style of large Jōmon ossuaries. Earthenware vessels frequently used as ossuaries were divided into two types and sizes in the Late Jōmon period. The large type was used to contain the larger bones such as the femur. The small type was yet smaller than this example, reflecting the difference in treatment of the bones of the deceased after disinterment. There are examples of faces depicting the deceased on the necks of vessels. In the west of Japan there was a custom of burying one body in a set of two urns fitted together (*kamekan*). In such cases there was no need to first bury the dead for a period to cleanse the bones (*senkotsu*), so the burial could take place immediately after death.

The Jōmon practice of cleaning the

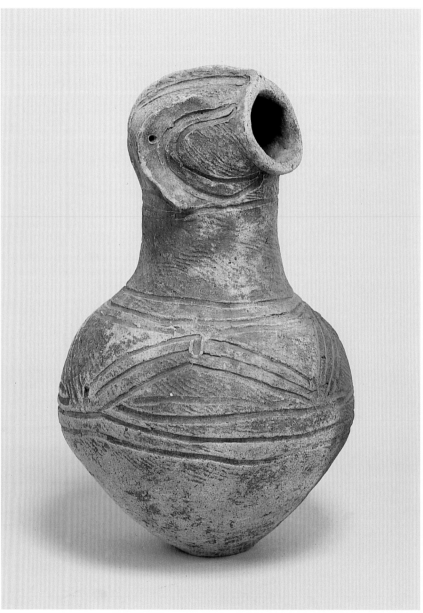

24

bones by interment and disinterment persisted in north-eastern Japan into the Yayoi period, and regional differences in the treatment of corpses are clearly seen. This vessel is a sensible shape for the cleaning of bones. Interestingly, when looked at head-on, the vessel appears to be weeping, with an expression of deep lamentation. TD

25 Figurine-shaped earthenware vessel

Middle Yayoi period (100 BC–AD 100)

Koshigoe site, Nagano Prefecture

Tokyo National Museum

H. 36.7 cm

At first sight this Yayoi period earthenware vessels looks like a figurine from the Jōmon world. The trunk is slender and widens into a conical shape on which is mounted a rounded head with the mouth wide open. Both head and body are hollow. The face is formed with a T-shaped clay strip for the eyebrows and nose, and triangular eyes of boldly inscribed broad lines. The mouth is depicted by a pattern of concentric circles. There are circular patterns on the sides of the head, and below these the ears are formed of applied clay. The neck is extraordinarily long. The arms are short and curved downwards, with small holes pierced through the ends. There are pad-like protuberances at the shoulders but no depiction of legs. The front and back of the trunk are decorated with a simple incised geometric pattern of straight and curved lines.

Many such relics contain fragments of human bone, and it is clear that they were used as pot-coffins. A number of examples have been found buried in pairs of pots, one large and one small. This possibly reflects a Yayoi practice of burying couples together. Such pairs from the Late Jōmon period (1500–1000 BC) were found at the Asōda Ōhashi site in Aichi Prefecture and the Ōasa 3 site in Hokkaidō. It is interesting that the figures of the women, which have clearly defined breasts, are the larger.

In the Beginning Woman was the Sun (Gensho, Josei Wa Taiyō De Atta) is the title of the autobiography of the social philosopher Hiratsuka Raichō (1886–1971). It reflects a body of scholarly opinion that the primitive society of Japan throughout the Jōmon period was matriarchal. It can be said that these figurine vessels indicate that the matriarchal structure of society governed burial customs. MH

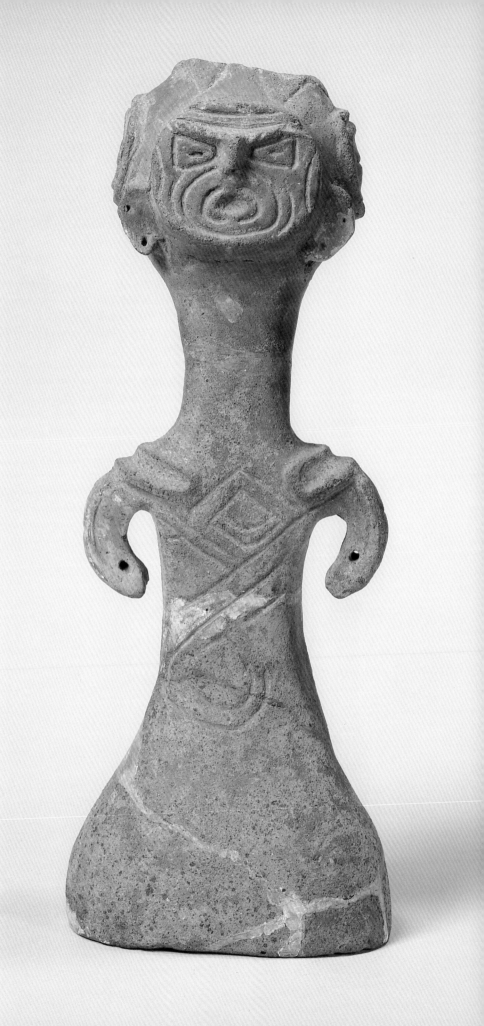

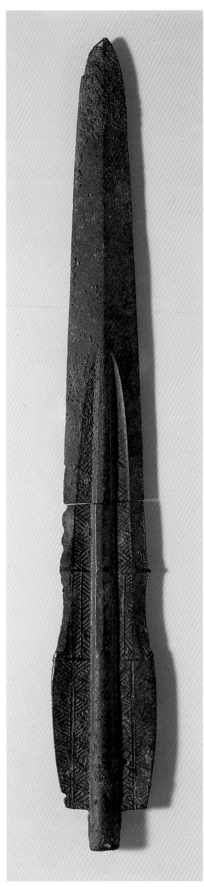

26 Waisted bronze sword

Yayoi period (300 BC–AD 300)

Kotsuro site, Hyōgo Prefecture

National Historical Folk Museum

L. 42.0 cm

The Yayoi period is characterized by wet rice cultivation and metal implements, bronze and iron having been imported at the same time. Iron was used for sharp implements. It followed that bronze should be used for ritual objects. Among these were *dōtaku* (bells) and bronzes in the form of weapons including *dōken* (swords), *dōhoko* (spears) and *dōka* (halberds). They were made large and decorative for the purpose.

The Kotsuro site, where this sword was excavated, is situated in Seidanchō of Mihara-gun, Hyōgo Prefecture in the south-west part of the island of Awaji. Ten *dōtaku* have been excavated from Seidanchō, making it a special locality in western Japan. This sword is one of 13 bronze *dōken* excavated together from the same site. They are all around the same size, between 40.5 and 45.2cm in length, but this one has a decorated groove, of which there are few examples.

There is a compound sawtooth pattern from close to the point to where the waist section starts. The waist section has a herringbone pattern, and the section between it and the base part also has a compound sawtooth pattern decorated within the triangles with continuous alternating sloping lines. This is a characteristic of the earliest types of *dōtaku* and is found on bronze halberds excavated from around Ōsaka Bay. The herringbone pattern is found in grooves of halberds excavated from northern Kyūshū, so this single example combining the culture of northern Kyūshū and the Kinki region is an important if subtle reflection of the political situation of this area. MM

27 *Dōtaku* with horizontal band decoration

Yayoi period (first century BC)

Fukuda Kinomuneyama site, Hiroshima City

Privately owned

L. 19.5 cm

Important Cultural Property

Dōtaku (bells) derived from the bronze bells of the Korean peninsula. Although no such bells have been excavated from royal tombs in the Korean peninsula, many have come from the tombs of individuals. From this it can be assumed that they were used for shamanistic rituals. In the Japanese archipelago a spiritual culture developed using these *dōtaku* for ritual from the Middle Yayoi period (100 BC–AD 100) centred on the Kinki region in the east of Chūgoku region, the east of Shikoku region, the Tōkai region, and the west of the Hokuriku region. Of the more than 500 *dōtaku* excavated in Japan to date, certain ones are considered particularly significant because of the place and method of their manufacture and their patterns. These are: the Muneyama site *dōtaku* of Fukudaki; the *dōtaku* from the Ashimori site of Okayama City (Tokyo National Musuem); the *dōtaku* said to have come from the west part of Tottori prefecture (Tatsūra Kōko Shiryōkan); the *dōtaku* thought to have been excavated in the western part of Shimane Prefecture (Izumo Honjin Kinen Zaidan) and those made from the same moulds; and the recently confirmed No.5 *dōtaku* excavated from the Yoshinogari site.

The pattern on the *dōtaku*, said to be from the west of Tottori Prefecture and thought to have been made more recently, is much simpler. The others, including this one, have a motif thought to be eyes in the upper of three sections defined by horizontal lines. This Gazing Eyes motif was once believed to be an

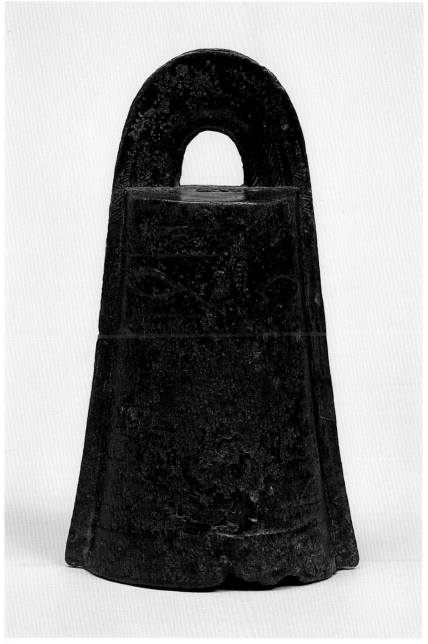

27

evil gaze called *jashimon*, but it is now believed to the *hekijamon* gaze which dispels evil, and there is no doubt that these eyes represent a *kami* or the spirit of the *kami*.

This example, however, was cast in northern Kyūshū where *dōtaku* are not thought to have been used for ritual. The same type of moulds have been found in Fukuoka City and in Tosu City of Saga Prefecture, although none so far match the excavated moulds. There is no doubt that this series of *dōtaku* were made in North Kyūshū, and with the exception of the *dōtaku* from Yoshinogari in Saga Prefecture, they have all been found in the central Chūgoku region. They can therefore be said to be valuable material showing the burgeoning relationship between the cultures of north Kyūshū and the Kinki region. MM

28 Three broad-waisted bronze spears

Yayoi period (first century BC)

Kōjin-dani site, Shimane Prefecture

Agency for Cultural Affairs

Maximum L. 83.6 cm

National Treasures

Among Yayoi period weapon-shaped bronzes, many were made in the Izumo and Kibi regions apart from Kyūshū. Moulds have been excavated in the Kinki region and bronze spears with grooves decorated with complex sawtooth patterns have been excavated from Ōsaka Bay. In northern Kyūshū the spear was the most important weapon-shaped ritual object, but bronze spears dating from the end of the middle Yayoi period to the late Yayoi period have only been excavated from the limited area of the west of the Chūgoku region to the south-west part of the Shikoku region.

At the Kōjin-dani site situated in the most easterly part of the Chūgoku region, six *dōtaku* (bells) and sixteen bronze spears were discovered, all having been buried together. The bronze spears were laid out with the cutting edges uppermost and the points laid alternately end to end and the *dōtaku* were laid out with their fins upwards and end to end. At a nearby site, 358 swords were unearthed similarly laid out in close-packed rows.

Of the sixteen bronze spears, seven were of the so-called *togiwake* type. This type involved polishing the blade in one direction after the casting, then taking a polishing stone around 2 cm wide and polishing at even intervals along the spine, alternately changing the direction of polishing. By polishing in this manner, light is reflected from the blade to give a shimmering appearance. Eighteen such bronze spears have been excavated from northern Kyūshū, and the seven from Kōjin-dani are believed to have been brought from there.

The large number of valuable bronze spears brought from northern Kyūshū has some political significance. The 358 bronze swords excavated from the same site are of a type that have only been excavated in Izumo, and many among them are cast from the same mould. The fact that the powers of northern Kyūshū sent so many of their highly prized spears to Izumo points to a political relationship with the Kinki authority and respect for the power of Izumo. MM

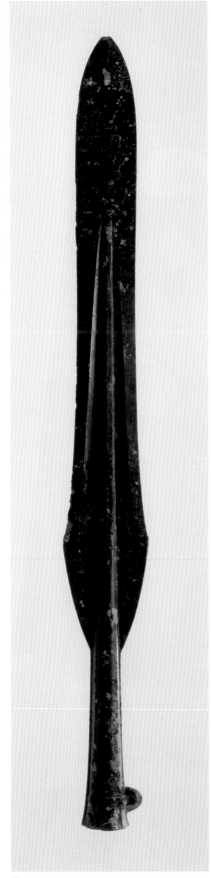

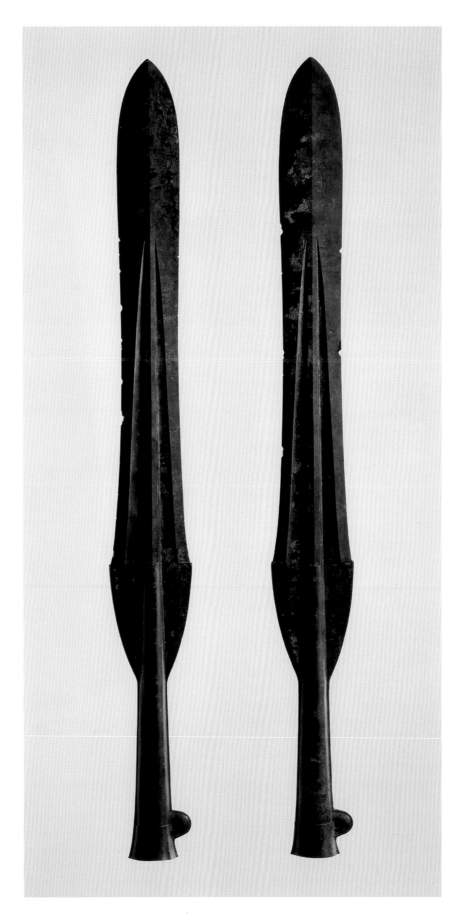

28

29 *Dōtaku* with crossed-band pattern and illustrations

Yayoi period (first century BC)

Sakuragaoka site No. 5

Kōbe City Museum

H. 39.1 cm

National Treasure

Fourteen *dōtaku* (bells) and seven bronze halberds were unearthed from the same site at Sakuragaoka in Kōbe City. Among the bells, five were from the early stage of development, and nine were from the middle stage. The bronze halberds were all of the type which have been excavated from around Ōsaka Bay.

About 500 *dōtaku* have been excavated, of which some ten per cent have some kind of pictorial motif. Those with the most perfect shape and pictorial decoration include the exhibited piece, Sakuragaoka No. 4, the crossed band pattern example excavated from Kagawa Prefecture (Tokyo National Museum), and a *dōtaku* which once belonged to the Edo artist Tani Bunchō (1763–1840), of which only a rubbing survives. From the common characteristics of the shapes and pictorial motifs of these four examples it can be deduced that they were made over a short period of time in the latter part of the middle Yayoi period, and that they were either cast by the same artisan or by members of the same group.

From the pictorial content, this *dōtaku* is believed to be the earliest. On one side (29a) it has a frog, a praying mantis, a spider, a water strider, a snake which has caught a frog being pursued by a man, three men in dispute and an archer aiming at a deer. On the other side (29b) are a lizard or newt, two dragonflies, a man with an I-shaped implement and a fish, a heron with a fish and a snapping turtle or tortoise, and two people threshing grain. All are depicted in fine lines.

The depictions are stylized. The heads of the female threshers are triangles, and the head of the man pursuing the deer is a circle. From this it can be seen that men and women are distinguished by the shape of the head. The decorations on the eight surfaces of this *dōtaku* and decorations on other *dōtaku* provide

29a

important data for considering the role of *dōtaku* in ritual, although a fully rational interpretation might not be possible. However, there is a strong case for suggesting that they were for rituals aimed at securing a rich autumn harvest in as much as the creatures depicted all appear in the fields around early summer. The theory is reinforced by the threshing scene and the raised-floor building on the *dōtaku* excavated from Kagawa Prefecture. MM

29b

30 *Dōtaku* with crossed-band pattern

Yayoi period (second–third century AD)

Ōiyama No.2 *Dōtaku*

Ōiwayama site, Shiga Prefecture

Tokyo National Museum

H. 71.4 cm

Important Cultural Property

Until thirty-nine *dōtaku* were excavated in 1996 from Kamoiwakura in Shimane Prefecture, the group of fourteen excavated in 1881 and the ten excavated from immediately beside that site in 1962 represented the largest known group found in a single site. The two groups comprising twenty-four bells all date from the late stage of development. Among them is the largest yet found, being 134.7 cm in height. There are illustrations on *dōtaku* dating from early in the Yayoi period but the most perfect examples date from a mid point in the period (cat. no. 29, the Sakuragaoka No. 5 piece).

During the later stage of development, the bells become increasingly larger, probably reflecting a change from ritual significance, to an increasing regard for size and decoration. This piece is one of the few decorative *dōtaku* of large size. Others include one excavated from Isonokami (Imperial Household Agency Archive) and another is thought to have been cast from the same mould excavated from Nara Prefecture (Shimma Kōko Shiryōkan). From the Tōkai region came the Akugaya *dōtaku* from Shizuoka Prefecture, the Onodōdō *dōtaku*, and the Shikiji No.1 *dōtaku* (all Tokyo National Museum). The Isonokami *dōtaku* and the one cast from the same mould, although made in the later stage of development, represent early examples of the flowing water motif. The others made in the very latest stage are decorated with highly stylized birds.

There have been no *dōtaku* excavated from tombs. Most have been excavated from mountain sites overlooking places of habitation. This custom is different from the northern Kyūshū tradition of burying bronze weapon-shaped objects in the tombs of chieftains and indicates that the *dōtaku* were not regarded as the

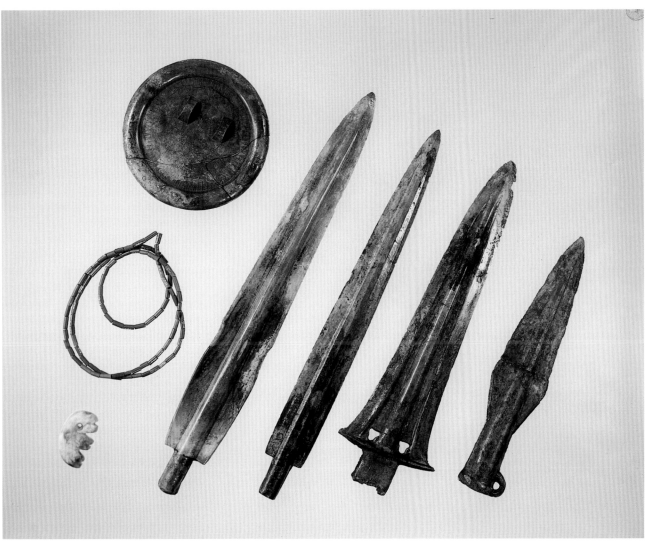

31

property of individuals, but were rather communally owned ritual objects. This being so, the decorations on *dōtaku* should tell the story of essential rituals of communities or *shinwa* (tales of the *kami*). As time passed and beliefs changed, the ritual of burying *dōtaku* was abandoned. Rituals based on individual authority developed with the onset of the Kofun period (third–sixth century AD). MM

31 Two bronze swords, bronze halberd, bronze spear, tubular beads, *magatama* jewel and mirror with two bosses

Yayoi period (second century BC)

Yoshitake Takagi site, Fukuoka City

Agency for Cultural Affairs

L. longest: 33.4 cm

Important Cultural Properties

The Yoshitake Takagi site is situated in the Sawara plain of Fukuoka City. It is believed that the Country of Ito referred to in the Chinese Wei Dynasty chronicle was to the west of it, around present-day Maebara City, and that the Country of Na was to the south-east around present-day Kasuga City. Tombs thought to be of chieftains have been discovered in both places, many containing pottery jar coffins and wood coffins. These pieces were excavated from the No. 3 tomb.

The No. 3 tomb contained a wooden coffin measuring 3.7 m long, 2.9 m high and 0.9 m deep. The *magatama* (comma-shaped beads) and ninety-five tubular beads of jasper were recovered from the

region of the chest bones, having evidently constituted a necklace. At the right side of the body the fine-bladed bronze spear and sword were deposited together with the bronze mirror. On the left on the inside was the halberd, and beside it the other bronze sword with the point towards the feet. These fine bronze weapon-shaped objects have been closely dated to the earliest stage of development, but it is not known whether they were made in Japan or Korea. The jade *magatama* is unusual in that on its inside curve are three small notches with two larger notches cut between them.

This is an important assemblage showing that the concept of the 'Three Sacred Treasures' was already established by the Middle Yayoi period. MM

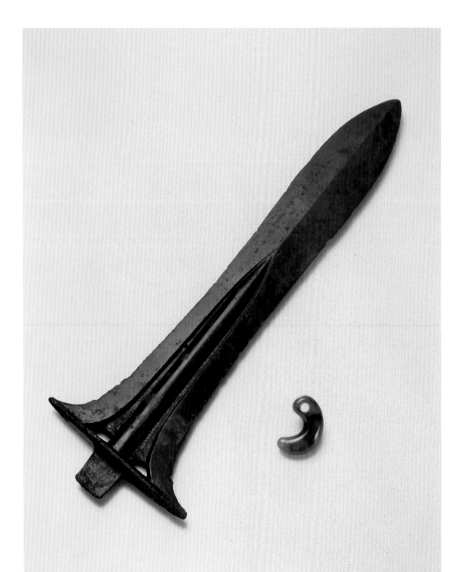

32

32 Comma-shaped
jadeite bead and bronze halberd

Yayoi period (300 BC–AD 300)

Izumo Ōyashiro Manai site (Kamosu Inochinushi
Jinja), Shimane Prefecture

Izumo Ōyashiro

Bead: L. 3.5 cm; halberd: L. 31.1 cm

Important Cultural Properties

The *magatama* (comma-shaped bead)
appears from the Late Jōmon (1500–
1000 BC) period onwards, and is said to
have originated as a tooth of an animal.
In the Yayoi period the shape became
more reminiscent of a crescent moon.

Some *magatama* have line engravings on
the head section and are known as
chōjigashira (clove-head). Their uniquely
Japanese forms developed during the
Kofun period (third–sixth century AD).
This example is of a deep transparent
green, made of the hard stone called
rokan which was used for jewellery.
Among other known examples, this
jewel compares with one from the Asuka
period (late sixth century AD–AD 710),
which was excavated from the founda-
tion of the tower of Asukadera Temple in
Nara Prefecture. Several sources of the
stone used for *magatama* are known in

Japan, but the only place where such a
fine quality material could have come
from is around Itoigawashi on the Japan
Sea side of Honshū. Hard-stone obtained
from this region was esteemed as mater-
ial for making jewellery from the around
the beginning of the Middle Jōmon
period (2500–1500 BC), and is recorded in
Japanese mythology (the *Nunagawahime*
legend). The Japanese people always
admired the beautiful deep greens of
jade and the transparent yellows of
amber, and invested them with a sacred-
ness transcending everyday use.

The halberd blade is comparatively
broad, made by the bronze casting tech-
nology brought from abroad. The halberd
was originally a weapon meant to be used
by armed horseback riders. The blade,
therefore, was fixed at a slightly down-
wards angle onto a pole. A very small
number of practical halberds of iron, on
which the blades could be made more
slender have been found in Kyūshū and
western Honshū from the Yayoi period.
Most examples so far excavated, however,
are of bronze like this piece. Such hal-
berds are brittle and blunt, and the tangs
of the blades are too small to be practical,
so they were made predominantly as
ritual objects for ceremonial use.

These objects were excavated in 1665
when a large rock was being removed
during building works in the grounds of
the Kamosu Inochinushi Jinja Shrine
about 200 m east of the *honden* (main
shrine) of Izumo Taisha. They have been
cherished as shrine treasures since that
time. There is no record of the exact cir-
cumstances of the excavation, but it is
most probable that the jewel and halberd
were ritual objects deposited as offerings
beneath the rock, which must have been
a *yorishiro* (temporary abode) for the *kami*
during the Yayoi period. The concept of
large boulders being the *yorishiro* of the
kami continued from the Jōmon period
(12,500–300 BC) right up to later times.
Unaffected belief in the *kami* is still a part
of everyday life in the Izumo region,
which is an ancient sacred locality. MH

33 Mirror with design
of buildings

Kofun period (third–sixth century AD)

Samida Takarazuka Kofun site

Imperial Household Agency

Diam. 22.5 cm

Around the central boss of this mirror are four landscapes, each with a single building: a raised-floor dwelling, a low-floored dwelling, a raised-floor store-house and a pit dwelling.

The raised-floor dwelling (top) is of hipped-and-gabled roof construction, with a ladder and handrail on the right, and what appears to be a balcony and a parasol (*kinugasa*) on the left. The low-floored dwelling (right) also has a hipped-and-gabled roof, and what could be an earthen platform at the lower storey. The raised-floor storehouse (left) has a gabled roof and a ladder on the left. There is a parasol on the pit dwelling (bottom), which has an open door. The same depiction of a pit dwelling is found on ring-pommelled swords (*gantō tachi*). Pit dwellings are assumed to be the houses of ordinary people, but the parasol on the depiction is evidence of more than usual significance. Birds are seen on the roofs of all the buildings except the raised-floor storehouse. There are trees between the buildings. There are also representations of two deities.

Dwellings of this nature are thought to have been inhabited by particularly rich and powerful members of the community. Their depiction on this mirror reinforces the theory that mirrors had become symbols of wealth and authority, ritually interred in the *kofun* (tombs) of the powerful.

The mirror is particularly important as, together with *haniwa* (clay images) in the form of dwellings, it shows the building technology of that age. TD

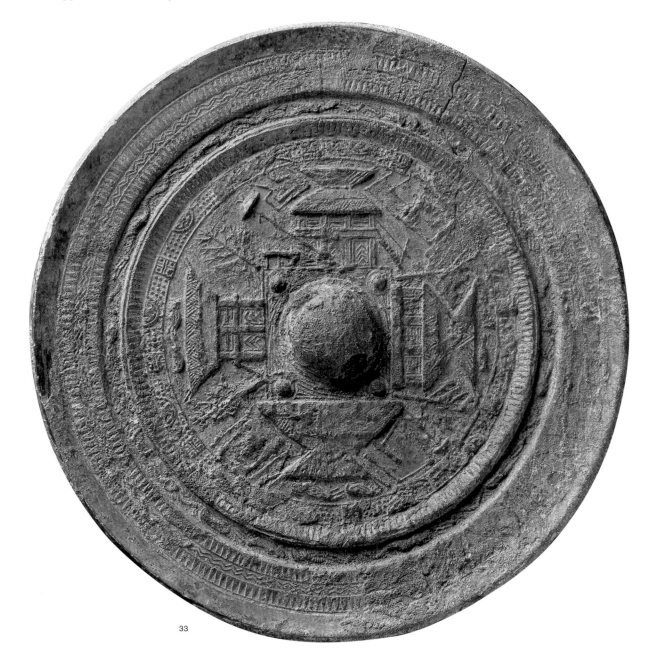

33

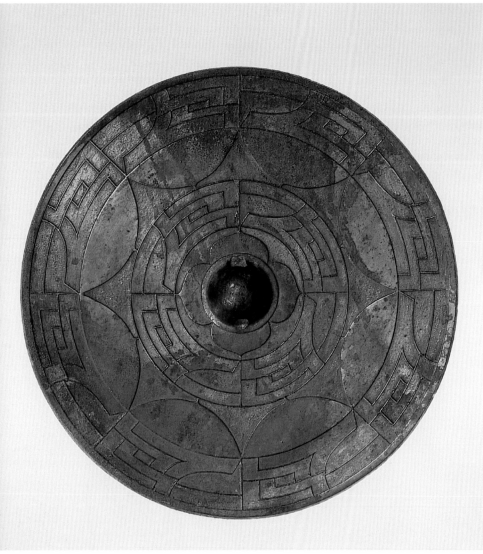

34

mainland Asian imports. There are two further bands of the *chokkomon* pattern of straight and curved lines.

A number of mirrors of the transitional type that show the strength of the link between the interconnecting arc and *chokkomon* designs have been found in Nara Prefecture, but the only mirrors with this particular design are the three excavated from this Shinyama *kofun*. The *chokkomon* is essentially Japanese, although other designs combining straight and curved lines were used in the Jōmon and Yayoi periods. The design is found on the walls of stone tomb chambers, sword mountings, shields held by *haniwa*, and on other objects as a magical device to ward off calamity.

The design of this mirror is rather simpler than other *chokkomon* designs, and belongs to a late period. The mirror is an extremely important statement of the development of the *chokkomon* as a symbol of authority with magical significance, in combination with the interconnected arcs design imported a hundred years previously. TD

34 Mirror with *chokkomon* design

Kofun period (fourth century AD)

Shinyama Kofun site, Nara Prefecture

Imperial Household Agency

Diam. 28.0 cm

Together with depictions of buildings (cat. no. 33) and hunting scenes, the *chokkomon* is a uniquely Japanese design on mirrors.

This mirror has a central boss with a four-petalled motif and a band of eight interconnected arcs, both taken from

35 Pictorial mirror

Kofun period (fifth century AD)

Unknown provenance

Kyoto National Museum

Diam. 20.9 cm

It is known that the manufacture of bronze mirrors in China declined between the end of the second century and beginning of the third century AD. If, as has been conjectured, the 'triangular rim creatures and deities' mirrors, which have only been excavated in Japan, had been brought from Wei Dynasty China, then this mirror would have been among the last sent in large numbers. Both the Yamato authority, which continued the custom of making bronze mirrors after the Yayoi period (300 BC–AD 300), and the provincial powers which supported the

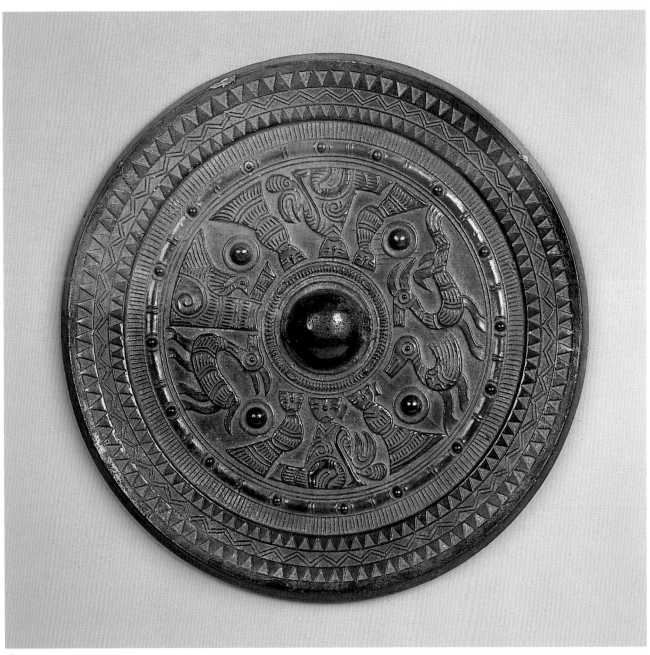

35

craft cast their own bronze mirrors from the mid Kofun period using the imported Chinese mirrors as models. This mirror was cast in Japan. There are many such examples with designs sculpted in level relief like this one. The inner section has a triad of deities arranged on either side of the central boss, and two each of what are

believed to be birds and horned deer arranged facing anticlockwise about the central boss, with a band of raised nipples between them. Around these is an outer section with another band of nipples, a comb-tooth band, a sawtooth band, and a wave-form band, all enclosed as far as the rim with a final sawtooth band.

The decoration on this mirror faithfully copies Chinese models, but there are many other examples whose outer sections have a compound design of sawtooth bands together with various typically Japanese motifs such as bands of *magatama* (comma-shaped beads). MM

36

36 Mirror with six creatures and six bells

Kofun period (fifth century AD)

Provenance unknown

Sen-oku Hakuko-kan Museum

D. 12.1 cm

Mirrors with peripheral bells are representative of Japanese mirrors as opposed to the imported Chinese products. There are many examples of such bells on horse trappings like the *suzu gyoyō* and *gan suzu*, and on bracelets. It is noteworthy that there are numerous examples of bells on horse trappings excavated from eastern Japan, which might be relevant to the provenance of this piece. The female figure (cat. no. 42) carries a six-belled mirror, which is believed to have been equipment for the *miko* (female shamanistic ritual attendants). There are examples with four to ten bells, but most have five or six. Examples occur with four, seven or eight bells in order of decreasing frequency. The patterns found in the inner sections may be of nipples, creatures, deities, rosary-style beads or a continuous arc design, but the nipple motif is most prevalent. MM

37 Mirror with dragons

Kofun period (fifth century AD)

Munakata Taisha Okitsu-gū site, Okinoshima Island, Fukuoka Prefecture

Munakata Taisha

D. 22.0 cm

National Treasure

The *daryū* (dragon) type mirror is based on the Chinese design of deities with or without creatures, but is uniquely Japanese. The *daryū* is an imaginary sea creature said to be a form of *wani* (alligator?), but its shape is more like a dragon or lizard. It is reputed to be able to jump sideways but not upwards. Its voice is terrifying, it expels clouds in its breath, and it is able to cause rainfall.

This mirror has both deities and creatures. The inner section has a triad of deities above and below, with two long-necked *daryū* to the left and right, and with raised nipples arranged between them. Around these are bands of compound sawtooth and rosary bead motifs, rows of semicircles and continuous bands of sawtooth, comb-tooth and rhomboids extending to the rim.

The mirror was excavated from site No. 17 on Okinoshima, where rituals were conducted on a large boulder from the latter half of the fourth century through the fifth century AD. Other relics from this period include Japanese-made mirrors on the Chinese Han and Wei Dynasty models, jasper bracelets, iron weapons, tools and ritual implements made of talc, all similar to Kofun period buried material of the same era. MM

37 ▶

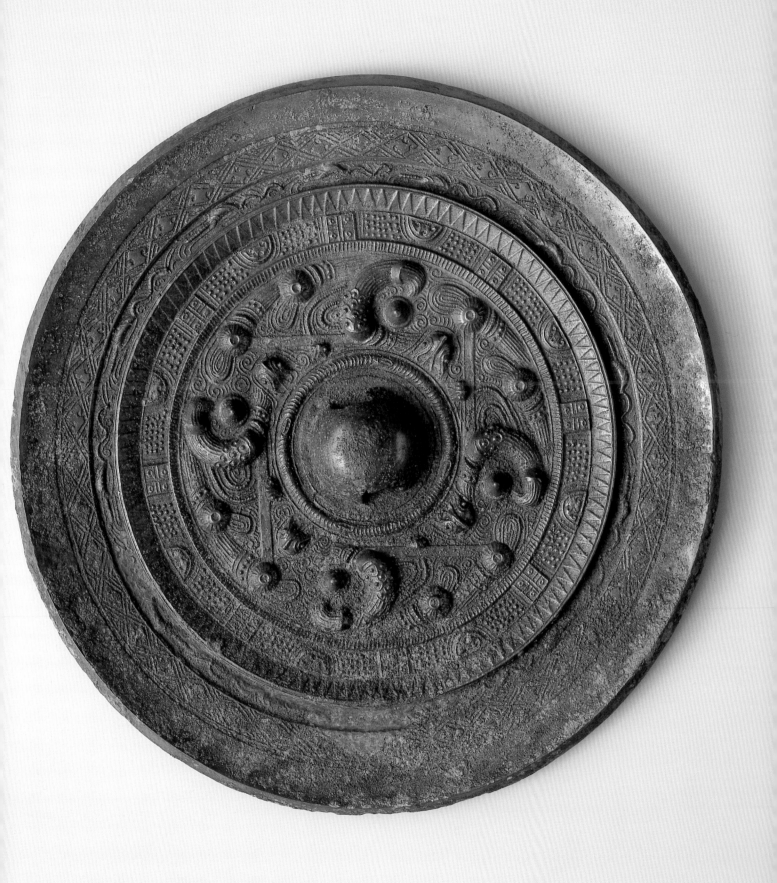

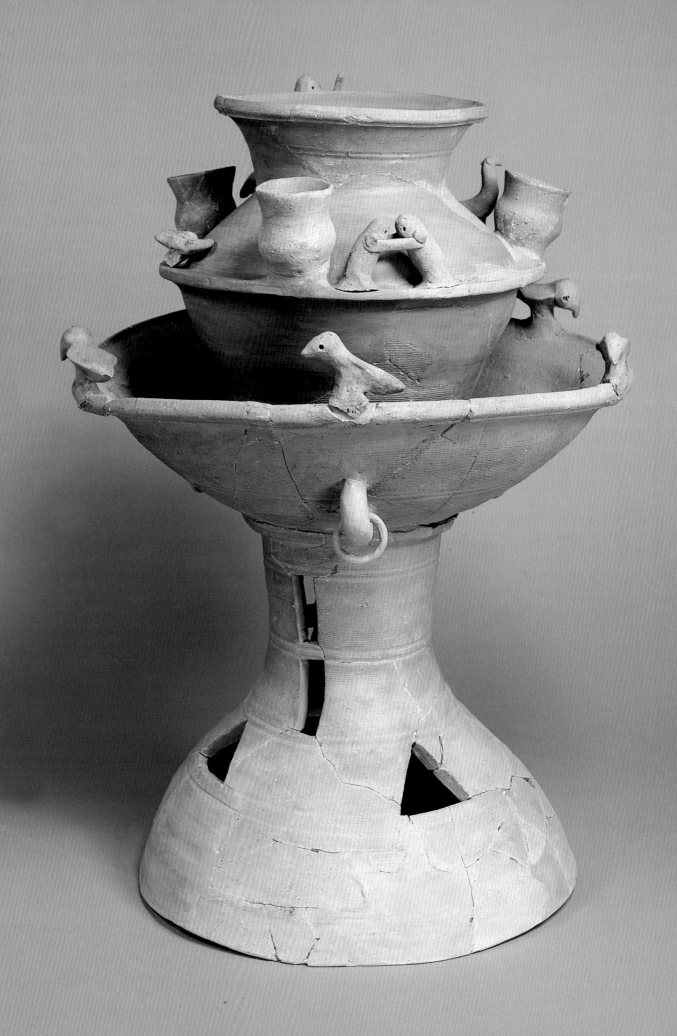

A BIBLIOPHILE® GIFT FOR YOU

BRITAIN'S BEST POSTAL BOOK BARGAINS

If you Introduce us to a Bookloving Friend...

We try to avoid expensive advertising, which inevitably puts up the prices to existing customers and rely on recommendations from you to maintain our mailing list.
Please send us the names of friends who may be interested in Bibliophile and if they buy we will send you a voucher to reduce the cost of your future purchases.

****** **£2** IF YOUR FRIEND'S FIRST ORDER IS FOR UP TO £10 ******

****** **£5** IF YOUR FRIEND'S FIRST ORDER IS OVER £10 *******

****** **£7** IF YOUR FRIEND'S FIRST ORDER IS FOR UP TO £15 ******

****** **£10** IF YOUR FRIEND'S FIRST ORDER IS OVER £20 ******

Please gain the permission of the individual, school or library and remember to include your own name, address and customer number. Welcome them to book club with no ties, fees or editor's book-of-the-month to the forgetful!

Help us to cut costs by giving full postcodes. Thanks.

NAME
ADDRESS..............
.............................
.............................
POSTCODE.............

NAME
ADDRESS..............
.............................
.............................
POSTCODE.............

NAME
ADDRESS..............
.............................
.............................
POSTCODE.............

NAME
ADDRESS..............
.............................
.............................
POSTCODE

NAME
ADDRESS..............
.............................
.............................
POSTCODE.............

NAME
ADDRESS..............
.............................
.............................
POSTCODE.............

NAME
ADDRESS..............
.............................
.............................
POSTCODE.............

NAME
ADDRESS..............
.............................
.............................
POSTCODE

38 Vessel and stand with applied models

Kofun period (sixth century AD)

Noguchi No. 1 Kofun, Tottori Prefecture

Kurayoshi City Museum

H. 49.5 cm

Important Cultural Property

This vessel was excavated from the surrounding moat in front of the stone chamber of the 29-metre-long Noguchi No.1 *kofun* (tomb). So it is known to have been used in rituals conducted in front of the tomb. The stand for the vessel is decorated around the rim with five birds and five freely suspended rings around the outside. The lower part of the pedestal has three triangular openings on the upper part with two rows of rectangular openings between the triangles.

The vessel nestling on the stand has a raised flange around the middle section, above which are three small vessels. Between these are a dog and a mounted man chasing a deer, two sumō wrestlers, and three birds which it may be imagined have been previously shot by the mounted archer.

Similar examples of such decorative *sueki* (high-fired, wheel-turned ceramics) are known from other sixth-century *kofun* of western Japan. The style derives from tombs around Keishū in the south of the Korean peninsula, but such vessels were apparently not used for rituals outside the tombs there. MM

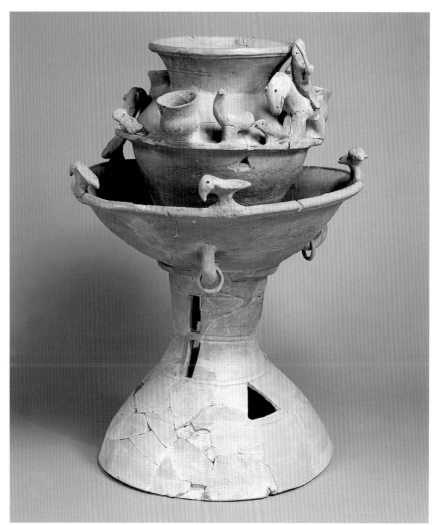

38

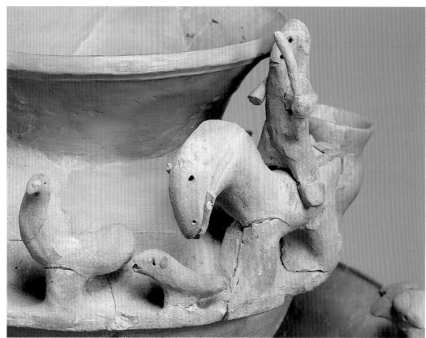

38 detail

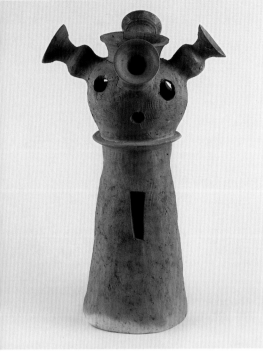

39

39 Pedestalled vessel with applied smaller vessels

Kofun period (sixth century AD)

Ueno site, Tottori Prefecture

Agency for Cultural Affairs

H. 50.5 cm

Important Cultural Property

The Ueno site is a *tateana* (shaft tomb) of irregular rectangular shape, measuring 4.2 m from east to west, and 3.9 m from south to north. Twenty pieces of pedestalled *sueki* (high-fired, wheel-turned ceramics) like this and five with no pedestals were found in a centre area of 1.8 m x 1.25 m, deposited in an orderly arrangement. This *sueki* looks like a vessel on a stand, but in fact it is one piece formed integrally. There are three rectangular openings spaced regularly around the pedestal, and a triangular-sectioned raised hoop-like band at the joint of the pedestal and the vessel. The vessel has a roughly globular body, and opens directly into the cylindrical section of the pedestal. The mouth is everted, and the shoulder has four smaller vessels with everted mouths aligned in four directions whose bases are pierced through the parent vessel. There are circular holes pierced below the smaller vessels, and three more holes below these on the body of the vessel.

Around the walls of the mound tomb were discovered post holes, so it is apparent that there was originally a roof covering the tomb below which the vessels were placed. This type of structure is prevalent in Tottori Prefecture and part of Shimane Prefecture, and is of interest even though the nature of the ritual is unknown. MM

40 Wine pourer with modelled decoration on a stand

Kofun period (fifth century AD)

Haneto Kofun. Fukuoka Prefecture

Ise Shrine, Chōkokan

H. 70.0 cm

Important Cultural Property

The Haneto *kofun* (tomb) had already been excavated in the Edo period (1615–1868). This piece was in the collection of Eto Masazumi, a priest of the Daizaifu Tenmangū Shrine during the Meiji era (1868–1912). It was presented to the *Chōkokan* (archive building) of Ise Shrine to make sure of its preservation.

The wine pourer resting on the stand is a large, globular, short-necked vessel of archaic shape. It has two apertures in the centre of the body, and four smaller wine pourers of the same shape as the main vessel arranged on its shoulder. The shoulder is decorated with a combed two-stage wave-form and the centre with an impressed-comb pattern.

The large stand is formed as a seat for the vessel with a pillar section, and a pedestal section. The uppermost part of the pillar section is somewhat round in form, with three rectangular openings in the upper part and five openings in the lower part. The pillar section is further divided into four parts by two parallel lines, each with four rectangular openings. There are *magatama* (comma-shaped beads) and circular applied mouldings around the outside of the seat and the upper part of the pillar. The remarkable thing about this stand is the modelled decoration over both the pillar and pedestal sections. On the upper part of the pedestal section is a turtle and three dogs barking at it. These are being watched by a person carrying a child. There are five more turtles escaping upwards around a spiral path along the pillar section.

This is a representative *sueki* of the Kofun period, interesting not only for its modelled decoration but also for the refinement of such a large piece. MM

41 Vessel with human face

Kofun period (third–sixth century AD)

Katayama site, Nagano Prefecture

Kokugakuin University Archaeological Museum, Tokyo

H. 17.9 cm

The body of the vessel has a human face in its gently inward-curving surface. Ribbons of clay applied to the upper part form the ears, openings form the mouth of the face, and a triangular piece of clay forms the nose. At the rim of the mouth of the vessel are two protruding pieces applied like fish fins, one to the right and one to the left. The ends of these pieces give the impression of hands, so that this vessel becomes a telling representation of a human figure with both hands raised. This vessel differs greatly from the usual Kofun period pots in that vivid marks of the coils used in its making remain on the inside and the outside. It is also different from the kind of vessels normally used for cooking.

At first sight the vessel has points in common with the *hitogata* (human form) vessels of the Yayoi period (300 BC–AD 300) but its purpose is basically different from those and the earlier Jōmon period figurines. Whereas the Jōmon fig-

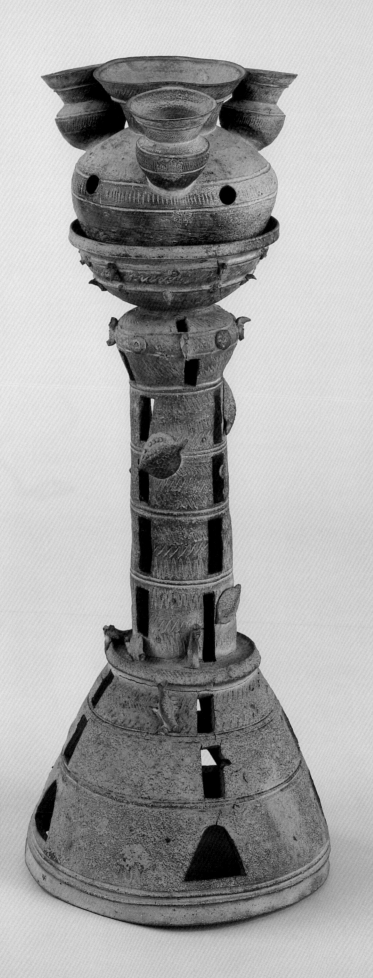

urines depict beings who have transcended the natural world and were made as ritual objects to pray for the prosperity of one's descendants, and the vessels of the Yayoi period with human faces were essentially equipment for funerals, the *hitogata* of the Kofun period developed as objects of a sacred nature. They reverted to the ancient world of ritual (*matsuri*, or festival). However, unlike Jōmon figurines, they were used as implements for human beings to manipulate the *kami*, as the concept of *kishin shieki* (messengers of the *kami*, or shamans) developed.

From the Kofun period onwards, the concept of shamans developed against the background of an orthodox religious belief that the natural world transcended the power of people, and that this was expressed as the *kami*. Vessels with human faces were made as a substitute for one's own self and were used to have impurity and sin exorcised, according to this basic belief. The Shintō beliefs emphasize purity and have no concept of the original sin of Christianity. Shintō decrees that human beings are born pure, and commit evil under the influence of external influences. Impurity (*kegare*) can be washed away through earnest faith and purification rituals.

This vessel is believed to be a ritual object into which people breathe their impurities and seal them therein, to be disposed of elsewhere. MH

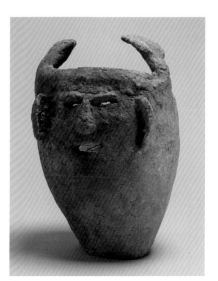

42,43,44 *Haniwa* figures of a girl with a sword, a kneeling boy, and a boy with a shield

Late Kofun period (sixth century AD)

Tsukamawari No. 4, Tumulus Kofun

Gumma Prefecture

Agency for Cultural Affairs

On loan from Gumma Prefectural Museum of Art History (42, 43) and Gumma Archaeological Research Centre (44)

H. 78.7 cm, 49.4 cm, 153.4 cm

Important Cultural Properties

Haniwa are open-fired earthenware objects which were arranged around the *kofun* (tombs) of chieftains in the late Kofun period. They appear around the middle of the third century AD from the Kinki region to the Chūgoku region and were models based on vessels used to contain offerings. By the late Kofun period they had developed into models of stirrups, shields, other military equipment and human figures. As the number of regions in which they were made increased, large *haniwa* were made in places as far away as the Kantō region. These examples are typical of the human-figure *haniwa* made in Kantō.

The figure of the girl (cat. no. 42) stands on a cylindrical base. She wears a flaring lower garment like a skirt, carries a mirror pouch on her left hip and holds a sword in her right hand. She also wears

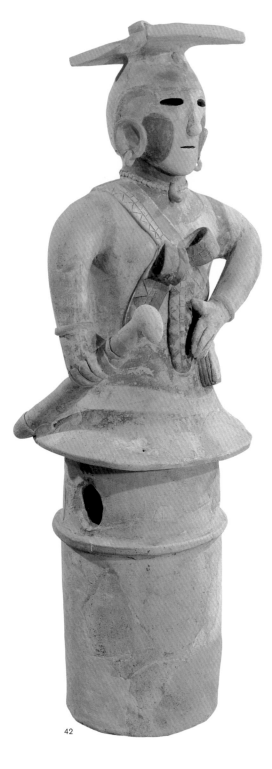

42

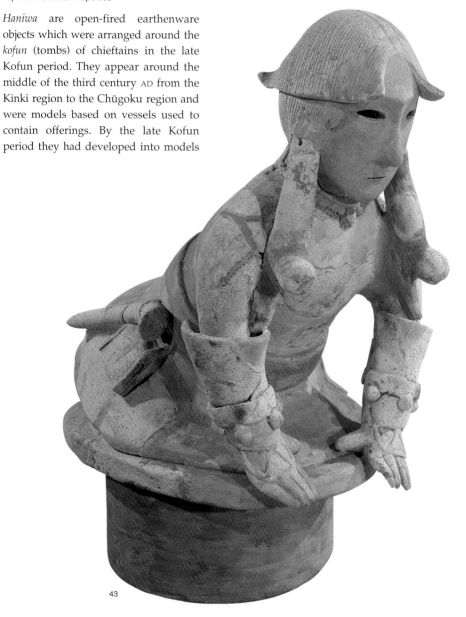

43

an *osui* (decorative sash for ritual use) over her right shoulder and across her left side. The pommel of the sword is rounded and decorative and therefore more for ritual than practical use. Her head looks directly to the front and her expression is one of dignity and gentleness. Her hair is dressed in a manner similar to the Shimada *mage* (chignon) style of the later Edo period (1615–1868) and her cheeks are rouged. She wears earrings and a necklace of *magatama* (comma-shaped beads) and other beads.

The figure of the boy (cat. no. 43) wears a sword at his waist, has armour gauntlets on his hands, and kneels with both hands resting before him on the ground. His hair is parted in the centre in bunches halfway down, from which hang objects like *suzu* (little bells). The stern facial expression and the line of his mouth suggest a young soldier. His posture, known as *kikyō*, is the traditional attitude of respect with which superiors were greeted in those days. This *haniwa* would have been placed as a military guardian for the chieftain buried in the tomb.

The *haniwa* of the boy bearing a shield (cat. no. 44) is different in feeling from the other two examples. The trunk and base are formed of an integral cylinder with a hole in the top into which the head is inserted on a cylindrical rod, forming a tall male figure. The flange-like protuberances on the sides of his body depict a shield held upright before him. The shield has a geometric decoration of interlocked triangles, which is of strong ritual significance.

These three *haniwa* were arranged around the *kofun* in a manner to show loyalty to the departed chieftain in representation of a ritual intended to protect and revive his spirit. The preservation of the spiritual power of the chieftain was of utmost importance for the regional rulers, and the ritual was of great social and religious significance. MH

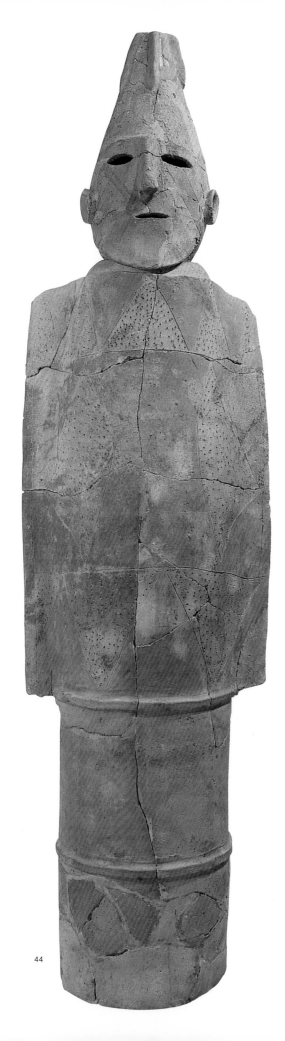

44

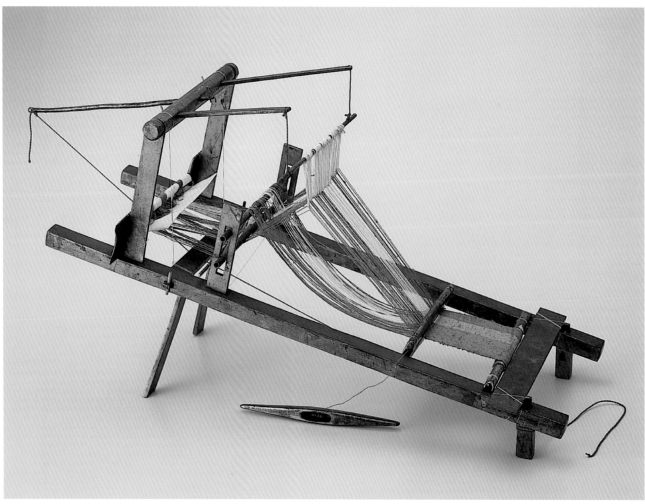

45

45 Miniature gilt-bronze loom

Middle Kofun period (fifth–early sixth century AD)

Munakata Taisha Okitsu-gū site, Okinoshima Island, Fukuoka Prefecture

Munakata Taisha

L. 48.0 cm

Important Cultural Property

The *hata* (loom) is a miniature weaving machine made up of assembled gilt bronze components (the thread and woven textile are reproductions). It is formed of cast and gilt-bronze rectangular longitudinal pieces on the left and right, joined together by transverse plate sections. The spool supplying the thread (*sao*) and the shuttle (*hi*) that passes the warp through the weft are both of gilt-bronze and belong with the loom.

Looms were used to weave the garments made as offerings to the *kami*, and have always been regarded as sacred

objects. This piece is a representative relic of votive rituals, and was placed as an offering in the *Okanagura*, a sacred depository, on the island of Oki-no-shima. According to the *Shosha Engi* by the Confucian scholar Kaibara Ekiken (1630–1714), Kuroda Nagamasa, *daimyo* (feudal lord) of Chikuzen Province (the northern part of present-day Fukuoka Prefecture), heard about the existence of votive offerings on the island. He obtained some, including a weaving loom, but later returned them in fear of retribution by the *kami*. This loom is believed to be that very piece.

Okinoshima is a solitary island, just four kilometres in circumference, lying in the Genkainada Straits between northern Kyūshū and the Korean peninsula. It is 57 km from Kyūshū and 145 km from Pusan in southern Korea. The island was an important point of contact along the

route of cultural flow from China and Korea to Japan, and has remains from as long ago as the Early Jōmon period (5000–2500 BC). But the most important aspect is that, during the five hundred years between the Kofun period and the early Heian period (AD 794–1185), the island became more than just a stepping-stone along the route of movement of artefacts, and became a place of continuous and frequent deposits of rich votive offerings.

From the nature of the offerings it is possible to chart the gradual change from Japan's dependence on importing techniques of manufacture from China, including the technology of arms and armour, to the development of a strong national character in religious offerings at the time of unification into a nation state.

The site lies on the south part of the

island on a mountainous ridge rising steeply from the sea. The island is covered with dense forestation, but the site lies in a valley with the unique occurrence of a number of giant boulders piled up together. Under the largest of these boulders is a rock shelter, since ancient times called the *Okanagura.* Numerous offerings to the *kami* of the island were deposited there. It is said that this loom was once part of these deposits.　　MH

46　Gilt-bronze dragon head

Nara period (AD 710–794)

Munakata Taisha Okitsu-gū site, Okinoshima Island, Fukuoka Prefecture

Munakata Taisha

L. 20.0 cm

Important Cultural Property

This is a casting of the head of a dragon, its surface of bronze richly plated with gold. From the style it is believed to have been made in China. It depicts the dragon looking backwards with flowing curved lines. The eyes are wide open, and the beard swirls and flows in an expression of intense activity. Part of the beard forms a ring at one end of the object. The base of the head is hollowed for the insertion of a staff. This makes the piece a finial for the handle of a ritual parasol used to protect a king or noble, and the ring formed in the beard was for a cord used to suspend the canopy of the parasol. Such parasols were used in China and on the Korean peninsula and are depicted in the wall paintings of Dunhuang cave No. 159 in China and the Koguryō tombs in Korea. The same kinds of parasols were brought to Japan, and one is illustrated in the wall painting in the Takamatsuzuka *kofun* (tomb), showing its use by the nobility.

The relics on Okinoshima Island were deposited over many long years, but it is possible to divide the time into four distinct periods. The first was during the fourth and fifth centuries, when rituals involved using rows of rocks placed on top of a large boulder. The second was a period around the sixth century in which the rituals were conducted in caves and places shadowed by the great boulders. In the third period, in the early eighth century, rituals took place in sites somewhere between the shadow of the boulders and the open air. In the fourth period, there are open-air sites away from the large boulders. These periods correspond to the early and middle Kofun periods (third–sixth century AD), the Nara and the early Heian periods (794–1185). The scale of the sites and the content of the ritual deposits vary greatly over these four stages. The loom (cat. no. 45) was from the largest site, one in the shadow of the boulders. This piece is from the site in the open air, away from the boulders, and is one of two pieces excavated from there.

These ritual sites were scientifically investigated on a number of occasions between 1954 and 1971, when many artefacts were excavated. Several tens of thousand of objects, including pottery shards, have been retrieved, but only a fraction of the ritual sites have been excavated so far. The ritual sites on Okinoshima continue to slumber, guarded by the power of intense religious beliefs. For centuries Okinoshima has been known as the abode of Munakata Sanshin (the Three Munakata *Kami*) and is a sacred place protected by the nation. The Munakata Taisha Okitsu Miya Shrine is situated in the valley in which lies the ritual site. The whole of Okinoshima itself is regarded as the *go-shintai* (the manifestation of the *kami*) of this shrine. Even today Shintō rites require immersion in the sea for purification (*misogi*) before stepping on to the island. Although the island is uninhabited, there is always a solitary Shintō priest from Munakata Taisha Shrine who upholds the tradition.　　MH

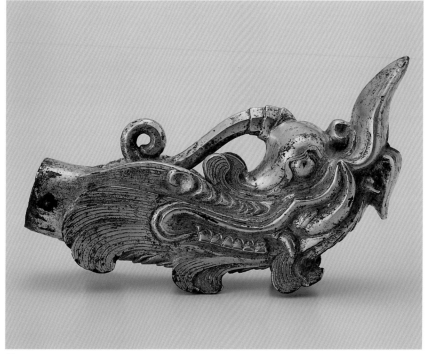

46

47

47 Miniature gilt-bronze five-stringed *koto*

Nara period (AD 710–794)

Munakata Taisha Okitsu-gū site, Okinoshima Island, Fukuoka Prefecture

Munakata Taisha

L. 34.0

Important Cultural Property

The instrument, a Japanese harp, is made from a bronze sheet turned over at the edges to form a trough with pieces fixed to it to take the strings known as *ryūkaku* (dragon horn). The whole is thought to have originally been gilded, but gilding remains only in one place. There are five holes to take the five strings, and corre-sponding to these, there are five bridges (*kotoji*) to tune the strings. The end flares out like a bird's tail in the shape of the *tobinōonokoto*, an instrument used in *kagurauta* (sacred ceremonial music). Like cat. no. 46, this example came from the site between the shadow of the boul-ders and the open air.

Music is a vital component of reli-gious ritual both in the East and in the West and over many centuries the uniquely Japanese instruments vital for Shintō ceremonies were developed. The most important of these are the *koto* and lateral flute (*yokobue*). Both the *koto*, called *yamatogoto* (from Yamato, the clas-sical word for Japan), and the lateral flute called *kagurabue* (from *kagura*, shrine ritual dramas) were constantly played during Shintō ceremonies.

Japan has the world's oldest orchestral music, *gagaku*. It is played during court rituals. *Gagaku* is divided into three types: pure ceremonial music, *kagurauta*; instrumental pieces brought from the continent of Asia around the Nara period, *tōgaku* from China and *komagaku* from Korea; and vocal pieces, *saibara* and *rōei* of the Heian period. Among the instrumental music imported from Korea, called the *sankan no gaku*, were three types: *shiragigaku*, that of Silla; *kudaragaku*, that of Paekche; and *komagaku*, that of Koguryō. These were brought to Japan during the Asuka period. *Rinyu* from Vietnam and *tenjuku* from India were brought by way of China during the Nara and Heian periods. All these were Japanized and standardized during the Heian period to create the *gagaku* music of today.

The *gagaku* orchestra is composed of three wind, two string and two percus-sion instruments. The wind instruments are the *ryūy-teki* (lateral flute), *hichiriki* (vertical flute) and *shō* (vertical tubed mouth organ). The strings are the *sō* (a kind of *koto*) and the *biwa* (a kind of lute). The percussion instruments are the *taiko* (large drum) and the *kakko* (small drum). The *sō* has thirteen strings rather than the more usual six, enabling a greater range.

This five-stringed *koto* is made in miniature as a votive offering to the *kami*, but its shape and the number of strings are close to those of the *yamatogoto*. MH

48 Double *magatama* stone (comma-shaped bead)

Kofun period (third–sixth century AD)

Tōgo-Takatsuki, Tottori Prefecture

Tottori Prefectural Museum

L. 10.5 cm

Important Cultural Property

This double *magatama* (comma-shaped bead) is of blue-tinged black talc with miniature comma shapes sculpted all over it. Such *magatama* were ritual objects in the Kofun period, found frequently in ritual sites in the central and Japan Sea side of Honshū, but they are few in number compared with ordinary *magatama*. This piece is of a complex form, rather dumpy, with two *magatama* joined side-by-side and a number of smaller ones applied over their backs. The whole is made from one piece of stone, and a close examination reveals numerous minute marks of the tools with which it was sculpted. After the smaller *magatama* were carved, the whole piece was polished to give it a lustre. The top section is pierced through with a circular hole into which a further hole opens to form a T-shape. Typically, *magatama* are used suspended vertically from the hole through the top section, but in this example the head and tail sections are equal and level, and it is thought to have been used in this alignment. It is the only extant example of a double *magatama*. It was discovered by chance in a field near Lake Tōgo in Tottori Prefecture. As few examples of double *magatama* have been excavated from among Kofun funerary

48

goods, it is believed that they were used primarily in religious rituals. It is unlikely that they were used as personal adornment, which ordinary *magatama* sometimes were.

The peculiar shape of double *magatama*, giving the impression of an imperfect moon, is thought to signify eternal life, with the smaller *magatama* representing endless prosperity for the descendants of the believers. Since there is little written record of religious faith during the Kofun period, this remains conjecture. However, just as the excavated ritual relics from Okinoshima and other sites are shown to relate to the origins of Shintō in folk beliefs, so there is a strong

possibility that the composition of the double *magatama* is linked to the concept of prosperity of descendants.

The three most sacred ritual objects in the Shintō faith are the mirror, the sword and the jewel, the latter a symbol of the *kami*'s mysterious powers. This strange and complex *magatama* could have derived from a strong desire on the part of ancient people to benefit from that mysterious power. MH

49 Clay figurines, implements and beads

Late Kofun period (sixth century AD)

Tanihata site, Tottori Prefecture

Kurayoshi City Museum

Largest figurine: L. 10.4 cm; *magatama*: L. 2.6 cm

Important Cultural Properties

The group consists of clay human figurines, animals, vessels, stone *magatama* (comma-shaped beads) and stone and clay spherical beads.

The human and animal figures are of a size that fits in the palm of the hand, made by extruding the heads, arms, and legs from the clay body of the human figures and the tails of the animals. All lack details of faces and limbs. The other objects are models of dishes and jars, models of mirrors formed of circular clay discs with a raised central boss, and model blades of agricultural sickles formed of strips of clay curved at the end. There are also disc-shaped objects decorated with point impressions and lines forming lattices which, although it may not be provable, could be models of food offerings to the *kami*.

These objects were excavated from near the entrance to a settlement where the *kami* were worshipped. From the circumstances of the excavation it is believed that these objects were used suspended from a *sakaki* tree, which was the *himorogi* (temporary abode of the *kami*) in a ritual to invite the *kami* to take up residence and safeguard the whole community. The ritual also involved purification aspects to overcome any unwitting defilement brought upon the community.

During the Kofun period Japanese religious beliefs assumed the form that has continued until the present day and is close to the Shintō philosophy of a fusion of ancestor worship and respect for nature organized into various ceremonial observances. The purification ceremony developed into the ceremonies of exorcism (*ōharai*) during the Nara period 200 years later. These clearly indicate the sense of cleanliness and purification inherent in Shintō and, with the establishment of Japan as a nation, were formally enacted at the end of June and December every year. Everyone from the emperor down, including all government officials, took part in order to eliminate the defilement that had come upon them unawares during each half-year period. These rituals developed into the *nenjū gyōji* (seasonal festivals) by which the *kami* could be approached afresh with a cleansed heart. The custom continues to this day. In shrines throughout the country, *ōharai shiki* (exorcism rituals) are held and *ōharai kotoba* (words of exorcism) are said. People blow their breath onto paper dolls, thus performing the rites of purification of their own defilement.

These objects are examples of the earliest village rites during the Kofun period, which developed into national rites. They demonstrate how the various ceremonies of the national Shintō faith grew from the beliefs of the people. MH

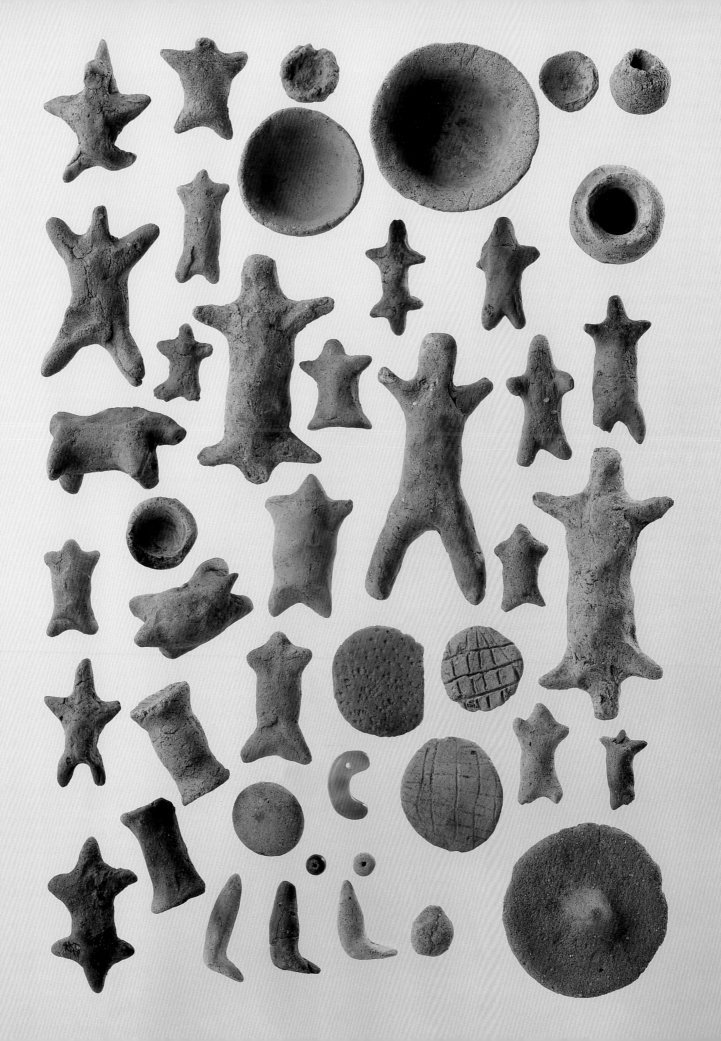

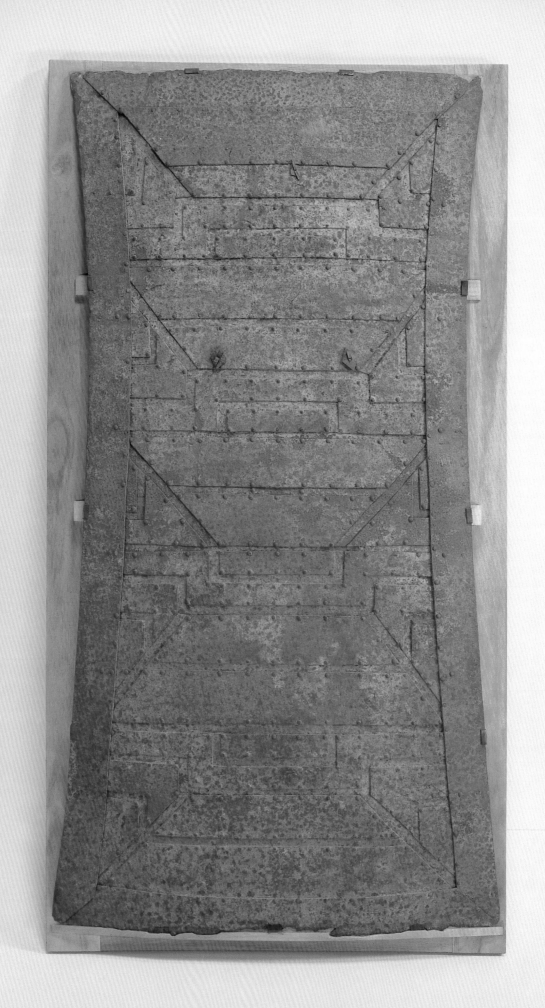

50 Iron shield

Middle Kofun period (fifth century AD)

Isonokami Jingū, Nara

L. 139.0 cm, W. 89.0 cm

Important Cultural Property

This is one of the two iron shields handed down over the ages as shrine treasure in Isonokami Jingū Shrine. It is constructed of beaten thin iron sheets joined together by iron rivets. The construction includes rectangular, triangular, and trapezoid plates. A little above the centre are two rhomboid pieces combining added strength with decoration, fitted over the rivets that were used to fix a handle on the inside. The sides curve in and the edges are defined by comparatively wider plates forming an outer rim.

The technology of making weaponry from rivetted iron plate came from China during the Middle Kofun period. This is confirmed by the method of manufacture of helmets and armour excavated from other *kofun* (tombs). The shield, then, was not for ritual but rather for practical use.

Isonokami Jingū is a shrine steeped in history and was already well established in the Kinki region of Honshū when the nation was unified under the imperial court of Yamato during the Asuka period (mid-sixth century–AD 710). The region was the centre of government of ancient Japan. A strong religion, developed from a compilation of the folk beliefs of the provinces, became closely linked with the government. In the course of time, shrines were built for the worship of the ancestral deities of the great clans, philosophy and ritual became unified, and Shintō became established. Isonokami Jingū was the ancestral shrine of the ancient Mononobe clan, custodians of weaponry for the Yamato court. Accordingly it combines a religious character with that of an armoury. Isonokami Jingū also possesses the sword called *Shichishitō*, which is a National Treasure.

This is a unique sword, with three auxiliary blades formed on the right and left of the main blade. It is thought to be the sword recorded in the ancient official record, the *Nihon Shoki*, as the Treasure Sword presented by the Koreans. The sword has an inscription of 61 characters stating that it was 'made by the king of Kudara (Paekche) for the king of Wa (Japan)' and is dated the equivalent of AD 369. The shields and the *Shichishitō* have been preserved as shrine treasures in the Isonokami Jingū since the Kofun period, unlike most objects of the period found by excavation. MH

51 Sword blade with inscription

Late Kofun period

Gumma Prefecture

Agency for Cultural Affairs

L. 64.5 cm

Important Cultural Property

This straight sword blade of a straight sword (*chokutō*) is said to have been unearthed by chance from a *kofun* (tomb) in Gumma Prefecture. Its mounting does not survive, but the blade is in good condition and has been preserved by the traditional Japanese sword-polishing method. It was made in the traditional way of forging Japanese swords by the repeated folding and beating of steel, and has a well-forged homogenous texture (*jihada*). The blade has an inscription inlaid in gold just above the tang. The inscription is unreadable due to being polished in the past, but traces of four characters can be made out.

There are no more than eight swords with inscriptions dating from the Kofun period in the whole of Japan, including this illegible one. It was not until the Nara period 200 years after this sword was made that a writing system developed, brought from China. The two oldest existing books in Japan record the mythology and history of the Yamato Court in Chinese script, taken from oral transmissions. The *Kojiki* (AD 712), compiled by Ōno Yasumaro, contains various regional mythologies in three volumes and is the first formal history of Japan. The *Nihon Shoki* (AD 720), compiled by Toneri Shinnō and Ōno Yasumaro, is in thirty volumes.

According to one theory, the first use of written characters in Japan is the inscription on a ceramic vessel of around the fourth century, but there is some doubt about this. There were inscriptions of objects of the earlier Yayoi period, such as the gold seal dated in accordance with AD 57 and inscribed *Kan no Wa no Na Koku Ō* (variously interpreted but clearly referring to the rulers or kings of Han China or Japan. There are also a number of inscriptions on bronze mirrors, but all of these had been imported from China. There is no direct proof that the Japanese had writing at that time.

As the mainland Asian culture was gradually introduced into Japan from the Middle Kofun period, there are inscriptions such as on the 'mirror with human figures' (*jinbutsu gazō kyō*). It is in Sunida Hachiman Shrine of Wakayama Prefecture and dated in accordance with AD 443. There are also the inscribed sword excavated from the Etafuna-yama Kofun in Kumamoto Prefecture and the sword excavated from the Inariyama Kofun, dated in accordance with AD 471. Written in Chinese-style writing (*kambun*), these refer to the lineage or genealogy of kings, in justification of royal authority, and provide a good idea of the nature of early Japanese writing. MH

52 Sword with ring pommel and dragons

Late Kofun period

Funazuka Kofun Tumulus, Ibaraki Prefecture

Ibaraki Prefectural Historical Museum

L. 113.0 cm, W. 11.8 cm

This is a straight-bladed sword (*chokutō*) with the ring-pommel of the grip decorated around the periphery with *suzu* (small bells) and with a pierced decoration of two pairs of opposed dragons, one small and one large. Each pair has a jewel clenched between their mouths. The iron blade is rusted and cannot be drawn from the scabbard. The pommel was made by pouring molten bronze into a mould, cutting the shapes of the dragons into the casting, and after sculpting the details. The whole was then gilded. The *suzu* have become solidified and no longer ring. The dragons are depicted flat but swelling out of proportion. The grip is decorated with fine silver strips and

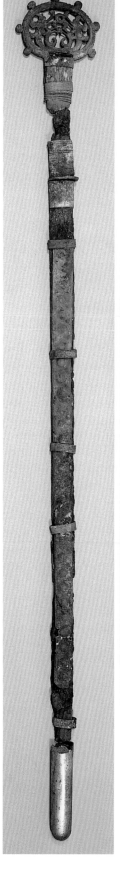

silver wire. The scabbard is of wood covered with thin gilt-bronze sheet plate decorated with embossed linked circles. The *okejiri gane* (chape) of the scabbard is a deep socket of gilded bronze.

This piece is representative of decorative swords of the Kofun period. Such swords are typical of the latter half of the Kofun period and were frequently buried with nobles. They include swords with annular pommels that are pierced and carved (*gantō tachi*) like this example, and those with pommels formed in fluted ovoids (*kabutsuchi tachi*). They have functional blades but the mountings themselves are highly decorative, denoting their use in ceremony as symbols of authority. There are very few examples decorated with *suzu* apart from this piece and the sword excavated from the Fujinoki *kofun* in Nara.

Kofun period decorative swords like this example help make the ideas about the origins of Shintō more concrete. As such swords, which were essentially practical weapons, came to be used ritually to symbolize the authority and dignity of noble families, they assumed a sacred character. The regional chieftains of the noble families came to be endowed with the same sacred nature as the *kami*, and their authority could not be challenged for religious reasons. This ancient concept of theocracy is common to the history of all nations. The concept gradually became more pronounced in Japan after the Kofun period and was the basis of the nation state established by the Yamato court in the two periods that followed. MH

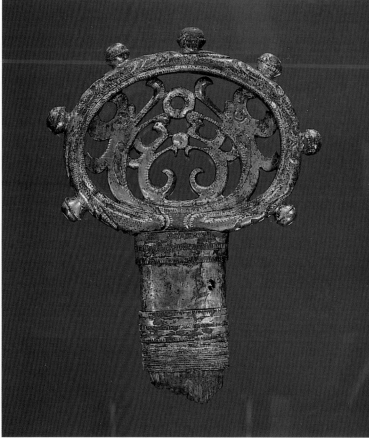

52

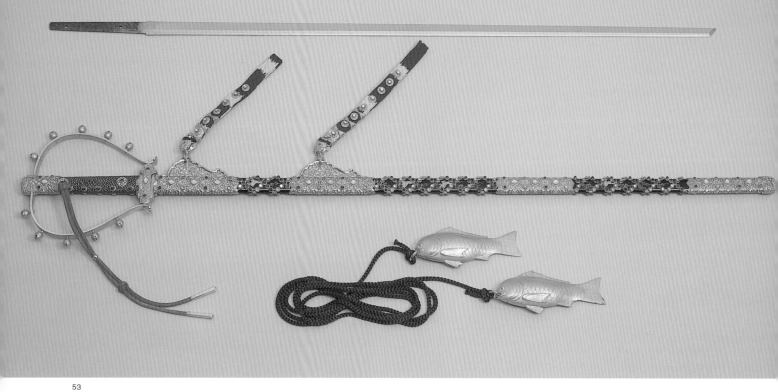

53 Gilt-bronze jewelled sword

Shōwa era (1974)

Jingū Goryō

Jingū, Mie Prefecture

L. 109.0 cm

The elegant hilt of this decorative sword has ten *suzu* (small bells) on a gilt curved *magarikane* (hilt), and a metal pommel. The scabbard has a mountain-shaped buckle, or belt-fitting (*obitorigane*), is wrapped in a metal strap (*shibarigane*) and has a decorative chape (*okejirigane*). The metal pieces of the mounting are decorated with around 450 inlaid pieces of precious stones, crystal, glass, amber, and other gems, hence the name *Tamamaki* (jewel-wrapped). The scabbard is lacquered black with a design of golden griffins and silver clouds. The straight blade is single-edged with a hard patterned edge (*suguha-zukuri*). The hilt is wrapped with ray-fish skin and banded with matt silver pieces. The cords (*tsuyuo*) suspended from the hilt are red-dyed deerskin. The gilt-bronze,

fish-shaped ornaments (*funagata*) tied to it are not directly related to the sword.

This sword was made for the twenty-year rebuilding ceremony (*shikinen sengū*) in 1974 as an offering to Amaterasu-ōmikami, deification of the sun and ancestral *kami* of the imperial household. She is feted in Kotai Jingū Shrine, at Ise shrine. It was replaced with another made exactly the same for the rebuilding ceremony in 1994, and withdrawn from the shrine. Such heavily decorated swords are not for practical use, but are made specially for ceremonial use as offerings to the *kami*. The encircling strips fitted with *suzu* and the method of decorating the hilt with silver pieces are in common with the dragon sword (cat. no. 52), so the origin of this form of decoration is seen to derive directly from ritual swords of the Kofun period (third–sixth century AD).

Jingū (Ise Jingū Shrine) is centred on the cult of two *kami*. They are Amaterasu-ōmikami in the Kōtai Jingū Shrine, which is generally known as the Naikū and Toyouke-no-ōkami in the

Toyouke Daijingū, which is generally known as Gekū. There are many subsiduary shrines devoted to the *kami* who have a close relation with the two.

Shintō is typical of polytheistic faiths in revering both nature *kami* and *kami* with a human personality. Jingū (Ise Shrine) and others of its affiliated shrines show this characteristic well . MH

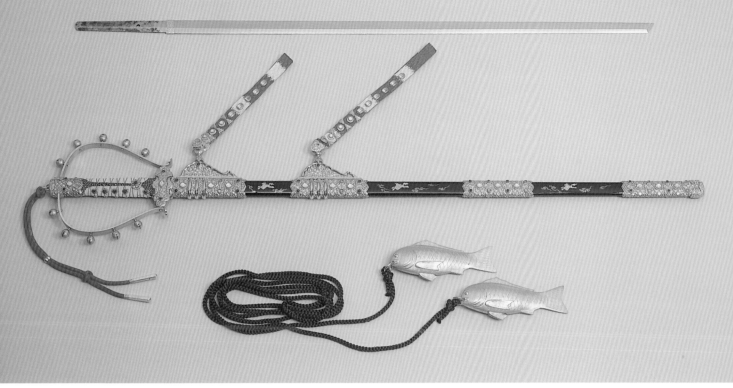

54 Gilt-bronze ornamented sword

Shōwa era (1974)

Jingū Goryō

Jingū, Mie Prefecture

L. 121.3 cm

The shape of the blade and the construction of the mounting of this sword are generally the same as cat. no. 53. However, it is not jewelled and lacks circular and oval metal pieces on the braid attached to the scabbard. The curved pieces either side of the hilt (*magarikane*) are also made the same, but according to the *Engi Daijigū Shiki*, an official record of ritual compiled in the Nara period (AD 710–794), this part of the hilt was lined with textile over leather. This shows that the sword was more for practical use than ritual. It is very close to the sword depicted on *haniwa* of the Kofun period (third–sixth century AD; see cat. nos. 42–44).

A remarkable feature of this sword are the two pale pink feathers of the Japanese crested ibis (*toki*, Nipponia nippon) attached to the hilt and held in place by a lattice of vermilion thread. The ibis is an extremely rare bird found only in China and Japan, which at the time of writing is down to one in Japan. Its beautifully coloured feathers are thought to have been used since the Nara period for the ornamentation of sacred Shintō treasures. There is no other example of this form of decoration on swords. The meaning in old Japanese of the name of this sword, *Sugari*, is 'slender and beautiful form'.

Like cat. no. 53, this sword was made in 1974 for the twenty-year rebuilding ceremony (*shikinen sengū*) and it was withdrawn from the shrine on the occasion of the succeeding event in 1994. The twenty-year rebuilding ceremony enacted at the Ise Shrine and its affiliated shrines is a ritual reflecting the most revered of Shintō concepts, that of 'regeneration'. The complete renewal of the shrine building (*honden*) and the replacement of all the appointments is designed to effect the spiritual rejuvenation of the *kami*. The ceremony has been enacted without fail since the Nara period for about 1300 years, except for a brief interlude during the civil wars of the medieval period. It is the most important ceremony held at the Ise Shrine. Every time, each of the more than 1500 shrine treasures is faithfully reproduced in the same form and by the same technology as far as possible, using the finest materials and employing the most skilled artisans. In this respect the *sengū* ceremony has the important cultural role of ensuring a continuation of the traditional crafts of ancient times.

Before the Meiji era (1868–1912) it was the rule that the replacement treasures should all be burned or buried upon their withdrawal from the shrine, so nothing earlier has survived. MH

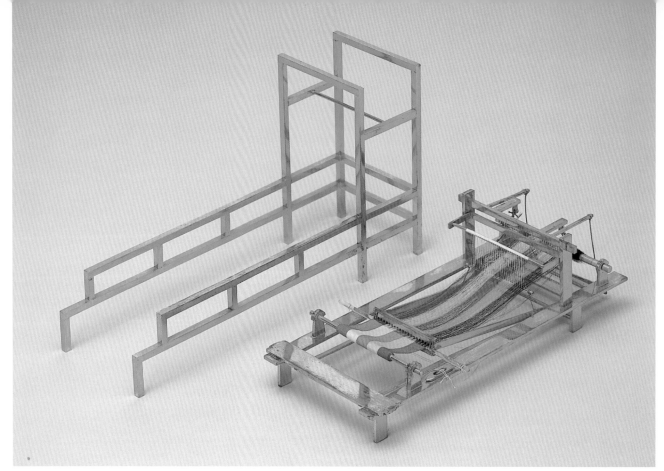

55 (lower right)

55 Miniature gilt-bronze loom

Shōwa era (1966)

Izawa-no-miya Goryō

Jingū, Mie Prefecture

L. 30.7 cm

The loom has an outer frame formed of a flat sheet to feed the silk threads, and components to ensure that the warp does not bundle and to carry the weft, all of which are made from gilt-bronze. The components are bonded to the frame with silver solder. A separate shuttle is used to pass the weft through the warp. In all, this piece is an accurate miniature of a practical weaving loom. Parts of the loom are decorated with mountain shapes. The miniature is set to weave a cloth of five vegetable-dyed colours and faithfully reproduces the actual weaving process. There is a separate stand made of slender gilt-bronze components.

The ancient form of the loom, known as *jibata* (local machine), had no legs. This example is of an improved version with legs and a seat for the operator.

Before the loom was introduced from China, weaving was done by hand mainly with vegetable fibres. The increased efficiency of the loom spurred the start of sericulture.

This example is one of the sacred treasures of Izawa-no-miya Shrine, one of the auxiliary shrines of Ise Shrine which is devoted to the ancestral *kami* of the emperor. Since the Nara period (AD 710–794) Ise Shrine has been rebuilt every twenty years, at which time all the shrine's buildings, large and small, and all the sacred treasures are replaced in a great ceremony called the *shikinen sengū*. This loom was dedicated to the *kami* of Izawa-no-miya who presides over weaving and is the servant of Toyouke-no-ōkami, the *kami* governing provisions and industry and Amaterasu-ōmikami, the ancestral *kami* of the imperial household deified as the sun. The loom was withdrawn from the shrine in 1986. The sacred treasures of Ise Shrine have an important religious significance emphasized by being faithfully reproduced

periodically in the *shikinen sengū* ceremony. The close similarity between this loom and cat. no. 45, excavated from the Munakata Taisha Okitsugū site of 1300 years before, is remarkable. MH

56 Long-necked ash-glazed bottle

Nara period (AD 710–794)

Tokyo National Museum

H. 55.0 cm, Diam. 36.5 cm

Important Cultural Property

This is a *sueki* (high-fired, wheel-turned ceramics) bottle of Japanese origin with a long neck and a foot in the form of a stand. It was excavated from the Kaniana Kofun in Toshi-chō of Toba City in Mie Prefecture. The body is a rather sandy consistency of ash-white clay, made by coiling prior to finishing on a wheel. The mouth flares widely outwards and has deep rounded edges. It has three sets of double lines incised around it at equal intervals. The shoulder of the body is

strongly ridged with a single raised line surrounding it. Below this line is an incised double row of combed sawtooth design. The whole body is precisely finished by turning it on a wheel and milling over the surface.

The technology for the manufacture of *sueki* came to Japan from the southern part of the Korean peninsula during the early Kofun period in the first half of the fifth century. These were the first ceramics made in Japan using a potter's wheel and fired in tunnel kilns situated on hillsides. The kilns could maintain high temperatures of around 1200°C to produce natural glazes from wood ash, which melted and settled on the pots. The first *sueki* were used as ceremonial objects for ritual both within a settlement and on the mounds covering the *kofun* (tombs). When eventually the *yoko-ana kofun* were introduced (stone chambers with a lateral passage for entry), such vessels came to be buried in large numbers within the chambers as funerary goods. *Sueki* of a large size with decorative components representing stands were developed for this purpose.

This *sueki* was made in the early Nara period for practical use as a liquid container, and it is among the largest of all long-necked bottles made in Japan during both the Nara and Heian periods (AD 710–1185). There is no firing deformation but there is one fine crack at the neck. The shoulder is covered with a rich, bright green, natural ash glaze. Usually a long-necked bottle of this size would be expected to suffer distortion at the top of the body because of the weight of the neck section, but there is no sign of such a defect in this piece. It would be virtually impossible to manufacture such a piece today. TS

57

57 Short-necked ash-glazed jar

Nara period (AD 710–794)

Idemitsu Museum of Art, Tokyo

H. 29.8 cm

This jar is a product of the Sanage kilns in what is today Aichi Prefecture. The Sanage region covered an area about 20 km east to west, and 20 km from north to south. About 1000 kiln sites have been identified, dating from the 850 years between the fifth and thirteenth centuries. Sanage was the ceramics centre in Japan during the Nara period, producing many miniature vessels for ritual as well as Buddhist water jars and libation vessels modelled on metal vessels. Many vessels have a natural glaze like this piece, which is made of an ash-white base material with a slight iron content. After being built up by coiling, it was finished on a wheel. The short neck section is formed vertically, and the body is gently rounded with a smoothly sloping shoulder. The base has an outwards-angled foot. The vessel has a splendid pale green ash glaze, formed by a method unique to the Sanage kilns. The natural glaze, obtained by allowing wood ash in the kiln to melt and settle on the pots, runs in streams from the mouth and over the shoulder. The jar has a lid which is also thickly ash-glazed. Many such jars were produced in the Sanage region in the latter half of the Nara period for regional government offices of Heijō, Heiankyō and elsewhere, and many others like this one were used as ossuaries. TS

58 Ash-glazed jar

Late Heian period (mid twelfth century)

Privately owned, Kanagawa Prefecture

H. 37.5 cm

Important Cultural Property

This is a product of the Tokoname kilns that continued the Sanage technology in the Chita Peninsula of Aichi Prefecture in the late twelfth century. The Tokoname kilns produced ash-glazed stoneware storage jars, bottles and mortars. Tokoname was the largest kiln group in medieval Japan, said to have consisted of more than 2000 kilns. It started with the manufacture of jars and bottles during the twelfth century and supplied medium and large storage vessels throughout the country from Kagoshima to Aomori, influencing other pottery regions such as Echizen, Shigaraki and Tamba.

This large storage jar has a relatively small base, a gentle swell in its rounded shoulder, and a splendid rich pale green natural ash glaze running thickly down the sides and accumulating in droplets at the base. The neck is short and perpendicular, with the mouth flaring strongly outwards at the top. The rim has a deep impressed line around the interior. The rest of the interior shows the marks of the coiling process by which it was made.

This is a rare example of a perfect ash-glazed jar of early period Tokoname ware. From the shape of the neck and mouth it is believed to date from around the mid twelfth century. Many jars like this were used as ossuaries and external containers for buried sutras. TS

58

59 Echizen ware jar with carrying loops

Muromachi period (second half of fifteenth century)

Fukuiken Tōgeikan

H. 42.0 cm, Diam. 37.5 cm

This is a product of the Echizen kilns of present-day Fukui Prefecture on the Japan Sea side of Honshū. The Echizen kilns were among the medieval kiln groups that adopted the technology and style of the Tokoname kilns of the twelfth century to make stoneware jars, bottles, and mortars. This jar is an impressive example of high-fired stoneware with a naturally occurring glaze rather than an applied glaze.

Rich green and blue-white natural glaze runs from the neck down to the base, flowing diagonally across the body of the jar. Streaks of the glaze turn upwards at the base to form rounded ends. This flow of natural glaze shows that, during firing, the vessel was at first leaning over at an angle in the kiln and then was turned upside down by turbulence in the kiln. Such a flow is entirely accidental, not achievable by design.

The jar has two loops at the sides of the sloping shoulder. These are unique to Echizen ware. The mouth is short and flares outwards with the sharp edge of the rim turned over and formed like a row of beads. The base is small and flat. TS

3 The First *Shinden* and the Birth of Shintō Images

In the recently published *Kodai no Jinja to Matsuri* (Ancient Shrines and Festivals, 2001), Kazuo Miyake (b. 1950) begins with the premise that the ancient imperial festivals were different from the festivals of provincial shrines. The first permanent *shinden*, buildings in which the *kami* were enshrined, were built when the government designated *kansha* (national shrines) in places where temporary structures had traditionally been erected to house visiting *kami* according to early religious beliefs.

The transformation occurred in four stages. The first stage was the primitive period before the establishment of *shinden*, comprising festivities to welcome the *kami* each year on their seasonal visitations. The facilities for these ceremonies were rudimentary, and were broken up afterwards. The second stage was around the seventh to eighth century when *shinden* were built in certain shrines, such as Ise Jingū and Isonokami Jingū, selected for their relationship with the ruling powers. The provincial governors also had *shinden* built within the national shrines. In the third stage, the early Heian period in the ninth century, the practice of ranking the *kami* according to their importance became more widespread, and the construction of *shinden* increased accordingly. At first this only applied to national shrines, but around the middle of the ninth century, the heads of the leading clans started the practice in their own shrines. More *shinden* were therefore built in the provinces. In the fourth stage, dating from the tenth century, the provincial governors were independently restructuring shrines and further *shinden* were built starting with the main shrine (*ichinomiya*) of each province.

The *kami* of Japan were believed to make annual seasonal visitations, returning to their own distant habitation after a specific period. A place was provided to welcome and entertain them. As the *kami* had not come to stay, there was no need for a permanent residence nor for an image to worship. It was sufficient to designate a forest, a mountain, or a boulder for the *kami* to occupy. The *kami* came to foretell health and prosperity, and then departed. That was the original Japanese concept. As imperial power became established, this simple belief changed and *shinden* were built as permanent residences for the *kami*. At this time, there was growing influence from Buddhism, which was brought to Japan in the sixth century. But the indigenous religion at the time had nothing like the ceremonies, images and grand temples of Buddhism.

The nature of shrines, and the construction of *shinden*, changed in accordance with these four stages, particularly with the concept of providing a permanent habitation for the *kami*. This theory is a useful tool for understanding the evolution and later development of images of the *kami*. It would be natural to expect an image to be worshipped inside a *shinden* housing the *kami*. But the object of worship need not necessarily be an image. It could be a bronze mirror, sword or jewel ('Three Sacred Treasures'), a change from worshipping something in nature like a forest, mountain, or rock to worshipping physical objects. This change did not arise from within the indigenous faith itself, but rather under the strong influence of Buddhism.

The earliest record of a *kami* image is documented in the *Tado Jingū-ji shizai-chō* (Record of the Properties of Tado Shrine-Temple). It tells

how, in the Nara period in the seventh year of the Tempyo era (AD 763), the priest Mangan Zenji built a hall at Tado Shrine (Mie Prefecture) and installed a *kami* image in it. But it is recorded with the name of a Bodhisattva, Tado Daibosatsu, so it was evidently made with a Buddhist conception.

The author of this essay believes that the process leading to *kami*-like images started with the amalgamation of Shintō and Buddhism, and then continued with the removal of the Buddhist component as follows. At first, with no preconceived idea of an image of the *kami*, the early worshippers must have looked for the *kami* nature in Buddhist images. For example, the Buddhist image in the shrine-temple (*jingū-ji*) of Ise Shrine was seen as Ise Ōgami, and the eleven-headed Kannon (now in the Shōrin-ji Temple collection) which was the main image of the shrine-temple for Ōmiwa shrine was the Buddhist manifestation of Mt Miwa, the *shintai* (object) of the shrine, in which the spirit of the *kami* resides. This was a significant phenomenon of the Nara period (710–794). But the following major change occurred between the late Nara and early Heian (794–1185) periods. Composite images not found in the Buddhist scriptures, such as a combination of Nyorai and Bodhisattva, or the combination of Nyorai and *Ten* (heavenly beings), were seen as *kami*. For example, the figure of Yakushi Bosatsu (formerly the property of Hozono shrine-temple) is a Bodhisattva form of the Buddha Yakushi in Jonen-ji Temple, Kyoto-Fu. The main image of Kōryū-ji Temple in Kyoto, the Kichijo Yakushi (above left), is a combination of a Heavenly Being and Yakushi Nyorai. Although it is not known what the Tado Bosatsu looked like, it was probably an example of this second kind.

Then in the ninth century, in the early Heian period, true *kami* images, what might be called 'kami-like *kami* images', evolved. A sculpture of the *kami* Hachiman-shin is a positive example of this type. The practice started when devotees of Usa Hachiman-shin, a provincial *kami* from Kyūshū, went to Nara to assist in the manufacture of the great Buddha of Todai-ji Temple, and the Chinju Hachiman Shrine was built at Todai-ji. It is not known whether an image was worshipped there at first. But when the capital was moved to Kyoto, Hachiman-shin Shrine was established in Tō-ji Temple there as a *chinju-sha* (protective shrine). The Hachiman triad which formed the *shintai* of the shrine still exists. There are conflicting theories as to whether it can be attributed to the date when Tō-ji Temple was established, but it does belong to the ninth century, and there is no doubt that it is among the oldest extant examples. The Inō shrine male *kami* figure in the exhibition (cat. no. 60) is also from this period. The *kami* images of this period were influenced by Buddhist images, as has been explained. They are generally of similar proportions. There are some small figures, but most were life-sized.

In the tenth century, smaller figures became the fashion. Many are seated figures of squat form with the knees splayed. It can be said that in this period *kami* images reverted to the original concept of 'object' as the *yorishiro* (temporary abode of the *kami*), in the way that originally boulders or old pines were worshipped as an 'object', being the *yorishiro* of the *kami*. There are some rare, well-proportioned, life-sized figures during this period, but in general the style continued without change until recent times.

If this transformation is compared with the building of *shinden* in shrines, and despite a certain time lag, there is a correlation between Miyake's stages two and three for the construction of *shinden* in national and regional shrines and the first *kami* images (the author's *kami*-like *kami* images). Stage four, during which shrines were being restructured in the tenth century, also relates to the rather simplified forms of images which signified a return to the original *kami* concept.

In this way, the application of Miyake's theory makes clear that there is a close relationship between the birth and development of *kami* images and the evolution and development of *shinden*.

SI

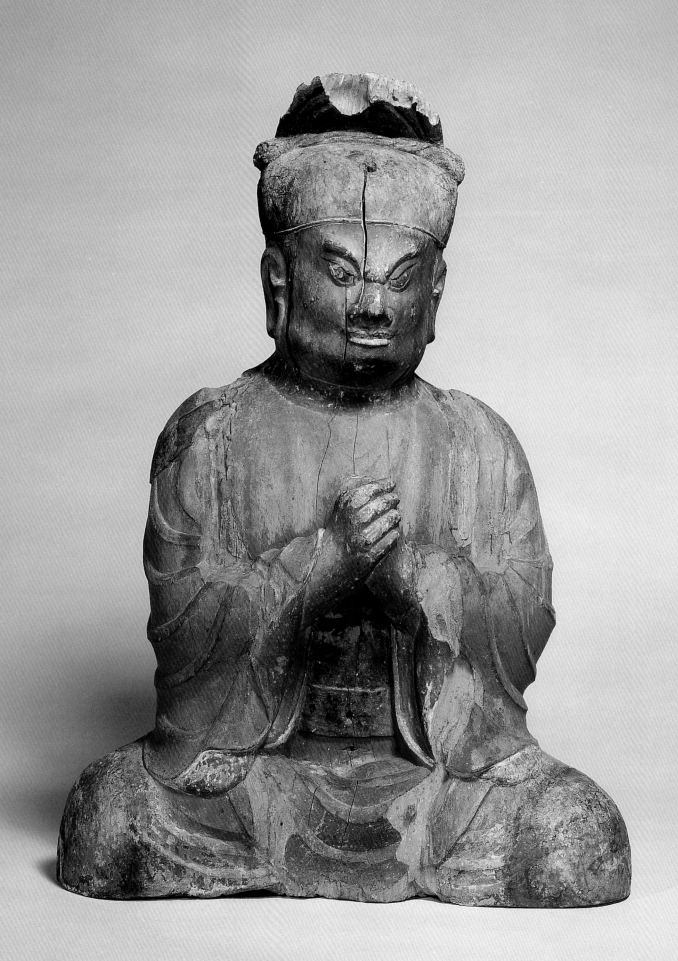

60 Seated male *kami*

Heian period (794–1185)

Inō Jinja, Mie Prefecture

Wood with pigment

H. 52.7 cm

Important Cultural Property

The first sculptural representations of *kami* in Japan date from the Nara period (710–794). An account in *Tado Jingū-ji garan engi shizai chō* (Historical Record of the Tado Shrine-Temple, compiled in the year 801) relates the following events that occurred about thirty-eight years earlier. The *kami* Tado, local deity of Ise Province (the eastern part of present-day Mie Prefecture), frequently gave prophecies to the monk Mangan, who lived in a religious settlement he had built on land to the east of the shrine. The deity stated that, because he had long indulged in deeply sinful practices, he had received the 'punishment of the way of the *kami*' (*shintō no mukui*). He wished to separate himself from his *kami* form and to follow the way of the Three Jewels (the *sambō*, the three Buddhist jewels of the Buddha, the Law and the Priesthood). In the southern part of the mountain where the

kami resided, a small hall and a statue of the deity were constructed. This is the earliest known example of a statue of a *kami*. As Mangan is known to have journeyed around the country promoting the amalgamation of Shintō and Buddhism, it is thought that this very amalgamation fostered *kami* sculpture.

This statue from Inō Shrine is made from a single piece of camphor wood (*kusu*), decorated with pigment. It was formerly the object of veneration in the main worship hall (*shinden*) but is now preserved at a separate location. The powerful, angry expression, with large, prominent eyes and nose; the ample, tensile rendition of all the areas of flesh; the deep carving of the drapery lines that leaves raised ridges – all these characteristics are also found in Buddhist sculpture of the ninth century. This indicates that the statue could have been made at that same period, making it one of the oldest surviving statues of a *kami*. Other factors are also characteristic of the early Heian period. These include the addition of a thin piece of wood to each knee to supplement the single block from which the main part of the statue is carved,

areas of modelling in dry lacquer and decoration of the drapery lines with cut gold-leaf.

The *kami* Inō is the local deity of the Inō area, and was awarded court rank in the year 865. The custom of awarding court rank to the various deities throughout the country became widespread from the eighth century onwards. It can be seen as an attempt to humanize the deities by incorporating them into the system of ranks that was part of the *ritsuryō* state system, established in the mid seventh century. Similarly, the way in which the *kami* has been sculpted in human form, wearing the costume of an official holding a *shaku* (a long, oblong, thin board used on ceremonial occasions), shows the same attempt to render visible and physical a divine being which essentially cannot be seen and has no form. This makes a date of around the year 865 reasonable for the figure. The angry expression, with sharply angled eyes and eyebrows, reflects its character as the proprietary deity of the locality (*jinushi no kami*), who might on occasion bring the misfortune of a poor harvest to the local population. OT

61 Seated female *kami*

Heian period (794–1185)

Matsuo Taisha, Kyoto

Wood with pigment

H. 53.9 cm

This statue of a *kami* in the form of a young woman dates from the Heian period and is in fine condition. The hair has been gathered into several strands that are combed up at the front and then fall down to about shoulder length at the back. At the top of the head the strands are tied into two topknots. A single outer robe goes from the upper body down to the legs and another robe is worn inside. The red colouring of the inner robe, visible at the neck, is the same as the large sleeves and legs, so it is thought to extend from the upper body to the legs as well. The collar decoration of the outer robe, also occurring on the robes of Buddhist sculptures of heavenly beings such as Kichijō-ten, is not found in statues of female *kami* before the ninth century.

The body and head of the statue are constructed from a single piece of camphor wood (*kusu*). Another piece of wood has been joined to this for both legs. The topknots (later additions) and the hands are made from small pieces of wood also joined on to the main piece. Black lacquer was applied all over the surface, onto which a ground of white and then coloured pigments were added. This technique is generally used in Buddhist sculpture, making this statue of a *kami* rather unusual. The decoration of the robe consists of a lattice of cut gold-leaf lines over which are painted a pattern of scattered flowers and the like.

Certain stylistic features, such as the longish face, the gentle, refined expression and the shallow carving of the drapery lines, are characteristic of Buddhist sculpture of the second half of the twelfth century. There is none of the rough simplicity of Shintō sculpture of the late Heian period. The carving of the robes and the treatment of the body is realistic and almost identical to the style of Buddhist sculpture of that period, so it is likely that this statue is the work of a Buddhist sculptor.

The statue was originally for the Taishi Hall (*taishi-den*) of Tsukiyomi Jinja, a shrine affiliated to Matsuo Taisha. Tsukiyomi Jinja adjoins Matsuo Taisha and is said to date back to the Nara period (710–794). The shrine moved to its present location in about the ninth century, but there is no history of the statue from that time nor from the Edo period (1615–1868), so the name of the deity is not known. However, the fact that the statue was elaborately carved and probably created by a Buddhist sculptor of the Heian period suggests that it was intended to be an important deity of the shrine.

There is an inscription written in ink on the base of the statue saying that repairs were made in 1741, including repainting. The areas of flesh colour and certain crude areas of colouring may have been part of the repainting. YK

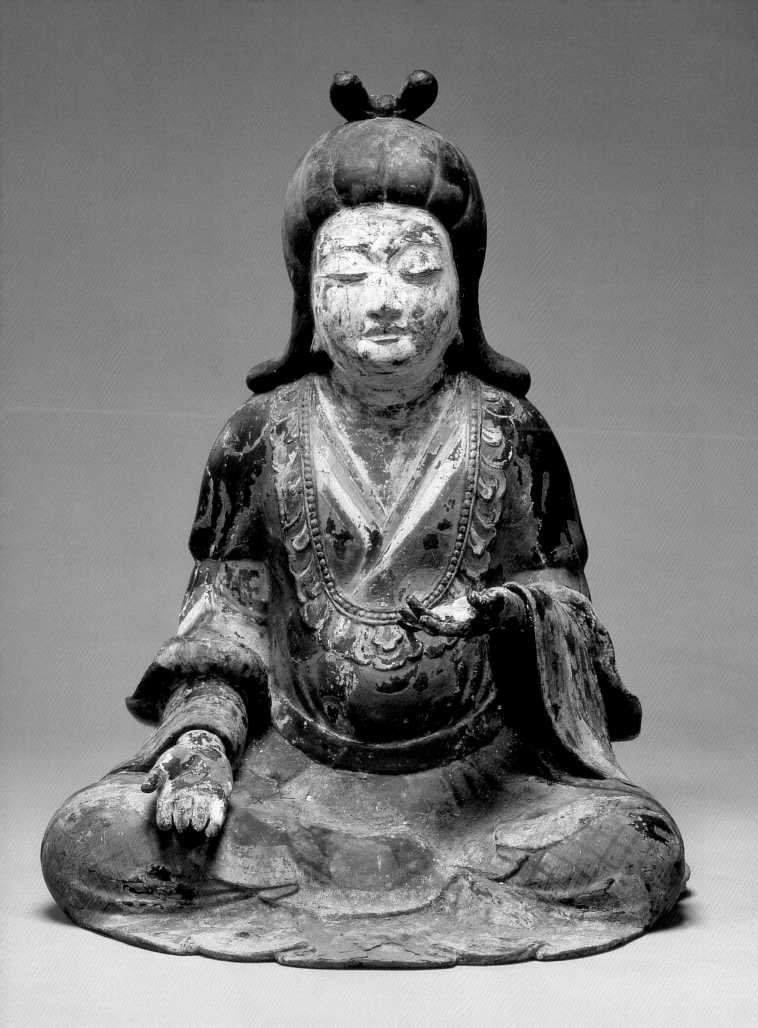

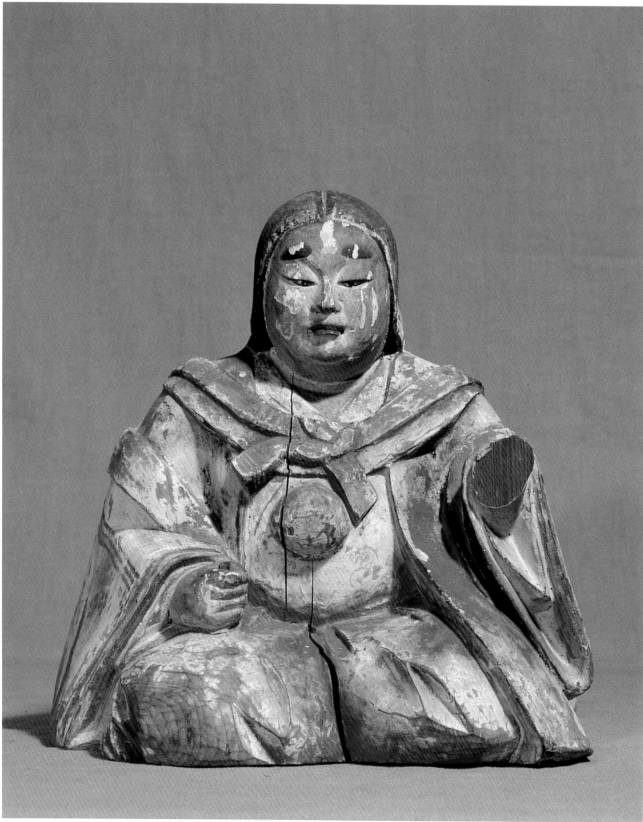

62a

62 Five small sculptures of *kami*

Kamakura period (1185–1333)

Seto Jinja, Kanagawa Prefecture

Wood with pigment

a Seated female *kami*, H.19.5 cm

b Seated *kami* Ōyamazumi-no-mikoto, H. 19.1 cm

c Seated female *kami*, H. 14.8 cm

d Seated male *kami*, H. 23.0 cm

e Seated male *kami*, H. 23.4 cm

Seto Jinja is situated at Seto in Kanazawa Ward, Yokohama City. According to shrine tradition, it was founded on the order of Minamoto no Yoritomo, the first shōgun in 1180 and attracted many believers as the protective shrine of Mutsu-ura, which served as the outer port for Kamakura in the medieval period.

Each statue is only about 20 cm high, but their superb execution belies this small size. Until recent years, the sculptures had been kept unseen in the shrine, and so they are in good condition, preserving much of their original painted decoration. Apart from the principal deity, Ōyamazumi-no-mikoto (62b), the names of the other deities are not known, but it does seem that they constituted a group.

All of the statues share the same plump face, somewhat puffed up at the bottom, making it fairly likely that all were made by the same sculptor. The carving of the drapery has a certain stiffness to it, but the facial expressions convey a sense of realism. The relatively free poses and the tinges of realism suggest a date as early as the Kamakura period. Only the male *kami* (62d), who originally held an object (now missing) in his raised left hand, may be later in date. It should be mentioned that experts in historical dress contest the dating of the two female *kami* who are seated with both their legs bent to the same side. They say that the manner in which a knot has been tied over their chests is more customary in the Namboku-chō period (1333–92).

All of the statues have angry expressions with the outside corners of the eyes raised upwards. It is common for male

62b

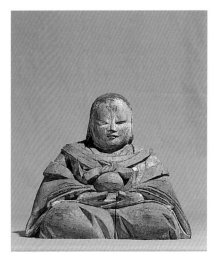

62c

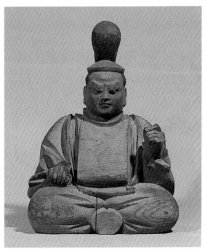

62d

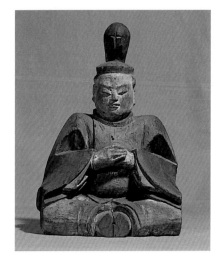

62e

kami to have this ferocious look, but unusual for female deities. There are other unusual characteristics in these examples. One of the female *kami* (62c) seems to have her hands held together in a ritual gesture (*mudra*), like a Buddhist statue. The female *kami* (62a), not only has the contested costume but also wears a half-spherical decoration of a type used by women on pilgrimages as protection of their purity, in order for them to be able to serve the deities. KY

63 Seated *kami* Daishōgun (Great General)

Heian period (795–1185)

Daishōgun Hachi Jinja, Kyoto

Wood with pigment

H. 100.2 cm

Important Cultural Property

According to the principles of ancient Chinese yin-yang beliefs (*yō-dō*), the *kami* Daishōgun (Great General) was the personification of the star Venus (*taihaku-sei*, or *kinsei*), the West Star. His role was to move to and live in each of the four points of the compass every three years, completing one circuit in twelve years. There were many taboos against performing activities towards the particular direction in which the Daishōgun was currently residing. From ancient times to the medieval period he therefore exerted great influence over many aspects of the lives of a broad spectrum of people of various classes, as the *kami* of 'warding-off directions' (*kata-yoke*) and 'warding-off disease' (*yaku-yoke*).

According to *Shūgai-shō*, a dictionary of the thirteenth or fourteenth century, there were three shrines in the vicinity of Kyoto at which the *kami* Daishōgun was worshipped. These were the Upper, Middle and Lower Shrines (alternatively, North, Middle and South Shrines). Two of these no longer exist, but the statue of the *kami* exhibited here comes from the single remaining shrine, which corresponds to the former Upper Shrine. It is located at what was the northwest corner of the imperial palace in Heian-Kyō (ancient Kyoto). Based on this fact, it can be said that the site for the so-called Road Banquet Festival (*dōkyō-sai*), originally held at the four corners of the imperial palace, became the location of the permanent shrine. The Road Banquet Festival was an ancient court festival

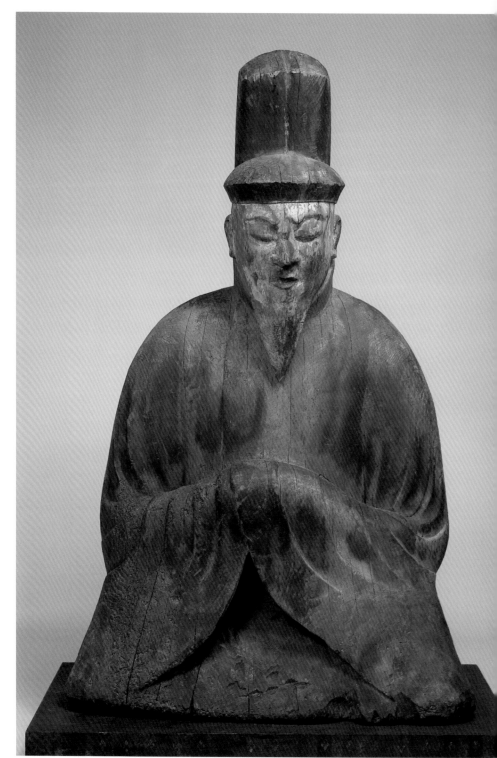

63

which consisted of holding banquets on the roads that entered the four corners of the capital, so that the *kami* of sickness would not enter the city.

There are a total of seventy-nine statues of *kami* in the shrine, including one identified recently. These are as follows: fifty statues wearing helmets and armour and with fierce, angry expressions; twenty-eight statues in formal court dress (*sokutai*), similar to the present example; who originally held *shaku* (ceremonial sceptres), all now missing, and one statue of a boy (cat. no. 64). Apart from eight standing figures (seven dressed as warriors, one as a courtier), all of the rest are seated. The majority are life-size.

Although there is some variation in the quality of their execution, in general they are done in a style characteristic of the late Heian period. It has been convincingly argued that all of the warrior and courtier figures depict a single deity, that is to say, the *kami* Daishōgun.

One possible explanation for the survival of such a large number of statues could be that they were donated to the shrine by people who had violated the directional taboo of Daishōgun and subsequently carried out rites in propitiation. Hoping to continue to ward off disaster over a long period, they donated more and more statues that have accumulated at the shrine. Against this idea, however, it should be pointed out that the statues do not show any noticeable difference in date. Comparing the example of the statues from Ogura Jinja (see commentary to cat. no. 64), the possibility should also be considered that the statues were intended as a group, all made at one time. TO

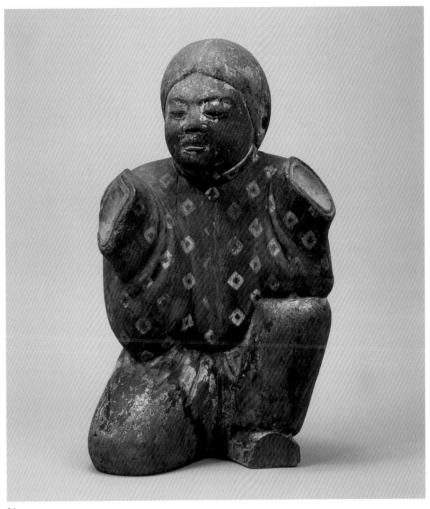

64

64 Young male attendant *kami*

Heian period (794–1185)

Daishōgun Hachi Jinja, Kyoto

Wood with pigment

H. 50.0 cm

Important Cultural Property

Like cat. no. 63, this is one of the seventy-nine statues of the *kami* that are preserved at Daishōgun Hachi Jinja. This is the only one of the group taking the form of a boy. His hair is fastened at the back and his face is tilted slightly upwards towards his right. He sits with his left knee raised. This pose suggests that he was an attendant, designed to be placed at the side of a main deity rather than as a single statue for veneration. The relatively broad treatment of the carving of the face is also found in the rest of the group of seventy-nine statues.

It was long thought that these were the only surviving statutes of the *kami* Daishōgun. In recent years, however, another group of nineteen statues has been discovered at Ogura Jinja in the southernmost part of Kyoto Prefecture. These are all small in size, less than 20 cm high, and date from the late Heian period. The contents of this second group are: seven figures dressed as warriors; eleven figures in formal court dress (*sokutai*); and one statue of a male figure with his hair tied at the back like the present example and in a pose with one knee raised. It is probable therefore that the content of the two groups of statues was the same. TO

65 Seated Hachiman-shin, Okinagatarashi-hime, Hime-gami

Kamakura period (1185–1333), dated 1326

Akana Hachiman-gū, Shimane Prefecture

Wood with pigment

a Hime-gami, H. 45.2 cm

b Okinagatarashi-hime, H. 44.4 cm

c Hachiman-shin, H. 72.3 cm

Important Cultural Properties

This is a Hachiman *kami* triad, with Hachiman-shin as the central deity, flanked by Okinagatarashi-hime and Hime-gami as attendants. This iconography of combining *kami* of three localities into a single set was already a practice in early Heian period (794–1185) Hachiman triads at Tō-ji and Yakushi-ji. In the Heian period, Hachiman-shin statues take the form of monks. Here, however, the sculpture has a secular appearance, the result perhaps of superimposing onto Hachiman-shin the form of Emperor Ōjin (r. AD 270–310), ancestor of the imperial line. Formal court costume (*sokutai*) in native style became the common dress for statues of male *kami* from the Kamakura period onwards.

Hachiman-shin (cat. no. 65c) is dressed in the formal court hat (*koji-kan*) with its characteristic tall protrusion at the back, and formal court outer-robe (*hō*). He holds a ceremonial sceptre (*shaku*) with hands held together in front of his stomach. Okinagatarashi-hime (cat. no. 65b) has her hair in a single topknot with the ends hanging down at the back. She is seated with the sash of her robe tied rather high on her chest. Hime-gami (cat. no. 65a) basically has a similar appearance, except that she has scarves in her hair that hang down in the front and back of the topknot and she wears an outer-robe with short sleeves (*haishi*).

As to their construction, all three statues were made using the joined-wood (*yose-gi*) method, Hachiman-shin in Japanese nutmeg (*kaya*) and the two female *kami* in white cedar (*hinoki*). All three statues have carved eyes. Hachiman-shin has two pieces of wood joined together, front and back, with the join behind the ears, and was hollowed out inside. Separate pieces were then added to the sides of the body beyond the width of

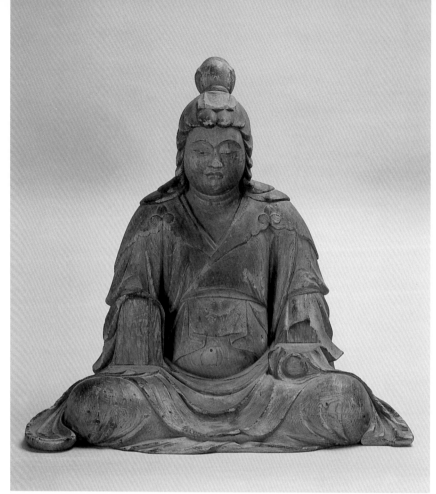

65a

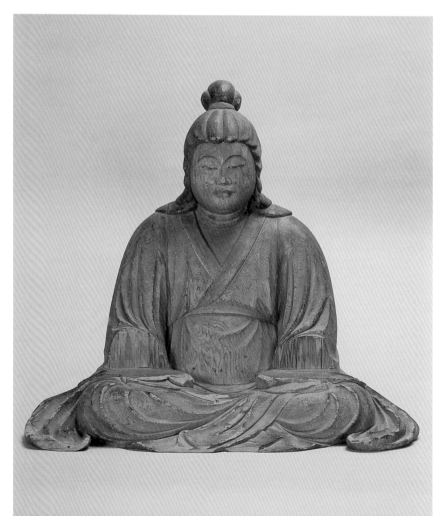

65b ▶

65c ▶

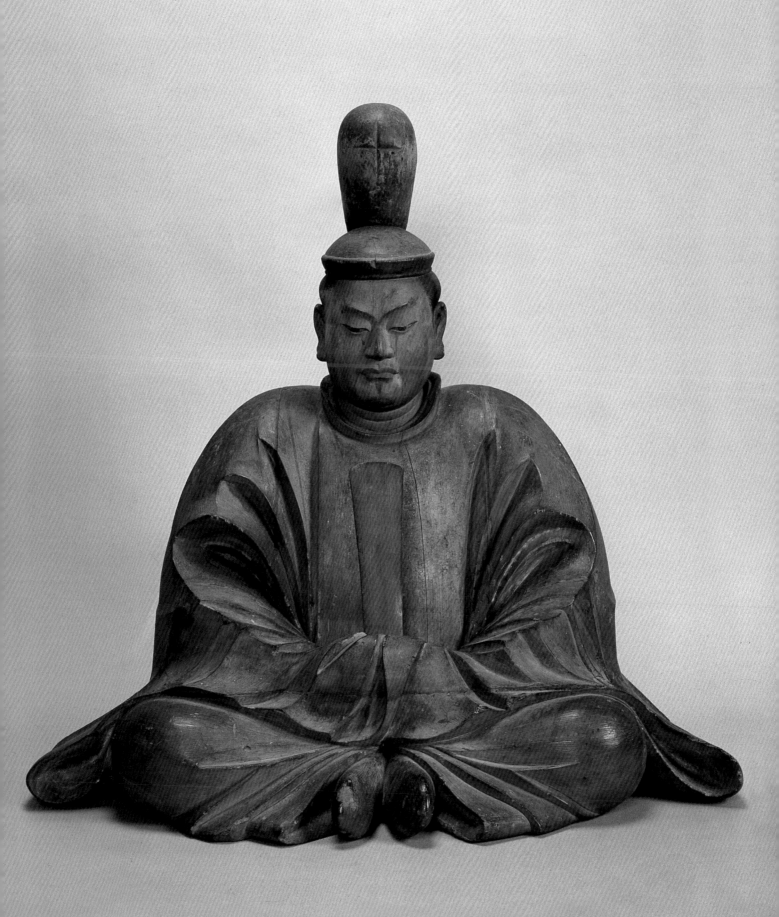

the shoulders, to each of the sleeves and to each of the legs. Okinagatarashi-hime and Hime-gami are similar to Hachiman-shin in construction except that a single piece was added for both their legs in each case. Most of the surface pigment has flaked away to reveal the bare wood. However, black colour remains on the cap, the hair, the eyebrows and the eyes, and vermilion red pigment on the lips.

The Hachiman-shin statue maintains a certain solemnity for all its approachability: the eyes and eyebrows are raised at the outer edges in a dignified manner, the small nose is appropriately proud in character and the fairly full lips are drawn into a single horizontal line. In contrast to the carving of the face, which is realistic and sensitive, the body is characterized by an abbreviated structure of drapery lines and the carving is deep and strong. The expressions of the female *kami* are also clear, but the carving of their bodies is finer in comparison to Hachiman-shin and their robes are depicted without any sense of exaggeration. The triad is arranged in a good balance, with the male *kami* larger and the female *kami* smaller, but this configuration is unusual for sculptures of *kami* and seems rather to have emulated the style of Buddhist statues.

One of two wooden tags placed inside the statue of Hachiman-shin reveals that all three of these statues were made by the Great Buddhist Sculptor (*dai-busshi*) Kyōkaku of Yamashiro Province, and were erected on the twelfth day, eighth month, first year of the Karyaku era (1326). This is one of the most precious examples of *kami* statues to have survived from the late Kamakura period. KY

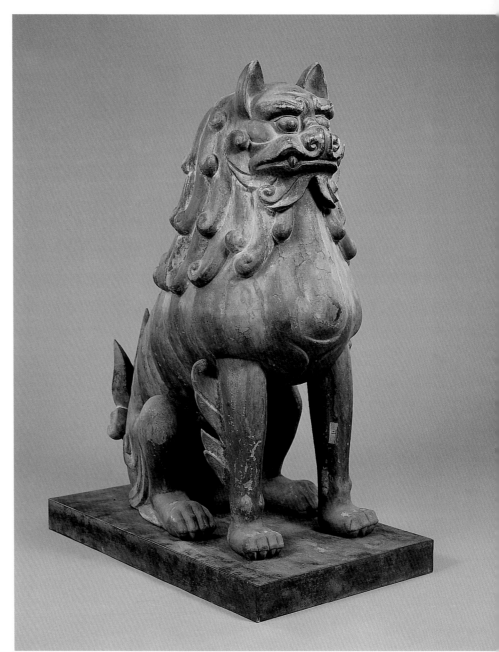

66a

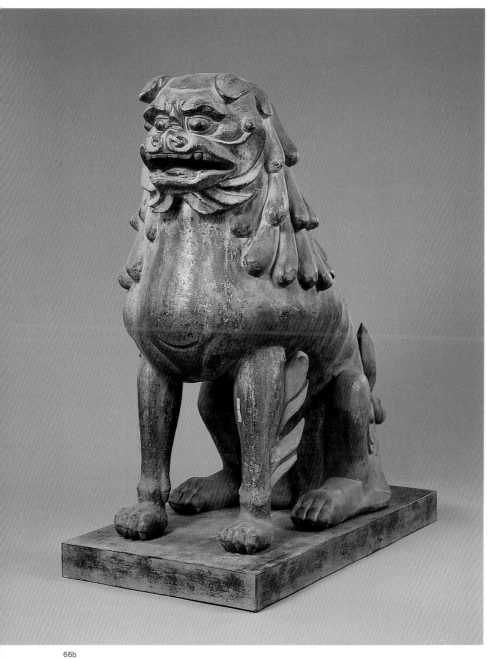

66b

66 Lion dog (*koma-inu*) and Chinese lion (*shishi*)

Heian period (794–1185)

Kibitsu Jinja, Hiroshima Prefecture

Wood with lacquer and metal-leaf

a Lion dog, H. 83.0 cm

b Chinese lion, H. 78.6 cm

Important Cultural Properties

closed mouth and a single horn on the right. Such sliding door paintings originally dated from the ninth century and may have set the style for later pairs of a Chinese lion and lion dog. The practice continued to be popular throughout the rest of the Heian and subsequent Kamakura period. It seems likely that statues of a Chinese lion and lion dog were used in the imperial palaces, as weights to stop blinds and curtains from billowing in the Shishin-den and Seiryō-den halls.

Both beasts crouch with their front legs aligned together. They face more or less to the front, though the Chinese lion (cat. no. 66b) turns its head slightly to the left and the lion dog (cat. no. 66a) looks slightly upwards.

The construction is of white cedar in the joined wood (*yose-gi*) method. Three pieces of wood are joined together arranged from front to back, and the inside is not carved out. The eyes are carved. The surface is covered with lacquer and metal-leaf. Both of the tails are later additions but otherwise there are very few repairs and the statues are in good condition.

The small heads and the poses represent an earlier style of the Heian period. However, the manner in which the faces have become more pointed and the ends of the manes more rounded is getting closer to the style of the subsequent Kamakura period.

The precincts of the present Kibitsu Jinja Shrine have shrunk from what was originally a much wider area with many buildings. Even though it is not mentioned in the register of *kami* names, the *Engi-shiki* (early tenth century), it has long been known as the Main Shrine (*ichinoimiya*) of Bingo Province and, according to shrine tradition, is said to have been founded in the early ninth century. However, the earliest definite mention of Kibitsu Jinja in historical records dates from the late Heian period. By about the twelfth century, the shrine was fully established and flourished as the Main Shrine of Bingo Province. It is likely that the present statues were made at about that time. KY

A pair of sculptures of beasts are frequently placed on the verandah of shrine buildings or in the garden at the front, intended to protect the shrine. In the past, both were referred to as lion dogs (*koma-inu*). In the Heian period, however, it is clear that the two beasts were not the same. A pair were painted on sliding doors within the Shishi-den Hall of the imperial palace: a Chinese lion with open mouth on the left, and a lion dog with

67 Lion dog (*koma-inu*) and Chinese lion (*shishi*)

Heian period (794–1185)

Shirayama Hime Jinja, Ishikawa Prefecture

Wood with lacquer and pigment

a Lion dog, H. 85.9 cm

b Chinese lion, H. 86.0 cm

Important Cultural Properties

This pair of a Chinese lion and a lion dog were placed in the outer hall (*gaijin*) of the Main Shrine at Shirayama Hime Jinja. With a height of more than 80 cm, they are among the largest of their kind in Japan. Moreover, they are among the very few examples that date back to the Heian period.

Shirayama Hime Jinja is the original shrine of the nationwide Shirayama Shrine network and was called Shirayama Hongū (Shirayama Main Shrine). Mt Shirayama (now known as Mt Hakusan) was worshipped as a sacred site by *Shugendō* mountain-climbing sects and horse stations were established at the entrance to each of the pilgrimage routes in Kaga, Echizen and Minō Provinces. Shirayama Hongū became the hub of the Kaga horse station and flourished from the Heian period onwards.

The Chinese lion (cat. no. 67b) crouches with its mouth open and head turned slightly to the right. It originally had ears

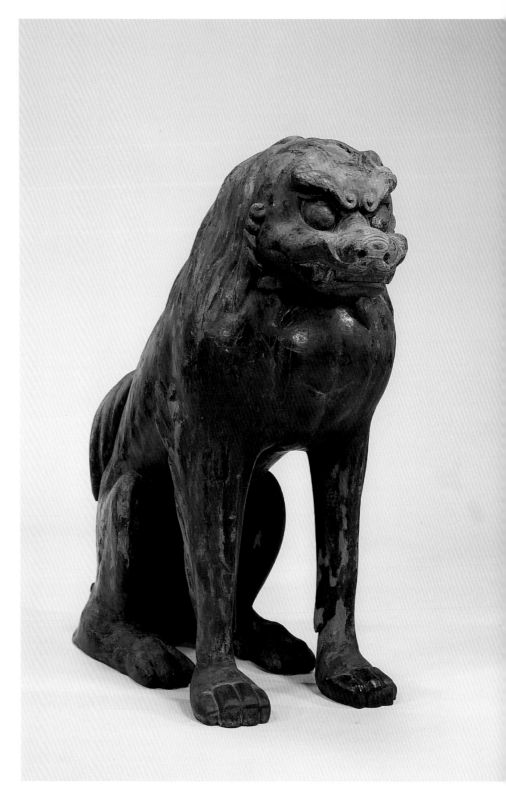

67a

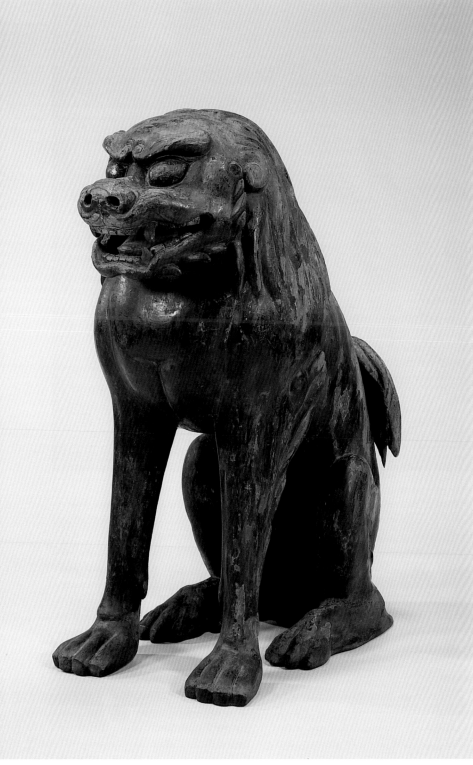

67b

but both are now missing. The lion dog (cat. no. 67a) crouches with its mouth firmly shut and frowns so that its forehead forms a ginkgo-leaf shape where the eyebrows meet. A mark on the top of the head shows that it originally had a single horn.

The Chinese lion is made of white cedar (*hinoki*) and was constructed using the joined-wood (*yosegi*) method. It is formed of three components joined front-to-back. The body consists of two hollowed pieces joined along the middle. The rear, including the two hind legs, is a separate component. The front is formed from two pieces joined above and below the mouth. In the case of the lion dog, the body is not hollowed and the front is one piece with the nose separate. Otherwise, the construction is the same as the Chinese lion. Originally the statues were coloured, but all of the surface pigment has flaked away and the raw wood beneath the layer of lacquer has been revealed.

The eyes and noses are large and the heads are somewhat large in comparison to the bodies. The angry expressions are fairly realistic. In contrast, the body and legs are exaggeratedly thin. The calmness of their expressions suggests that they date from the twelfth century. KY

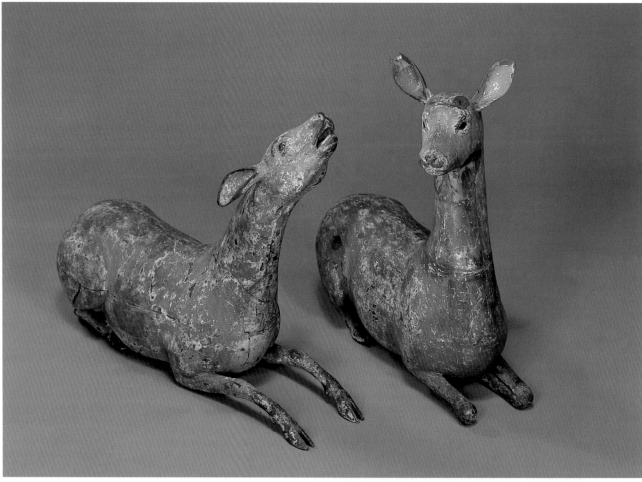

Left 68a, right 68b

68 Sacred deer

Kamakura period (1185–1333)

Kōzan-ji, Kyoto

Wood with pigment

a Female deer: H. 46.5 cm

b Male deer: H. 46.0 cm

Important Cultural Properties

The temple of Kōzan-ji in Kyoto was granted in the year 1206 to the monk Myōe (1173–1232) by Retired Emperor Gotoba, to promote the success of the Kegon Sect of Buddhism. Myōe was successful in bringing about a revival and the temple subsequently attracted many adherents. This pair of statues of male and female deer was enshrined until the Edo period (1615–1868) in the sub-temple Sekisui-in at Kōzan-ji. Sekisui-in was originally Myōe's own hermitage. This building was swept away in the flood of 1228 and the name Sekisui-in was transferred to the nearby Tōkyōzō (East Sutra Storehouse). There were four

protective shrines (*chinju no yashiro*) at Kōzan-ji associated with the deities Dai Byakkō-shin, Kasuga Daimyōjin, Zemmyō-shin and Sumiyoshi Myōjin. It became the custom at Sekisui-in for paintings of Kasuga Myōjin and Sumiyoshi Myōjin to be worshipped, and it is known that these two statues of deer were placed in front of their painted images. This is thought to reflect Myōe's special personal worship of Kasuga Myōjin.

Both statues were constructed from white cedar (*hinoki*) using the joined-wood (*yose-gi*) method. The body of the male deer (68b) consists of top and bottom pieces joined together and the head and neck both have front and back pieces joined together. The inside was hollowed out and crystal eyes inserted. The four legs were joined on separately. The body of the female deer (68a), too, has top and bottom pieces joined together, the neck has left and right

pieces, and the head top and bottom pieces. The inside was hollowed out and crystal eyes inserted.

The male deer kneels with its neck stretched upright and ears raised, looking as if it is staring off into the distance. The female deer has a somewhat plumper body, its forelegs are out-stretched and it cries off into the distance. In Japan deer are normally shown standing in a static pose, as in the case of sacred deer sculptures and deer mandala paintings. Here, however, these deer are lifelike, having been freely sculpted without any limitations imposed by religious concerns. The Buddhist statues at Kōzan-ji were the work of the leading Kei school of specialist Buddhist sculptors. The calm, relaxed sculpting style of the present pieces – like the statues of lion dogs (*koma-inu*) and the deities Zemmyō-shin and Byakkō-shin also preserved at the same temple – suggest sculptors work-

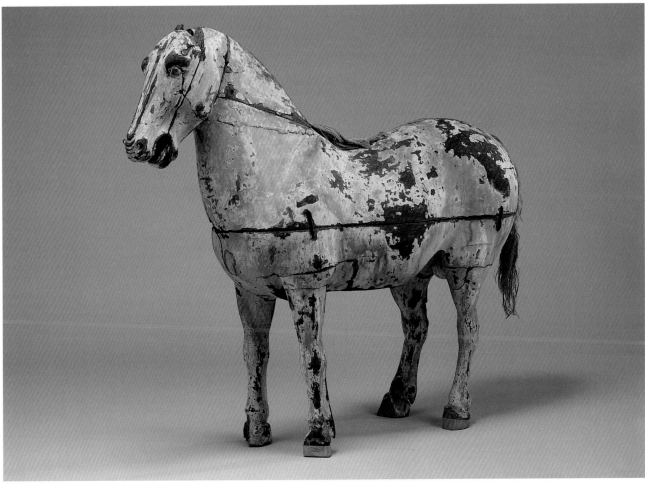

69

ing in the circle of Tankei (1173–1256) in the first half of the thirteenth century. Like the famous painted handscrolls *Frolicking Animals* (*Chōjū giga*) also preserved at Kōzan-ji, these sculptures of deer suggest that Myōe had a very special spiritual interest in animals. They occupy a unique place in the history of animal sculpture in Japan. YK

69 Horse

Kamakura period (1185–1333)

Kōzan-ji, Kyoto

Wood with pigment

H. 75.1 cm

Important Cultural Property

This statue of a horse has been preserved at Kōzan-ji Temple, together with the pair of deer (cat. no. 68). Like the deer, it was placed before the shrine to the deities Kasuga Myōjin and Sumiyoshi Myōjin in the Sekisui-in sub-temple.

The statue was constructed of white cedar (*hinoki*) using the joined wood (*yose-gi*) method and has carved eyes. The body consists of an upper and lower piece joined together, the head has a front and back piece, and the neck a left and right piece. Onto this were joined separate ears (now missing), a section under the belly (now missing) and the four legs. The inside of the statue was hollowed out.

The exact purpose of the statue is not clear. However, horses are mentioned no less than seven times in *Yume no ki*, Myōe's written account of his dreams, and it seems that he had a special belief in horses or they had some special religious significance for him. Myōe preached that all animals have the Buddha nature in them. At Kōzan-ji there is also a statue of a dog and these animal statues can all be interpreted as concrete manifestations of Myōe's beliefs of this kind.

The horse is depicted with its legs straight upright. It lacks any sense of movement. However, the moulding from the back to the hind legs is precise and powerful and is surely the result of careful observation of an actual horse. This may be a simple rendition of the beast at rest, yet the workmanship is every bit as fine as the deer and the statue was probably made at almost the same period, in the first half of the thirteenth century. KY

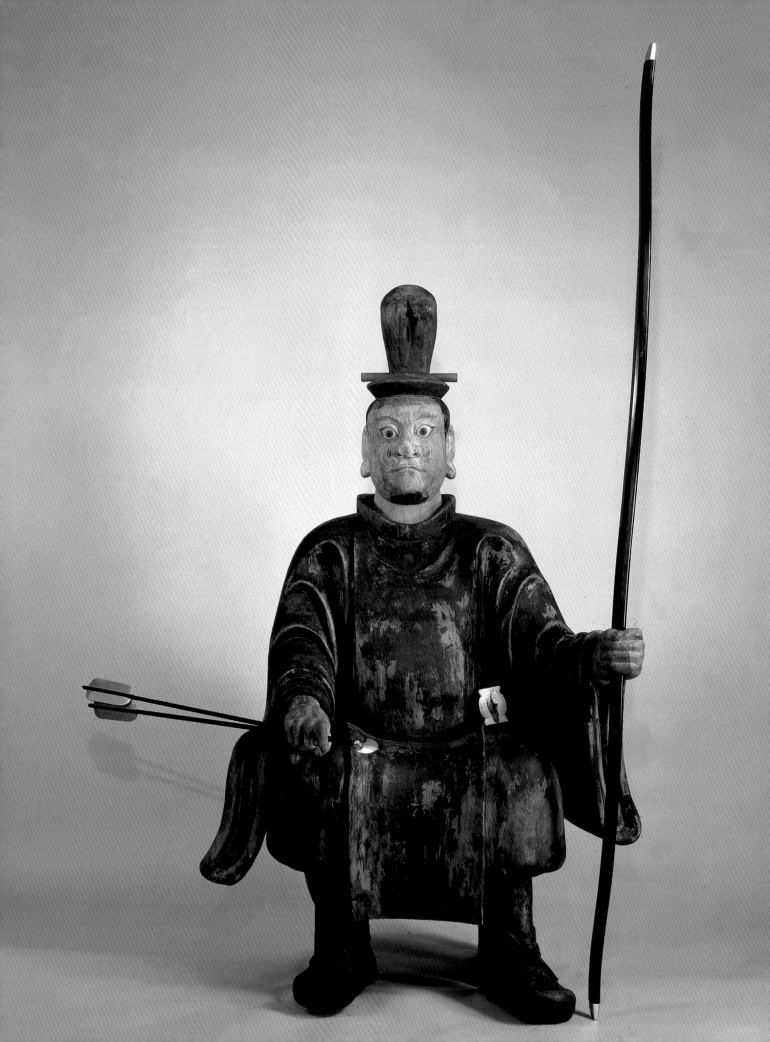

70 Heavenly Beings of the East and South: seated gateway guardian *kami* (*Shumon-jin*)

Kamakura period (1185–1333)

Ōyamazumi Jinja, Ehime Prefecture

Wood with pigment

a Heavenly Being of the East, H. 92.7 cm

b Heavenly Being of the South, H. 92.4 cm

Important Cultural Properties

It is customary to worship statues of *kami* dressed in hunting clothes and holding bows and arrows, positioned at the gateway to a shrine. These are referred to as *zuijin*. The original meaning was an official guard who protected courtiers when they went on outings. However, this is a word that dates from the Edo period (1615–1868) and later: in earlier times one term used was *kado-marōdo* (a *kami* who comes from elsewhere to live in a gateway). Several scattered examples are known in western Japan made before the Kamakura period: the oldest known statues, dated 1162, are at Takano Jinja, Okayama. The two statues included in the present exhibition are from a set of four from Ōyamazumi Jinja. In recent years these have undergone repairs which involved taking the statues apart. This revealed dates of 1322 and 1323 inside the statues and the name of the Buddhist sculptor who made them, one Shūsei. This makes them the second oldest dated example, after the statue at Takano Jinja. It seems likely that the Ōyamazumi Jinja statues were made when the shrine was rebuilt after a fire in 1322.

The set of four statues consists of two figures seated on chairs and two standing. Each of them holds a bow and arrows and all have similar expressions and apparel. The text of the inscriptions mentions the term *shumon-jin* (gateway guardian *kami*) and also gives each statue a specific name, such as Nampō-ten (Heavenly Being of the South) and Hokuhō Bishamon-tennō (Heavenly King Bishamon of the North). From this it can be seen that this set of four *kami* have characteristics connecting them to the Shitennō, the Four Heavenly Kings of

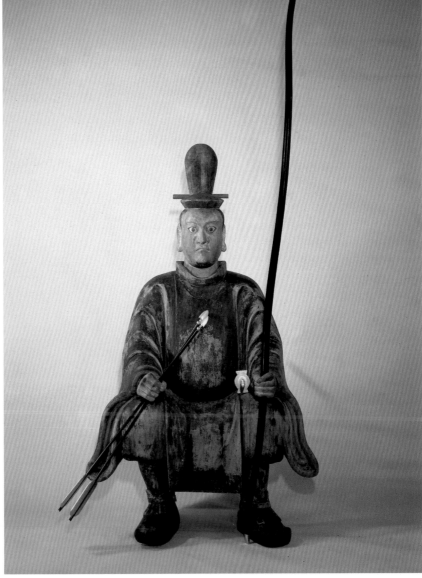

70b

Buddhism, who are guardian deities of the four directions (Bishamon also has the name Hokuhō-ten, Heavenly Being of the North). Also in the inscriptions were references to the names of the monks who were responsible for *shuji* (single Sanskrit characters used to express the titles of Buddhas and Bodhisattvas) and *misogi-gaji* (ceremonies to invoke blessings on the wood used to make the statues). There was also a small statue of a Buddha inside the statues. Overall, Buddhists contributed a great deal to the dedication of the statues, which reflect their ideas and tastes. The construction techniques, too – combining intricate pieces of wood, carving out the interior and so on – are the same as those used for Buddhist sculpture of the same period, in as much as the statues were indeed made by a Buddhist

sculptor. Nevertheless, the overall simplicity and purity of form can also be recognized as characteristics generally typical of statues of *kami*.

No other works have been identified by the sculptor Shūsei. In the inscription he is given the title Mimasaka-no-Hōgen. Mimasaka refers to the Mimasaka Province and *hokkyō* (Bridge of the Law) was a rank customarily bestowed on monks and priests. The form of the sculptor's name and his title are similar to those of one Mimasaka-no-Hōgen Shūkei, who is recorded as having been the great-grandson of Unkei, the most famous Buddhist sculptor of the Kamakura period. (*Hōgen*, eye of the law, was one rank higher than *hokkyō*.) Bearing in mind the date of the statues, it is possible that Shūsei was a pupil of Shūkei.

◀ 70a

TO

71 Four masks

Muromachi period (1333–1573)

Atsuta Shrine, Aichi Prefecture

Wood and pigment

H. 19.9–26.6 cm

The Atsuta Shrine in the central part of Honshū is where one of the 'Three Sacred Treasures', the sword known as *Kusanagi no shinken*, is installed as the *shintai* (the abode of the spirit of the *kami*). The shrine is known for a number of ceremonies practised nowhere else. Many of these are based on agricultural rituals, and others are based on ancient traditions surrounding the *shintai*.

These four masks were not worn, but were concealed beneath the sleeves and passed among the participants in the ritual. This seems to suggest that the masks had a magical function.

Two masks are of an old man and a man in his prime, both with severe expressions, and two are of young men with artless, happy expressions. The old man (71a) has a beard and high nose, and gives the impression of fearful power, that of someone from a un-worldly place (a *kami*). He grimaces with his mouth sharply pursed as if blowing, an attitude which originally expressed the blowing of auspicious sayings, or blowing to keep a fire going, as with the *ibuki* (blowing) mask of *kyōgen* drama, but conversely there is something senile in his expression. The man in his prime (71b) has almond eyes reminiscent of the Noh mask of Chichi-no jō, but less styl-ized, and so seems more like a real person.

The two masks of young men (71c and 71d) are made the same way, the exuberant expressions and their large eyes and noses reminiscent of *bugaku* masks. As there are no standard masks for comparison, it is difficult to estimate their date, but they are certainly not later than the Muromachi period. TO

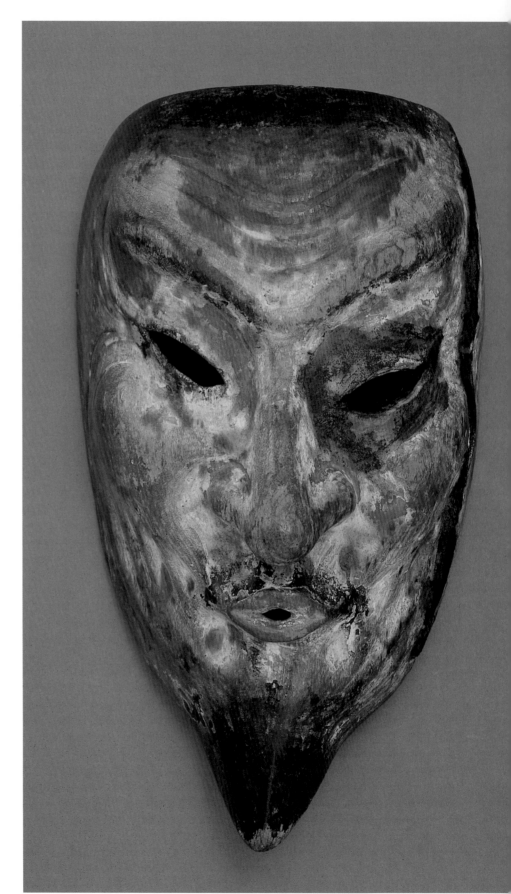

71a

71b

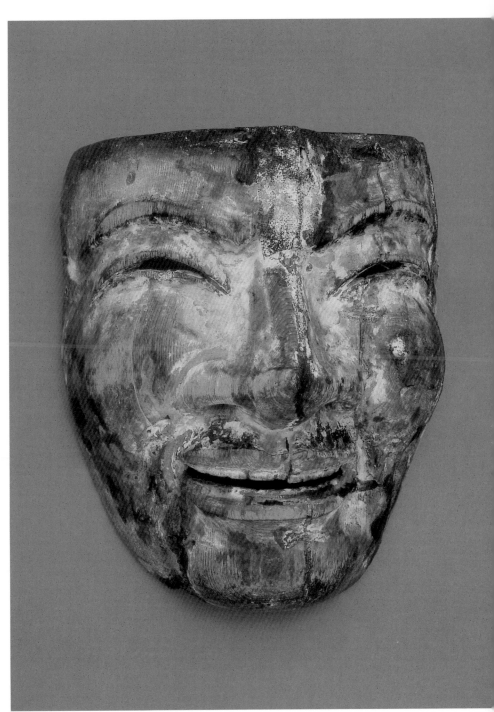

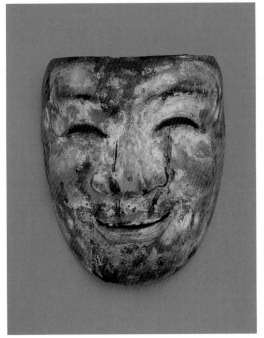

71c

71d

72 Mask of an aged woman

Kamakura period (1185–1333)

Chūsonji Temple, Iwate Prefecture

Wood with pigment and hemp

L. 17.6 cm

Feasts with song and dance known as *ennen* (extending years) used to be conducted following memorial services in temples, mainly of the Tendai sect. The content was in praise of the temple as a whole and of the guardian *kami* of the ground on which it stood. There were dances, songs, and dramas in prayer for prosperity. In the Tendai sect, the *ennen* was practised in a space called the *goto* in the rear of the Jōgyōdō where the monks studied. The ceremony feted a *kami* named Madarashin as the deity of entertainment. It was popular from the Heian (794–1185) to the Muromachi (1392–1573) periods but declined in later centuries and is rarely practised today.

At the Chūsonji temple in north-east Japan, built by the powerful Fujiwara family who flourished in the twelfth century, the *ennen* was held over two days each April in a festival at the affiliated shrine of Hakusan Gongen. On the first day, the *yoban* (fourth programme) drama was performed. Three masks were used: those of an old man, a young woman and an older woman. The mask of the aged woman was this piece, of which the mask nowadays used in the *ennen* is a copy. The mask of the young woman has a date equivalent to 1291 incised in it. This mask of the aged woman is of a different style, and is believed to date from the thirteenth or fourteenth century. The face is roughly carved with a deeply wrinkled, laughing expression, giving it a big-hearted yet slightly sinister look. The rhythmical curves with which the nose, eyes and wrinkles are carved give an impression of vitality. This kind of distorted expression on primitive clay masks is seen as a depiction of the convulsions of a magician in an induced trance or a shaman in a state of possession by the *kami*. The mask exemplifies the medieval expression of the primitive and ancient tradition of the female shaman (*miko*). TO

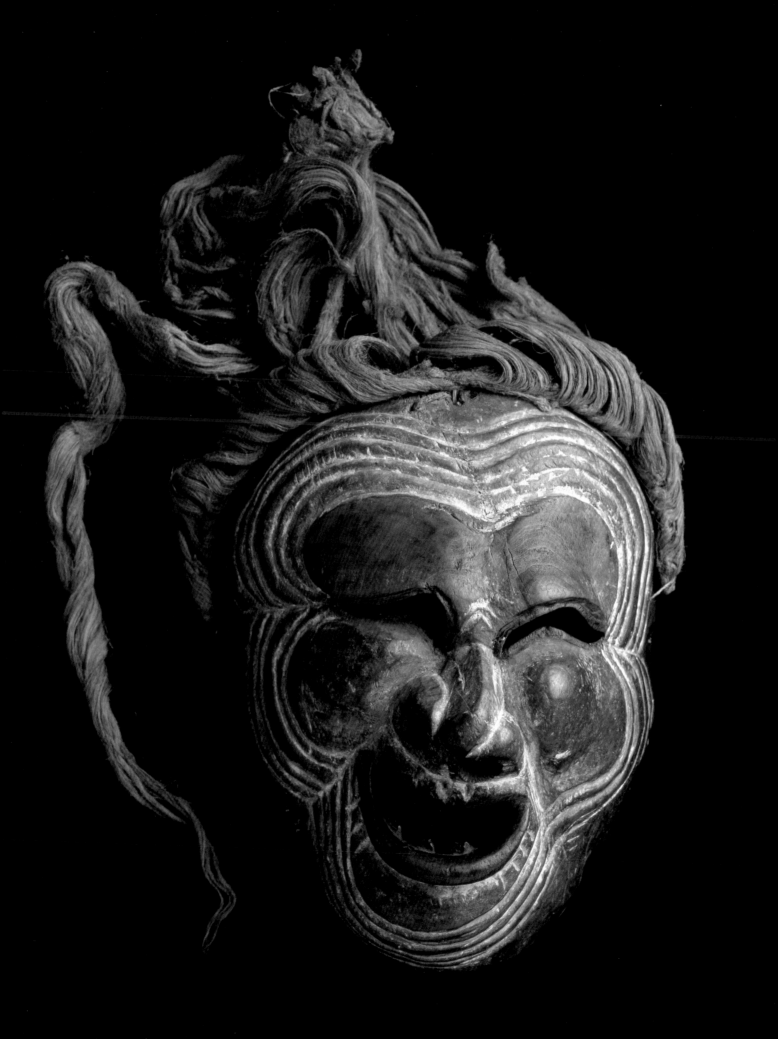

73 Two demon masks

Heian period (794–1185)

Fuki-ji Temple, Ōita Prefecture

Wood with pigments

H. 21.6; 20.5 cm

Buddhism has flourished in the Kunisaki peninsula of Ōita Prefecture since the Heian period, and many Buddhist relics are found there. The main form of Buddhism in the area, the Mountain Buddhism of the Tendai sect, has deep-rooted connections with the Usa Shrine situated at the base of the peninsula. The area had close relations with central Japan, and actively promulgated the amalgamation of Shintō and Buddhism (*shimbutsu shūgō*). Fukidera Temple has been the place of worship for successive generations of the family of the head priests (*daigūji*) of Usa Shrine over the ages. The present temple building dates from the twelfth century, and is famous for its beautiful wall paintings.

This pair of masks is inscribed on the inside with a date probably equivalent to 1147, and the statement that they were used in the annual *shushōe* ceremony in Fukidera. The *shushōe* is a ceremony at the New Year, in many cases accompanied by the *tsuina* ritual of exorcising demons, which originated in China. The *shushōe* ceremony accompanied by this *tsuina* ritual was widespread among temples of the Kunisaki peninsula, although largely discontinued today. The masks were worn by demons known as *suzu-oni* since they carried *suzu* (bells).

One demon (73a) has an open mouth and a fierce look in the eyes, and the other (73b) has slightly narrowed eyes and a friendly smile. They are probably a male and female couple. The demon masks used in the *tsuina* ritual are usually of beastly appearance with horns and exposed fangs, but this pair have

73a

rather handsome faces. There are no other similar examples for comparison, and although it might be difficult to confirm the date of 1147, the warm expressions and rich treatment of the flesh is common to sculptures of Heavenly Beings (*tembu*) of the late Heian period, so it is probably acceptable. TO

4 *Kami* and Buddhas

The prominent characteristic of Mahayana Buddhism, which was transmitted eastwards from its birthplace in India, was the philosophy of compassion extended to all sentient beings to achieve Enlightenment. This philosophy recognized that the possibility of achieving Buddhahood was not only attainable by humans, but by all creatures on earth as well.

The basis of the ancient Japanese belief in *kami* was formed around the worship of nature and ancestral spirits. The worship of nature was nurtured by recognizing the ability of *kami* to provide either blessings or misfortunes to human lives. This belief was expressed by soliciting *kami* to reside in receptacles (*yorishiro*) such as mountains, rocks, trees and mirrors. The worship of ancestral spirits was practised by soothing the spirits regularly and inviting them from their normal residing places such as the summit of a mountain, a peninsula or islands, to a nearby field or the shore. In short, the worship of *kami* in Japan was based on an animistic belief that perceived the presence of *kami* and the force of their actions within the seasons. Therefore, Mahayana Buddhism and the Japanese worship of *kami* shared a fundamentally similar and broad belief in nature.

During the Nara period (710–794), various aspects of continental Chinese culture were also introduced to Japan by the official envoy to the Tang Dynasty (*kentōshi*), but when the official exchange with China was terminated in the Heian period (794–1185), the adopted culture was modified and was transformed to a national Japanese culture. The relationship of Buddhas and *kami* was consolidated, and the theory of Origin and Manifestation (*honji suijaku*) was developed with an analogous approach to the teaching of the Lotus Sutra. According to this theory, Japanese *kami* were the manifestation of Indian Buddhas who had come to save the Japanese people. By the late Heian period, an individual *kami* was paired with its original Buddha (*honjibutsu*), and the *honji suijaku* theory came into being. For example, the original form of the *kami* Kumano Gongen was assumed to be the Amida Buddha.

In the Kamakura period (1185–1333) Buddhas and *kami* were even more systematically combined by the fertile philosophy of Tendai Buddhism which had been introduced to Japan by Saichō (767–822) and his followers. Though threatened by the non-believing Mongols in continental Asia, Japanese Buddhism established the cosmology of Buddhas and *kami* during this period, with the Buddha Vairocana at the pinnacle. Under these circumstances, various images of Shintō–Buddhist paintings (*suijaku-ga*) and Shintō–Buddhist mandalas (*suijaku mandara*) were created at many shrines. These often depicted the cosmology of Buddhas and *kami*. There are nearly 300 examples of such paintings from the medieval period, and some of the most characteristic examples of Shintō–Buddhist paintings are included in the present exhibition.

One of the most representative genres of medieval Shintō–Buddhist paintings is the shrine mandala (*miya mandara*) which depicts the scenery of shrine landscapes. The two Kasuga Miya Mandara (cat. nos. 74 and 77) portray the landscape of the Kasuga Shrine in Nara with the sacred mountain of Mt Mikasa at the top and the shrine compound below. The Hie-

Sannō Miya Mandara (cat. no. 81) depicts the scenery of the Hiyoshi Shrine in Shiga Prefecture with the sacred mountain of Mt Hachiōji in the centre, and the Fuji Mandara (cat. no. 88) is based on the veneration of the most famous mountain in Japan, Mt Fuji. These *miya mandara* portrayed the sacred residing place of Buddhas and *kami* from a high, overhead viewpoint, often with a focus on the sacred mountain, and embellished them with precious pigments such as gold. Consequently, these shrine mandalas possess features of both devotional and landscape paintings, and offer an idiosyncratic quality among paintings of East Asian art history.

The underlying philosophy for the concepts of *sansen sōmoku shikkai jōbutsu* (mountains and rivers, trees and grass, all things on earth can attain Buddhahood) and *shaba soku jōdo* (the Pure Land in This World) was based on the Tendai theory of the Original Enlightenment (*hongaku shisō*), which advocated a positive affirmation of the world. This theory was a product of harmonious fusion between Mahayana Buddhism and the traditional worship of Japanese *kami*, both of which shared a common outlook towards nature. The landscape depicted in shrine mandalas was understood to symbolize the compassion of Buddhas and *kami*. A similar attitude prevails in contemporary Japanese religiosity, which equates the feeling of peace with the natural landscape of shrines among trees.

For medieval people, the presence of *kami* was sensed in minute signs in nature, such as a breeze, an encounter with animals that were seen as messengers of *kami*, and a flickering reflection in a mirror. Since the medieval period, the elusive presence of *kami* has been described as a shadowy appearance (*yōgō*), and paintings depicting the moment of a *kami*'s appearance were called *yōgō-zu*. The Kasuga Myōjin yōgō-zu (cat. no. 79) and the Kumano Gongen yōgō-zu (cat. no. 82) are two representative examples of the genre. The first image was commissioned by an aristocrat from the Fujiwara family who glimpsed the *kami* in his dream. The face of the *kami* is hidden behind the blind of his carriage in the painting. The second example depicts an image perceived by a pious old woman of Kumano Gongen, emerging from a five-coloured cloud on the shore of Nachi. The lower half of the *kami* is covered by the sweeping cloud. These *yōgō-zu* are characterized by their essentially contradictory qualities of capturing the image of *kami*, who have no substance, and the keen Japanese sensibility of detailing the fleeting aspect of nature. Such qualities were expressed in such words as *mono no aware* (the pathos of things), *wabi* (the quality of frugality) and *sabi* (patina of age). Such characteristics of *yōgō-zu* were also detectable in sculptures of *kami* which, unlike Buddhist sculptures, partially deny the physicality of the gods.

Some Shintō–Buddhist mandalas represent the cosmology of Buddhas and *kami* in a visual, geometric diagram in the manner of esoteric Buddhist mandalas. One example of this type is the Kumano Honjaku Mandara (cat. no. 84) depicting the *kami* of three Kumano mountains in Wakayama Prefecture with their numerous attendants, the *Ōmine hachidai dōji* (the eight boy attendants of Ōmine) and *Kumano kutsumo ōji* (the ninety-nine princes of Kumano). Another is the Shirayama Sansha Gongen-zō (cat. no. 87) depicting the *kami* of the snow-covered sacred Mt Hakusan. The characteristics of medieval Shintō–Buddhist paintings can be observed even in these schematic mandalas with their images of a sacred landscape.

Another genre of paintings depicts the history and legend of shrines (*engi-e*). These follow the examples of Buddhist *engi-e* to illustrate the history and miraculous episodes concerning the *kami* of various shrines. The Tamatare-gū engi (cat. no. 91) and the Kotobiki no miya engi (cat. no. 90) both combine scenes from history and legends to illustrate the efficacy of the *kami*. They provide important sources for deciphering medieval religious practices as well as being valuable examples of medieval Japanese style landscape paintings (*yamato-e*). SG

74 Kasuga Shrine mandala

Kamakura period (1185–1333)

Minami-ichi-machi, Nara

Colour on silk

H. 187.8 cm, W. 108.8 cm

Important Cultural Property

Kasuga Myōjin is the collective name for the four *kami*, Takemikazuchi-no-mikoto, Futsunushi-no-kami, Amanokoyane-no-mikoto and his consort Hime-gami. They are the tutelary and ancestral deities of the Fujiwara clan, the most powerful nobles from ancient times. The Kasuga Shrine was founded during the earlier Nara period (AD 710–794) to house these *kami*. In 769 the *kami* were invited by religious leaders to dwell at the foot of Mt Mikasa, the sacred mountain in the province of what was then Yamato. Inviting certain *kami* to reside in a specific location was common to religious practice of the day. The theory of Origin and Manifestation (*honji-suijaku*), developed during the late Heian (794–1185) and Kamakura periods, to explain the Shintō-Buddhist relationship by interpreting *kami* as the manifestations of Indian Buddhas who had come to save the Japanese people. Various devotional paintings (*suijaku-ga*) were produced to illustrate the amalgamation of *kami* and Buddhas, the most prevalent among these Shintō-Buddhist paintings being Kasuga mandalas based on the cult of Kasuga Myōjin. Approximately 160 examples are known today, and about half of these are Kasuga Shrine mandalas.

The composition of shrine mandalas follows an accepted model. This usually includes the entrance gate (*torii*) at the lower centre of the image. The viewers are invited to follow the golden shrine approach (*sandō*) among the trees towards the east (upper section), passing the second gate to reach the main shrine buildings on the left and the Wakamiya Shrine on the right. The five Buddhist counterparts (*honjibutsu*) of the Kasuga *kami* are depicted above the shrine, and a full moon rises above Mt Mikasa and Mt Kasuga at the uppermost section as if to symbolize spiritual purity.

The characteristic depiction of landscape in shrine mandalas can be observed in this painting. The organization of the shrine compound is geometric, gold pigment is used, and the shrine is embellished (*shōgon*) to look like the Pure Land in Buddhist belief. To medieval people, this beautifully enhanced image of the shrine symbolized the compassion of the *kami*. Besides the shrine architecture, many symbolically religious icons were included, such as the sacred trees (*yōgō-matsu, yōgō-sugi, kami-gaki-no-mori*). The word *yōgō* literally means 'shadow facing', and indicates the manifestation of *kami* merely sensed in a breeze or a reflection in mirrors, or perceived in dreams. Such shrine mandalas depicting the sacred iconography of landscape occupied a distinctive genre in the history of East Asian paintings.

This painting from Minami-ichi-machi, Nara, is the largest among the numerous Kasuga Shrine mandalas. Despite its huge size, it is executed meticulously. Figures of several worshippers are seen in front of the main shrine, and faces of shrine maidens and boy attendants are peeking from behind the door of the ritual stage. It is not known if these figures may be portraying actual people connected to the commissioning of this painting, for this is the only example of human figures among all the Kasuga mandalas. The inclusion of human figures makes this an exceptional example of its genre. SG

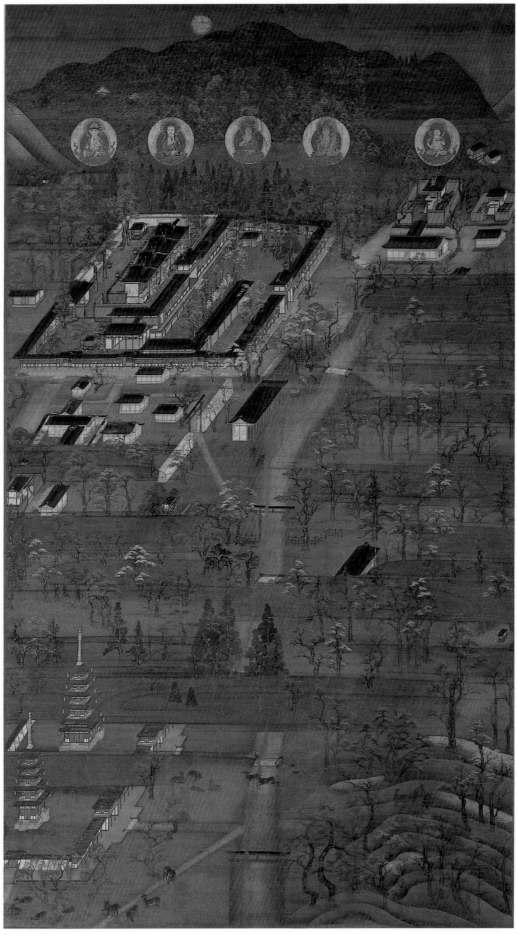

75 Yoshino Mikomori shinzō

Nambokuchō period (1333–1392)

Fujioka Shinzō, Tokyo

Colour on silk

H. 85.3, W. 38.8 cm

The female deity is seated on a straw mat (*tatami*), facing the front. Her hands are hidden inside the sleeves of her garment, and the layers of colours create a fine gradation around the sleeves and the edges of her apparel. Her outer garment is decorated with motifs of double-petal cherry blossoms in the scrolling Chinese grass (*karakusa*) style. This motif and the mountains in the background both seem to indicate Mt Yoshino. Therefore, this image can be identified as the Yoshino Mikomori deity. Her serious facial expression seems appropriate for a devotional image of *kami*. As images of female deities are rare, this painting is a valuable early example.

The *kami* Mikomori was originally a deity connected with water called Mikubari, but the name became corrupted to Mikomori (literally, 'child minder'), and the deity came to be known as the protector of children. Her appearance has a close similarity to the wooden statue of the seated Tama-yori-hime-no-mikoto, also called Mikomori, in Yoshino Mikumari Shrine (dated 1151).

A mirror (dated 1051) engraved with a female deity flanked by a male deity and a monk has been excavated from Mt Yoshino. She is wearing a Chinese style robe similar to a Buddhist heavenly being. She is clearly identified as the protector of children, so providing evidence that the worship of a child protector was already established in Yoshino earlier than the Nambokuchō period. OH

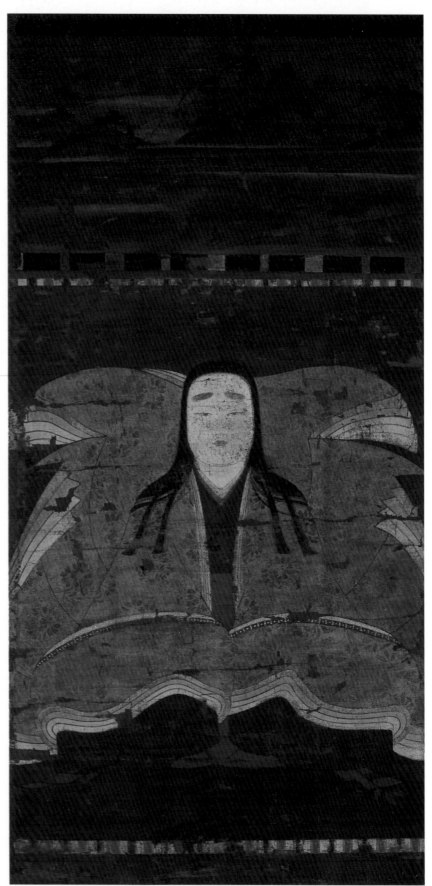

75

76 Kasuga Pure Land mandala

Kamakura period (1185–1333)

Nōman-in, Nara

Colour on silk

H. 100.0 cm, W. 41.8 cm

Important Cultural Property

The lower half of this mandala is similar to the standard Kasuga Shrine mandalas (cat. nos. 74 and 77), but the upper half depicts a splendid Buddhist Pure Land (*jōdo*). This Pure Land resembles the Western Paradise of the Buddha Amida, but the central deity here is the Buddha Miroku who is surrounded by the Buddha Yakushi, Jizō Bosatsu, Jūichimen Kannon and Monju Bosatsu. These five are Buddhist forms (*honjibutsu*) of the *kami* of the Kasuga Shrine. Therefore this image represents the Pure Land of Kasuga.

A sweeping cloud is rising from the Third Shrine in the mandala. It carries a standing figure of Jizō Bosatsu, who leads a monk towards the Pure Land. The scene could depict an episode from the *Kasuga Gongen kenki emaki* (The Miracles of the Kasuga Deity Scrolls) of 1309, now in the Imperial Collection. According to the episode, the monk Shōen from the Kōfuku-ji Temple had fallen to hell after his death, but he was rescued by Kasuga Myōjin in the form of Jizō Bosatsu and was taken to the Pure Land.

It was commonly believed that the Pure Land existed beyond Mt Kasuga and hell beneath the field of Kasuga. The place name *Jigoku-dani* (valley of hell) still remains today. This image suggests the special religious significance of the Kasuga Shrine and its landscape. SG

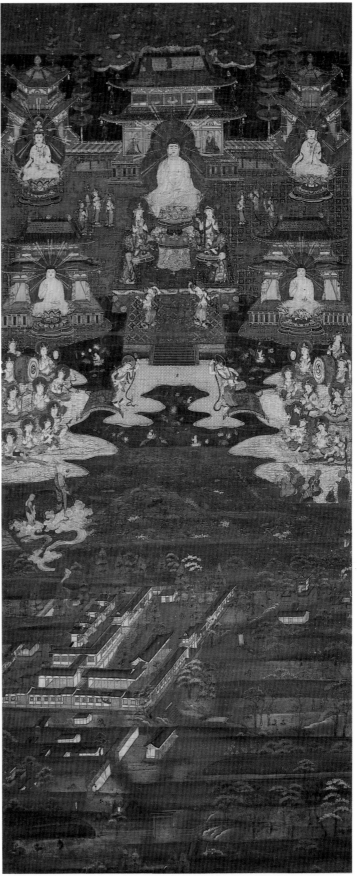

76

77 Kasuga Shrine mandala

Nambokuchō period (1333–92)

Seikadō bunko, Tokyo

Colour on silk

H. 159.4 cm, W. 68.9 cm

This mandala is thought to date approximately one century later than cat. no. 74, but the composition is similar. It shows a bird's-eye view of the shrine complex from the entrance gate at the lower centre to Mt Mikasa at the top. Small cartouches with names are added to the architecture, and several groups of deer can be seen here and there. In comparison to the earlier one, the landscape of this mandala is more stylized and decorative. Mt Mikasa in the upper section is filled with semi-circular trees executed in a pattern like fish scales, a decorative technique idealizing the beauty of the sacred mountain. The partially misty landscape is dotted with brightly coloured cherry trees and cryptomerias epitomizing the pleasure of a blossoming spring, and the shrine is perceived as the Pure Land on earth.

A passage from the Kamakura period manuscript *Koshaki dankan* (Fragments from the Records of the Ancient Shrine) describes the beauty of Kasuga: 'In our land of Japan, there is no place better than Mt Mikasa to admire the moon, and there is no place better than the field of Kasuga to enjoy flowers.' It seems that the beauty of the moon and flowers pleased the deities, too.

In this mandala, a white sacred deer is depicted on the summit of Mt Mikasa. The deer is carrying the sacred tree on his saddle, which supports a golden mirror. Deer were regarded as the messengers of the *kami* at Kasuga, and there is a genre of paintings called Kasuga Deer mandala that features the sacred deer (cat. no. 78). According to shrine history, Kasuga Myōjin did arrive on top of the sacred mountain riding a deer. This image, therefore, is thought to represent the legend of the founding of the shrine.

The uppermost section of the painting, in which a group of *kami* and buddhas are depicted, is separated from the landscape. These figures represent the ten *kami* of the Kasuga, Wakamiya, and other subsidiary shrines, and their Buddhist counterparts. The principal figures are: the *kami* of the First Shrine with the Buddha Sakyamuni and Fukukenjaku Kannon in the top register; the Buddha Yakushi for the Second Shrine; Jizō Bosatsu for the Third Shrine, Jūichimen Kannon for the Fourth Shrine, and Monju Bosatsu and Fudō Myō-ō for the Wakamiya Shrine. There is a type of mandala called *honjaku* which depicts only these figures. The distinctive character of this painting is the combination of all three types of Kasuga mandala – shrine mandala, deer mandala and *honjaku* mandala – into one composition. A similar example is held in the MOA Museum, Shizuoka Prefecture. SG

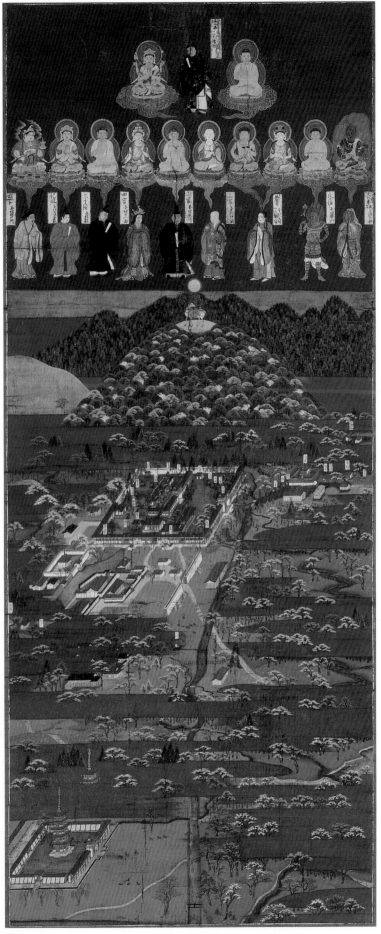

78 Kasuga deer mandala

Kamakura period (1185–1333)

Nara National Museum

Colour on silk

H. 76.5 cm, W. 40.5 cm

The sight of deer roaming in the area of Nara around Kasuga Shrine, Kōfuku-ji Temple, Tōdai-ji Temple and the Nara National Museum infuses a feeling of peace to visitors even today. Deer in Nara were valued as messengers of the Kasuga Myōjin, the four tutelary dieties of the powerful Fujiwara clan, from ancient times. The history of the shrine claims that the Kasuga Myōjin arrived at Kasuga on the back of a deer in the year 768. Journals of aristocrats from the Heian period (794–1185) describe the encounter with deer during visits to the shrine as an auspicious omen. Messengers of *kami* were treated accordingly with respect, and hunting or cruelty to deer was strictly forbidden. The word *shin-roku* (sacred deer) began to appear in texts during the Kamakura period when the worship of *kami* was boosted.

Kasuga deer mandalas were created to express veneration of the deer, and nearly forty examples survive today. The standard composition features the sacred deer, white or chestnut, with the sacred tree (*sakaki*) standing on the saddle, supporting a mirror. Many of them also include the sacred mountain Mt Mikasa in the upper section. In this example, a shrine gate (*torii*), probably the second of the shrine, appears at the lower centre, and a white sacred deer on a cloud is depicted among flowers in the shrine compound. It is one of the most exquisite examples in existence, painstakingly painted with a refined use of gold pigment. SG

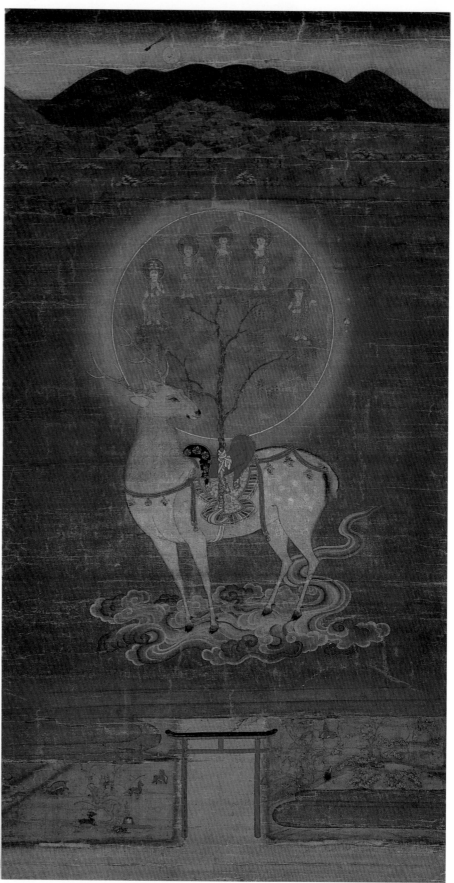

78

79 Kasuga Myōjin yōgō-zu

by Takashina Takakane

Kamakura period (1185–1333)

Fujita Art Museum, Osaka Pref.ecture

Colour on silk

H. 52.1 cm, W.33.0 cm

Important Cultural Property

One of the Kasuga Myōjin, tutelary deities of the powerful Fujiwara clan, clad in black formal robe, is seated in a stationary court carriage in a field of beautiful autumn grass. The upper section of the painting is obscured by mist. It contains five circles, each one containing the buddhist forms of Kasuga and Wakamiya Shrines. The text below the picture explains the provenance of this image as a scene from the dream of the Chancellor Takatsukasa Fuyuhira. He claimed that the Kasuga Myōjin appeared in the garden of his residence and presented him with a book, most likely to be a secret manual on poetry. The face of the deity is hidden behind the blind of his carriage. This conforms to the convention of the period when the portrayal of faces of *kami* and emperors was avoided.

The inscription on the box states that it was painted by Takashina Takakane, the artist responsible for the twenty scrolls of the *Kasuga Gongen kenki emaki* (The Miracles of the Kasuga Deity Scrolls) of 1309. Takakane was an accomplished painter who rose to head the imperial painting studio, and was active in the late Kamakura period. He is highly regarded for his contribution to the development of traditional Japanese-style painting (*yamato-e*). SG

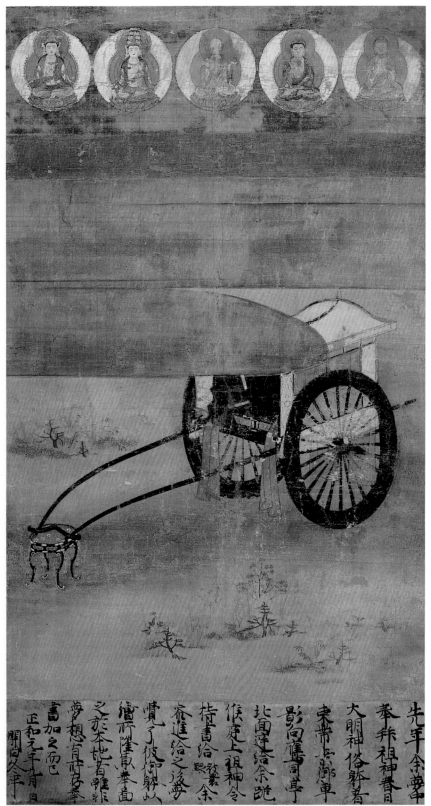

79

80 Kariba Myōjin
and Niu Myōjin

Kamakura period (1185–1333)

Kongōbu-ji, Wakayama Prefecture

Colour on silk

Each H. 83.0 cm, W. 41.0 cm

Important Cultural Properties

The founder of Japanese Esoteric Buddhism, Kōbō Daishi (Kūkai) (774–835) encountered two hunters with dogs while searching for a suitable location for training disciples in the mountains of Yamato and Kii. According to a record from the year 1004, the hunters guided Kūkai to the mountains of Kōya, and announced themselves as the parent and child *kami* Kōya and Niu, the proprietary deities of the area. In a later period, Niu came to be known as the consort of the male *kami* Kōya and began to be depicted as a female *kami* as in 80b.

Similar to the Yoshino Mikomori image (cat. no. 75), the female *kami* (80b) is seated on *tatami* (straw mat). Sliding doors with a landscape painting are depicted in the

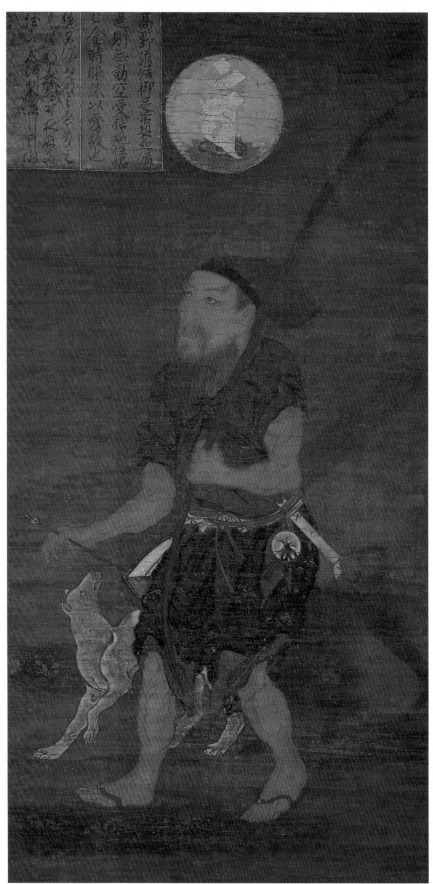

80a

background. The composition features a bird's-eye view of the sea and islands, and the meandering shorelines are painted in gold pigment. A coloured poem sheet (*shikishi*) is attached in the top right corner, describing the deity's wishes for salvation through devotion to Miroku (dedication to Buddhism). The circle in the top centre contains a Sanskrit character on a lotus pedestal. This letter is the symbol of the Buddha Dainichi of the Womb World from the Mandalas of the Two Worlds, and it corresponds to the Buddha Dainichi of the Diamond World whose symbol is depicted on the painting of the Kōya Myōjin (80a), the other of the pair. The Womb World and the Diamond World were regarded as a pair of corresponding elements, such as the male/female analogy, but the Esoteric philosophy proposed that the elements were unified rather than opposed.

The female deity Niu is depicted as a court lady of the early Kamakura period, making this image valuable as a portrait of women of the period. OH

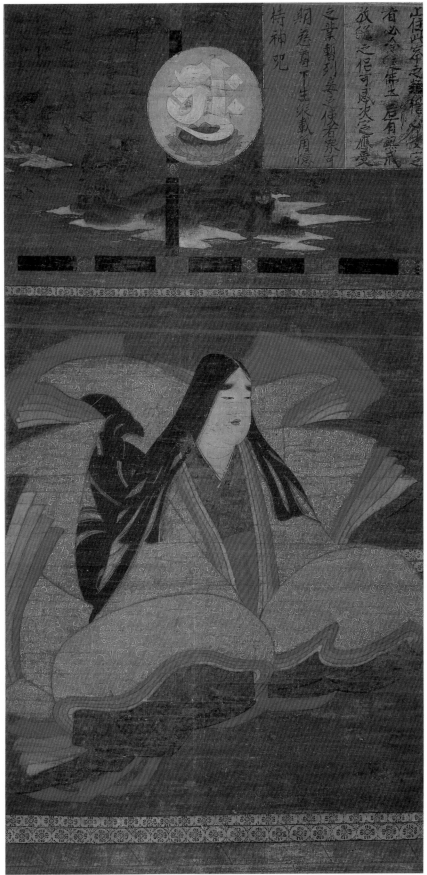

80b

81 Hie-Sannō mandala

Kamakura period (1185–1333)

Hyakusai-ji, Shiga Prefecture

Colour on silk

H. 143.5 cm, W. 76.5 cm

Important Cultural Property

Sannō is the name for deities who are enshrined in Hie Shrine (present-day Hiyoshi Shrine) at the eastern foot of Mt Hiei, and they are regarded as the protectors of Tendai Buddhism as well as the proprietary deity of Mt Hiei. The two principal *kami* are Ōyamakui-no-kami of the Eastern Main Shrine (Ni-no-miya), and Ōnamuchi-no-mikoto of the Western Main Shrine (Ōmiya). Another shrine, Usa-gū (Shōshinshi) was added to the previous two, and the three shrines were collectively called Sannō Sansei (three sacred mountain kings). Numerous subsidiary shrines were grouped together as the 108 Sannō shrines, and the *kami* of these shrines were acknowledged as the manifestations of buddhas and were called the Sannō Gongen. With the development of the theory of Origin and Manifestation, the original Buddhist forms of each *kami* were assigned as Shaka for the Ōmiya, Yakushi for the Ni-no-miya, Amida for the Shōshinshi shrines, and so on. Writings such as the *Yōtenki* (Records of the Bright Heaven) and *Sanke yōryakki* (Abridged Records of the Mountain Home) encouraged the theoretical merging of the Sannō Gongen into Tendai Esoteric Buddhism during the Kamakura period. As the original buddha form of the Ōmiya shrine deity was regarded as Shaka, Sannō Shintō asserted the superiority of the Ōmiya Shrine *kami* above all others. This influenced the spread of the Tendai theory of the Original Enlightenment.

Sannō mandalas are devotional paintings illustrating the cosmology of the Sannō *kami* and buddhas in visual terms. This example from Hyakusai-ji Temple depicts the figures of Sannō *kami* and buddhas in the sacred shrine landscape, and elements from shrine mandalas and figure mandalas (*sonzō mandara*) are both incorporated. The entire landscape of Hie Shrine is depicted from the three ver-milion bridges over River Ōmiya in the lower section to sacred Mt Hachiōji in the upper section. The *kami* of the principal seven shrines are depicted in their Buddhist forms and placed at the appropriate geographical positions, while the *kami* of the subsidiary shrines are depicted in their Japanese *suijaku* forms beside the Buddhist figures. The landscape is painted in the authentic *yamato-e* (traditional Japanese) style, and several sacred monkeys are added to the scene. (Monkeys are the sacred animal of Hiyoshi Shrine, and many mandalas include monkeys.) A similar type of mandala is part of the Reiun-ji collection.

Sannō Shintō of the Kamakura period was strongly influenced by the Tendai theory of the Original Enlightenment, and the landscape of Hie was interpreted as the Pure Land on this earth governed by the compassion of buddhas and *kami*. In this painting, the architecture of the shrine was ignored in order to emphasize the sacred landscape itself. SG

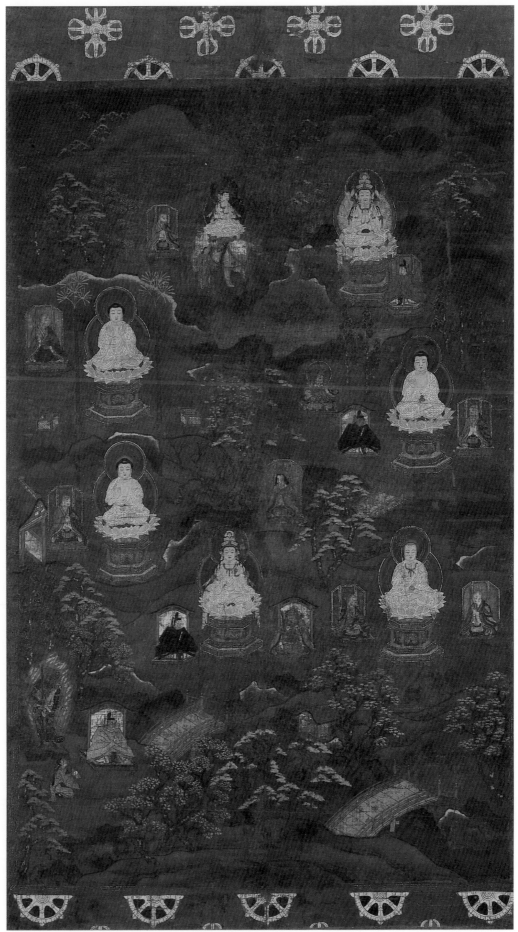

82 Kumano Gongen yōgō-zu

Kamakura period (1185–1333)

Dannō Hōrin-ji, Kyoto

Colour on silk

H. 114.0 cm, W 51.5 cm

Important Cultural Property

The figure of the Buddha Amida, the Buddhist original of the *kami* of Shōjōden (the principal shrine of Kumano) is emerging from a cloud before an old woman. The painting is also called the 'Manifestation at the Seaside Shrine of Mt Nachi'. According to the text accompanying the painting, a seventy-year-old woman from Natori in the province of Ōshū arrived at the shore of Nachi when the august figure of the Buddha Amida appeared before her. She then accomplished her pilgrimage to Kumano for the forty-eighth time, fulfilling her vow. By the late Kamakura period, the Kumano cult became widespread from aristocratic circles to commoners.

The composition of this painting is based on the popular Buddhist images of 'Amida over the Mountain' (*Yamagoshi raigō-zu*), but the lower half of the Buddha is hidden behind a cloud instead of a mountain. Such images were created to accommodate the growing need of the Kumano cult, and artists experimented with inventive devices to depict new subject matter in *yōgō-zu*. For example, the Buddha's left hand behind the cloud is vague and insubstantial, so depicted by a technique originating in China.

The eulogy in the upper section was added by the Zen priest Nanzan Shiun of Engaku-ji Temple in the autumn of 1329 for the nun Shishin. She was possibly the old woman depicted, which indicates that the painting was created before that date. According to the inscriptions on the back of the mount, two copies of this image were made, each dedicated to Shōjōden Shrine at Kumano and the Grand Shrine at Ise. From her connection to Nanzan Shiun and Ise Shrine, the nun Shishin is thought to have come from a noble background, but details of her life are unknown.　SG

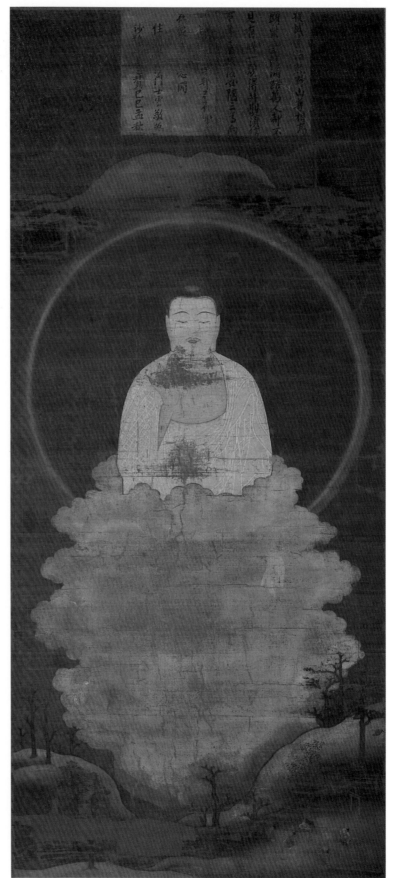

82

83 Ikoma mandala

Kamakura period (1185–1333)

Nara National Museum

Colour on silk

H. 104.8 cm, W. 41.8 cm

Important Cultural Property

The mandala depicts the entire land-scape of Ikoma Shrine in Nara, and the figures of *kami* in their Buddhist forms are placed by the Ikoma mountains in the background with some narrative elements added near the upper section.

The shrine architecture is organized in an orderly manner, and the seven shrine buildings in the most sacred inner sanctuary are shown within the fence (*tamagaki*) in the centre. The group of five shrines on the left enshrine the *kami* who are related to Hachiman, while the shrine on the extreme right enshrines the principal *kami* of Ikoma, and the adjacent shrine in a diagonal angle enshrines his consort. The five Hachiman *kami* are identified from the right as Emperor Ōjin (who is also identified as Hachiman), his father Emperor Chūai, his mother Empress Jingō, the father of Empress Jingō, and the mother of Empress Jingō. The figures above the architecture represent the Buddhist counterparts of these *kami*. They are from the left, Monju, Jizō, Jūichimen Kannon, Shaka, Amida, Yakushi, and Bishamon-ten. A cauldron is placed beside the gate building in front of the shrines, and several buildings such as the ceremonial dance stage and assembly hall are placed among the trees in the foreground.

In the upper left corner, a figure of a *kami* wearing a black formal robe and a court hat is depicted on a cloud with his attendants. The same group appears again on the summit of Mt Ikoma, using the simultaneous narrative technique. This figure in a black robe seems to be Hachiman who assumes the major role in this mandala. The original male and female *kami* of Ikoma seem to have been relegated to lesser roles when the worship of the warrior *kami* Hachiman was boosted during the time of social unrest and the Mongol wars. OH

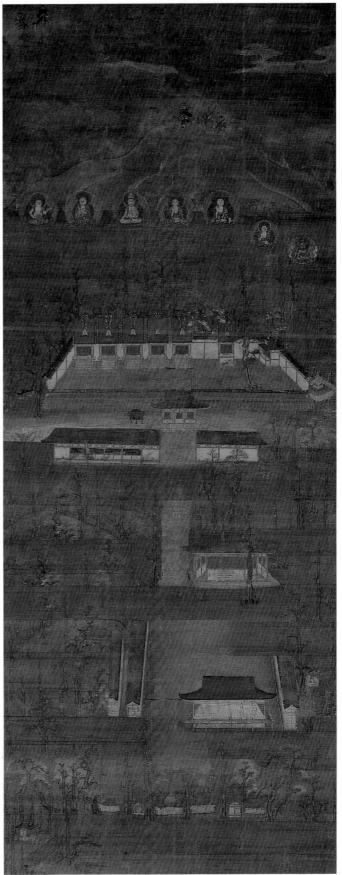

83

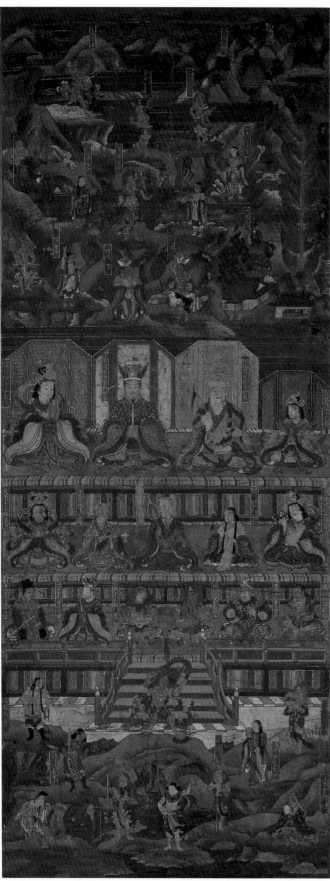

84

84 Kumano honjaku mandala

Kamakura period (1185–1333)

Seikadō bunko, Tokyo

Colour on silk

H. 100.7 cm, W. 39.7 cm

Kumano Sansho Gongen is the collective name for the three *kami* who are enshrined in Kumano-ni-masu Shrine (Hongū), Kumano Hayatama Shrine (Shingū), and Kumano Fusumi Shrine (Nachi Shrine) on the three mountains in present-day Wakayama Prefecture. The three shrines developed independently, each promoting the worship of their own *kami*: Ketsumiko-no-mikoto at Hongū, Hayatama-no-mikoto at Shingū, and Kumano Fusumi-no-mikoto at Nachi Shrines. When the mutual exchange of ideas between the mountain sects (*Shugendō*) of the three mountains progressed towards the end of the ninth century, they began to be combined as a group. By the late Heian period (794–1185), a large religious training ground, Kumano Sanzan (the three mountins of Kumano) was established. At the same time, the original Buddhist forms of the *kami* were designated as Amida for Ketsumiko-no-mikoto, Yakushi for Hayatama-no-mikoto, and Senju Kannon for Fusumi-no-mikoto, and the three *kami* began to be called Kumano Sansho Gongen. They were later joined by *Gotai-ōji* (the five princes) and *Yonsho-myōjin* (the four great *kami*), and the group *Kumano Jūnisho Gongen* (the twelve avatars of Kumano) was established.

Kumano mandalas were created for the worship of *Kumano Jūnisho Gongen*. As the Kumano region was situated a long way from the capital, beyond the mountains of Ōmine, it was considered to be the next world by the people of the capital. A great number of pilgrims, including retired emperors, undertook the long journey to Kumano during the late Heian and the Kamakura periods. The development of the Kumano cult encouraged the creation of many mandalas, and the earliest mention of it appeared in an early Kamakura period text.

There are various types of Kumano mandalas, such as shrine mandalas which place the focus on the shrine landscape; those with a strong focus on *honji* (Origin) or *suijaku* (Manifestations) figures; and others which combine all these elements. This particular example is a typical *honjaku* (Origin and Manifestation) mandala, and it features figures of *kami* and Buddhas neatly organized in rows. The three main *kami*, Sansho Gongen, are depicted largest in size. The mountain range of Ōmine, the waterfall of Nachi and other elements of shrine mandalas are added. A similar example is in the Wakayama Prefectural Museum. SG

85 Sōgyō Hachiman yōgō-zu

Kamakura period (1185–1333)

Ninna-ji, Kyoto

Colour on silk

H. 92.7 cm, W. 50.9 cm

Important Cultural Property

Hachiman was originally a tutelary deity of the Usa family in the province of Buzen (present-day Ōita Prefecture), but he was invited to the capital to assist in the construction of the Great Buddha of Tōdai-ji temple during the Nara period (710–794). The worship of Hachiman was integrated into Buddhism and Hachiman received the title of *bosatsu* (Bodhisattva) by the early Heian period (794–1185). The image of Hachiman has a long history, and it was mentioned in the *Tōhōki* (Record of Treasures of To-ji). According to this, Hachiman was enshrined in Tō-ji Temple during the Kōnin era (810–824), and three sculptures of him, in the guises of a monk, a female and a lay figure, were commissioned. Another record mentions a painting which was kept in Jingo-ji Temple during the Shōhei era (831–838). The extant examples usually depict Hachiman as a middle-aged monk, wearing a Buddhist outer garment (*kesa*), holding a staff with six rings (*shakujō*) in his right hand, a crystal rosary in his left hand, and seated on a red lotus with a red halo, an appropriate depiction for a

85

bosatsu (divine being in human form). Examples include the paintings in Jingo-ji and Jōkōmyō-ji Temples.

This painting from Ninna-ji Temple is unusual. It depicts two seated officials just inside the open door of the shrine-like building. They are holding sceptres and bowing. A large figure of Hachiman, wearing an outer garment (*kesa*), is depicted from the back. Though it is not confirmed, it is thought that this scene depicts the courtier Wake no Kiyomaro when he received the oracle from the *kami* Hachiman in Usa Hachiman Shrine in 768. The prophecy concerned Empress Shōtoku's decision to abdicate in favour of her advisor, the monk Dōkyō. The

most interesting feature of this painting is the faint shadow, corresponding to the figure of Hachiman, painted in a thin ink wash on the white wall in the background. It is untypical to suggest the manifestation of the *kami* with a shadow, and it was probably inspired by the artist's own grasp of ink painting technique.

Many images of Hachiman and Hachiman mandalas were created during the late Kamakura period when the Hachiman cult was boosted by the Mongol wars. They represent an aspect of Shintō-Buddhist paintings that was inspired by the religious fervour of the period. SG

86

86 Yoshino mandala

Kamakura period (1185–1333)

Saidai-ji, Nara

Colour on silk

H. 94.3 cm, W. 39.9 cm

Important Cultural Property

Mt Yoshino, situated at the northern end of the Ōmine mountain range in the central Nara Prefecture, has long been famous for its cherry blossoms. The area was the oldest sacred training ground and attracted mountain ascetics from the Nara period (710–794). During the Heian period (794–1185), the legendary founder of the *Shugendō* ascetic movement, En no Gyōja, claimed that he had seen a vision of Zaō Gongen in the midst of Mt Yoshino. Thereafter the area became a major training centre for the *Shugendō* ascetics. Mt Kimpusen was called the ascending mountain while Mt Yoshino was called the descending mountain.

The Yoshino mandala depicts Zaō Gongen, En no Gyōja and other *kami* associated with Mt Yoshino. These *kami* include the proprietary deity of Mt Yoshino, Konsei Myōjin, Komori Myōjin, Katsute Myōjin, Emperor Gozu, Sanjūhakkasho Myōjin, Sanage Myōjin, and Tenman Daijō Itoku Tenjin, all indigenous *kami* associated with the local clans. Beside these *kami*, the eight attendants of Zaō Gongen, Ōmine Hachidai dōji, are also depicted. *Shugendō* followers maintained their iconography into the modern period, and more than ten examples of similar Yoshino mandalas survive today.

This mandala from Saidai-ji Temple is the oldest known example. The figure of Zaō Gongen is particularly dynamic, and the use of gold pigment in his hair and the motifs on his garment is meticulous. The deities' costumes are embellished with motifs on top of ground colours, using the traditional, formal technique. The painting style has much in common with the *Shōtoku Taishi eden* (illustrated histories), such as the examples in Shitennō-ji and Jōgū-ji Temples which were popular in the fourteenth century.

At that time two rival branches of the imperial family were struggling to succeed to the throne and the Kamakura

87

government (*bakufu*) strongly influenced the selection. Emperor Godaigo's faction (the Southern Court) fought battles and held rituals to overthrow the government. This mandala from Saidai-ji Temple was probably created by the followers of Prince Moriyoshi, the third son of Emperor Godaigo, to pray for the fall of the government. SG

87 Shirayama Sansha Gongen-zō

Kamakura period (1185–1333)

Shirayama Hime Shrine, Ishikawa Prefecture

Colour on silk

H. 79.7 cm, W. 42.7 cm

Important Art Object

Mt Hakusan is a dormant volcano spanning the border of Ishikawa and Gifu Prefectures, and its lower slope stretches as far as Fukui and Toyama Prefectures. The main peak, Gozen-no-mine, rises 2,702 metres. The beauty of the mountain, snow covered in all seasons, was praised in poems from the time of the *Man'yōshū* (Ten Thousand Leaves) compiled in the eighth century. It was revered as a sacred mountain by the indigenous people from ancient times, and three climbing routes from the provinces of Kaga, Echizen and Mino were developed in the year 832. When the mountain cult and the theory of Origin and Manifestation were introduced to the province of Echizen in the middle to late Heian period (794–1185), Mt Hakusan was established as a sacred location founded by the monk Taichō in 717. The *kami* of the three peaks, Myōri Daibosatsu of the Gozen-no-mine, Ōnamuchi-ni-mikoto of the Ōnanji, and Shōshirayama-betsusan-daigyōji of Betsusan, were assigned to their Buddhist counterparts, Jūichimen Kannon, Amida and Shō Kannon respectively, and the Hakusan cult was systematized in theory and ritual. The provinces of Kaga and Mino also acknowledged this cult, and the three starting points of the mountain routes (Heisen-ji Temple in Echizen, Shirayama Hime Shrine in Kaga and Nagataki-dera

Temple in Mino) came under the control of Enryaku-ji Temple. The provinces flourished as religious training grounds for mountain ascetics throughout the medieval period.

Shirayama Sansha Gongen-zō is a painting based on the Hakusan cult, and depicts three seated *kami*, each one in front of three-fold screens. They are Shirayama Myōri Gongen (of Shirayama Shrine) in a Chinese style robe with a jewelled crown in the centre; Tsurugi-no-myōjin (Konkengū Shrine) in a formal robe with bow and arrows on the right; and San-no-miya-hime (San-no-miya Shrine) also in a Chinese style robe and a jewelled crown on the left. Three Sanskrit symbols appear above the raised canopy at the top: Dainichi, Jūichimen and Senju.

There are other examples of Shirayama mandalas which include figures of *kami* from the Upper Seven Shirayama Shrines and subsidiary shrines, with the monk Taichō, and the *kami* Fuseri-no-gyōja and Kiyosada-gyōja in the lower section. These mandalas may have been used as their main icon by the members of the religious confraternity Shōgon-kō, organized by the monks working at Shirayama Main Shrine. SG

88 Fuji mandala

Muromachi period (1392–1573)

Fuji-san Hongū Sengen Shrine, Shizuoka Prefecture

Colour on silk

H. 180.6 cm. W. 118.2 cm

Important Cultural Property

Mt Fuji has been revered as a sacred mountain since the Pre-Historical period, and what is thought to be a primitive ritual site dating back to the Middle Jōmon period (2500–1500 BC) still remains. It has been admired as a sublime pinnacle, a spiritual mountain of *kami* and a guardian of the nation in traditional poetry. The Fuji cult developed around the belief in the water deity of the mountain as the source of precious water, but also around the deity of volcanoes, the source of eruptions. A breakaway cult formed around the deity of volcanoes. According to the history of the shrine, *Fuji Hongū Sengen shaki*, Mt Fuji erupted during the reign of Emperor Kōrei (290–215 BC), and the country was devastated. In order to suppress future eruptions, the powerful *kami* of Fuji was enshrined near the foot of the mountain in the third year of the rule of Emperor Suinin (29 BC–AD 79). The *kami* of Fuji was moved from the mountain shrine to its present location in the year 806 by Sakanoue Tamuramaro, and was thereafter called Asama-no-kami.

The cult of Fuji proliferated with the development of mountain asceticism (*Shugendō*) during the Heian period (794–1185), and the practice of pilgrimages was established by the Muromachi period. It was widely believed that climbing Mt Fuji could prevent misfortune, and it became widely popular to make a pilgrimage, though mainly in the eastern provinces. The regulation of pilgrimages during the Edo period (1615–1868) encouraged the organization of religious confraternities, Fuji-kō. This mandala was created during the Muromachi period and recorded the scene of devotees climbing the mountain, possibly to explain the procedure (*etoki*).

Mt Fuji is depicted near the top with three separate peaks. The three Buddhist deities (*honjibutsu*), a Bodhisattva, Amida and Yakushi (right to left), appear on each peak amidst showering lotus petals. The sun and the moon are depicted on either side of the mountain. The thick pine forest of Miho by the sea occupies the centre of the lower section, surrounded by fishermen's boats floating in Suruga Bay. Included in the lower left corner are the three famous landmarks (*meisho*) of the tower of Seiken-ji Temple, the Tōkaidō highway and the barrier of Kiyomi-ga-seki.

The bands of mist and trees are piled high between the scenes of famous places in the lower section and around the summit of the mountain in the upper section, emphasizing the height and size of Mt Fuji. The use of stylized cloud shapes to indicate a great distance, height or the passage of time was a distinctive technique of Japanese style painting (*yamato-e*). Numerous buildings of Sengen Shrine are depicted among trees, including the largest building, distinguished by its roof of tree bark (*hikawa-buki*); it is the main hall. There are many human figures, including devotees purifying themselves with water in the mist and shrine maidens performing the sacred dance. Some pilgrims holding torches are moving along the winding path between the shrine buildings towards the Buddhas on the summit.

This mandala is an exceptionally fine painting and the largest among similar examples. The strong brush strokes suggest that it was painted by an artist with training in Chinese style painting (*kanga*). This technique and the seal in the lower right corner indicates the name Kanō Motonobu (1476–1559). If Motonobu himself did not paint the mandala, it would have been one of his contemporaries of the Kanō school. TK

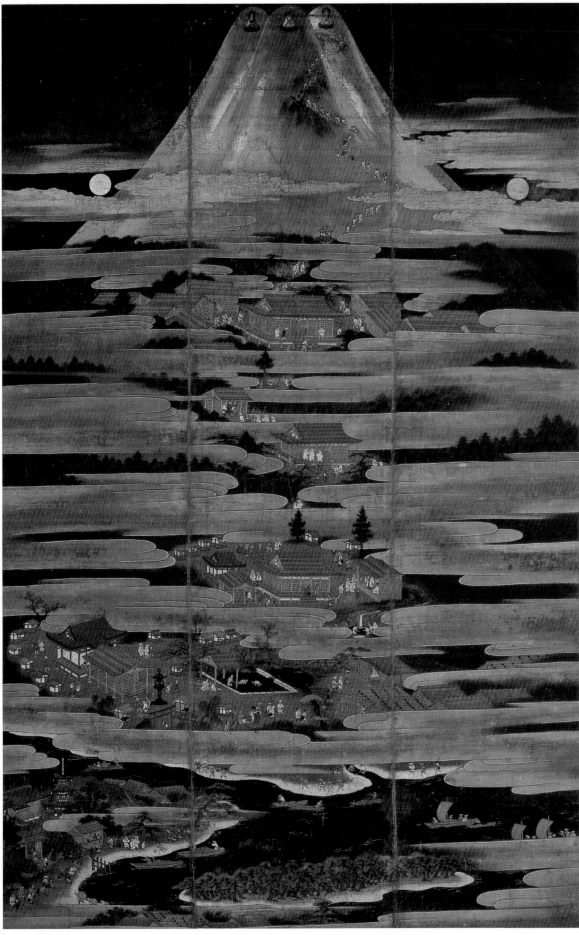

89 Sanjū Banshin-zō

Muromachi period (fifteenth century)

Nara National Museum

Colour on silk

H. 142.5 cm, W. 58.7 cm

Sanjū Banshin are the thirty protective deities who, each day of the month in turn, guard the Tendai Buddhist scripture *The Lotus Sutra*. The origin of Sanjū Banshin goes back to 1073 when a monk of Mt Hiei entreated twelve *kami* to protect the scriptures. The group was soon expanded to thirty, and they include *kami* of the best-known shrines in Japan. The *kami* of the following shrines were assigned in order the days of the month:
1 Atsuta, 2 Suwa, 3 Hirota, 4 Kehi,
5 Keta, 6 Kashima, 7 Kitano, 8 Ebumi,
9 Kibune, 10 Ise, 11 Hachiman,
12 Kamo, 13 Matsuo, 14 Ōhara,
15 Kasuga, 16 Hirano, 17 Ōbie,
18 Hie, 19 Shōshinshi, 20 Marōdo,
21 Hachiōji (Kibi), 22 Inari,
23 Sumiyoshi, 24 Gion, 25 Sekizan,
26 Takebe, 27 Mikami, 28 Hyōzu,
29 Naeka, 30 Kibi.

Early paintings usually depict the deities in five or six rows on a plain background, but this one places the deities in a shrine-like interior similar to Sannō mandalas. Each deity is seated on a platform in front of a three-fold screen with a pair of guardian lions (*komainu*) in the foreground. The iconography of each *kami* seems to be a little ambiguous, but the mandala is stylistically mature, the composition is precise and it is painted with great care. The choice of deities reflects the practices of Enryaku-ji Temple, as Shinra, who is closely associated with Onjō-ji Temple, a rival temple of Enryaku-ji, is not included. The deity of Kasuga was included despite the fact that the shrine was not for adherents of Tendai Buddhism. OH

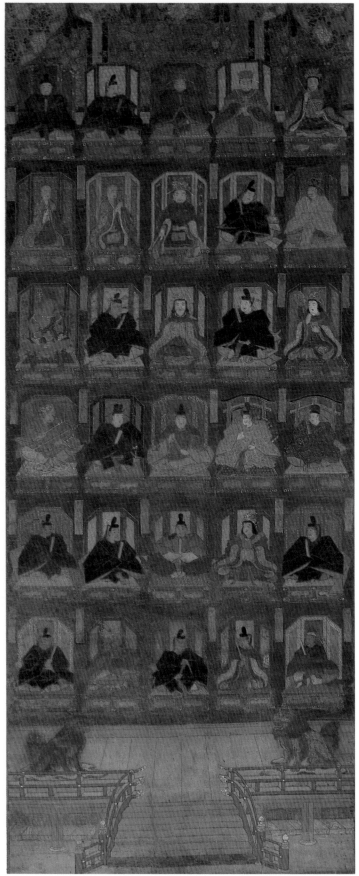

89

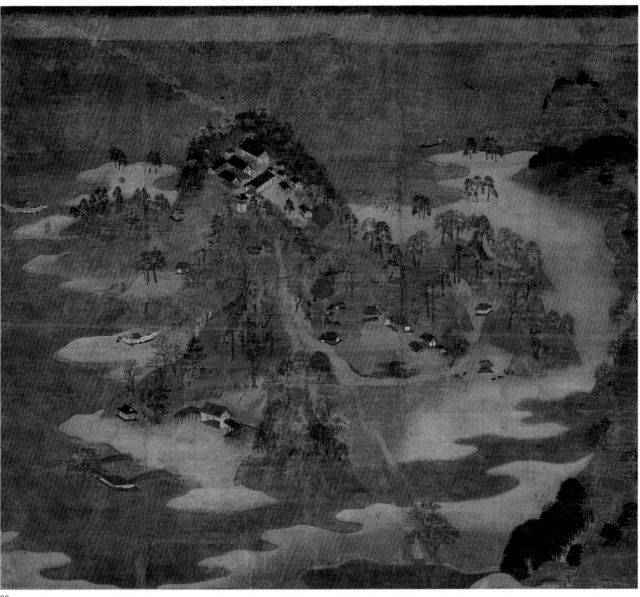

90

90 Kotobiki no miya engi

Kamakura period (1185–1333)

Kannon-ji, Kagawa Prefecture

Colour on silk

H. 102.1 cm, W. 140.3 cm

Important Cultural Property

The bird's-eye view of Mt Shippō, which projects into the sea like an island, shows Kotobiki Hachiman Shrine near the summit and its auxiliary temple (*jingū-ji*) Kannon-ji of the Shingon sect at the foot of the mountain on the right. The two structures by the shore may be the halls for Buddhist ritual *hōjōe*, during which captured fish or animals were released.

According to the *Kotobiki no miya engi* (The Origin of Kotobiki Shrine), dated 1302 and held in Kannon-ji Temple, a white cloud appeared from the direction of Usa Hachiman Shrine in Kyūshū in the year 703, accompanied by a boat from which wafted the serene sound of *koto* (Japanese harp) music. The painting is based on this story, and the clouds in the upper left are depicted in distinctive shapes to express the miraculous nature of the event. The boat is depicted near the shore in the upper half of the left-hand side, and the same boat appears again, being pulled up the mountain.

This mountain was described in a travel journal from the Kamakura period as shaped like Mt Hachiman in Kyoto, and in a fine location surrounded by the sea. The painting conveys the beauty of the landscape and has a quality akin to the genre of famous place paintings (*meisho-e*). It has an inscription on the back stating that it was painted by Tosa Mitsunobu in 1493, but the painting style indicates an earlier date, possibly the early fourteenth century.

The gentle composition and the harmonious colours combine to create a fairy-tale atmosphere, but the rendition of shrines and temples gives a good picture of their appearance in that age. OH

91 Tamatare-gū engi

Muromachi period (1392–1573)

Tamatare Shrine, Fukuoka Prefecture

Colour on silk

H. 184.2 cm, W. 130.0 cm

Important Cultural Property

Tamatare Shrine houses the *kami* Taishōgun Kōra Daimyōjin. This painting, one of a pair, depicts the mythological story of Kōra Daimyōjin, who aided Empress Jingū (AD 201–269) during her expedition to conquer Silla (part of present-day Korea). The other painting of the pair (not in the exhibition) depicts the landscape of Tamatare Shrine.

The story of legendary beings commences in the upper right corner, but the scenes do not necessarily follow the story in order. The figure of the first emperor, Jimmu (660–585 BC) appears in the upper right corner although he is not in the story. The building stretching towards the left is labelled as the palace of Takaanaho in the province of Ōmi (Shiga Prefecture), the capital established by the fourteenth emperor, Chūai. Due to attacks from Silla, Emperor Chūai and Empress Jingū moved to the palace of Kashii, and they are depicted below Emperor Jimmu, facing each other.

The next scene on the left shows the coffin of Emperor Chūai on two trees. The emperor died on the island of Toyoura in the province of Nagato (Yamaguchi Prefecture), which is depicted in the upper centre of the picture. Empress Jingū is seated on the island with some attendants, one of whom may be Takeshi-uchi no Sukune, who is another legendary character. The empress appears again in the uppermost left, washing her hair, with another woman who may be the *kami* of Ise.

The figures in the interior of the building just to their left are probably Takeshi-uchi and Kōra Myōjin who is the main character of this painting. As a *kami* of warfare, Kōra Myōjin assisted the conquest of Silla. In the centre left, court music is played to welcome the *kami* of Kashima who was to act as a navigator. He appears on the sea, with his face hidden, and Empress Jingō in armour appears in the centre right. The tree in the centre symbolizes Mt Funaki, which provided wood for building the war ships. Ships with dragon figureheads are depicted nearby.

In the extreme right is the island of Tsushima where the pregnant Empress Jingū stopped. The two *kami*, Kashima and Kōra are seated, facing each other on the shore in the centre. Kōra appears again just below with Toyohime, the *kami* of Kawakami, who brought a jewel from the Dragon Palace. The ships floating on the rough sea are the Japanese forces, while the Silla forces appear at the lower left. The scene just above on the left depicts Empress Jingō in armour inscribing the submission of Silla on the huge rock with her bow. The scene of the empress giving birth to Hachiman is depicted in the lower right corner.

The inscription on the box containing this painting states that it was created in the year 1370 by an artist called Ninchi to replace the original painting, which had been damaged. The slightly clumsy painting style indicates that Ninchi may have been a provincial artist from Kyūshū. OH

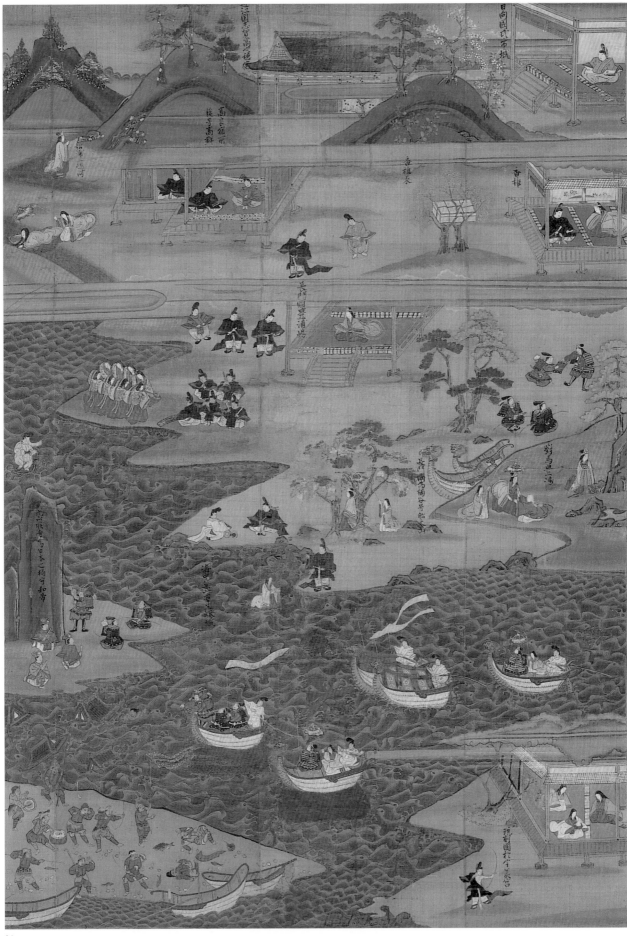

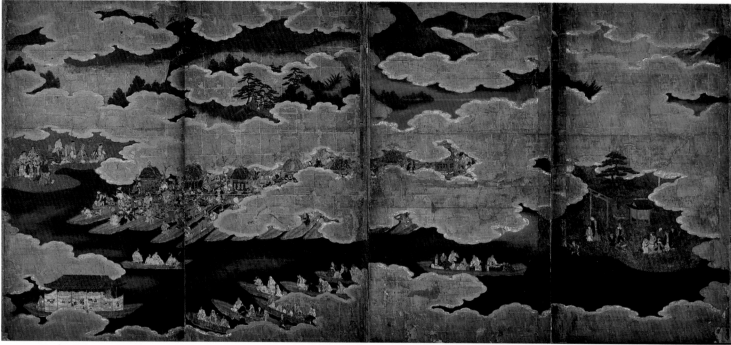

92a

92 Pair of four-fold Hie-Sannō festival screens

Momoyama period (1573–1615)

Dannō Hōrin-ji, Kyoto

Gold and colour on paper

Each H. 168.0 cm, W. 370.0 cm

Important Cultural Properties

These paintings originally adorned the sliding doors (*fusuma*) of a study (*shoin*) in Dannō Hōrin-ji Temple, but they were remounted as screens to preserve them. The Sannō festival is still held annually for the tutelary deities of Tendai Buddhism and the proprietary deity of Mt Hiei, enshrined at Hiyoshi (Hie) Shrine in Sakamoto in Ōtsu City, Shiga Prefecture. The indigenous *kami* of Hiyoshi Shrine was Ōyamakui-no-kami of Mt Hachiōji, enshrined as the proprietary deity. He was joined by Ōnamuchi-no-kami from Miwa in the year 668, enshrined in the Western Main Shrine, and was renamed Ōhie-no-kami (*kami* of great Mt Hiei), or Ōmiya. The original *kami*, Ōyamakui-no-kami, was called Obie-no-kami (*kami* of small Mt Hiei),

and was enshrined in the Eastern Main Shrine. When Enryaku-ji Temple was established on Mt Hiei in the ninth century, these two *kami* were revered as the guardians of the temple, and attracted ardent followers of Tendai Buddhism.

Two more shrines, Shōshinshi (Usa Hachiman) and Marōdo (Shirayama-hime-no-kami), came to be affiliated with the Western Main Shrine, while three more shrines, San-no-miya, Jūzenji and Hachiōji, joined the Eastern Main Shrine, all of which were collectively called the Upper Seven Shrines of Sannō. The number of *kami* increased gradually, and the Middle Seven Shrines and the Lower Seven shrines were established to form a group of twenty-one Sannō shrines by the medieval period. Hiyoshi Shrine eventually grew to incorporate 108 inner shrines and 108 outer shrines.

The origin of the Sannō festival can be traced to the ancient harvest festival in which the *kami* was invited to come down from the mountain and was presented with a request for an abundant harvest. The scenes on the screens depict

two major rituals held annually during the Sannō festival between the beginning of the third month and the middle of the fourth month.

The right-hand screen (92b) shows the shrine landscape of Hiyoshi in the upper section with the town of Sakamoto in the lower half. The scene depicts the ritual of the sacred tree (*sakaki*) in progress, and a procession of people carrying the sacred tree is about to reach the shrine gate. The *sakaki* was regarded as a receptacle (*yorishiro*) of *kami*, and this ritual was held on the thirteenth day of the fourth month when the sacred tree was carried back to the Western Main Shrine after a period at Shi-no-miya Shrine in Ōtsu.

The left-hand screen (92a) depicts the festival on the fourteenth day of the fourth month when the seven sacred palanquins carrying the *kami* were taken from the Western Main Shrine to Lake Biwa. The boats carrying the palanquins are about to leave from the shore of Seven Willows, heading towards another boat in the lower left. This boat is the setting for the scene of the ritual of Awazu

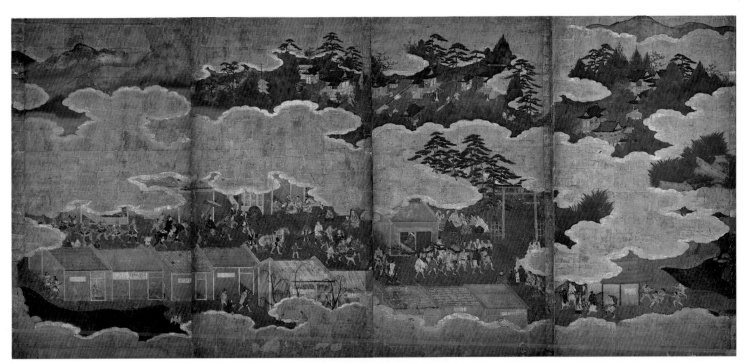

92b

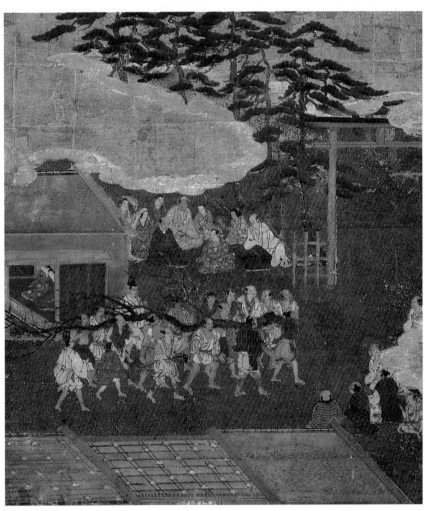

92b detail

when a meal of millet was dedicated to the *kami* on the lake, accompanied by music. The impressive scene includes many boats carrying spectators on the lake, and the pine tree of Karasaki can be seen on the shore to the right. According to the legend of Hiyoshi Shrine, Ōnamuchi-no-kami landed on the pine tree of Karasaki after his journey from Miwa across Lake Biwa. The palanquins are carried back to the Western Main Shrine on the following day, and the festival comes to the end.

Apart from the Hie-Sannō screen from the Suntory Art Museum (cat. no. 93), these screens are the earliest examples of Hie-Sanno festival scenes. The composition is well organized, with the busy scenes of spectators reserved to certain areas. The screens in the Suntory Art Museum display the characteristics of Japanese style painting (*yamato-e*) of the Tosa School, while this pair are executed in Chinese style painting (*kanga*) by an artist of the Kanō School. They date from not later than the Keichō era (1596–1615).

TK

93a

93 Pair of six-fold
Gion Sannō festival screens

Momoyama period (1573–1615)

Suntory Art Museum, Tokyo

Gold and colour on paper

Each H. 138.0 cm, W. 335.0 cm

The right-hand screen (93b) of this pair features the Sannō festival of Hiyoshi Shrine in Ōmi Sakamoto, and the left-hand screen (93a) features the Gion festival in Kyoto. The climax of the Sannō festival is depicted on the right, with the seven Sannō palanquins being carried across the lake by boats. They are racing towards another boat off the Karasaki shore where the ritual meal of millet is presented to the *kami*, and Lake Biwa is busy with other boats carrying spectators. The town of Sakamoto is depicted on the right-hand shore, and the pine tree of Karasaki appears on the left. The shore is as busy as the lake with more spectators, who seem to follow the boats towards Karasaki. The background is filled with bright green fields, and Enryaku-ji Temple in the distance appears in between the golden clouds.

The left-hand screen depicts the festival of Gion Shrine where the purifying deity, Emperor Gozu, is enshrined. The origin of the Gion festival goes back to the year 869 when an epidemic raged in the country. A priest of Gion shrine, Urabe Hiromaro, conducted a ritual to dispel pestilence by sending sacred palanquins to Shinsen-en with sixty-six ornamental towers measuring two *jo* (approximately 6.06 m). The festival has been held annually in the sixth month since the year 970, and the townspeople take the initiative in the festival by making ornamental floats and towers.

The lower half of the screen portrays the procession of floats in the streets of the capital, held on the seventh day of the sixth month, while the upper half depicts the journey of the sacred palanquins held on the fourteenth day. The climax of the two separate rituals are combined in one screen. The palanquins seem to be travelling through Sanjō (Third) Street in Kyoto, and the floats are travelling down Shijō (Fourth) Street. The roof of the float leading the procession appears among golden clouds on the fourth leaf (from the right) of the screen. The procession seems to have changed direction just before reaching the bridge over the Kamo river, and is moving down Teramachi Street. The last float, shaped like a ship appears in the extreme left of the screen. The temporary resting place (*otabisho*) for the *kami* of

Gion is depicted in the lower part of the fifth leaf.

The golden clouds across the whole picture unify the separate elements, but also act as indicators of the separate scenes and symbolize the passage of time between ceremonies.

From the style of painting, the screens are attributed to the followers of Tosa Mitsumochi. Mitsumochi is credited for the illustrated scroll, *Kuwa-no-mi-dera engi* (The Origin of Kuwa-no-mi-Temple), and was active during the Muromachi period (1392–1573). The landscape seen from an aerial view and the minute details of the scroll resemble the painting style of these screens. The artists of the Tosa School carried on the traditional native *yamato-e* style of painting, and presided over the imperial painting studio. It has been suggested that the screens were possibly commissioned by the Ashikaga shōgunate. They are important examples of the authentic *yamato-e*-style festival scenes dating back to the Muromachi period, and differ markedly from the *kanga* (Chinese style) painting of the Dannō Hōrin-ji screens in the use of colours and the depiction of meticulous details. TK

93b

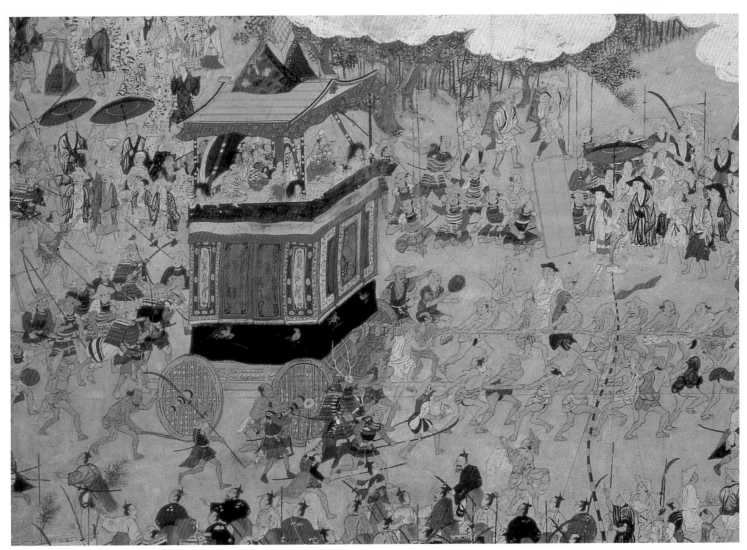

93a detail

5 The World of Ancient Sacred Treasures

During the Nara period (710–794), the halls (*shaden*) exclusively designed for rituals began to be built at shrines, and the *kami* enshrined in these halls were personified. The shrine buildings developed diversely under the influence of residential, Buddhist or palace architectures in the Heian period (794–1185), and the rituals were defined by various household and personal objects dedicated to the daily needs of the *kami*. These ceremonial objects were called sacred treasures (*shimpō*). They were produced by skilled artisans with the best materials and technology then available, and they represent precious examples of the decorative arts of their time.

The personification of *kami* brought a change in the character of shrine treasures. The traditional treasures with spiritual significance from the Kofun period (third–mid-sixth century AD), such as mirrors, swords and jewels, were still offered, but their mystical elements gradually yielded to more practical and luxurious items which reflected the aristocratic culture of the period. Furthermore, court ranks began to be bestowed on *kami*, and new shrine treasures appropriate to these high ranks were commissioned.

With the improvement of shrine facilities during the Heian period, the *shaden* were identified as palaces where the *kami* resided permanently, therefore requiring provisions for the everyday life. Shrine treasures dedicated to the *kami* in such circumstances included sacred robes, accessories, furniture, arms and armour, all of which were similar to or even more sumptuous than those of the contemporary aristocratic patrons.

During the Heian period the enthronement of a new emperor was accompanied by the imperial custom of donating sacred treasures to the fifty-three national shrines. By this means, the new emperor hoped for the *kami*'s protection during his reign.

New treasures were also dedicated by the imperial family, nobles, the shogunate and other powerful families to mark the occasions of rebuilding (*sengū*) of shrines or to deliver special prayers to major shrines such as Ise, Kasuga, Kumano, Itsukushima, Izumo and Atsuta, and the catalogue of treasures grew and diversified.

The exact date of the first shrine ritual involving the donation of sacred treasures is not certain, but one of the earliest textual evidences appears in the *Shoku-Nihongi* (Additional History of Japan). It records the dedication of sacred treasures to Ise Shrine on the tenth day of the fifth month in the year 738.

The systematization of regulations concerning the sacred treasures began in the early ninth century. The *Kōtai jingū gishiki-chō* (Regulations on

the Rituals of Ise Shrine) and the *Toyuge-gū gishiki-chō* (Regulations on the Rituals of Toyuge Shrine) were issued in the year 804, and by the time the *Engi-shiki* (Procedure of the Engi era) was issued in 927, the regulations were established as the criteria nationally.

Sacred treasures were dedicated to Ise Shrine on the following occasions.

- The founding of the shrine.
- The regular rebuilding of the shrine.
 Ise Shrine has been completely rebuilt every twenty years since the late seventh century, except one interruption of 123 years from the late fifteenth century.
- The enthronement of a new emperor.
 (These treasures were called 'Great Sacred Treasures' as they were commissioned only once during each reign.)
- The regular festivals of thanksgiving.
- Special rituals when aristocratic messengers were sent with offerings.

These occasions were all organized by the state. The greatest number and variety of treasures were those made on the occasion of the rebuilding.

With the exception of the original treasures of the shrine, most items such as textile and furniture were replaced by the imperial and noble families or the shogunate to mark the rebuilding or special rituals. Only a few textiles survive because of their fragile nature.

The custom of regular rebuilding was based on the concept of rebirth of the *kami*, called *miare*. The renewal of the shrine buildings and objects was believed to breathe new life into the *kami*, who would then save people from sickness and disasters with new energy. When the treasures and shrine were renewed, the old treasures were withdrawn according to the logic of *miare*. In order to distinguish the old treasures from the new, the old ones are called ancient sacred treasures (*koshinpō*).

The ancient sacred treasures held today in the major shrines, and in many other lesser shrines, are these preserved objects once dedicated to the shrines at their rebuilding or on special occasions. They include costumes, accessories, textiles, arms and armour, equestrian gear, stationery, furniture and musical instruments. These are made from various materials such as metal, lacquer, wood and textile.　TS

94 Various ancient sacred treasures from Asuka Shrine

Muromachi period (1390)

Kyoto National Museum

a Crown: H.18.0 cm

b Crown box: H. 38.0 cm, W. 33.9 cm

c Wooden sceptre: H. 43.0 cm, W.4.0 cm

d Sceptre box: H. 12.0 cm, L. 51.5 cm, W.13.6 cm

e Two pairs of shoes: L. 21.8 cm, 23.6 cm

f Shoe box: H.16.1 cm, L. 26.7 cm, W. 23.6 cm

National Treasures

These ancient sacred treasures come from Asuka Shrine at the foot of Mt Hōrai near Niimiya City, Wakayama Prefecture, which was formerly a subsidiary shrine of Shingū Kumano Hayatama Shrine. They are now kept in Kyoto National Museum. The list of items match almost exactly the description of treasures dedicated to Asuka Shrine in the eleventh month of 1390, recorded in the *Kumano Shingū goshinpō mokuroku* (List of Sacred Treasures in the New Kumano Shrine and dated 1390), which lists treasures from thirteen shrines.

In addition to the six items exhibited, the surviving items out of nineteen are: an outer robe, a singlet, a pleated back skirt, a divided skirt, a sash, a lacquered belt, a cover, a hair-piece, a painted cypress fan, a box for robes, a lacquered robe stand with sprinkled silver decoration (*gin-makie*), a white bronze mirror, and a lacquered pine and camelia cosmetics box.

The cosmetics box contains a white bronze mirror, a silver box for teeth stain (*ohaguro*), a silver powder box, a silver incense box, a pair of silver tweezers, a pair of silver scissors, a silver ear cleaner, a silver hair divider, a silver eye-brow liner, a silver painting brush for teeth, a silver comb cleaner, a small silver chrysanthemum dish, a white porcelain dish, a silver comb and a lacquered comb.

Most of these items exemplify the artistic style of the Muromachi period.

The lacquered pine and camelia cosmetics box in particular matches the record in the *Kumano Shingū goshimpō mokuroku* which describes it as a lacquered box in a thick pearskin-ground (*nashiji*) with silver shell decoration of pine and camelia motifs. The box is fashioned similarly to another pearskin-ground lacquered box in Kumano Hayatama Shrine, which attests to the authenticity of its provenance. The Asuka Shrine collection includes rare objects such as the lacquered belt (*sekitai*), which was worn by men with the formal robe and was jewelled according to ranks. The Kumano Hayatama Shrine *sekitai* has been lost.

Comparison of the list of costumes in the *Kumano Shingū goshimpō mokuroku* with those remaining in the Asuka Shrine collection reveals that about half of the items have been lost, such as a short robe and an undergarment. Some items that are not mentioned in the list, however, are thought to be additions of the later period.

94a

94b

94c

94d

94e

94f

The following treasures are part of the present exhibition.

CROWN: A plain black lacquered crown of flat weave hemp with a narrow front and a back projection, perforated at the front and back. A hair ornament (*kanzashi*) is attached, but the silk tail (*ei*) is missing.

CROWN BOX: The *aikuchi-zukuri* (flush-lidded construction) wooden box is black lacquered, trimmed with tin. The outside of the box is decorated with pine branches and cranes in sprinkled silver, and the inside is lined with red brocade of lotus flowers and butterflies.

WOODEN SCEPTRE: This is made of yew (*ichii*).

SCEPTRE BOX: Like the crown box, it is black lacquered, trimmed with tin. A branch of paulownia is depicted in sprinkled gold on the lid. The inside of the box is lined with red brocade.

TWO PAIRS OF SHOES: One pair of shoes is made of wood, the other pair of leather. They are covered in red brocade with a floral motif. One pair is lined in white, the other in pale green twill silk.

SHOE BOX: A wooden box of *aikuchi-zukuri*, covered in black lacquer. The edges of the lid and the body are gilded, and the outside of the box and the inside of the lid are decorated with floral motifs of Chinese grass and flowers in sprinkled silver. The inside of the body is lined with red brocade. TY

95 Bronze mirror with peonies,
karakusa and long-tailed birds

Heian period (twelfth century)

Kasuga Taisha, Nara

Diam. 30.3 cm

Important Cultural Property

See cat. no. 96.

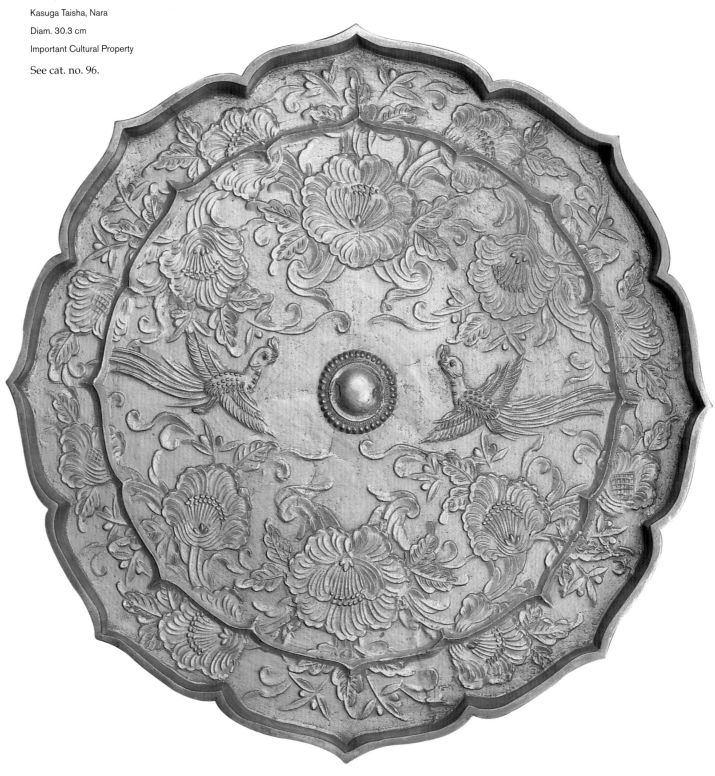

96 Black lacquer mirror box

Heian period (twelfth century)

Kasuga Taisha, Nara

H. 10.0 cm, Diam. 33.5 cm

Important Cultural Property

This mirror and its box were preserved as ancient sacred treasures in Kasuga Shrine in Nara. The sacred treasures of early periods were of a strong ceremonial character, but when shrine halls began to be built during the Nara period (710–794), the attendant personification of *kami* encouraged the dedication of furniture, arms and armour, and textiles to shrines. Many of the ancient sacred treasures in Kasuga Shrine date from the late Heian period when the personification of *kami* became widespread, and the sacred treasures are valuable sources for the study of the period. As it was customary for emperors and nobles to donate gifts on their visits to the shrine, these objects reflect the luxurious lifestyle of the Heian aristocrats.

The box has a wooden core covered in black lacquer and shaped with eight-pointed corners (*hachiryō-gata*). The edges of the lid and the corresponding section of the base are trimmed with tin. The surface of the lid swells up gently, and eight raised lines and eight grooves radiate out alternately towards the thin flat edge. The curve of the inside of the lid corresponds to the outside and is also lacquered in black. The body has an eight-pointed flat base with attached sides. The shape called *hachiryō-gata* (eight peaks) has eight curved sides whose centres project out in an arc. Eight mirrors in this shape fit into the box, of which one is exhibited (cat. no. 95).

The provenance is inscribed in ink on the outer box containing the mirror box, according to which the damaged lid of this particular box was made into a cake tray with legs from a dressing table in 1891. It was restored to its original shape in 1930 by a lacquer expert of Kasuga Shrine, Horibe Kōsai. Kōsai was a pupil of Yoshida Rissai, who contributed greatly to the development of lacquer technique in Nara by reproducing the treasures of the Shōsō-in in the Meiji era (1868–1912). Kōsai also helped to repro-duce the Shōsō-in treasures. He specialized in the lacquer technique called *kasuga-sabi*, which produced an antique purplish shade on black lacquer. The finish on this mirror box may be his work.

In comparison to the large number of eight-cornered mirrors in existence, only a few mirror boxes survive. The Heian period examples such as this box are particularly rare. There are only two other examples, one in Kasuga Shrine and one in Suntory Art Museum (formerly in Kasuga Shrine). These three examples share a similar shape, size and decoration. TY

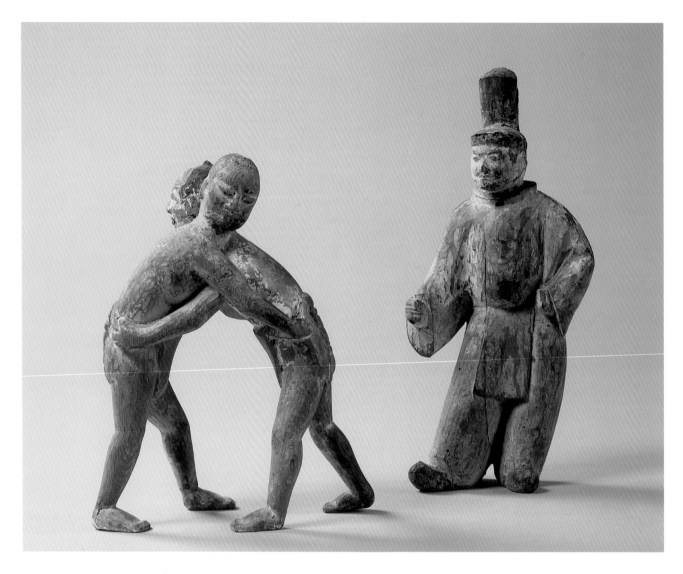

97 Wooden *sumō* figures

Muromachi period (1392–1573)

Mikami Jinja, Shiga Prefecture

Tallest: H. 16.0 cm

Sumō is well known today as the national sport of Japan. It is a type of wrestling peculiar to Japan, but similar sports seem to have existed once elsewhere as well. The origin of *sumō* in Japan can be traced far back in history, as some clay figurines (*haniwa*) and decorations on *sue* ware pottery suggest that the activity existed in the Kofun period (third–sixth century AD). Later textual sources indicate that *sumō* was included in the calendar of imperial events in the Heian period (794–1185), customarily played in front of emperors in the seventh month of each year. Following this example,

shrines also began to dedicate *sumō* to their *kami*, but depictions of the sport in the early to medieval periods are rare.

These figures of wrestlers, both wearing only loincloths, are portrayed in the interlocking position, and a figure of the referee (*gyōji*) stands nearby. The referee is wearing a formal hat (*bokutōkan*) with a wide projection (*koji*), a hunting robe (*karigine*), a pair of trousers with legs gathered at the ankles (*sashinuki*), and shoes. He stands at ease with his right foot forward, hips slightly back, his left hand on his hip and his right hand holding an object that is now missing. All three figures are carved from one piece of Japanese cypress and coloured.

Mikami Shrine is an ancient shrine, situated near the sacred mountain Mt Mikami, and *sumō* has been a part of

the harvest celebration for centuries. The tradition continues to this day with children's *sumō*, once known as sacred *sumō* and performed by young *kami* (*Wakamiya-dono sumō goshinji*). The history of sacred *sumō* at the shrine goes back to the medieval period.

It was once customary to donate a wooden model of horses to shrines, and these *sumō* figures may have been dedicated to the shrine in a similar act. Since the *sumō* tournament at shrines was supposed to be judged by the *kami*, the slightly larger figure of the referee in this group is sometimes interpreted as a supernatural being. YK

98 Bronze plaque
fragment with incised image
of Zaō Gongen

Heian period (794–1185), dated 1001

Sōji-ji Temple, Tokyo

H. 68.0 cm, W. 76.1 cm

National Treasure

99 Cast bronze plaque
with image of Zaō Gongen

Heian period (794–1185)

Ōminesan-ji, Nara

H. 53.3 cm, W. 30.3 cm

Important Cultural Property

Zaō Gongen is an indigenous deity of
Japan who was revered as the main icon
of mountain asceticism (*Shugendō*) based
in Mt Kimpu in the Yoshino area, pre-
sent-day Nara Prefecture, but his origin
is ambiguous. The legend maintains that
the founder of the *Shugendō* movement,
En no Ozunu (En no Gyōja), a mystic
active in the seventh to eighth centuries
visualized the image of Zaō Gongen on
Mt Kimpu in the late seventh century,
Shōhō (932–909), a monk from the
Daigo-ji Temple in Kyoto, commissioned
a statue of Kongō Zaō Bosatsu at Mt
Ōmine. This deity is understood to be
one of the attendants protecting the main
icon, Nyoirin Kannon, and the original
form of Zaō Gongen was probably such
a guardian deity. By the tenth century,
Kongō Zaō Bosatsu was revered inde-
pendently as an important guardian
deity of Mt Kimpu. In the eleventh cen-
tury, the practice of sutra burial became
popular among the aristocrats who wor-
shipped Kongō Zaō Bosatsu, and he was
perceived as the manifestation of the
Buddha Sakyamuni in Yoshino. The
appellation of Gongen (avatar, a tempo-
rary representation) began to be used
from around this time. The cult of Zaō
Gongen based on Mt Ōmine began to
spread to the *Shugendō* movement

98 front

98 back

throughout the country, and inspired the creation of many images.

There are over two hundred surviving images of Zaō Gongen dating from the Heian period, most of which are on mirrors and plaques or gilt-bronze figures excavated from Mt Ōmine. They are mainly related to the ascetic movement. The characteristics shared by these Heian period images shows the deity holding a ritual instrument in his raised arm. The other arm is lowered and he is stamping on the ground with one leg while raising the other. His hair stands on end, and his expression is a fierce glare. The details vary enormously: a different arm or leg can be raised; various forms of ritual instruments, crowns or pedestals are added; backgrounds vary. The diversity of images indicates a complex fusion of iconography originating from various deities, such as Shukongōshin from the eighth century, and the Esoteric Buddhist deities Kongō-dōji and Godairiki Bosatsu, introduced from China in the ninth century. The emergence of the indigenous deity Zaō Gongen within the cult of Mt Ōmine incorporated numerous elements from the existing iconography and characteristics of Buddhist images in the developing stage. The many various forms of the deity were initially all accepted as Zaō Gongen of Mt Ōmine, but eventually an archetypal form developed embodying the typical characteristics of the present pieces.

The fragment (cat. no. 98) is a sacred image (*mishōtai*) incised on a cast bronze plaque in the shape of a mountain. Unfortunately, a large part of it has been lost, but it was presumably held upright by inserting the lower part into a stand.

The back of the plaque is inscribed with some Sanskrit characters, the date (the third year of the Chōhō era) and the name Takumi-no-tsukasa. This indicates that it was manufactured in the imperial studio in 1001.

It is the oldest dated example among the extant images of Zaō Gongen, and presents him typically with a fierce expression, three eyes, two arms, raised right hand holding a three-pronged *vajra* and raised right leg. The most unusual feature of this plaque is the depiction of demonic deities with multifarious expressions, posture, costumes and attributes in the background. The incised lines are supple and fluid, with only a few thick lines. The figures of deities are neatly incised, and their arrangement is precise, yet not monotonous. The space is filled with a strong tension. Although this image is the earliest among the dated examples, it is the most accomplished work. Apart from its art historical significance, it is recognized as an important historical artefact of the Zaō Gongen cult. It is known that the plaque was enshrined at the summit of Mt Kimpu (Mt Ōmine) during the Edo period (1615–1868) and provides evidence that the cult flourished.

The cast bronze plaque with the raised line image (cat. no. 99) is one of the numerous images of Zaō Gongen excavated from Mt Ōmine. The typical characteristics of Zaō Gongen can be observed even more clearly than in the fragment (cat. no. 98) in its details. They include his crown with Esoteric Buddhist ritual instruments, the stretched second and third fingers on his hip, and the rock-shaped pedestal. Cords were threaded through the circular holes in the upper section to suspend the plaque, and it was presumably worshipped as an icon. Other examples of cast bronze plaques with relief images exist, but this plaque is unusual in the use of a raised outline and the gently swelling surface of the face, body and limbs. The combination of line and facets for the depiction of rock is skilfully executed. Over all, the cast bronze technique was employed to create a painting-like effect. SI

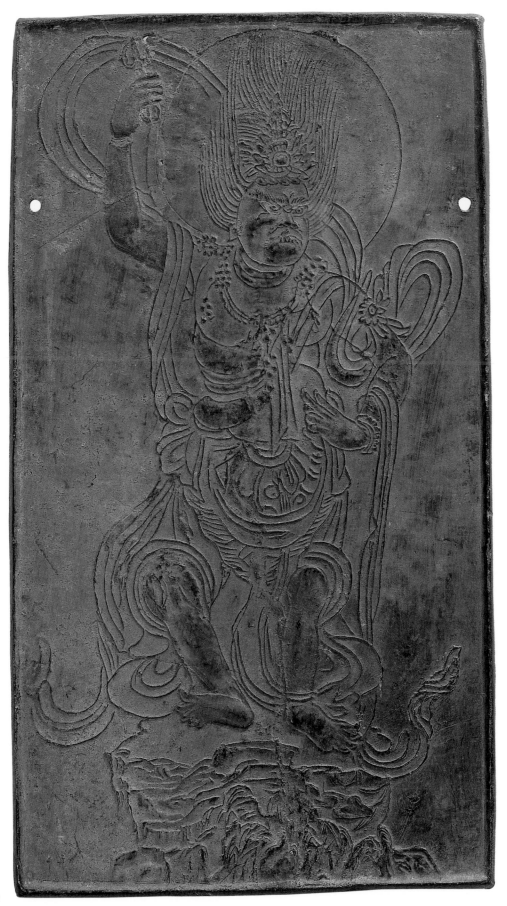

100 *Kakebotoke* with images of Kumano Jūnisha Gongen

Kamakura period (1185–1333)

Hosomi Art Institute, Kyoto

Diam. 41.3 cm

Important Cultural Property

This cast bronze plaque is one of the articles related to the mountain cult at Kumano in the province of Kishū (present-day Wakayama Prefecture), and it depicts thirteen figures of Buddhist manifestations (*honjibutsu*) from the twelve Kumano Shrines. The figures of the deities are gilded, and their facial features are added in ink and vermilion. The projections at the back of the figures are inserted into holes in the plaque and secured on the reverse. The aureoles behind the deities are pierced with scrolling floral motifs. The circular bronze plaque is plated in tin to imitate a mirror, and strengthened by a piece of wood at the back. Two metal rings are attached for suspension. The technical and stylistic features, such as the attachment of separately cast figures on the bronze sheet, the addition of cypress wood for strengthening, and the forms of figures, date it from the early fourteenth century. It is the earliest example of a sacred image (*mishōtai*) with thirteen deities of the twelve Kumano Shrines, and it is valued for its fine finish and excellent condition.

Suspended circular simulated mirrors with three-dimensional figures of Shintō or Buddhist deities, such as this plaque, are called *kakebotoke*. They were hung under the eaves of shrines and halls housing images of deities, and began to be made in the Heian period from around the second half of the eleventh century. *Kyōzō* with incised or painted images of deities on real bronze mirrors were produced in the preceding stage of religious development. It can be said that, chronologically, *kyōzō* developed into *kakebotoke*, but *kakebotoke* is a modern term, and both *kyōzō* and *kakebotoke* were called *mishōtai* in the Pre-Modern era. The term *mishōtai* denoted the actual existence of *kami*, but it was also used broadly for all objects symbolizing *kami*.

Bronze mirrors were often enshrined as treasures in the distant past. Such mirrors incised with Buddhist deities or mandala first appeared in the Buddhist context from around the tenth century, but with the development of the theory of Origin and Manifestation (*honji-sui-jaku*), concrete images of *kami* in their original Buddhist forms began to be depicted on symbolic mirrors. The *honji-suijaku* theory is an amalgamation of Buddhist philosophy from abroad and the indigenous Shintō faith, and Japanese *kami* were interpreted as the manifestation of Indian Buddhas and Bodhisattvas. From the eleventh century onwards, therefore, images of *kami* and Buddhas began to be depicted, and plaques imitating mirrors (cat.no.98) were sometimes used. The plaques began to be suspended by cords at about the same time. The flat surface gradually assumed a solid quality in the twelfth century when cast bronze plaques with relief figures such as cat.no.99, and plaques with thin attached figures and metal rings for suspension were created. The object called *kakebotoke* became distinctive. From the thirteenth century onwards, the figures became almost three dimensional. They were cast separately and then attached to the base. As they increased in size, stronger metal fittings were attached. SI

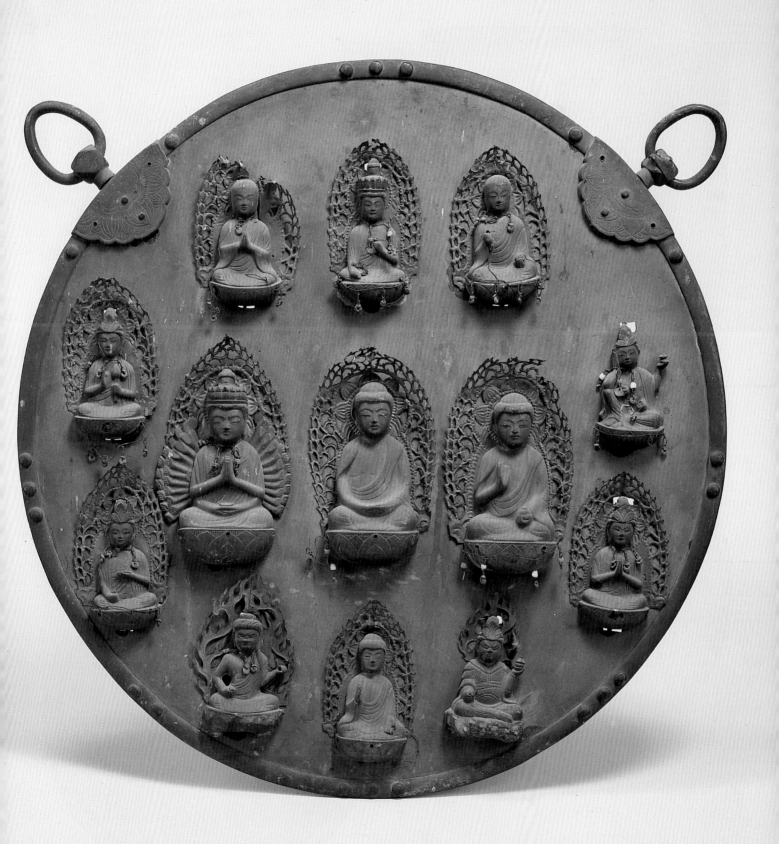

101a

101 Daijingū black lacquer miniature shrine

Kamakura period (1185–1333)

Saidai-ji, Nara

Miniature shrine: H. 55.5 cm, W. 44.2 cm;
Mirrors: Diam. 30.3 cm, 11.8 cm

Important Cultural Property

Daijingū is commonly known as Ise Shrine in Mie Prefecture, which attracted ardent devotion from an early period. This miniature shrine (101a) contains two white bronze mirrors that are regarded as the sacred images (*mishōtai*) of the shrine. The miniature shrine is made of wood, covered in black lacquer with gilt-bronze metal fittings. The front and back of the shrine are fitted with doors that open outwards from the centre, and two wooden panels are fitted inside.

The front of the panels is decorated with multicoloured mandalas composed of Sanskrit characters (*shuji*). The back of the panels (101b) has a circular indentation with a mandala of Sanskrit characters, and the surrounding area has Sanskrit characters in gold on a black lacquer ground. The edges of the panels and the sunken circles are trimmed with gilt bronze fittings. The white bronze mirrors (*mishōtai*) were fitted inside the circular areas. One of the mirror's motifs

101c

101d

(101c) are of two cranes on a shore in the lower half and cherry flowers in full bloom in the upper half. The other mirror's motifs (101d) are of water and a sandy shore, birds, insects such as dragonflies and locusts, a spider web, foxtail flowers and snake gourds.

Eight documents, five kind of medicine, and five kinds of grains (not in the exhibition) were found in the space in between the two panels. The documents are related to Eison's visits to Ise Shrine. Eison (1201–90) was a priest of Saidai-ji Temple in Nara who worked tirelessly for the revitalization of the temple, and contributed greatly to the history of Japanese Buddhist thought. He visited Ise Shrine three times in his lifetime, and he is well known for his devotion to the awesome power of the *kami*.

Eison's attitude towards *kami* reflects the Shintō-Buddhist syncretism of the period, which is clearly illustrated in this miniature shrine. The fronts of the two panels holding the mirrors are decorated with the Womb World (101e) and the Diamond World (101a) mandalas which symbolize the fundamental principles of the universe in Esoteric Buddhism. The Womb World was sometimes identified with the Outer Shrine of Ise, while the Diamond World was identified with the Inner Shrine. The mirrors symbolizing these two shrines were placed in the corresponding mandalas, and this miniature shrine is a testimony to the correlation of Esoteric Buddhism and the cult of Ise cultivated by Eison.

The miniature shrine is simply covered in sombre black lacquer, but once it is opened, its meticulous artistry is obvious. The mandalas depicted on the panels are executed with skill. Though the motifs on the mirrors show a tendency towards rigid stylization, they are finely cast, and noteworthy for the large size and the detail of the cherry blossoms on one mirror, and the rare motifs on the other. As they were stored in the miniature shrine, the mirrors and the mandalas are in excellent condition. Specialist skills in painting, lacquer and metalwork are abundantly evident in this work. SI

101b

101e ▶

102 *Tachi*-type sword blade

Late Kamakura period (early fourteenth century)

Made by Kagemitsu and Kagemasa

Saitama Prefectural Museum

L. 22.4 cm

National Treasure

The *tachi*-type sword (102a) was worn at the belt suspended from cords or chains (cat. no. 105) when the wearer was on horseback. The inscription on the tang of the blade (102b) is of the two smiths Sahei-no-Jo Kagemitsu and Saburō Kagemasa of Osafune village in Bizen Province (present-day Okayama Prefecture). They were invited to Harima Province (present-day Hyōgo Prefecture) in order to make this sword (102c) as a treasure for the Hiromine Shrine. The commissioner and donor of the sword is named as Okabara Tokimoto, a native of Chichibu in Musashi Province (present-day Tokyo, Saitama, and part of Kanagawa Prefecture). The sword was important as a possession for the *kami*, being one of the 'Three Sacred Treasures'. Some swords were designated as the *shintai*, the earthly receptacle for the spirit of the *kami*. The Shiawa district was a source of iron transported along the Yoshii river to Osafune for swordmaking, explaining the connection with these two smiths. Both of them made a number of swords which are honoured as National Treasures.

The beauty of this sword lies in its shape, the various textures of steel in the folded structure of the blade, and the heat-treated area (*hamon*) with varied crystalline structures along the cutting edge. Kagemitsu and Kagemasa made blades with straight *hamon*, with undulating patterns (*gunome*), or the pattern known as *chōji* (cloves) from its likeness to a row of clove flowers. During the Kamakura period, smiths developed greater control over forging and heat-treating processes and introduced decorative metallurgical effects on the blades. Bizen Province work of the period is characterized by the white shadow along the body of the blade, called *utsuri* (reflection), as visible on this blade (102a). VH

◀ 102b, 102a, 102c

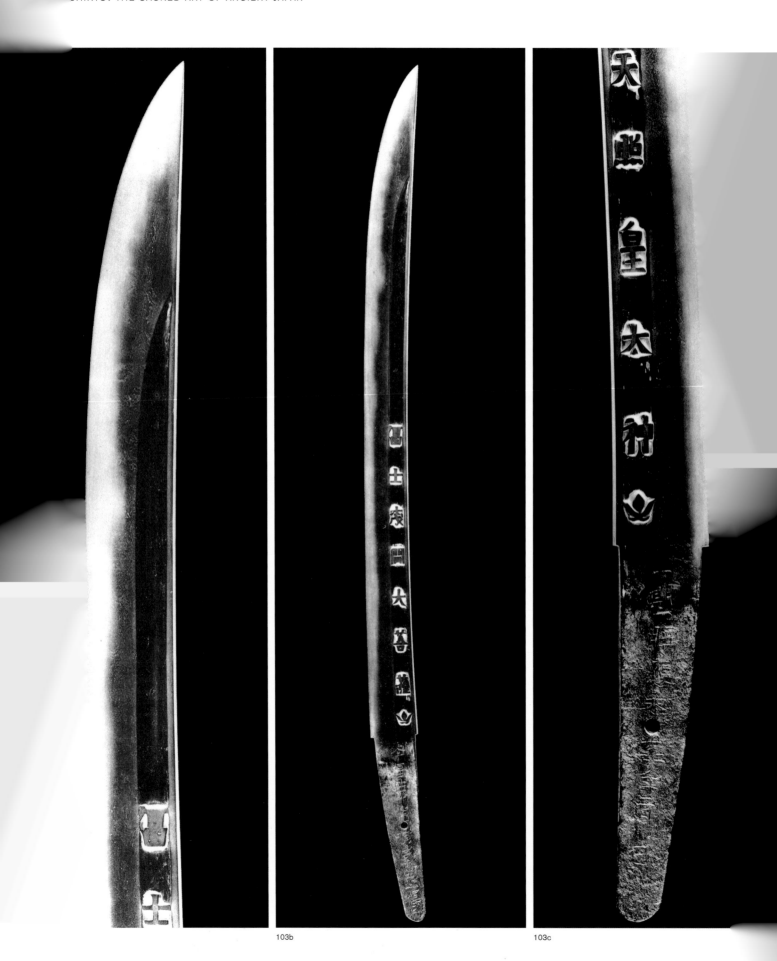

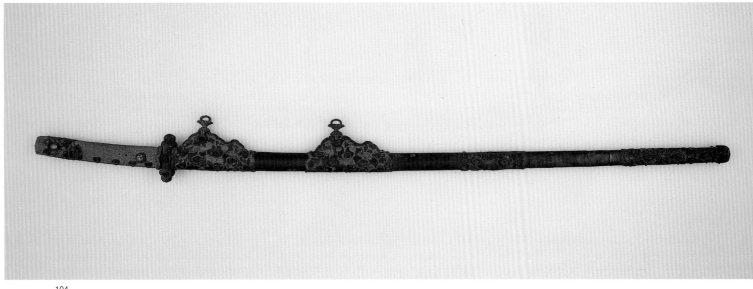

104

103 *Wakizashi*-type sword

Made by Miyamoto Shikibu No Jo Nobukuni

Muromachi period (1392–1573), dated 1397

Fuji-san Hongū Sengen Jinja

Shizuoka Prefecture

On loan to Tokyo National Museum

L. 43.9 cm

Important Cultural Property

The inscription on the tang of this sword (103c) gives the name of the maker, Nobukuni and says that it was a votive gift to Fuji Hongū Shrine. It also has the words *ichigo hitogoshi* signifying 'One Sword in a Lifetime'. It is probable that Nobukuni made this sword as his personal offering to the shrine.

The inscription on the blade's *omote* (103a) (the side seen when the blade is placed with the cutting edge up and the point to the right) is *Fuji Sengen Daibosatsu* (103b, The Great Bodhisattva of Sengen Shrine of Mt Fuji). On the reverse (*ura*) (103c) it says *Amaterasu Kotaijin* (The Imperial Kami Amaterasu, known as the Sun Goddess). The ends of the grooves have depictions of lotus petals intimating a Buddhist rebirth of the *kami*.

The main *kami* of Sengen Shrine, or more formally, Asama Shrine, is the female Konohana-no-saku-yabime-no-mikoto, but also revered are Ninigi-no-mikoto and Oyamatsumi-no-kami. The shrine marks the start of the pilgrims' route up Mt Fuji. The mountain was also associated with the Buddhas Dai-Nichi Nyōrai (Vairocana) and Amida (Amitabha). Pilgrims of the Amida sects considered the climb to the summit of the mountain analogous to entry into the Pure Land, the heaven of Amida Nyōrai. There are shrines with the same name throughout Japan, of which those of the Higashi Yashiro district in Yamanashi Prefecture (Kai-no-Kuni Ichinomiya) and this shrine are well known. VH

104 Black-lacquered *tachi*-type sword mounting

Heian period (twelfth century)

Kasuga Taisha, Nara

L. 108.6 cm

National Treasure

This sword is one of the sacred treasures of Kasuga Shrine. The black-lacquered scabbard has metal fittings carved with floral arabesques in the Chinese style.

Traces of colour survive in places, and there are settings for precious stones (now missing). The hilt is wrapped in rayfish skin, and some lapis lazuli and other gemstones remain in their settings on the pommel. The blade (not exhibited) is of steel, but as it was never heat-treated, it was not intended for use in combat. There are traces of gold lacquer designs on the black scabbard, indicting that the sword must once have been very luxurious. Such mountings were standard for high-ranking courtiers on ceremonial occasions.

This example may be compared with the faithful twentieth-century reproductions of earlier swords which form part of the sacred treasures of Ise Shrine (cat. nos. 53, 54). As the custom was for sacred treasures to be replaced periodically, few survive from an early period. This example accordingly is of great historical as well as spiritual importance. VH

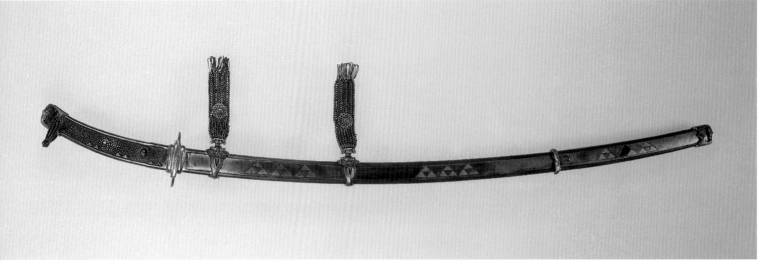

105

105 Hyogogusari *tachi* sword mounting

Kamakura period (thirteenth century)

Tokyo National Museum

L. 103.8 cm

Important Cultural Property

The metal fittings of this sword mounting are of undecorated silver. The hilt is wrapped with rayfish skin and edged in silver. The wooden scabbard is completely clad in silver with three sets of triplicate designs plated with gold and with engraved outlines, signifying the triple-fish-scale clan badge of the Hōjō family. The hilt is pierced with a row of purely decorative pins with heads of the same triangular shape, representing the retaining pins or sword mountings of earlier periods.

Swords in such mountings were popular as luxurious gifts between warriors and the nobility in the Heian (794–1185) and early Kamakura periods, but thereafter were generally made as devotional offerings to shrines and temples. This example was given by one of the Hōjō clan to Mishima Shrine. VH

106 *Tachi*-type sword blade

Heian period (eleventh–twelfth century)

Made by Yasutsuna

Tokyo National Museum

L. 71.7 cm

Important Art Object

The tang (106c) of this sword is signed with the two-character name of Yasutsuna, who worked in Hōki Province, the western part of present-day Tottori Prefecture. It is representative of the earliest of the fully developed curved swords made around the middle of the Heian period, although, according to old Japanese records, Yasutsuna was working in the Daidō era (806–809). The technology of forging swords by repetitive folding, welding, and finally heat-treating by quenching the heated blade in water was used in China during the Kofun period (third–sixth century AD). Many straight swords were brought from China during the middle Kofun period, and Japanese artisans learned the technology from immigrant Chinese and Korean smiths. For several centuries, the technology was gradually improved and took on a uniquely Japanese character. Sword-making became one of the most important professions, and the forges of swordsmiths were regarded as sacred places. Sword manufacture was carried out with prayers and purification rituals of Shintō. The respect for tradition, materials and the part that nature plays in

metallurgy, and the willingness to learn and adapt from other cultures at the heart of Shintō have all contributed to making the Japanese sword the finest cutting weapon of any culture. Such respect and willingness to adapt lies at the root of the Japanese ingenuity in industry.

The first curve in Japanese sword blades started in the tang and later became a deep curve around the bottom of the blade, with the upper part of the blade virtually straight. The fully developed curve came about sometime in the middle Heian period, together with the blossoming of the Japanese courtly culture. At the same time, the Japanese cursive script (*hiragana*) was developed from Chinese characters. Since the stages of sword polishing are mentioned in the *Engishiki* (Record of the Engi era, 901–22), it can be inferred that the highly polished Japanese sword blade was regarded as an object of intrinsic beauty at the time.

The hues and textures of the mixture of different qualities of steel and the free patterns of the heat-treated edge of the sword are said to resemble natural phenomena such as cloud formations, lightning and distant mountain profiles. In this respect, the beauty of the sword blade is paralleled by the beauty of ash-glazed ceramics (cat. nos. 56–59), which in ancient times was thought of as the result of the activity of the *kami* of the kilns, beyond the immediate control of people.

VH

106a, 106b, 106c ▶

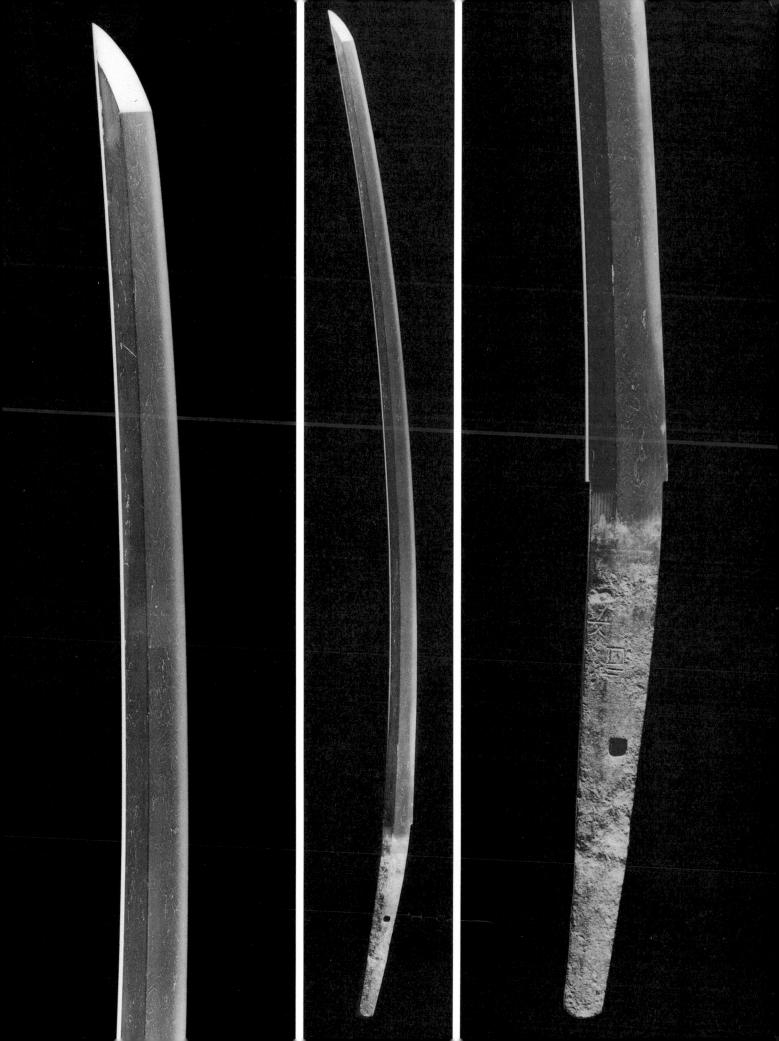

107 Ōyoroi
(Great Harness) armour

Muromachi period (sixteenth century)

Hasedera Temple, Nara

Cuirass: H. 34.7 cm; skirt: H. 20.5 cm

Important Cultural Property

It is known from excavated objects and from the decorations on *haniwa* (clay figurines) that *tankō-* and *keikō*-type armour was being worn during the fourth to sixth centuries of the Kofun period (third–sixth century AD). *Tankō* were made of layers of iron plate, mainly for protecting the trunk, a style found everywhere in the world throughout history. *Keikō* are formed of a number of platelets (*kozane*) of iron or leather linked together by cords to cover the whole body and were particularly influenced by the horse-riders of Asia. In the latter half of the eighth century, during the Nara period, the old social system changed, and a warrior class (*bushi*) emerged to flourish in each province. Armour-making changed from official to private manufacture. Improvements in the manufacture of *keikō* resulted in the creation of the

ōyoroi (great harness) for the cavalry and the *dōmaru* (round the trunk), but at the time called *haramaki* (stomach wrap), for the infantry. Then in the fourteenth century a simplified form of the *dōmaru* was developed and the *hara-ate* (stomach protector) was added.

In the latter half of the sixteenth century, the method of warfare changed from cavalry combat to group combat using spears and guns. This required the addition of further pieces to cover the whole body, such as sleeves and leg-pieces, so new fashions called *tōsei-gusoku* (equipment of the times) emerged. Japanese armour can be divided into the five categories of *ōyoroi*, *haramaki*, *dōmaru*, *tankō* and *keikō*. The earlier styles of these continued to be made in later times.

Major characteristics of the *ōyoroi* were that the cuirass did not close on the right side but was covered by a separate piece called the *waidate*, and the skirt (*kusazuri*) was in the form of a box with pieces in front, behind and to the left and right. The earliest surviving *ōyoroi* date from the tenth century, but most are from the twelfth century onwards. The early

pieces are practical and simple in design, but armour tended to veer away from practicality towards ornamentation in the thirteenth century.

This *ōyoroi* is constructed from platelets (*sane*) linked in groups of three (*sanmaizane*). The important parts, like the front, are formed of alternating rows of black lacquered leather and black lacquered iron platelets to give added strength. The platelets are joined together with braid and decorated with gilt-bronze chrysanthemum and paulownia flowers. The sides are protected with large sleeves of similar construction. The ancient style is followed in the great width of the platelets and their use in sets of three, but the overall tailoring appears to have been improved at a later time. This armour was dedicated to Yokiten Jinja Shrine of Hasedera Temple in Nara by Rōbō Takakata in 1597. The same shrine fetes Sugawara no Michizane (845–903), a scholar later to be deified as the Tenman Tenjin, and it is believed to have been established in its present situation in the thirteenth century. The Rōbō family played an important role as leaders of armed monks (*sōhei*) employed for generations in Hasedera Temple.　SI

108 Fifty-eight-plate helmet with coloured braid

Muromachi period (sixteenth century)

Sata Jinja, Shimane Prefecture

H. 10.2 cm

Important Cultural Property

Helmets of this sort were composed of a bowl to protect the head and a piece to protect the neck (*shikoro*). The bowls were formed of iron plates joined with rivets called *hoshi* (stars) protruding over the surface. Often the helmets were lacquered black. They were sometimes packed with straw as a shock absorber, held in place by a hemp inner cap.

Early helmets had few iron plates and the rivets were large. As technology progressed, the number of plates increased and the size of the rivets decreased. The sense of self-expression, too, became stronger and the helmets were fitted

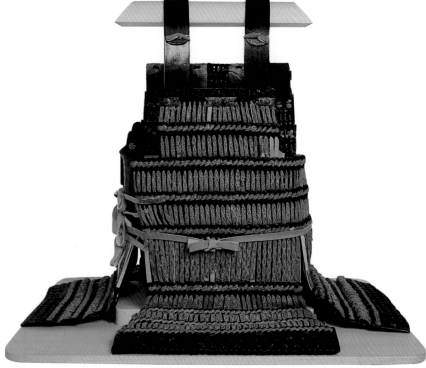

107

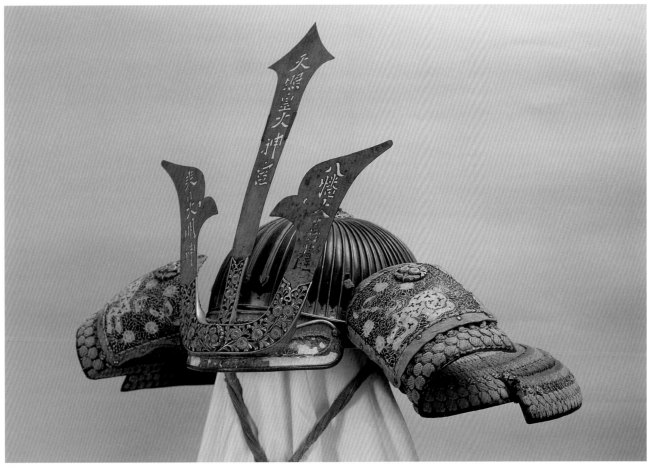

108

with large, gorgeous crests. By the sixteenth century there were many strange variations in the shape of the bowl, forming mountains, animals, marine creatures and tools, among others.

This helmet is formed of a hemispherical bowl of thirty-two iron plates with ridges formed along their edges, and is lacquered black overall. The support for the frontal crest is of gilt-copper, pierced with a design of chrysanthemum flowers and stems. The crest is also of gilt-copper and is pierced with two invocations: Hachiman Daibosatsu (The Great Bodhisattva Hachiman) and Kasuga Daimyōjin (The Great Illuminating Deity of Kasuga Shrine). On the front also is a plate of gilt-copper called a *maetate*. It is in the form of a double-edged sword (*ken*), pierced with the invocation Amaterasu Kōtai Jingū (the Sun Goddess). The *shikoro* is formed of rows of leather platelets stiffened with black lacquer, linked together by purple, vermilion, pale green and white braid which

are woven through many holes. The *shikoro* is swept back on the left and right at the front, and has pieces of dyed and cut-out leather depicting lions (*shishi*) and peonies. The technology of manufacture and the design sense are similar to those of the *haramaki*-type armour (cat. no. 109), and it is thought that this helmet may have been made in the same workshop.

The ensemble of the three deities on the *kuwagata* (hoe-shaped section) and *maetate* reflects a branch of faith which flourished from the Kamakura period (1185–1333) and throughout the Edo period (1615–1868). Many sets of three hanging scroll paintings of the triad, with Amaterasu-ōmikami in the centre, flanked by Hachiman Daibosatsu on the right and Kasuga Daimyōjin on the left, were made as objects of worship. The triad paintings were known as Sansha Takusen (Oracle of the Three Kami), and had written invocations relating respectively to honesty, purity and benevo-

lence. In the Heian period around the eleventh and twelfth centuries, the Fujiwara family wielded absolute power at the imperial court. They revered Amaterasu-ōmikami, the ancestral *kami* of the imperial family, and their own ancestral deity, Kasuga Myōjin. As a protector deity of Buddhism, the *kami* Hachiman became recognized in the latter half of the eighth century by the Buddhist appellation Hachiman Daibosatsu (The Great Bodhisattva Hachiman). In the Kamakura period around the thirteenth century, the three deities came to be regarded as a set, and in line with the concept of the amalgamation of *kami* and Buddhas (*shimbutsu shūgō*), they were revered in both Shintō and Buddhism. This popularization significantly affected the history of Shintō in the fifteenth century. SI

109 Set of armour,
iroiro odoshi-style *haramaki*
with helmet and sleeves

Muromachi period (sixteenth century)

Sata Jinja, Shimane Prefecture

Cuirass: H. 24.8 cm; skirt: H. 31.2 cm;
helmet: H. 11.8 cm

Important Cultural Property

The *dōmaru* (round the trunk) style of armour was devised in the Nara period (710–794) as an improvement on the existing armour. It is characterized by the cuirass closing on the right side and the skirt called a *kusazuri* formed of from five to nine pieces suspended in such a way as to allow free movement. Later, in the fourteenth century at the end of the Kamakura period, the *dōmaru* was simplified, and the *haramaki* (stomach wrap) evolved. However, the names *dōmaru* and *haramaki* became confused during the sixteenth century and were interchangeable during the Edo period (1615–1868). The present-day nomenclature is the Edo version. Both types of armour were developed for the use of low-ranking infantry. They were easy to put on, take off and move around in. Eventually high-ranking warriors came to use such armour, and they were made as sets with sleeves and helmets.

The use of platelets in linked groups of three in this armour is an early style. The braid linking them is not original, since the armour was rebuilt when it was dedicated to the shrine.

This armour is the *haramaki* type in which the cuirass is joined at the back. The skirt (*kusazuri*) is of seven pieces. It is made of black-lacquered platelets linked by purple, vermilion and white braid, with gilt-copper fittings at strategic places. The sleeves are of the same kind of construction. The upper parts of the sleeves and the cuirass are covered with pieces of dyed leather decorated with a design of lions (*shishi*) and peonies. The helmet is formed of thirty-two plates joined together with the turned-back edges of each plate forming a vertical ridge, the whole being lacquered black. The back and side neck protection (*shikoro*) comprises black-lacquered platelets linked together by coloured braid like the sleeves and cuirass. On the front of the helmet is a large decorative crest of gilt-copper. This widens out at the top in a form called *kuwagata* (hoe shape), this one modelled on the leaf of the *kaji* or *kuwa* tree of the mulberry family. The body armour, cuirass, sleeves and helmet with its extravagant crest is typical of the sixteenth century in the Muromachi period, when the use of the *haramaki* by elite warriors was prevalent. Sata Jinja Shrine is dedicated to the *kami* Sata Daishin. It is of great age, and the name is recorded in a local record of the late eighth century. It came under the protection of a noble military commander who governed the area during the Age of Wars (*sengoku jidai*) from the fifteenth century. This armour was dedicated by one of those military lords, Amago Tsunehisa (1458–1541), in supplication for continuing victory in battle. There are many surviving examples of military equipment dedicated to the *kami* in order to ensure victory. The shrine also possesses a further set of armour complete with helmet and sleeves (Important Cultural Property), similar to this one in its technique of manufacture and decoration. SI

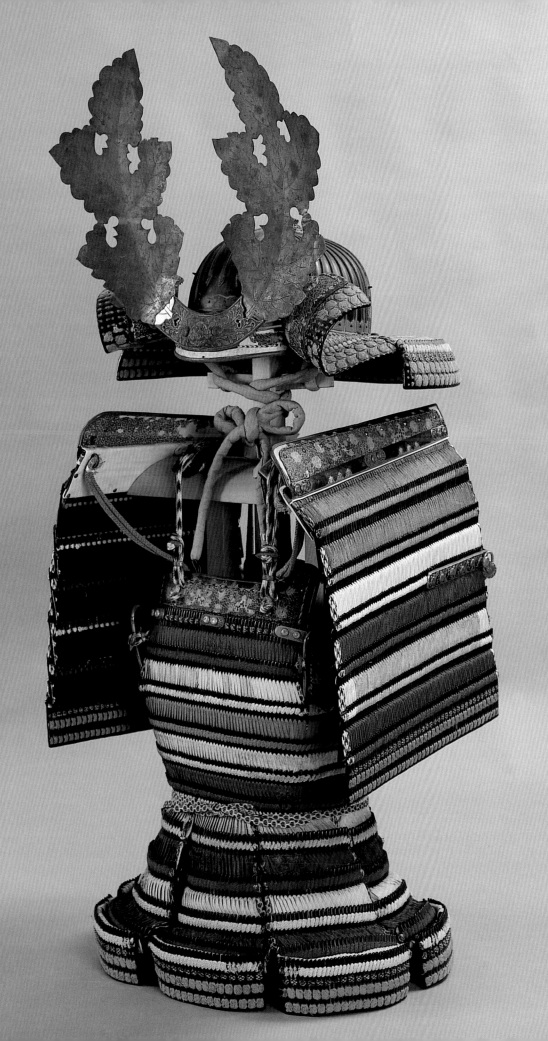

110a, outer box

110b, outer box

110 Kasuga dragon jewel boxes

Nambokuchō period (1333–92)

Nara National Museum

Outer box: H. 43.3 cm, W. 51.8 cm, D. 44.5 cm; inner box: H. 37.8 cm, W. 38.6 cm, D. 37.4 cm

The two boxes are made of Japanese cypress covered in black and transparent lacquer and painted in colour on both the exterior and interior of the lids. The painting on the exterior of the lid on the outer box (110a) is indistinct because of extensive loss of pigment, but seems to depict a dragon and waves. The interior of the lid is well preserved (110e), and the figures of the Wind God, Thunder God, eight male deities dressed in formal robes and carrying a dragon, and three dragons are depicted in a landscape of pine trees, hills and flowing water.

The side panels of the outer box are also decorated with landscape elements and various figures. The pigment is partially lost in the upper section of the front panel (110b), whose discernible left part shows the Twelve Guardian Deities (*Jūnishinshō*) and a male *kami* riding on a deer. The *kami* holds a branch of the sacred tree. On the right part, a female *kami* on a deer also holds a branch of the sacred tree and the Ten Kings of Hell (*Jūō*) appear. The right-hand side panel (110c) depicts a female *kami* and a youthful *kami* riding deer, and the Twelve Constellations (*Jūni-kyū*). The left-hand side panel (110d) shows a male *kami* with a bow and arrow on a deer, surrounded by the Twelve Devas (*Jūni-ten*). Gilt-bronze fittings are attached at the appropriate corners.

The inner box (110g) has a similar construction, but its exterior is simply decorated with a repeated wave pattern. The exterior of the lid has a painting showing eight figures of demonic deities holding jewels, and cattle, a horse, a carriage and a ship among the landscape elements.

110c, outer box

110d, outer box

110e, inside lid of outer box

The interior of the lid (110f) is similar to the exterior, but the deities are holding different objects and one of them is shown as a youthful *kami*.

The subject matter of the paintings derives from two main themes, the first of which is the dragon. Many of the motifs are related to dragons, such as a dragon with a jewel, the Eight Great Naga Kings carrying a dragon, demonic deities and a youthful deity holding a jewel (said to symbolize the dragon), and the conventional wave pattern for the background. The second theme is the *kami* of Kasuga. The five figures on the side panels of the outer box are thought to depict the five main *kami* of Kasuga. The deer are depicted in customary style with a saddle, stirrups and a protective cover. The iconography of the four groups of Buddhist deities needs to be investigated further, but some of them represent the attendants of the Buddhist counterparts of the Kasuga *kami*. For instance, the Twelve Guardian Deities are the guardians of Yakushi who are regarded as the Buddhist form (*honji*) of the Second Shrine of Kasuga, and the Ten Kings of Hell are associated with Jizō who is the *honji* of the Third Shrine.

Textual sources indicate the worship of Hachiryūshin (Eight Dragon Deities) at Kasuga in the late twelfth century, and these boxes presumably contained the dragon's symbol, a jewel. Esoteric Buddhism from the ninth century sometimes identified the jewel with the relic of the Buddha Sakyamuni. With the spread of Shintō–Buddhist syncretism,

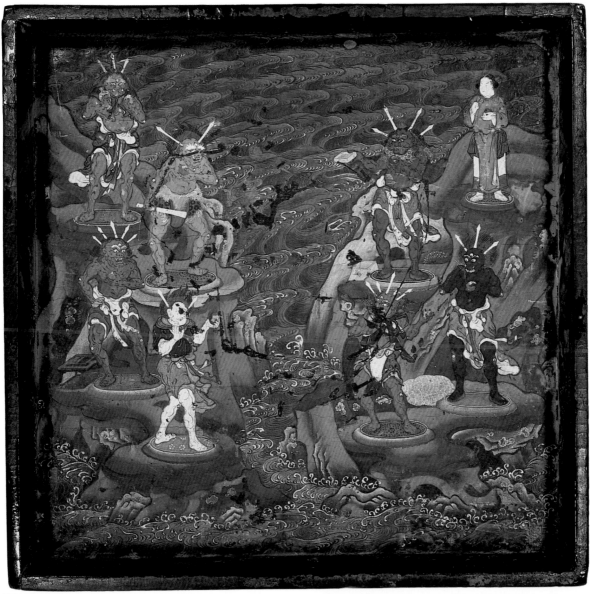

110f, inside lid of inner box

relics and jewels attracted ardent devo-
tion at Kasuga Shrine from the thirteenth
century onwards. These boxes reflect the
synthesis of devotion to Kasuga Shrine,
the jewel and the dragon deity. They are
the only examples of their kind, and
details of the iconography still remain to
be clarified. SI

110g, inner box

Chronology

Jōmon Period	12,500–300 BC
Incipient Jōmon	12,500–8000 BC
Initial Jōmon	8000–5000 BC
Early Jōmon	5000–2500 BC
Middle Jōmon	2500–1500 BC
Late Jōmon	1500–1000 BC
Final Jōmon	1000–300 BC
Yayoi Period	300 BC–AD 300
Early Yayoi	300 BC–100 BC
Middle Yayoi	100 BC–AD 100
Late Yayoi	AD 100–AD 300
Kofun Period	third–sixth century AD
Asuka Period	late sixth century AD–AD 710
Nara Period	AD 710–794
Heian Period	AD 794–1185
Kamakura Period	AD 1185–1333
Nambokuchō Period	AD 1333–1392
Muromachi Period	AD 1392–1573
Momoyama Period	AD 1573–1615
Edo Period	AD 1615–1868
Meiji Era	AD 1868–1912
Taishō Era	AD 1912–1926
Shōwa Era	AD 1926–1989
Heisei Era	AD 1989–

This convention has been adopted in the light of current scholarship although it is acknowledged that advances in archaeology and historical studies inevitably bring discrepancies and changes.

Bibliography

Aikens, C. & Higuchi, T., *Prehistory of Japan*, New York, London, Academic Press, 1982

Aston, W. G. (trans.), *Nihongi: Chronicles of Japan from the Earliest Times to AD 697* (translation of the *Nihongi*, otherwise called the *Nihon shoki*), London, *Transactions of the Japan Society*, 1896, reprinted Charles E. Tuttle Co. Inc., 1972

Barnes, G., *Proto-Historic Yamato: Archaeology of the First Japanese State*, University of Michigan Center for Japanese Studies, 1988

Blacker, C., *The Catalpa Bow: A Study of Shamanistic Practices in Japan*, London, Harper Collins, 1992

Bocking, B., *A Popular Dictionary of Shintō*, Curzon, 1995

Brashier, K., 'Longevity Like Metal and Stone: The Role of Mirrors in Han Burials', *T'oung Paou* LXXXI, pp. 201–29, Leiden, E. J. Brill, 1995

Breen, J. & Teewan, M. (eds) *Shintō in History*, Curzon, 2000

Chamberlain, B. H. (trans.), 'Kojiki', London, *Transactions of the Asiatic Society of Japan*, 1882

Downs, J. et al., *Horses and Humanity in Japan*, Japan Association for International Racing, 1999

Edwards, W., 'In Pursuit of Himoko: Postwar Archaeology and the Location of Yamatai', *Monumenta Nipponica* 51.1, pp. 53–79

Edwards, W., 'Mirrors on Ancient Yamato: The Kurozuka Kofun Discovery and the Question of Yamatai', *Monumenta Nipponica* 54.1, pp. 76–106, 1999

Grotenhuis, E. ten, *Japanese Mandalas: Representations of Sacred Geometry*, University of Hawaii Press, 1999

Guth, C. & Kageyama, H., *Shintō Arts*, exhibition catalogue, New York, Japan House Gallery, 1976

Herbert, J., *Shintō, The Fountainhead of Japan*, New York, Stein and Day, 1967

Imamura, K., *Prehistoric Japan: New Perspectives on Insular East Asia*, London, UCL Press, 1996

Inagaki, E., *Kodai no Jinja Kenchiku*, series *Nihon no Bijutsu* no. 81, Tokyo, Shibundō, 1973

Inokuchi, Y., 'Komochi Daisuke Tsubo Ni Miru Kodai No Shūryō', abstract from *Narazaki Shōichi Sensei Koki Kinen Ronbunsho*, 1998

Jenyns, S., *Japanese Pottery*, London, Boston, Faber & Faber, 1971

Joly, H. L. & Inada, H., *Sword and Samé*, London, 1913

Kageyama, H., *Shintō Bijutsu*, series *Nihon no Bijutsu* no. 18, Tokyo, Shibundō, 1967

Kageyama, H., *The Arts of Shintō*, series *Arts of Japan* no. 4 (trans. C. Guth), Weatherhill, 1977

Kageyama, H., *Shinzō*, Hosei Daigaku Shuppankyoku, 1978

Kaneko, E., *Majinai no Sekai I*, series *Nihon no Bijutsu* no. 390, Tokyo, Shibundō, 1996

Keene, S., *Nō: The Classical Theatre of Japan*, Kōdansha International, 1966

Kidder, E., *Ancient Japan*, Oxford, Elsevier Phaidon, 1977

Kobayashi, T., *Jōmonjin Tsuiseki*, Nippon Keizai Shimbunsha, 2000

Kobayashi, Y., 'Dōhankyō', in *Kofun Jidai no Kenkyū*, Aoki Shoten, 1961

Kobayashi, Y., 'Sankakubuchi Shinjukyō: Keishiki Bunri Hen', in *Kofun Bunka Ron*, Heibonsha, 1972

Loewe, M., 'The Imperial Tombs of the Former Han Dynasty and Their Shrines', *T'oung Paou* LXXVIII, pp. 302–40, Leiden, E. J. Brill, 1992

Matsumoto, S. et al., *Dōken, Dōtaku, Dōhoko to Izumo Ōkoku no Jidai*, Tokyo, NHK, 1986

Matsunaga, D. & A., *Foundation of Japanese Buddhism*, vol. I: *The Aristocratic Age*, Los Angeles, Tokyo, Buddhist Books International, 1974

Minamoto, H., 'Yamatai: The Elusive Kingdom', *Japan Quarterly* Oct–Dec 1983, pp. 373–87

Mori, K. (ed.), *Kodai Nippon no Chie to Gijutsu*, Asahi Culture Books, Ōsaka Shoseki, 1983

Mori, K., *Tennōryō Kofun*, Tokyo, Daikōsha, 1996

Nara Kenritsu Kashihara Kōkogaku Kenkyūsho, *Kurozuka Kofun Chōsa Gaihō*, Gakuseisha, 1999

Nara National Museum, *Sangaku Shinkō no Ihō*, exhibition catalogue, 1985

Nara National Museum, *Ko-Shimpō: Masterpieces of Art Treasures Dedicated to the Gods of Japanese Shintoism*, exhibition catalogue, 1989

Nara National Museum, *Hakkutsu Sareta Kodai no Zaimei Ihō* (*Ancient Archaeological Treasures, Inscribed Works*), exhibition catalogue, 1996

Oba, I., *Shintō Kōkogaku Kōza* (7 vols), Tokyo, Yūzankaku, 1957

Ogasawara, N., *Gyoken*, Tokyo, Mainichi Shimbunsha, 1999

Okada, Y. & Koyama, S., *Jōmon Teidan*, Tokyo, Yamakawa Shuppan, 1996

Sansom, G. B., *Japan: A Short Cultural History*, Tokyo, Tuttle, 1973

Sasaki, K., *Nihon Bunka no Kisō o Saguru*, Tokyo, NHK Books, 1993

Sasaki, T., *Nihonshi Tanjō*, Tokyo, Shūeisha, 1991

Sekiguchi, M., *Suijakuga*, series *Nihon no Bijutsu* no. 274, Tokyo, Shinbundō, 1989

Shiba, R., *Rekishi no Naka no Nippon*, Tokyo, Chūō Kōbunko, 1976

Shimane (Shimane Kenritsu Yakumo Tatsu Fudoki no Oka), *Seidōki no Sekai: Kantei Kōjindani to Kamosu Iwakura*, Shimane Prefecture, 1998

Stevens, J., *The Marathon Monks of Mount Hie*, Shambala, 1988

Sugahara, S., *Nihon Shisō to Shimbutsu Shūgo*, Tokyo, Shunjusha, 1996

Tanabe, S. (ed.), *Shimbutsu Shūgo to Shugen*, series *Nippon no Bukkyōo*, Shinchōsha, 1989

Tanaka, M., *Wajin Sōran*, series *Nihon no Rekishi* no. 2, Shūeisha, 1991

Tatsumi, J., *Majinai no Sekai II*, series *Nihon no Bijutsu* no. 361, Tokyo, Shibundō, 1996

Tokyo National Museum, *Hiezan to Tendai Bijutsu: The Art of Tendai Buddhism*, exhibition catalogue, 1986

Tōo Nippōsha, *Yomigaeru Jōmon no Kyodai Shūraku*, 1995

Torigoe, K., *Between the Gods and the Emperor: A New Reconstruction of the Early History of Japan*, Memoirs of the Research Department of Tōyō Bunko no. 33, Tokyo, 1975

Umehara, T., *Bi to Shūkyō no Hatten*, Chikuma Shobō, 1967

Umehara, T., *Yamato Takeru*, Tokyo, Kōdansha, 1986

Umehara, T. & Yasuda, Y., *Mori no Bummei: Junkan no Shisō*, Tokyo, Kōdansha, 1993

Waley, A., *The Nō Plays of Japan*, London, George Allen & Unwin, 1921

Warner, L., *The Enduring Art of Japan*, New York, Grove Press, 1952; London, Evergreen Books, 1958

Watanabe, Y., *Shintō Art: Ise and Izumo Shrines*, series *Heibonsha Survey of Japanese Art* no. 3, New York, Tokyo, Weatherhill, Heibonsha, 1974

Wontack Hong, *Paekche of Korea and the Origin of Yamato Japan*, Seoul, Kudara International, 1994

Yasuda, Y., *Mori to Bunka*, NHK Ningen Daigaku April–June 1994, p. 120

Yoshimura, T., *Kodai Ōken no Tenkai*, series *Nihon no Rekishi* no. 3, Shūeisha, 1991

Glossary

aramitama Angry and restless spirit.

Bodhisattva Enlightened being who postpones full Buddhahood in order to help other sentient beings attain Enlightenment. (*See also bosatsu*)

bosatsu See Bodhisattva

bugaku Form of drama originating in India and China and adapted for the entertainment of the Japanese court and the *kami* during the Nara period.

chigi Cylindrical beams projecting from the gables of a shrine building in the form of an X.

chokkomon Unique Japanese design of interlocking straight lines and curves with magical significance, perfected during the Kofun period.

cord pattern Characteristic decoration on ceramics of the Jōmon period, made by pressing twisted cords into the wet clay.

dogū Clay figurines from the Jōmon period.

dōsojin Figures of deities, usually of stone and sometimes in pairs, erected at crossroads, bridges, village boundaries and other susceptible places to protect against misfortune. The Bodhisattva Jizō often fulfils this function.

dōtaku Bronze ritual bell used in agricultural rites during the Yayoi period.

engi History or legend concerning a temple or shrine.

Engi-shiki Record in fifty volumes dealing with government, customs, court, etiquette and ritual during the seventh to ninth centuries. Completed in AD 927 and adopted in 962.

Fudoki Records of provincial customs, legends, agriculture and industry commissioned by the court in AD 713. Only the Izumo *Fudoki* survives complete, but fragments remain for Bungo, Hizen, Harima and Hitachi.

gagaku Imperial court orchestral music derived from Chinese origins and introduced into Japan during the Nara period. Instruments include the *koto*, *biwa* (a kind of lute), *shō* (a 17-pipe bamboo mouth organ) and various flutes and drums.

gantō-tachi Sword mounting of the Kofun period, with a bronze or iron ring pommel.

gigaku Masked dance drama which flourished in the Nara period, said to have been brought to Japan from Korea by Mimashi of Paekche.

gohei Cloth or, more usually, paper strips, folded into zigzag streamers and attached to a wooden wand as offerings for the *kami*.

go-shintai See shintai

hamon Pattern of crystalline steel along the hardened edge of a sword blade.

haniwa Literally 'ring of clay', placed around the mound tombs of rulers as guardians in the Kofun period. Originally cylindrical forms, they were developed to represent objects such as stirrups and houses, as well as the figures of warriors, shamans and animals.

harai (*harae*) Purification ritual, sometimes arduous, conducted by a Shintō shrine priest, involving prayer and the flourishing of a wand with sacred paper appendages.

himorogi Place or object serving as a temporary residence for the *kami*. (*See also yorishiro*)

honden Main building or inner sanctum of a shrine complex in which the *kami* resides (also *shinden* or *shoden*).

honjibutsu Original Buddhist form of *kami*, according to the theory of *honji-suijaku*.

honji-suijaku Origin and Manifestation theory, developed during the Heian period, which explained Japanese *kami* as manifestations of Indian Buddhas. *Kami* are often represented on mandalas paired with their Buddhist equivalents. (*See also honjibutsu, mandala*)

iwakura See himorogi, yorishiro

Jimmu Traditionally, the first emperor of Japan. (*See also Nihongi*)

jingū-ji Buddhist temples built within a shrine compound.

jinushi-no-kami (*chinjū*) A *kami* who protects a locality.

Jōdō The Pure Land of Amidism.

Jōmon Literally 'cord pattern', describing the decoration on the earliest pottery found in Japan, after which the period is named.

kabutsuchi-no-tachi Sword mounting of the Kofun period, with an egg-shaped pommel.

kagura Literally '*kami* enjoyment', a form of dance-drama, usually masked, in which episodes are enacted from Shintō creation mythology and other related ritual.

kaimyō Individual's Buddhist name, now allotted upon death.

kakebotoke Circular plaque with images of Buddhist deities or *kami*, usually made of bronze and often suspended under the eaves of shrine or temple halls.

kami Holy entities of Shintō. (*See also* pp. 14–18)

kanga Chinese-style painting.

katari-be Hereditary occupation of narrators of histories and mythology who served the court before and during the Nara period, a tradition which persisted in several provinces.

katsuogi Horizontal cylindrical beams placed across the roofs of shrines.

kegare Pollution associated with contact with sickness, death, menstruation and the eating of meat, broadened under the influence of Buddhism to include the concept of spiritual pollution.

Kei school School of Buddhist sculptors named after Kōkei, Unkei and Kaikei, who worked in Kyoto during the thirteenth century.

kentōshi Japanese official envoys to China during the Sui (AD 589–618) and Tang (618–906) dynasties. The missions were for diplomatic, trade and cultural exchange and often included Buddhist monks, and they ended because of political instability in China towards the end of the Tang Dynasty.

kikyō Attitude of respect, shown by kneeling and touching the ground in front with the hands extended.

kinugasa Long-handled parasol originating in China and used by the aristocracy during the Kofun period. These are sometimes included among shrine offerings and are used in some ritual Shintō processions.

kofun Mound tombs with stone chambers used for burial of rulers of provinces and the early emperors of the third to sixth centuries AD, and after which the period is named.

Kojiki Record of Ancient Matters, completed in AD 712, Japan's oldest extant chronicle. It records events from the mythological age up to the reign of Empress Suiko (r. AD 593–628) and was commissioned by Emperor Temmu (r. AD 673–86).

komainu, shishi Lion dogs and Chinese lions which stand in pairs as protectors at the entrances to shrines. The mouth of the lion dog is closed while that of the Chinese lion is open.

komochi Literally 'child-bearing', a term used to describe artefacts with smaller modelled shapes on their surface.

ko-shimpō Ancient shrine treasures withdrawn from their status as property of the *kami* after faithfully replicated replacements are offered to the shrine as part of the periodic regeneration ritual. (*See also sengū*)

koto Plucked stringed instrument of Chinese origin, usually played while kneeling on the ground, which features in the *gagaku* ceremonial court music.

kyōzō Figure of a deity inscribed on a mirror forming a symbol of a *kami*. (*See also mishōtai*)

magatama Comma-shaped ritual stone jewels, prevalent during the Yayoi and Kofun periods.

mandala (*mandara*) Painting, often of geometric design and usually in the form of a hanging-scroll, used in Esoteric Buddhism to demonstrate the relationship between deities, to depict their abodes on earth or to show Paradise, and frequently used as lecture aids by travelling monks.

miko Female shrine attendants originating in the female shamans of the Kofun period, or possibly earlier.

mishōtai, shōtai Symbol of a *kami*, usually in the form of a bronze mirror or sculptured image.

misogi Purification of the person with water or salt, ranging from rinsing the mouth and hands when visiting a shrine to total immersion.

miya-daiku Profession, largely hereditary, of carpenters specializing in the traditional building of palaces and shrines.

nigimitama Placated or gentle spirit.

Nihongi Chronicle of Japan, completed in AD 720. Japan's oldest official history, commissioned by Emperor Temmu (r. AD 673–86), covering events from the mythical age of the gods, including the creation myths, up to the reign of Empress Jitō (AD 686–97).

norito Shintō prayer recited by priests in praise of the *kami*, requesting tangible benefits.

oharai See harai

renjōmon Motif of parallel lines on ceramics of the Kofun period, made by impressing a comb across the surface of the clay and stopping it at intervals.

ryūsuimon Literally 'flowing water', a motif on ceramics and bronzes of the Yayoi period comprising wavy lines.

sabi Term used in the tea ceremony, denoting the concept of 'the patina of age'. (*See also wabi*)

sakaki Sacred tree, generally referring to *cleyera ochnacea* or *theacca* (japonica), a bushy evergreen shrub with narrow glossy leaves and small fragrant white flowers.

sandō Long passageway approaching a shrine, between the *torii* gate and the shrine building. (*See also torii*)

Sanshu no Jingi The 'Three Sacred Treasures', consisting of sword, mirror and comma-shaped jewels, which form the imperial regalia.

sengū Periodic rebuilding of shrine halls to ensure the continuing regeneration of the spirit of the *kami*.

senkotsu Cleaning bones by means of an initial burial followed by disinterment at a later date, in order to rebury the bones in clay funerary vessels.

shaku Flat wooden sceptre of authority, held by court officials and shrine priests.

shakujō Metal staff with six rings symbolizing the six realms of existence, carried by Jizō Bosatsu.

shimboku Sacred tree in which a *kami* is believed to reside, possibly girded by a *shime-nawa* (straw rope).

Shimbutsu Hanzan Rei Law of 1868 separating Buddhism and Shintō. Buddhist temples were dismantled and removed from shrine premises.

shime-nawa, shirikume-nawa Woven straw rope marking a sacred place or shrine.

shinden See honden

shinroku Sacred deer, originally messengers of the Kasuga Myōjin, the four tutelary deities of the powerful Fujiwara clan. Deer are allowed to roam freely in present-day Nara, where the Kasuga Shrine is situated.

shintai Literally 'kami body', a place or object considered to contain or represent the presence of the *kami*.

shishi See komainu

shoden See honden

shōtai See mishōtai

Shugendō Mountain asceticism, founded by the legendary religious leader En no Gyōja in the seventh century AD. (*See also yamabushi*)

shuji Sanskrit characters symbolizing Buddhist deities, frequently used in Esoteric Buddhism.

sueki High-fired stoneware ceramics made on the wheel, based on technology brought from Korea during the fifth century AD, predominantly used for funerary ritual in the Kofun period.

sugari-no-tachi Literally 'elegant slender sword', a type faithfully reproduced at periodic intervals at least since the Nara period as a shrine treasure for Ise Jingū. (*See also sengū, tamamaki-no-tachi*)

sumō Type of wrestling and a national sport of Japan. The object is to force the opponent out of the ring or to make him touch the ground with any part of his body other than the soles of his feet.

sutra Sacred Buddhist text containing the discourses of the Buddha.

suzu gyōyō Decorative flat pieces of iron, clad with gilt-copper and with small *suzu* bells along their edges, used as hanging decorations for horse harnesses during the Kofun period.

tamagaki Literally 'jewel fence', a fence surrounding a shrine building.

tamamaki-no-tachi Literally 'jewel-wrapped sword'. (*See also sugari-no-tachi*)

tate-ana kofun Vertical-entry stone chamber mound tomb of the Kofun period. (*See also kofun, yoko-ana kofun*)

torii Wooden shrine gate marking the entrance to a sacred shrine compound, usually consisting of two upright wooden posts supporting two crossbeams. From the Edo period some were painted red, but most are left unpainted. (*See also sandō*)

ujigami Originally an ancestral clan deity, later becoming indistinguishable from a local guardian *kami*.

ujiko Parishioner (local inhabitant) of a shrine.

umadaka Flame-decorated Jōmon pottery, named after the Umadaka site in Niigata Prefecture where it was first found.

vajra Ritual thunderbolt of Esoteric Buddhism and the attribute of a number of its deities. The single-pronged *vajra* represents non-duality; the three-pronged, the triple concept of Buddha, lotus and *vajra*; and the five-pronged, the five principal Buddhas.

wabi Term used in the tea ceremony, denoting restrained good taste as embodied in the concept of 'the quality of frugality'. (*See also sabi*)

Wei shi Chinese record of the Wei era (AD 220–65), compiled in AD 297, which includes a section on Japan before the unification of the nation, describing social customs and recording mutual diplomatic activity.

yamabushi Literally 'mountain sojourner', an adherent of the *Shugendō* cult. (*See also Shugendō*)

Yamato Present-day Nara Prefecture and the classical name for Japan, where, according to the *Nihongi*, the first emperor Jimmu settled. Yamato has been controversially identified with Yamatai, one of the pre-unification kingdoms referred to in the Chinese *Wei shi*. (*See also Jimmu, Nihongi, Wei shi*)

yamato-e Native Japanese painting tradition. (*See also kanga*)

yashiro Shintō shrine.

Yayoi Pottery style named after Yayoi in Tokyo, the site at which it was first discovered, and after which the period is named.

yōgō The presence for just an instant of a *kami* or Buddha, which may be indicated by a slight atmospheric change.

yoko-ana kofun Horizontal-entry stone chamber mound tomb of the Kofun period. (*See also kofun, tate-ana kofun*)

yorishiro Prepared place or object, such as a tree, stone or anthropomorphic image, in which the spirit of the *kami* resides and which is venerated as a representation of the *kami*. (*See also himorogi*)